Kathy Battista is a Faculty Member and Founding Prog......
Director of the MA Contemporary Art Program, Sotheby's
Institute of Art, New York and a writer and curator.

"For a clear, organized book about the current generation of young feminist artists and what they owe to the previous generations you can't do better than Kathy Battista's new book. Thoroughly researched and well written, this book will be referred to for years."

Betty Tompkins, artist

"An important book … it goes beyond a mere scholarly examination of feminist art, but accounts for a key feminist text itself."

Anja Foerschner, G12HUB Gallery, Belgrade

"Battista's unique understanding of an exciting new wave of feminist artists in New York dissects the umbilical cord connecting them to radical practitioners of the 1970s."

Catherine James, Lecturer in Academic Practice, University of the Arts London

"I recommend reading this carefully researched new book which chronicles both classic and the emerging new generation of feminist artists. You'll find, surprisingly, some of the most recent work to be both sexy and very entertaining. The book contradicts the common notion that feminist artwork can be dismissed as being just politically correct."

Dan Graham, artist, writer, male feminist

"Kathy Battista clearly has her finger on the pulse of the contemporary art world, for this deeply satisfying new wave feminist reader not only situates the here and now in the artwork and labor of early generations of feminist artists, but even more importantly expertly identifies the most relevant voices in contemporary art today, all of whom base their practice and thinking in the battles fought some 50 years ago. This is the story of half a century of critically important voices that we need now more than ever."

Eric Shiner, Artistic Director, White Cube, New York

NEW YORK NEW WAVE

The Legacy of Feminist Art in Emerging Practice

By Kathy Battista

I.B. TAURIS

LONDON • NEW YORK • OXFORD • NEW DELHI • SYDNEY

I.B. TAURIS
Bloomsbury Publishing Plc
50 Bedford Square, London, WC1B 3DP, UK
1385 Broadway, New York, NY 10018, USA

BLOOMSBURY, I.B. TAURIS and the I.B. Tauris logo are trademarks of
Bloomsbury Publishing Plc

First published in Great Britain 2019

Cover design: e-Digital Design
Cover image © K8 Hardy, *The Path 8*, 2011, courtesy of the artist and Reena Spaulings

A catalogue record for this book is available from the British Library.

A catalogue record for this book is available from the Library of Congress

ISBN: HB: 978-1-8488-5894-7
 ePDF: 978-1-7867-3482-2
 eBook: 978-1-7867-2482-3

Series: International Library of Modern and Contemporary Art

Typeset by Newgen KnowledgeWorks Pvt Ltd
Printed and bound in Great Britain

To find out more about our authors and books visit www.bloomsbury.com
and sign up for our newsletters.

Contents

List of Illustrations

List of Figures

List of Plates

Acknowledgments

I would like to thank the editors who brought this book into existence over the past decade. Liza Thompson, the original commissioning editor, showed great faith in inviting me to do two book projects; this book is a follow up to *Renegotiating the Body: Feminist Art in 1970s London*. I also had the pleasure of working with Anna Coatman in the formative stages of the project. Baillie Card played a key role by reading the first draft manuscript; her careful consideration and generous feedback helped shape the book into cogent form. And finally, Lisa Goodrum, Margaret Michniewicz, and Production Editor Arub Ahmed have taken the book into fruition and I've been delighted to work with them throughout the production phase.

I am forever grateful to the artists who spent time with me, sometimes on numerous occasions, to discuss, dissect and examine their work. I've benefitted from their generosity, hosting me in their studios, on Skype, as well as with telephone calls and emails. I am grateful to Diana Al-Hadid, Ange, Elizabeth Bick, Zoe Buckman, Judy Chicago, Coco Dolle, Cheryl Donegan, Zackary Drucker, VALIE EXPORT, LaToya Ruby Frazier, Rachel Garrard, Kate Gilmore, Sherin Guirguis, K8 Hardy, Micol Hebron, Susan Hefuna, Valerie Hegarty, Cindy Hinant, Katie Holten, Marta Jovanovic, Dawn Kasper, Mary Kelly, Lisa Kirk, Liz Magic Laser, Nadja Verena Marcin, Alex McQuilkin, Rachel Mason, Sarah Meyohas, Marilyn Minter, Narcissister, Virginia Overton, Alix Pearlstein, Carolee Schneemann, Colin Self, Tchabalala Self, Barbara Smith, Betty Tompkins, and Naama Tsabar.

I'd like to acknowledge the generous assistance given to me by several librarians in New York and Los Angeles. Erin Elliott, the founding librarian at Sotheby's Institute of Art NY, was a constant source of support and guidance. Her shining spirit and enormous generosity will never be forgotten. Tom McNulty at NYU Bobst Library is a wonderful colleague and supporter. And I'd like to thank the staff at the Getty Special Collections for several visits over the past years.

My colleagues at Sotheby's Institute of Art are always a source of inspiration and guidance. I am thankful to Kibum Kim, Tim Goossens and Lowell Pettit for offering useful suggestions. Kathleen Madden connected me to artists and gallerists.

Morgan Falconer, Judith Prowda and Elizabeth Pergam are sources of great collegiality. Melanie Mariño, Stephan Pascher and Amanda Olesen read drafts of chapters and offered formative advice. Former colleagues Mary Rozell, Jonathan Clancy and Lesley Cadman were also supportive during early phases of the book.

I am thankful to the many curators whose work has inspired me and who were so generous in their time: Catherine Morris, Sabine Breitwieser, Dean Daderko, Tim Goossens, Anke Kempkes, Omar Lopez Chahoud, Julie Martin, Maura Reilly, Anthony Spinello, Amy Smith Stewart, Nicola Vassel.

I am also appreciative to MA students who have given me suggestions for the book and in general provided inspiration, including Robin Newman and Alexandria Deters. Hadley Beacham and Adriana Pauly also provided meticulous and thorough research assistance. Natalie Ng stepped in as research assistant for the final phases and was essential to the completion of picture research and permissions as well as indexing.

I am thankful for the staff at many galleries and foundations who helped with image requests and rights, including Emily Bates at Gavin Brown Enterprise; Rachel Ng and Kathy Grayson at The Hole; Brittni Zotos at Andrea Rosen Gallery; Alejandro Jassan at Alexander Gray Associates; Laura Blanch at Galerie Laurent Godin; Jasmin T Tsou and Marie Catalano at JTT NYC; Ellen Robinson at Cheim & Read; Guilia Vandelli at Richard Saltoun Gallery; Isabelle Hogenkamp at Mitchell-Innes & Nash; Galerie Lelong & Co; Emily Wang at Reena Spaulings Fine Art; Bridget Casey at Ryan Lee Gallery; Adrian Piper Research Archive (APRA Foundation Berlin); Katarina Jerinica at The Estate of Francesca Woodman; Melissa Chase and David Alvarez at the Brooklyn Museum; Haley Shaw at Salon 94; Michael Apolog Gomez at Judy Chicago Studio; Alex Logsdail and Rute Ventura at Lisson Gallery.

Several galleries also supported this research by inviting me to curate exhibitions. Bosi Contemporary, formerly on the Lower East side of Manhattan, hosted two related exhibitions in 2014. Shulamit Nazarian entrusted me with the launch of a new gallery space in downtown Los Angeles in early 2017. The resulting show was formative for chapter five of this book. I also had the great fortune to curate a show at Fountain House Gallery in June 2017, which featured several of the artists in the book.

Finally, I am so thankful to have the loving support of family and friends who have been supportive throughout the development of this project. Arnold and Susan Battista have always believed in me. Sabrina Battista Gollust and Nick Gollust offered their home in Los Angeles on several occasions. Carole Feld and David Levy also hosted me and provided feedback on the project. Bridget and Polly Pierpont are constant sources of support as is RMP. And Fifi, my constant companion, is the angel that keeps me smiling.

Introduction

This book is the result of my attempt to answer many questions regarding the legacy of feminist art. How was feminist art initially received and how do we view it from a retrospective position? How have feminist themes been interpreted by artists and become incorporated within certain contemporary practices, from performance and activist-based works to more traditional media? How do emerging artists invested in feminism seek to build upon and move beyond the initial feminist strategies and approaches to create a nuanced practice for the twenty-first century? Why is a strident resurgence of feminism witnessed today in the work of young women as well as gay and trans artists? This book explores these questions among others, seeking to comprehend how we understand feminism's original impetus, how that has been interpreted over the past five decades, as well as its role in art practice today. The book presents contemporary practitioners who are well-versed in their feminist art histories and who create work that acknowledges, and in some places, challenges that of their forerunners. The artists presented in this book are discussed in terms of their relationship to specific themes, primarily including their engagement with historical practice, their interest in building upon such predecessors, and their parsing-out of gender relations and feminist issues in the early twenty-first century.

The emerging art presented in this book, in contrast with much of the historical feminist art discussed, is not necessarily acknowledged by the artists as feminist or primarily concerned with gender politics; equal gender representation is only one of several intersecting issues that concern artists today. Further, it is also relevant to all incarnations of gender

1

and sexuality; younger men, queer, and trans artists are also engaged with or are influenced by these debates alongside young female artists. As feminist theorists such as Judith Butler, Germaine Greer, Kate Millett, Betty Friedan, and Sheila Rowbotham have long argued, gender is a complex, constructed notion rather than a biological determination. The feminist editors and writers around the journal *m/f* were among the first theorists to embrace these complex formations of gender in Europe during the 1970s.[1] Today, these original theories, which were developed within specific intellectual circles and in academia, are still relevant, but to a much wider audience, as witnessed in the mass media, for example, in television shows as diverse as *Transparent* and *Rupaul's Drag Race*. Gender is no longer commonly accepted as a binary construction, but rather a spectrum of experiences. Today's artists engage and celebrate the plurality of positions within this debate, including the idea of an unfixed gender identity, resistant to traditional societal categorization.

After researching feminist British art of the 1970s for over a decade in London, I moved to New York to establish a MA program. Always eager to research the local milieu, I wanted to ascertain how feminism – in both the art world and popular culture – has impacted a new generation of practitioners based in New York whose professional lives had only begun in the twenty-first century. In most cases, these practitioners have been raised by parents who lived through the second wave of 1970s feminism and were educated by professors who participated within the debate; they listen to artists who have acknowledged the importance of feminism in popular culture, from Lady Gaga and Taylor Swift to Beyoncé and Anohni; they watch television series like *Girls*, written by the avowed activist (and daughter of feminist artist Laurie Simmons) Lena Dunham, and listen to podcasts by similar authors and personalities. It may be fair to say that feminism has never been so prevalent in the popular cultural life of the US. Like their radical predecessors, these younger artists continue to engage in debates over the body, gender assignation, sexuality, equal pay, and freedom of artistic expression. Indeed, after decades such as the 1990s when feminism was not at the forefront of public consciousness, the issue of women's rights has returned to the vanguard. Even before the new US administration was sworn in (in early 2017), feminism was experiencing a resurgence of interest. Now with a conservative government whose priorities include challenging previously hard-won battles such as *Roe v. Wade*, the importance of equal rights has once again become paramount. Each artist in this book is affected by the present government in

the US, and their work is an important form of activism, albeit overtly or in more discreet terms.

One might argue that the same observation could be made about emerging art practice in the Middle East, Asia, South America, or other such geographic areas. The events of the past decade such as the Arab Spring and protests in China have inspired artists to incorporate these issues into their work. However, I chose to narrow the scope of this book to present-day New York City, which occupies a unique position within the contemporary art world. New York is, and always has been, a multi-cultural city and as such the tremendous array of backgrounds and influences of artists is inspiring. It has historically been a city where people who are not accepted in other locations have sought refuge. While New York may be read as a microcosm of the larger world, in its plurality of races, languages, and ethnicities, it is also unlike any other place in the world. It has a character and frenetic energy unlike other cities in the United States. It is also the center of the art market, now an over-60-billion dollar industry anually. For this reason, I consider New York a fascinating and important litmus test for art practice and trends in art production.

New York is the city where many artists made history with practice informed by feminist ideology: from Joan Jonas, Merle Laderman Ukeles, Carolee Schneemann, Lorraine O'Grady, Adrian Piper, Mary Beth Edelson, Joan Semmel, Nancy Spero, and many others in the 1970s, to Barbara Kruger, Jenny Holzer, Cindy Sherman, and Laurie Simmons, who came of age in the 1980s, to recent "rediscoveries" of artists who have been working here for decades without proper recognition, including Betty Tompkins and Marilyn Minter. These women artists have played important roles in the institutional history of art, with major museums shows and publications; however, in the past decade they have also become important market players whose work is shown in international art fairs, galleries, and biennials. Yet, the market value of each artist mentioned above, with the exception of Cindy Sherman, is still a fraction of that of their male colleagues. For these opposing reasons it is important for me to understand how their work has informed the work of younger artists based in this city today. While we may feel that women artists today don't face the same issues that their feminist forebears did, it is plainly evident in the market that sexism still exists.

All of the feminist predecessors that I mention above are still active today. Thus, in one aspect the "legacy" of feminist art is embodied in their current

work. Laderman Ukeles was the subject of a retrospective exhibition at the Queens Musuem in 2016; Joan Jonas represented the United States with a new body of work at the Venice Biennale in 2015; Adrian Piper won a Golden Lion at the Venice Biennale in 2015 and currently runs a foundation dedicated to art, philosophy, and yoga. Carolee Schneemann continues to produce new video installations, and her work is now represented by major commercial galleries including P.P.O.W. and Galerie Lelong. She was also the recipient of The Golden Lion Lifetime Achievement Award at the Venice Biennale in 2017, an important indication of how central the role of feminist art has become in the mainstream art world. Thus, feminist art's legacy is also present in the current work of these pioneers. One could write a wonderful book on the twenty-first century work of second-wave feminist artists. For the purposes of this book, though, I am interested in how generations of feminist thought are evidenced in the work of young practitioners today.

There are also many artists from further-flung destinations whose work I am passionate about: Carmen Argote, Shirin Guirguis, Audrey Chan, AL Steiner, Rachel Lachovitz, Alexis Zoto, and Micol Hebron from Los Angeles; Julie Verhoeven, Oriana Fox, Marvin Gaye Chetwynd, Cally Spooner, Goshka Macuga, Nicola Tyson, Helen Marten, and Magali Reus from London; Shadi Ghadirian and Shohreh Mehran from Tehran; Pussy Riot from Moscow; Mengli Xi and Cao Fei from China, and so many more.[2] However, I focus on New York as it is the city that I inhabit and where I interact with artists across these generations. I hope that others will continue the work begun here on an international scope and include more women artists in their research.

New York is a rich and fertile ground for this type of activity, and it is a city where young people can express radical ideas without fear of punishment or isolation. In fact, these artists are often celebrated for their positions rather than persecuted, an important distinction from some of the artists in locations listed above.[3] Is it problematic to focus on a city that has largely and undisputedly been the center of the art market that in many ways is not a microcosm of the larger art world? It is precisely for this reason that it is imperative. In a city where young artists such as Oscar Murillo, Lucien Smith, Dan Colen, and others pejoratively referred to as Zombie Formalists, can reach atmospheric prices before the age of 30, artists are once again choosing, as did artists involved with Happenings, Judson Dance Theatre, and other movements in the late 1950s, 1960s, and 1970s, to challenge the status quo through non-traditional art forms such as performance and installation. As witnessed in the postwar art milieu where artists increasingly turned to a dematerialized practice with

works that employed new technology, performance, and time-based media, today there is a resurgence of radical, boundary breaking art practice.[4] In intervening decades, for example, the 1980s and 1990s, performance was scarcely seen as more traditional forms of painting and sculpture dominated the art world. There were of course exceptions – artists who never wavered from performance, such as Marina Abramovic, Karen Finley, Laurie Anderson, and David Medalla. However, since the millennium there has been a tremendous resurgence of performance-based work, as seen for instance in the New York-based Performa biennial established in 2005 by RoseLee Goldberg.

Art that challenges the art market, for example, that of Andrea Fraser or Wade Guyton, has also moved from the margins to the center. Such practice seemingly has a dialectical tension with the blue-chip art market; however, many artists who engage with a critical, polemical, or performative practice today have achieved market success: Ryan Trecartin, and the collaborative duo Jonah Freeman and Justin Lowe, are only two examples of many that could be named. In the past, artists who challenged the system, including Gustav Metzger and Hans Haacke, could not expect commercial gains. Stephanie Dieckvoss writes, "While deliberate efforts on the part of artists to subvert or challenge the market developed in the post-war period, they seem to have intensified in the first decades of the twenty-first century due to the rapid growth of the contemporary market."[5] Today, more than ever, ephemeral and radical practice is embraced by mainstream New York galleries such as Marian Goodman, P.P.O.W., and Galerie Lelong. With the recent political climate of protest in the United States, it is indeed an apt time to reconsider the influence of a generation of artists who were born out of the late 1960s protest culture and how today's emerging artists respond to this legacy.

A significant distinction between the emergence of feminist art and the first decades of the new millennium is the increasingly global nature of our world, and thus of recent practice. In the 1970s, feminist art was dominated by a middle-class, academic, predominately white population. This does not mean that they have ownership of this area, rather that the proliferation of art exhibited, published, and reviewed derived from this demographic. Important work in this field has been done to remediate this. It has been firmly established that feminism in this period was also thriving in Latin America and many other geopolitical regions, as well as in African American and Chicano communities of artists.[6]

Artists discussed here represent a plethora of cultures and ethnicities. This book is written in New York and thus occupies a typically diverse

perspective: artists from an array of backgrounds are part of the dynamic scene that comprises emerging art in New York. I have consciously recognized this plurality of experiences and hope that this is conveyed in the book. As always, the book represents a subjective and abridged selection of artists. Each artist discussed in the book is selected for their acknowledged interest in the legacy of feminist ideology and practice, as well as for the innovative quality of their own work, which moves forward an earlier discussion in a new manner. From self-portraiture as exploring one's identity and depictions of the female figure, to abstraction and conceptual practice, each artist in this book engages with feminist forerunners while advancing the issues from a twenty-first-century perspective. Several of the artists in the book have worked for artists – feminist or otherwise – that came of age in the 1960s and 1970s; the influence of the earlier artists on their work is profound. One caveat that I must acknowledge here is that similar to the range of practices and approaches to second-wave feminism, the current generation cannot be lumped together under a certain type of practice or heading; indeed, it is this diversity of approaches that makes the subject open-ended and inherently impossible to contain.

New York New Wave is titled as such to avoid placing a numerical wave on this generation of artists. While some have termed today's practitioners as fourth-wave, this is problematic in my view. Who articulates where waves begin and end? It is established that the first wave refers to the suffragists who fought for women's right to have an equal vote and thus an equal say in our governance. The second wave is becoming more clearly identified as we move away from it; the generation of 1960s and 1970s women artists, who came of age during the popular tide of the women's movement in the West, can be firmly recognized. However, it is more difficult to define where the third wave begins and if it has ended. For this reason, I term the artists herein as a new wave. It is also a nod to new wave popular music of the early 1980s, which grew out of the punk rock movement, but gained more widespread acceptance due to its synthesis of various styles. I find a correlation with the artists I've selected for this book, who likewise synthesize styles from a range of inspirations and sources, from feminist artists to popular culture and male artists of the Minimal and Conceptual Art movements.

This book emerges from meeting and working with many of the artists herein. It presents artists working within the legacy of second-wave feminist themes and practices, seeking to understand how these artworks sit within theoretical treatises on twentieth- and twenty-first-century feminism,

respecting and engaging with that discourse. I am indebted to the ground-
work laid by writers, including Catherine Grant, Kate Mondloch, Juli
Carson, and Amy Tobin, who look back at feminist art from a twenty-first-
century perspective. I'm also indebted to curators such as Maura Reilly,
Catherine Morris, and Cornelia Butler, who paved the way for a revival of
interest in feminist art by staging important exhibitions that redressed the
lacuna of institutional attention to this topic. I tackled my subject with a
curatorial methodology: I started with the artists themselves, doing studio
visits, looking at work, and conducting lengthy and successive discussions
with them, as well as with curators and writers who support this type of
work. I have also selected many of these artists for exhibitions and worked
with them in a curatorial capacity. Betty Tompkins, Cheryl Donegan,
Cindy Hinant, Narcissister, and Martine Gutierrez were included in *I'll
Be Your Mirror*, an exhibition I curated for Art and Culture, in homage to
the Nan Goldin Whitney Museum of Art mid-career retrospective of the
same name from 1997. Naama Tsabar, Cindy Hinant, Alex McQuilkin,
Sarah Meyohas and Virginia Overton were included in *Escape Attempts*,
an exhibition at Shulamit Nazarian Gallery in Los Angeles that looked at
the legacy of Minimalism from a twenty-first-century feminist perspec-
tive. Cheryl Donegan was included in *The Art of Fashion* exhibition that
I curated for Fountain House Gallery in New York.

I argue in this book that a body of new work – only a fraction of which is
detailed here – is indebted to feminist art of the preceding decades, intersected
with a host of other movements, styles, and influences. As feminist art was not
typified by a certain style or a unified format, unlike most art movements, art
informed by the women's movement took many and diverse forms. Today's
practitioners similarly engage with gender debates through a variety of
formats, from performance and video to photography, sculpture and concep-
tual, process-based art. The richness of this new landscape reflects the diversity
of positions expressed within the work. Throughout each chapter, I argue for
the continued relevance of earlier generations of feminist art, as well as the
importance of acknowledging this as groundwork for new practice that builds
upon this legacy.

In Chapter 1, I examine original concepts around feminism and fem-
inist art, as well as how this movement is now situated within art history.
I discuss feminist art in terms of curatorial practice, institutional support,
and its position within the art market. Feminism, which has seemingly
infiltrated into popular culture, is also discussed as an evolving ideology,

which sets it apart from other political and historical movements. I also situate New York City within this history. Indeed, its dominant position in today's market makes it an obvious choice for this examination.

In Chapter 2, I present an emerging generation of artists who revisit what are now considered canonical themes and works from earlier women artists – including those by Cindy Sherman, Francesca Woodman, Lynda Benglis – in places adopting their original formal language and inserting their reinterpretation of similar themes. Portraiture (and self-portraiture in particular) is a genre found throughout the history of art and especially feminist art practice. I discuss emerging artists who pay homage to earlier generations, through the lens of Catherine Grant's notion of the feminist fan, arguing that younger practitioners experiment with and advance upon the feminist tradition of questioning the representation of women. From painting and sculptural installation to digitally manipulated photography, I examine how artists are redefining and interrogating the conditions and expectations of the representation of women, carrying on a feminist aesthetic through themes of identity, role-play, and gender stereotypes.

Chapter 3 presents the legacy of performance art – as seen live as well as in documentation – and its central tenets. I discuss feminist performance art and the centrality of the artist's body in 1960s and 1970s art practice and how this has affected the work of younger artists. Also, a new generation of artists who do not use their own bodies in performance but adopt a directorial role is discussed. These artists in particular reflect a departure from earlier generations of performance art, finding their agency as conductors of activity rather than actors within it. This may be seen as a democratization and opening-up of performance art, a nod to the participatory trend of relational aesthetics, as well as an indication of increased institutional and financial support for such work.

Chapter 4 continues the discussion of performance art and the body, looking at the slippage of gender construction as exemplary of how feminist art has advanced: in the second wave of feminism, the social and biological construction of gender was central (although hotly debated) to much of the feminist debate. The same issues are examined today. However, the artwork produced by a new generation of artists – Narcissister, Kalup Linzy, Colin Self, Chez Deep, Martine Gutierrez – reflects the evolution of these themes, using humor and play as artistic devices.[7] The role of labor in this work, which often can appear effortless, is discussed for its relationship to feminist debates over division of labor as well as equal pay.

Chapter 5 examines how a current generation of artists is engaging and appropriating a formerly male canon of work. It analyzes how movements such as conceptual art, minimal art, and fashion photography, previously dominated by male figures, have been reexamined to excavate women artists of these genres who were previously overlooked. In the 1970s, feminist artists protested not only against their exclusion from major exhibitions but also against work that they found offensive: work that objectified the female body, for example, was a hot topic. When Allen Jones showed his *Women as Furniture* at Tooth Gallery in 1970 London, Laura Mulvey wrote a scathing critique of it, and she (with colleagues including Mary Kelly) protested the Miss World competition that same year. Since that time, younger artists have emerged to support similarly challenging work while still advocating a feminist position. In addition, many younger female artists reexamine minimal and conceptual art. This chapter presents the work of artist Marta Jovanovic who engages with the work of earlier artists, with equal doses of homage and critique. It also looks at the work of Cindy Hinant, Naama Tsabar, Alex McQuilkin, and Virginia Overton, who infuse the vocabulary of Minimal Art with their own subjectivities. A fitting end to my discussion of the legacy of feminist art, this chapter illustrates how younger artists concerned with gender quote from a variety of influences.

1 Feminism: The New Wave

Feminism has played a pivotal role in the historical trajectory of art in the twentieth century, irrevocably changing how the representation of gender is perceived and discussed. Feminist art was created by a generation of women who engaged with central debates around the women's movement in their art practice. Prior to this movement, the female body in the history of art was often limited to the idealized representation of the female nude, the Madonna, aristocratic portraiture, or the immoral or victimized fallen woman. These Venuses and Madonnas, primarily painted by male artists, make up the canon of Western art history. Feminist artists challenged many of these accepted norms of depicting the female within art.[1] Judy Chicago championed vaginal imagery, previously a taboo subject in the history of art, in an oeuvre that moves effortlessly across media, from paintings, ceramics, and large-scale sculpture to firework displays. As Germaine Greer wrote in her ground-breaking book *The Female Eunuch*: "The vagina is obliterated from the imagery of femininity in the same way that signs of independence and vigor in the rest of her body are suppressed."[2] Indeed, the vagina was deemed out-of-bounds as acceptable subject matter for centuries.[3]

Chicago, her colleague Miriam Schapiro, and 25 of their students – Karen LeCoq, Nancy Youdelman, Faith Wilding, Suzanne Lacy, and Janice Lester, among others – challenged the patriarchal role and male domination of art practice and pedagogy through their *Womanhouse* project, which ran from January 30 to February 28, 1972.[4] *Womanhouse* was a project in which Chicago

and Schapiro worked collaboratively with their students on the second feminist art program at the California Institute of the Arts to create installations and performances in a transformed abandoned mansion.[5] It is a landmark achievement in the history of feminist art that was influential and even replicated in London.[6] In this project artists challenged the notion of acceptable themes for art practice by including subjects such as rape, menstruation, marriage and childbirth. On the East Coast Martha Rosler, Joan Jonas, Mary Beth Edelson, Adrian Piper, et al. used their bodies in performance and video art that rejected the traditional means of art-making as espoused by the legacy of centuries of male painters and sculptors that came before them. Similar to the diversity of practice was the plurality of approaches to feminism, from the grassroots radical to the psychoanalytic or Marxist. Women artists and scholars questioned the male canon and whether inclusion within such was a feminist goal. In essence, I argue that scholars such as Nochlin, Pollock and Parker, Greer, and others created a feminist canon during this rich and fertile era of the 1970s, when feminist ideas were developed en masse in popular as well as academic circles.

The feminist art of the so-called "second wave" is understood to be the work associated with the popular rise of the women's movement, which had its initial stirrings in the late 1960s and came into its own by the middle of the 1970s. It is well documented that in the United States and Europe the impetus grew out of a popular movement where women campaigned for equal division of labor, both within the home as well as the workplace.[7] The Equal Pay Act (1963) in the United States and soon afterward in the UK, made it illegal to pay a woman a different salary than a man for the same position; however, we know that income distribution across genders is still not equivalent today. There is a dearth of female executives and those that exist, like women artists, are paid less than their male counterparts.[8] A *Fortune* 1998 ranking of the 500 most powerful companies in the US only contained two women CEOs; in 2013 the same list featured 28 females at the helm of the most powerful companies. While there has been progress, the inequity is by no means resolved.[9] This is not a dilemma that can be rectified overnight and a quota system would be flawed from the outset. Reverse discrimination favoring the female gender repeats the same tactics that feminism opposed: using a biological imperative to make policy decisions. While well-intentioned, positive discrimination is not a feasible solution; women still struggle to be recognized for their managerial and leadership skills. How can society ameliorate this imbalance?

A Woman's Place in the Art Market

Women's status in the art world has evolved similarly to the status of women in the corporate world. The National Endowment for the Arts reports that female full-time artists earn 81 cents for every one dollar by male artists and auction data reflects that only two women artists make the list of 100 most expensive artists of all time.[10] While there has been slow progress, the disparity is by no means alleviated. Indeed, the ebb and flow of progress is frustratingly sluggish. Perhaps it is this glacial pace that is a factor in the current resurgence of radical feminist art. While many of the artists in this book, who embrace difficult themes or challenging imagery, are represented by galleries, the stakes are still low for most artists taking a feminist position. The art market surges around them, yet these artists continue to make work that challenges and resists the upper echelons of the commercial system. Their critical and popular success proves that feminism has become more mainstream and even fashionable, but is still considered of lesser value than that of their male colleagues. As Carolee Schneemann has said, "Every smart gallery says 'Hey, I need a bad-mouthed cunt. Who's wild and crazy? I need one. Don't give me two. Just one…'".[11] Her quote is effective for discussing how the market has viewed feminism in the recent decades: they embrace it, but too often only for novelty value and not as an ongoing, abiding focus.[12]

Auction records are not perfect gauges of the market as more than half of the artworks sold globally are exchanged in gallery and private sector deals and therefore are not publicly recorded; however, they can be important indicators of collecting trends. Take, for example, Kara Walker and her contemporaries Chris Ofili and Robert Gober. In a May 2011 auction Kara Walker's *Desire–A Reconstruction* (1995) sold for her record price of $350,000. Ofili's *The Virgin Mary*, made just one year after Walker's record-breaking sale, sold for $3,939,250 in 2015. Gober's *The Silent Sink* (1984) sold for $3,600,000 in 2014. Ana Mendieta, an established and almost mythological fixture in both academic and institutional contexts, had a record price of only $168,682 in 2008. It signals progress that women artists, especially Walker and Mendieta, whose works challenge male authority and were radical gestures at the time of production, have entered the mainstream auction market. It is notable, though, the disparity in record prices in their works. In short, there is still a long way to climb towards market equality.

A team of economic researchers, including Renee Adams, Marco Navone, Roman Kraussl, and Patrick Werwijmeren, have been studying why artworks

of male artists fare better than those of women artists. Limiting their study to artists born after 1850, artists whose works were traded on at least 20 occasions, and ruling out artworks that broke the $1 million tier as that could skew the statistics, their sample found a 17 percent pay gap between male and female artists. The gap was most acute in countries where cultural bias against women, measured by labor participation, tertiary education enrollment, and percentage of women in parliament, was also high. Navone says:

> We think, but can't be certain, that cultural gender bias plays a role in the price gap, but it has been decreasing in the past 40 years in the US and Western Europe. Although on average, the price of artworks by female artists is still lower than male artists' work, nevertheless prices have been growing closer.

They also determined that investing in women artists therefore brought a higher return, at over 6 percent, than investing in male artists, at just under 5 percent.[13]

In the same article the authors quoted Cindy Sherman: "Women artists have to prove themselves exceptional in order to get their foot in the door, to be considered for something, whereas many, many mediocre men artists easily get by."[14] Sherman has come the closest to bridging the gap on this market disparity. Her *Untitled Film Stills* (1977) sold for $5,900,000 on 12 November, 2014. Her colleague, both in terms of age as well as gallery representation, Richard Prince, had a high-selling mark in 2016 with *Runaway Nurse* (2005–6), which sold for $8,500,000. However, most of Sherman's female colleagues sell for much less. *ArtNews* ran a feature about the disparity in prices for female artists in December 2014 after a Georgia O'Keefe painting sold for $44 million and a Joan Mitchell sold for $11,900,000 in May that year. The author noted that between 2008 and 2012, the 100 highest-selling lots did not include one female artist. In the same article, the philanthropist and activist Elizabeth Sackler was quoted on this disparity:

> Art sale statistics are a symptom, fighting for more money is but a Band-Aid … The disease we face is fundamental disrespect for women and unacceptable attitudes that women's thinking, observations, and creative output hold little value. I point you to the November 12, 2014 Christie's Post-War Contemporary Art auction that featured 82 lots: 79 men and three women.[15]

Sackler's words are poignant in that there is often a disconnection between the price of an artwork and the intrinsic value it plays in the history of art and the production of knowledge. While women artists are edging upwards in terms

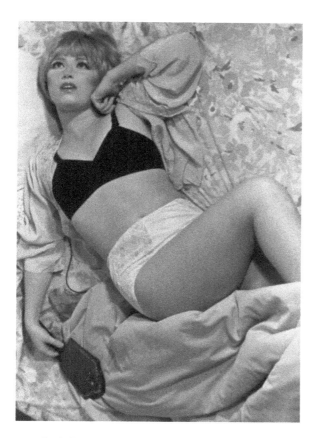

1.1 Cindy Sherman, *Untitled Film Still #6*, 1977. Gelatin silver print, 10 x 8 in. Courtesy of the artist and Metro Pictures, New York.

of market status, there are many more aspects to consider when analyzing feminist art practice, including gallery and institutional representation in terms of landmark exhibitions.

Feminist Exhibitions: From Blockbusters to the Local

As the representation of women in the contemporary art world has evolved in tandem with that of the corporate workplace, slowly the gender distribution of artists in galleries and major public collections has improved.[16] In the latter half of the first decade of the new millennium, there was a shift in museum practice and feminist artists transformed from relative obscurity to becoming the subject of

major exhibitions. In 2007, the blockbuster *WACK! Art and Feminist Revolution*, curated by Cornelia Butler, originated at the Museum of Contemporary Art Los Angeles and traveled to MoMA/PS1 and the National Museum for Women in the Arts in Washington, DC. *WACK!* represented an international and comprehensive approach to feminist art and, most importantly, showed a variety of work; the paintings of Miriam Shapiro, Lynda Benglis, and Audrey Flack; sculpture as diverse as Senga Nengundi and Ree Morton; performance documentation from Rose English, Adrian Piper, Yvonne Rainer, and Carolee Schneemann; and video work by Dara Birnbaum, Martha Rosler and Joan Jonas.

Another groundbreaking exhibition, *Global Feminisms*, also took place in 2007 at the Brooklyn Museum, to celebrate the opening of the Elizabeth A. Sackler Center for Feminist Art, which provides a permanent home for Judy Chicago's iconic installation *The Dinner Party*. Curated by Maura Reilly, this exhibition focused on contemporary feminist art from 1990 onwards and opened the dialogue to a wider diasporic community of artists. Featuring over 80 artists, the show not only presented a global perspective, it also challenged the Western strand of feminism that dominated the discourse in previous decades. Unlike *WACK!*, *Global Feminisms* presented mainly new media work, perhaps an inherent quality of work produced post-1990.[17] New media, including sound and digital art, are typically seen as more progressive modes of art production, free from the patriarchal domination of centuries of painting and sculpture. This type of practice also cuts across geographical borders and national boundaries, making it easier to share and create a dialogue in our digital age, compared to more physically cumbersome work.

Critical response to the show was tepid. Peter Schjeldahl wrote in the *New York Times* that it was "intermittently enjoyable"[18] and Roberta Smith wrote an ambivalent review of *Global Feminisms* in the *New York Times*, citing many important issues. Her concluding statement is quoted below:

> After the press releases proclaiming a "museum within a museum," the smallness of the Elizabeth A. Sackler Center for Feminist Art is surprising. But perhaps it will become unnecessary: it will certainly never be able to accommodate all the art, by women as well as men, that has feminist consciousness somewhere in its DNA. The word feminism will be around as long as it is necessary for women to put a name on the sense of assertiveness, confidence and equality that, unnamed, has always been granted men.[19]

Smith's misgivings about the exhibition at the Sackler Center concern the depressingly small space dedicated to art practice informed by feminism,

which she acknowledges as no longer a solely female paradigm. From the point of view of a student in the 1990s, for whom *The Dinner Party* was only an image in a book, and not available to be seen installed in a museum, the Sackler Center's permanent installation of the landmark exhibition, as well as new work made with a feminist agenda, is a welcome and significant addition to work by feminist artists.

That such an iconic and canonical work of feminism – representative of the collective spirit of the women's liberation movement – is now permanently accessible, is a momentous paradigm shift.[20] As other movements such as Pop Art, Minimalism, and Abstract Expressionism are part of the permanent collections of major museums of modern art, so should feminist art be included in a history of twentieth-century practice. Smith acknowledges the importance of this when she writes of feminism as "more important than Pop, Minimalism or Conceptual art because it is by its very nature bigger than they are, more far-reaching and life-affecting."[21] This mindset has been sorely lacking in past institutional practice. Museums are now scrambling to cover the holes in their collections; this is indeed another reason why feminist art has been increasingly seen on the marketplace in recent years.[22] In addition, the escalating market for work of blue-chip male artists of the 1970s has meant cash-strapped museums can find "bargains" with feminist art only recently gaining real worth, albeit still at a fraction of that of their male colleagues.

In 2008, the Guggenheim Museum in New York mounted two solo exhibitions devoted to the work of female artists. A full career retrospective of Louise Bourgeois was followed by *Catherine Opie: American Photographer*, a mid-career retrospective of the queer, LA-based artist and teacher. The latter featured work from a variety of her series of American subjects, from Midwestern landscapes to surfers, as well as the gay, lesbian, and trans community, representative of the artist's subjectivity and social milieu. These two artists represent polarities of the feminist spectrum: Bourgeois, who never identified herself as a feminist artist, nevertheless produced a body of work engaged with themes of identity, domesticity, trauma, and sexuality, became a role model for younger generations of artists – both female and male – who continue to explore such themes. Today she is considered a feminist. Opie is exemplary of a generation of artists who openly identify their sexual politics, have achieved market success and critical recognition, and make work engaged in the discussion of these ongoing themes. Her medium of choice, photography, still considered a new media genre, was only integrated within the canon of contemporary art in the preceding two decades, and was hitherto

seen as a less prestigious art form. Her interest in looking beyond the heteronormative model of US life, may also be considered as feminist.

The Guggenheim's decision to mount these exhibitions in the same year signaled progress: while in the preceding decades it was difficult for a female artist, let alone a feminist artist, to get into in a museum or gallery, in the early twentieth century they have entered the mainstream, albeit in minuscule numbers. A recent article cited the scarcity of exhibitions by women artists at the Museum of Modern Art – New York since the launch of its new building in 2004. In nine years of exhibitions there were only four solo shows dedicated to female artists. *New York* magazine critic Jerry Saltz commented on this disproportionate attention to female practitioners:

> If four shows in nine years sounds low to you, and it should, recognise that for MoMA this actually counts as progress. The museum's department of painting and sculpture, its largest and most prestigious division, went 16 years without mounting a solo show of a woman artist: before Murray, the last woman to get a proper MoMA retrospective was Helen Frankenthaler in 1989. Things get worse when you head downstairs to the painting and sculpture collection, where fewer than 10% of the art in the gallery's by-the-numbers tale of 20th Century art is made by women. … It amounts to apartheid…[23]

The Saltz article denounces the museum for neglecting to integrate women artists into their display of the nineteenth- and twentieth-century galleries, which are among the most popular in the museum.[24] Except for Louise Nevelson or Helen Frankenthaler, one would think the history of modern art was a solely male terrain if seen through the eyes of the MoMA displays. The 2017 survey exhibition *Making Space Women Artists and Postwar Abstraction* attempts, albeit as an afterthought, to redress the lack of women's monographic shows. However, this exhibition could have been ten separate exhibitions: it appeared the museum was trying to fix decades of underrepresentation by putting so many women artists in one exhibition. This lack of representation of female artists within key movements of twentieth-century art results in a lack of knowledge for young artists and historians. These major exhibitions affect emerging practice, as witnessed in the shift in art production related in this book.

Former PS1 and independent, openly queer curator Tim Goossens[25] discussed the outcome of exhibitions (including *WACK!*), suggesting that such blockbusters attract a wide range of visitors, including a large demographic of

art students and young artists. He acknowledged both the importance, as well as the shortcomings, of these large-scale feminist curatorial projects:

> What these big exhibitions (such as *WACK!)* did not do enough is engage with a younger generation of artists who address a third or fourth wave of feminism, and they kept it too historical, which perhaps makes sense in a first wave of trying to formulate a feminist art history. A lot has happened since Linda Nochlin's seminal article, but at the same time a lot still needs to be achieved. I also see the feminist fight connected to the Black/Afro-American art history fight and the queer art history struggle, so in a way lots of histories are piled together and many issues are combined in what isn't always seen as various separate questions of legacy.[26]

Goossens describes the intersectionality of Afro-American, queer, trans, and feminist art history as consciousness-raising ideologies. The civil rights movement called for equality between races; feminism called for equality between genders; and the queer rights movement called for the end of the criminalization and oppression of people based on their sexuality. The initial stirrings of feminism paved the way for further gender studies, queer theory, and coincided with the fight for inclusion of African American and Chicano art into an institutional art historical canon. Sadly, it seems that even with the scarcity of exhibitions devoted to women artists, institutions have progressed further with the exhibitions confronting gender difference than with issues of race or sexuality.

Goossens says:

> What Latin art is for the museum today (a new challenge, and a new focal point for many of the collections) is what feminist art was ten years ago. Luckily today people such as Yoko Ono and Hannah Wilke are part of the general art history and no longer need to be addressed only in courses of feminist art.[27]

It is true that a handful of female practitioners from earlier generations are part of a mainstream history, yet so many more remain occluded. Indeed, as museums in New York have begun to hire Latin American specialists, the legacy of feminist protest and research is evident in the plurality of curatorial and academic approaches today.[28]

Future Feminism is an exciting "relaunch" (as one of its members, Kembra Pfaler, has called it) of consciousness-raising championed by a collective of artists including Anohni,[29] Kembra Pfaler,[30] Joanna Constantine,[31] and Siera

and Bianca Casady;[32] this concept was discussed in intensive workshops over several years. The collective first presented their project to the public in September 2014 with an exhibition and a 13-night performance series at The Hole gallery in downtown New York.[33] Originally presented as a monologue on Anohni's live album *Cut the World*, this "essay" draws on radical feminism and queer politics, confronting religion, mainstream politics, and ecology with references from Sarah Palin and Gore Vidal to the Pope and the Dalai Lama. Anohni performed this as a seven-minute live soliloquy during an event with the Danish National Chamber Orchestra. Her words are striking for their simplicity and call to action:

> I'm someone who's looking for a reason to hope, and for me hope looks like feminine systems of governance being instated in, like, the major religious institutions and throughout corporate and civil life. And it might sound far-fetched, but if you look at your own beliefs, just imagine how quickly you accepted the idea that the ocean is rising and the ecology of our world is collapsing. We can actually imagine that more readily than we can imagine a switch from patriarchal to matriarchal systems of governance – a subtle shift in the way our society works.[34]

The concept of Future Feminism aligns transgender and queer communities, as well as the ecological preservation of the earth, admittedly a utopian ideology. In this regard it can be aligned with the second wave of feminism as witnessed in the 1970s; it is, for a contemporary position, curiously similar to the ecofeminism of Aviva Rahmani or Rebecca Solnit.[35] Artists across generations – from forerunners Lorraine O' Grady, Marina Abramovic, Lydia Lunch, Carolee Schneemann, and Laurie Anderson to younger artists including Narcissiter, NoBra, Dynasty Handbag, Jessica Mitrani, and Terrence Koh – created events and performances for a 13-day period.[36] Each performance, talk, reading, or film screening confronted the conflicting notions around feminism today, from Beyoncé preaching feminism at the Video Music Awards to the desperate condition of our global climate.[37] Some were sober and contemplative, such as Lorraine O'Grady's performance where 25 invited artists each read a paragraph of her seminal article on Manet's Olympia.[38] Others, such as Dynasty Handbag and Narcissister, used humor, music, and popular culture as foils. Still others, such as in a panel discussion chaired by Ann Snitow, approached the state of feminism today and future feminism as a concept from an academic perspective. Delivered to a packed audience with a large demographic of young women in their early twenties, it was encouraging to see that recent discussions

around feminism had evolved from a largely academic contingent. Suddenly it was on-trend to be a feminist; one of the most fashionable downtown New York galleries was supporting these events, which were all sold out, and merchandise related to the topic was being sold.[39] *Future Feminism* became a place to congregate and celebrate as well as a place to be seen.

Future Feminism is emblematic of a more encompassing approach to gender studies in recent years. The 13 tenets which were devised over several intensive workshops between the five collaborators include mantras such as "THE SUBJUGATION OF WOMEN AND THE EARTH IS ONE AND THE SAME"; "ADVOCATE FOR FEMININE SYSTEMS IN ALL AREAS OF GOVERNANCE"; and "RELIEVE MEN OF THEIR ROLES AS PROTECTOR AND PREDATORS". The legacy of Jenny Holzer's Truisms and Barbara Kruger's confrontational slogans are obvious forerunners here as well as mainstream catchphrases from the women's movement, such as "The personal is political."

But this alignment of women and nature that is a central tenet of *Future Feminism*, and a familiar concept in the history of ecofeminism, was increasingly seen as problematic.[40] The creation of a dyad between a male and female, natural and manmade world, is too easily formulated. These idealistic musings, while well-intentioned, seemed retrogressive and somewhat naïve to the theoretical branch of feminist thinking that gained precedence in the 1980s, although there has been too much generalization around this strain of feminism.[41] Eleanor Heartley has recently written on ecofeminism, and how the catastrophic effects of climate change have made many reassess the view that it was somehow reactionary:

> Rejecting the dualistic and mechanistic vision of nature that has dominated Western culture since the Renaissance, a feminist-inflected view proposes metaphors that stress the interrelationship between humanity and nature, and regards nature as an organism whose health depends on the well-being of all its various parts, human and nonhuman alike.[42]

The *Future Feminism* project succeeds in integrating the societal malaise of late capitalism across genders, locations, and infrastructures; from government to religion to the art market, the Future Feminists seek active reform. The exhibition of the 13 tenets, printed on pink marble tondos – an ironic nod to Biblical commandments – seemed the least consequential aspect of the project; the energetic gathering of young and older generations, of men and

women, of downtown and uptown, was the beacon signaling that feminism was back in force in 2014 New York.

Another exhibition that ran concurrently with *Future Feminism* on the Lower East Side in New York also took contemporary feminism as its theme. Artist Coco Dolle curated an exhibition at Sensei Gallery featuring artists who work across disciplines and styles, with the commonality that they all identify as feminists.[43] *Milk and Night* is a collective of artists and curators who explore the role of feminism, past and present, in the art world. This exhibition presented the feminine experience in all its sensual glory and is important for its intergenerational dialogue. Seasoned art world veteran Betty Tompkins showed one of her *Fuck* paintings. Ange, from the fashion team threeASFOUR showed prints from her Instagram-based art series, a daily posting on social media that turns selfies into feminist statements.[44] Jemima Kirke, better known for her role as an actress in Lena Dunham's HBO series *Girls*, presented more traditional work in the form of a painted self-portrait.

The young performance artists Go! Push Pops also participated. Initially a trio, now a duo, Go! Push Pops (Katie Cercone and Elisa Garcia De La Huerta) wear outrageous outfits with exuberant colors, long hair extensions, and exude a playful sense of unabashed style. They met at the School of Visual Arts in New York (SVA), when they found they were both interested in feminism as a way of art and life. Speaking about their interest in intergeneration feminism, both members acknowledged their debt to earlier generations as well as the urgency to come to New York City:

> Katie Cercone: I studied feminism and wrote my undergraduate thesis on feminist art of the 1970s, mostly Californian, and then I went to art school because I was so motivated by that and came to the United States for feminism.
> Elisa Garcia De La Huerta: I became interested in feminism reading about contemporary artists, women artists from the 1980s, and just wanted to be here...[45]

Go! Push Pops, as well as a wide array of individual practices in *Milk and Night*, had much the same message as the Future Feminism exhibition just a short distance away: that feminism was once again at a groundswell and that young practitioners felt it was an important touchstone for their practice. This was picked up in the critical response to the exhibition. Kate Messinger wrote in the *New York Observer*:

> The belief that feminism can be an intrinsic part of living, rather than reduced to a political posture – that everyone is inherently a feminist if you believe in equality – is a unifying theme between the work at "Milk and Night" and The Hole's "Future Feminism."[46]

While the critical reception was supportive, the significance of the self-organized and alternative approach echoes tactics of the second-wave feminist movement of the 1970s, including the Guerrilla Girls, as well as fanzine Riot Grrrl culture of the 1990s, and Pussy Riot in the twenty-first century, to name only a few of the many instances of such collaborative factions.

An important New York space run by women should be noted here. Cleopatra's was a small gallery in Greenpoint founded by four women: Bridget Donahue (formerly of Barbara Gladstone and Gavin Brown and now of her own eponymous gallery), Bridget Finn and Erin Somerville (both formerly of Anton Kern Gallery), and Kate McNamara (then a curator at PS1 and now at RISD). They signed a ten year lease on a former studio space of an artist friend. The name came from a disused sign on the awning that read 'Cleaopatra's delicatessen'. Each of these founding members, while ensconced in key institutions of the upper echelon contemporary art world, felt that they wanted to work beyond the confines of commercial or hierarchical constraints. Cleopatra's was not specifically dedicated to feminist art, but its experimental nature and general ethos reflect a feminist ideology.

McNamara commented on this:

> I believe Cleopatra's was a feminist project, though not explicitly, and feminism can and should engage all genders. I think that by showing all genders within the context of an all female-run space, we reflected a feminist strategy and one could not help but look at the work with a feminist lens. All women-run spaces like NYC's A.I.R. or Providence's Dirt Palace are incredibly important and again were influential in many of the ideas, tools and strategies employed by Cleopatra's.[47]

Also like *Womanhouse* and *A Woman's Place*, Cleopatra's was a do-it-yourself space where ideas could be tested. Exhibitions here ranged from young artists who had not previously shown in New York to esteemed figures including Michel Auder, early work by Jessica Stockholder, solo work by the gallerist Janice Guy, and a show about curator Lynne Cooke's curatorial process. Cleopatra's also mounted shows of untrained artists, for example Irving Feller, an 83 year old furrier around the corner who had maintained an art studio for over fifty years that was full of paintings and drawings.

The breath of the work on display echoed the programming of The Situation Room and is evidence of the departure from earlier forms of alternative feminist exhibition practice. After ten years of their lease, and two members leaving for jobs in other cities, Cleopatra's closed in early 2018. It remains an important example of women working outside of the confines of the established system, on virtually no budget, and presenting the work of colleagues and friends that they admired. Set outside of the rent-driven worlds of LES and Chelsea galleries, this type of DIY space, in addition to the exhibitions devoted solely to feminist art, is born out of the legacy of second-wave feminist practice.

Feminist Art History Today

In the second decade of the twenty-first century, gender studies and feminism are integrated into the canon of higher learning in the visual arts. This insertion into the mainstream educational system, as well as the institutional world of museums, is an ambivalent position. Does being in the mainstream mean that your views are no longer radical? And what now constitutes the avant-garde? Has feminism reached its goals? And concurrently that would beg the question, have we achieved racial, economic, and sexual equality? Feminist scholars today take a retrospective position and consider how their education was formative and how to convey this to successive generations. For example, in the genre of gender studies, some of the binaries of first-wave feminism – straight/lesbian, motherhood/career, makeup/no makeup, bra/no bra, radical/mainstream, intellectual/grassroots, and so on – have proven overly reductive. Binaries such as these only served to segregate feminists; rather than probing the nuances and differences among feminist practitioners, many took these simplified dichotomies on board, which fractured the movement and hindered its impact. The term post-feminism, originally intended to move beyond such binaries, actually became bastardized to embody them.

Post-feminism is a term that was coined by Susan Bolotin in 1982 and popularized in the 1990s in common parlance and mainstream media.[48] This popular usage connotes a resolution to the problem of gender inequality, which is certainly not evident in society, the larger art world, or the contemporary art market. The term post-feminism may be confused by the proliferation of other "posts" coined at a similar time, including postmodernism, an umbrella term to suggest the fractured state of understanding human experience in the latter half of the twentieth century and "post-colonialism," which indicates a specific historical

period that can be read as a precise era when European powers gave up their colonial dominions. Post-feminism was discussed for the first time in an academic milieu by Toril Moi in 1985 in her book *Sexual/Textual Politics*.[49] In its popular usage, post-feminism suggests, like postmodernism, the status "after" feminism, in the backlash generation as described by Susan Faludi. Feminism in this perception becomes at its worst pejorative, and at its best an outdated word. Amelia Jones writes of the danger of subsuming feminism into the postmodern condition. Critiquing the work of Jameson as well as Freudian scholar Laura Mulvey, Jones warns of the so-called feminine power to "disrupt" modernist purity:

> These incorporative disempowerments of feminist critiques are crucial to art criticism's maintenance of certain modernist and ultimately authoritative and masculinist models of artistic value even under the guise of postmodernism. As suggested earlier, these models draw from avant-gardist ideologies to construct oppositional categories of "progressive" versus "regressive" postmodern art practices...[50]

Misha Kavka wrote that Moi's connotation was not a temporal indicator, as in "after" feminism, but rather a break in the idea of feminism that "would deconstruct the binary between equality-based 'liberal' feminism and difference-based or 'radical' feminism."[51]

Feminism as an alternative position will continue to disrupt and serve a specific purpose, providing a foil to the homogeneous modernist paradigm. Feminism is thriving and is still an urgent necessity, as seen in the current political climate in the United States. The correct use of Moi's post-feminism, and its rejection of binaries, is more relevant than ever today, as a way of unpacking gender politics in art. Feminism itself is not a sufficient word to incorporate the plethora of positions – straight or LGBTQ – into its parameters. Kavka eloquently writes that feminism "is but one name for the pursuit of justice, unifying the multiple histories of particular struggles that sometimes overlap with and sometimes work against one another."[52] Her redefining of feminism is useful when applied to what constitutes feminist art today.

Marcia Tucker, the first female curator at the Whitney Museum and founder of the New Museum, discussed in 2006 some of her misgivings about the inherent boundaries associated with the term feminist art. Her words are prescient of the new interest in a more plural, "Future Feminism":

> I have often said that I don't want women having what men have, women substituting for men. I want to change the power structures that create inequity in the first place. ... That's one of the reasons I have some real

doubts about the term *feminist art*. There are feminists who make art, there are feminists who make art that has a real political resonance, but the literal, to me, is the death of art... But you take an artist like Barbara Kruger, or Nancy Spero, or Cindy Sherman or Leon Golub – or *any* of the people who make so-called political art – it resonates on so many levels, it's so complex. It far transcends a label that you could put on it.[53]

What Tucker was discussing hadn't yet been termed as intersectional feminism; today her thoughts would be acknowledged as such.

Movements in popular culture reflect this sentiment, which opposes the ghettoization of feminism and resists the tendency towards binary positions. Madonna, Lady Gaga, Taylor Swift, and Beyoncé hold tremendous power in the global entertainment industry and yet transform themselves on a daily basis with makeup, hair, and costumes, flaunting female sexuality where the stakes are high; writers such as Alice Walker and Sapphire have made successful feature films based on women's struggles, in particular with patriarchal oppression and sexual abuse; Oprah Winfrey has partly based a career on the public's identification with her as a survivor of childhood abuse, poverty, and racism; movements such as the Riot Grrrls in 1990s grunge music and female hip hop artists have challenged the recording industry's male dominance.[54]

The international outrage and subsequent acclaim of Pussy Riot has also attributed to how twenty-first-century feminism has become fashionable to a younger audience. This dispersal of feminism is equivocal though; while the wider sweep of feminist thought is certainly a positive outcome of the initial movement, the plurality of feminist stances makes unified action difficult to achieve. Madonna's celebration of her sexuality in the 1990s may be read as a feminist stance. Beyoncé is taken seriously as a role model for young women while she performs in a skimpy Tom Ford bodysuit at the Video Museum Awards. These artists liberate their sexuality and use their own bodies as vehicles in the mass media, much as feminist artists did in a smaller circle of influence. These performers subvert oppressive hierarchies, though subsequently exploit them for commercial benefit. They understand that powerful female sexuality can be commodified and know the value of their cultivated personas. Feminism here becomes a capitalist imperative that can be monetized for personal rather than collective benefit, as originally intended.

As Alison M. Gingeras has written, "From the 19th century Suffragettes to the advent of Women's Studies to the hit tv show *Girls*: there has never been a unified, consensual Feminist vision."[55] Her words reflect that of so many others – Roberta Smith and Kavka included – that the guise of feminism takes

many incarnations. Feminist art has likewise taken many forms, from second-wave painters including Mira Schor, Sylvia Sleigh, Margaret Harrison, Joan Semmel, Miriam Schapiro, Audrey Flack, and Betty Tompkins, to performance art, installation, video, and conceptual work. This formal diversity continues today and will be further explored in this book. The younger feminists included use a variety of formal approaches to create work informed by gender politics. For example, while performance is still a main area of production, many artists have now stepped out of their work into a directorial role, as discussed in Chapter 3.

Part of the complexity of a retrospective view of the germination of feminist art history is understanding how to teach this to current and future generations of students. Art historian Moira Roth remarked on her own practice of relearning the canon: "Let me begin with my own re-education ... to teach myself to examine, and ultimately to reject, the underlying male assumptions about art history that had been presented as the objective voice of scholarship during my graduate training."[56] Artist educators are also asking similar questions. Judy Chicago, whose non-profit, Sante Fe-based organization, Through the Flower, has created a curriculum for teaching her seminal work *The Dinner Party* in schools, says,

> Yes, more women are showing. Yes, more women are represented in collections. But they still fit into a meta-male narrative. One of our goals is to integrate women's history into the mainstream, so it is no longer a separate, minor phenomenon. There is still an institutional lag and an insistence on a male Eurocentric narrative. We are trying to change the future: to get girls and boys to realize that women's art is not an exception – it's a normal part of art history.[57]

Chicago's patron Elizabeth Sackler was for several years chair of the Brooklyn Museum of Art and institutional practice evolved under her leadership as a strong feminist activist in one of New York's most important museums. As we approached the decade anniversary of the Sackler Center for Women's Art, now under the guidance of curator Catherine Morris, it was possible to take a retrospective look at the various activities and events of the past decade. Rather than creating a ghetto, it has become an important alternative platform for women artists, who are still statistically grossly outnumbered by male artists in the museum and institutional world.[58] For example, in summer 2017 Morris's exhibition *We Wanted A Revolution: Black Radical Women 1965–85* staged an overlooked part of feminist history.[59]

It is important to note that merely working with themes associated with feminist art – the use of the body, especially in live, confrontational performance; the reclamation of feminine and queer sexuality; materials as diverse as hair, textiles and embroidery, and in general "low" or so-called "trash" culture; self-portraiture as an construction of identity – does not mean an artist labels her/himself as feminist. It is rather that feminist tropes have become integrated into twenty-first-century art practice. In an era when almost anything is available at the touch of our fingertips feminism is no longer a grassroots movement but an significant cultural reference. Also, feminism has now spanned several generations so that most of the artists in this book grew up with this concept in all of its diversity, as part of our cultural consciousness. Judy Chicago spoke about the dearth of feminist predecessors for her as a young artist:

> Because there were so few visible women artists, I grew up mostly looking at male art and there were many role models among those artists in terms of their level of achievement. When I was young there seemed to be so few women who had been able to achieve at the level to which I aspired. Mostly it was men who had had that privilege. As I attempted to realize my creative goals, I kept encountering this intense resistance from the art world. I got to a point where I decided to look back at history to see if any women before me had faced and overcome similar obstacles, which is why I started looking back and learning about them. They played a very specific function for me, providing me with female role models, which I desperately needed. But only a few of them were artists and therefore, I had to forge my artistic identity primarily from what I learned from male artists.[60]

Feminist consciousness is pervasive even when unacknowledged or demeaned. Feminism is not only overtly present but has over the past 40 years irrevocably changed the way we think about art, the body, the relationship between the viewer and the artwork, and the innovation of various art practices.

The obvious change in the study of feminist art history is the huge influx of material that is now digitally available. As a graduate student in London during the 1990s, there were few options for studying feminist art: trawling through the body of literature on second-wave feminist art; scouring ephemera at libraries with feminist collections; or speaking with the practitioners themselves. Much has changed in the subsequent decades. Helen Chadwick's notebooks are digitized and available online on a site called *Turning the Pages*, hosted by the Henry Moore Institute in Leeds; Stanford libraries host *!Women Art Revolution*, the archive created by artist Lynn Hershman Leeson, an excellent online resource for artist interviews, among other things.[61] Many such examples now

exist and librarians, as much as artists and curators themselves, are an important part of this sea change. Also, in terms of open access, sites including YouTube, Ubu, and Vimeo, as well as social media platforms Instagram, Facebook, and Snapchat, mean that full-length works and snippets of artists' films and videos, interviews, and performance documentation are more than ever before available. Information today spreads instantaneously throughout the globe, except where censored, forbidden, or inaccessible via local infrastructure. This necessarily means that feminist art is easier to access, learn about, and discuss. Artists working in different corners of the globe can find sympathetic colleagues located thousands of miles away. This creates an advantage that artists of the 1970s did not have and represents a tremendous shift in accessibility of feminist material.

Beyond Gender: Feminist Strategies in Action

Feminist art practice has also, in the succeeding decades from its original stirrings, found resonance in the practice of mainstream male artists. The tendency towards the excavation of personal trauma, the construction of identity, as well as the use of low culture, punk aesthetic, and everyday objects, as evinced in 1970s–1990s feminist art, has been witnessed in work by subsequent generations, including the prominent artists Mike Kelley, William Pope.L, and Robert Gober. Their use of everyday objects differs from that of the Arte Povera or Pop Artists; here the "everyday" is unequivocally American, so-called "low culture," the result of late capitalism, including cheap foodstuff and condiments, stuffed toys, and dolls. The embrace of themes pioneered by feminist artists includes an exploration of the domestic, the use of everyday interrogation of personal history, and a confrontational approach.[62] Kelley, who was a student of Judy Chicago's at CalArts, discussed his oblique relationship to a feminist aesthetic that began as a student:

> when I went to art school I was really shocked to discover how much things were split on gender terms. Like when you took sculpture it was all men except for ceramics ... and so feminist art was something where that was the only place such issues in art production were starting to be discussed and where you could have some discussion, well maybe I don't want to make I-beam sculpture. I don't want to be David Smith. I want to make some other kind of sculpture and what would be the interest in doing something like that.
>
> Now in my background coming up out of Hippie culture such things were already talked about in terms of daily activities like oh you are going

to grow your hair to long or you are going to walk around in a dress or you are going to do this or do that? So all of these gender issues were already there in daily culture in a kind of counter culture and I was surprised when I went into art that they weren't so much operating there at least in kind of dominant art culture. So feminist art seemed to be of course this attempt to bring those kind of concerns into the art world.[63]

Kelley's words recount the position of a male artist who did not want to make typically male, heteronormative work. Feminism's conduit into counter-culture contributed to a negative perception in the public eye. Feminists don't wear bras, feminists hate men, feminists are angry; these are only some of the clichés that a new generation is still working to ameliorate. Today we understand that feminists take a myriad of guises, from corporate CEOs to stay-at-home mothers. Feminism in its initial stages may have been associated with 1960s counter-culture, but today it has moved into the mainstream, albeit not with total consensus.[64] Part of the backlash against feminism today is a misunderstanding of the ideology; it is not a prescriptive set of rules and actions, but rather covers a range of ideological positions. Unfortunately, there are many who mistake feminism as a stringent set of rules; for example, I want to get married and have children, so I'm not a feminist; I don't hate men, and so on. These simplified binaries, as discussed above, are misunderstood and not carefully considered.

Younger artists have acknowledged that feminism is no longer something one has to learn but is ingrained in our culture. New York-based Aurel Schmidt discussed how feminist concepts seemed pervasive in New York culture during her upbringing, although she did not engage directly with feminist theory:

I don't think you really need to be aware of feminist theory to under-stand the idea of feminism. I grew up in the 1990s and 2000s and I feel like everyone is aware of the basics of it. You don't need books to get an idea of sexism and feel like you don't want to take part in that behavior.[65]

Artists discussed in this book, including Schmidt, have become engaged and move beyond the important work that has been laid out by previous generations of feminist artists and activists.

New York: A Center for Radical Feminism

New York has long been a center for feminist activity. In the 1970s, many of the leading proponents of feminist art – Joan Jonas, Martha Rosler, Carolee

Schneemann, Adrian Piper, Lorraine O'Grady, Mary Beth Edelson, Betty Tompkins, Merle Laderman Ukeles and many more – lived and worked in the city. At that time, New York provided cheap living and work space; artists rented or bought lofts that are now impossible to acquire or even occupy as a young artist. Today, New York is one of the world's most expensive places to live; in the 1970s, downtown New York was a post-industrial wasteland and became a focal point for feminist and radical artists. Los Angeles also became known as an important center for feminist art, much due to the work done by Judy Chicago and Miriam Schapiro and their feminist art program;[66] however, New York was a crime-ridden and dangerous city, very different to the laid-back West Coast atmosphere. The work created in the respective cities reflects the ethos of each location.

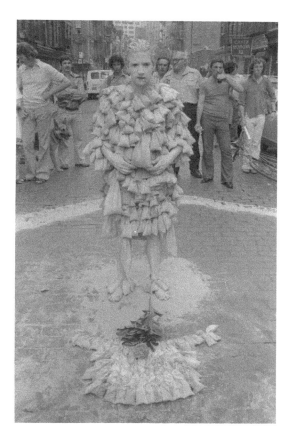

1.2 Betsy Damon, *7,000 Year Old Woman*, New York, 1977. Photography: Su Friedrich. Courtesy of the artist.

Martha Rosler commented on the distinction between East and West Coast feminism:

> Some of the differences between the East and West Coasts may be instructive. The West Coast women tended more toward the formation of communities, creating their new discourse and working toward instituting their ideas within the context of those communities. In New York, with its larger network of people and the allure of the preeminent art institutions, activities were often directed outward. Consensus seemed to be based on political actions and statements rather than on collective adjustments of theory, study, and art-making, although study groups were an important element. But intellectual considerations were broader, and there were more competing theories, and East Cost women were unlikely to seize on a few simple tenets such as the "vaginal imagery" thesis.[67]

The formation of collectives and communities on the West Coast enabled large projects such as *Womanhouse* to take place.[68] The "vaginal imagery" discussed by Rosler was indicative of the group of artists associated with Schapiro and Chicago. Long considered an essentialist strain within feminism, today it might be more productive to view it as related to the material culture of the West Coast. Incorporating techniques such as surfboard and automobile construction, ceramic making, and embroidery was undeniably West Coast in spirit.

The tenor of East Coast work can be understood when looking at some of the direct street actions created by feminist artists. Betsy Damon performed her *7,000 Year Old Woman* on the street in New York in 1975, appearing as a Neolithic goddess with her body and hair painted white and lips painted black. She was covered by 400 bags of colored sand to suggest the breasts of Artemis of Ephesus. Damon cut each sack of sand in a ritualistic performance.[69] Adrian Piper's *Catalysis* works from 1970 similarly tested the limits of people's tolerance by engaging in repulsive acts in public spaces of the city. For example, she rode the subway and shopped for books covered in vinegar, eggs, and cod liver oil and walked through the lobby of the Plaza Hotel with helium balloons attached to her hair, teeth, and nose.[70] A few years later Jenny Holzer's *Truisms* (1977–82), as seen displayed on an electronic sign in Times Square as part of *Messages to the Public* in 1982 continued in this tradition of direct confrontation of viewers in urban space. In this series the artist created pithy slogans such as "PROTECT ME FROM WHAT I WANT"; "ABUSE OF POWER COMES AS NO SURPRISE"; and "I AM AWAKE IN THE

PLACE WHERE WOMEN DIE." Laura Cottingham's *Not For Sale* and Lynn Hershman's *WAR: Women Art Revolution* are both video essays that speak to the distinctions between East and West Coast strains of feminism and are excellent resources for further reflection on the distinction between the two geographical centers. While this book focuses on New York, it is important to remember the interaction between the East and West of the US. For the reasons cited in my Introduction, the following chapters present a selection of today's NYC based-artists artists working in the legacy of feminism across both coasts.

2 Revisiting Feminist Artworks and Re-envisioning a Feminist Practice for the Twenty-first Century

The emergent generation of artists is among the first to have an era of feminist practitioners from whom to learn. Where feminist artists of the 1970s were keen to create signature aesthetics through the use of new materials, including their own body, textiles, found objects, photography, and video, artists of the emergent generation now have the luxury of embracing decades of female art created across these media. Indeed, women from the first generation of feminist artists have commented on the lack of historical role models; the lacuna of information available on women artists was equaled by a shortage of literature in the movement at that time. Suzanne Lacy discussed this lack of feminism in the literary tradition with fellow artist Lynn Hershman Leeson:

> Well, remember that was in '68/'69 and the beginning of the feminist movement was just starting to occur in this country. And there was very little written – there was Betty Freidan, and *The Feminine Mystique* ... and Simone de Beauvoir's *Second Sex*, that was it. Anybody that was beginning to get the sense of these ideas had very little to draw on.[1]

A reclamation of the history of women's practice was a major tenet of an original wave of feminist art critics. In the United States, Linda Nochlin's influential essay "Why have there been no great female artists?" examined the socioeconomic factors that hindered women's inclusion in art history. British historians Roszika Parker and Griselda Pollock, in their book *Old Mistresses*, attempted to redress the dearth of female "masters" by reclaiming artists such as Angelika Kaufman and Mary Cassatt. This reclamation, which has been an

ongoing project only begun in the 1970s, continues today. Most recently, the art market has been witness to a period of reclamation, with artists including Hannah Wilke, Carolee Schneemann, Betty Tompkins, and Linder now populating the booths of major art fairs. For decades work by these artists had virtually no market value.

One of the integral shifts is that a current generation of artists has a history of women's art to draw upon, reference, and advance. Nochlin wrote in 2003,

> In 1971, I wrote an essay titled "Why Have There Been No Great Women Artists?" but I don't really believe that "greatness" is the issue at present. Women artists are recognized as among the most stimulating, provocative, and visually inventive of contemporary art makers."[2]

An article in *The White Review* reported findings that 30 percent of the artists on show in London were female.[3] This is obviously not going to remain static; it is also a significant increase from an earlier era where the Guerrilla Girls reported that 4 percent of the works on view in a museum were made by women. (The Guerilla Girl) Kathe Kollwitz spoke of the incident that caused the group to form:

> In 1984 the Museum of Modern Art opened an exhibit called "An International Survey of Painting and Sculpture," and in this exhibition there were one-hundred-sixty-nine artists, very few were women or people of color. I think the number of women was thirteen or seventeen. It was pretty pathetic. So the women's caucus for art I think it was called a demonstration in front of the museum and I remember Frida Kahlo and I, the Guerrilla girl Frida Kahlo, and I Kathe Kollwitz, went to this demonstration.[4]

The Guerilla Girls themselves have moved into the mainstream on an institutional scale. Their work has been shown at La Biennale Venice Biennial 2011, they have made appearances on popular television shows, and are now hosted by museums, such as their Twin Cities Takeover in January 2016.[5] The increase from under 10 percent to 30 percent of female artists shown is noteworthy. It is clear that the numbers are working in the right direction, although the market share of women compared to male artists is still appreciably lower.[6]

In this book I argue that there is a marked increase in the mining of women's art by an emerging generation of practitioners. Now that there is a history to draw upon, refer to, critique, and expand, artists discussed in this chapter

refer to both historical and living women artists who have made significant contributions to the history of art practice. Some younger artists continue to use themes from the work of Lynn Hershman Leeson, Margaret Harrison, Jo Spence, Cindy Sherman, Barbara Kruger, and others; some artists actually reference earlier feminist artworks or artists themselves as a form of homage.[7] Referencing earlier generations, I argue that these artists carry forward feminist debates and ideologies even when they are building on the history of art produced by male artists; however, they do so in a multi-layered manner consistent to their twenty-first-century context. Their practices are an important development in today's art ecosystem as they represent a resurgence of interest in and acknowledgement of earlier generations of feminist art.

Fandom and Homage to Feminist Artists

In order to articulate the complex relationship that some younger artists have with their feminist predecessors, it is worth examining Catherine Grant's writing on fans of feminism. Citing a recent nostalgia for the political past of the late 1960s and 1970s, Grant uses the figure of the fan to discuss how younger artists riff on feminist artists from this era. Grant writes:

> The figure of the fan, then, combines the reader with the writer, and sees the fan object as a key component in the formation of the fan's own identity. The passionate attachment to the object of interest is one that is not passive, but instead alters the object to suit the fan's needs, taking a fascination for something as a starting point, which can then also start a process of negotiation and transformation of the object.[8]

I will use Grant's concept to discuss the work of artists who quote from earlier artists, building upon the earlier practice to serve their own needs. Many of the artists that I write about below have acknowledged an admiration close to fandom for the work of earlier artists. However, they take liberty to create works that, as Grant says so eloquently, "combin(e) the past and present in an active dialogue, one that does not seek to simply reinstate the past, but to rework it differently, passionately, and perhaps even politically in the present."[9]

Cindy Hinant is an artist who hails from the Midwest, but relocated to New York to study,[10] and now lives and works there. She is a notable young practitioner who revives questions regarding gender, sexuality, and desire, which were prevalent in second-wave feminism, in her work. From

self-published books of pornographic fan fiction dedicated to Britney Spears[11] to drawings and videos, Hinant's work cuts across media, borrowing amply from her predecessors to raise questions that have not been resolved.

Hinant has made work with direct reference to a founding generation of feminist artists. *Women* (2010) features the torsos of iconic women artists Lynda Benglis, Francesca Woodman, Carolee Schneemann, Hannah Wilke, Marina Abramovic, K8 Hardy, and Yoko Ono. Each artist is presented from belly to neck, in a detail from appropriated photographic imagery from their iconic works. For example, *Women (Lynda)* shows the artist's body from her infamous 1974 *Artforum* ad, where she posed naked except for sunglasses and a double-ended dildo. The source of much outrage, this incident is notorious in feminist art history and has become a symbol for the confrontational nature of much of the work made at that time. Hinant, however, says it was not Benglis but Hannah Wilke that inspired this work:

> Hannah Wilke was the inspiration for my piece *Women* because she makes me wonder if and how women can take control over their own sexual image. I like the ambiguities and contradictions in her work and I notice that I trip over the same issues as her. It's amazing – the process of re-appropriating your own body from popular consumption. How could she not fail?[12]

Women elucidates in the ambivalence of its creator. While Hinant acknowledges a tremendous debt to the second wave of feminist artists – the work is not possible without theirs as palimpsest – she also knows the pitfalls of making provocative work and its perception by a mainstream audience. Hinant's *Women* implies the fandom that Grant has illustrated: it reworks the past into a present where issues around feminist artists and nudity is still a complex, unresolved argument.

Aurel Schmidt[13] also created an homage, albeit of a different sort, to Lynda Benglis's controversial ad in her drawing *Lynda* (2007). Typical of Schmidt's hyper-realistic confrontational drawing, which includes burnt-out sections of paper as well as the collaging of everyday objects, *Lynda* is a simple composition. Resembling a face, the drawing uses two burnt-out sections for eyes and a double penis for the smile, executed in Schmidt's trademark meticulous style in pencil on paper. The double-sided dildo is a direct reference to Benglis' 1974 *Artforum* intervention. The subject of great controversy, this was actually orchestrated by the artist's gallerist Paula Cooper, who helped Benglis place her work of art in the November issue of the magazine. By 1974, an

artist intervention in an art magazine would not seem unusual; Dan Graham had used magazines as sites for interventions since the previous decade. The problem with Benglis, however, was that she dared to flaunt her sexuality as a female artist, a troubling action at that time and, arguably, still problematic today. Subscriptions were canceled, vitriolic letters were written, and it resulted in two high-profile editors, Rosalind Krauss and Annette Michelson, leaving to start the theory-driven journal *October*. In 2009, *New York Times* critic Roberta Smith made this astute observation:

> The most startling phallus in the picture is perhaps the metaphorical one that results from this fine-tuned perfection: the sense of empowerment, entitlement, aggressiveness and forthrightness so often misunderstood to be the province of men. This more than any object, penile or otherwise, is what Lynda Benglis waved at the art world."[14]

What is less known in the mythology of this incident is that Robert Morris had also placed an ad in the same issue, showing himself nude in hardcore sadomasochistic garb of a metal collar, heavy chains, and a World War II soldier's hat; this, however, did not garner the resistance that Benglis's nude and dildo did.

Schmidt spoke about Benglis's controversy and her own drawing:

> That *Artforum* thing she did was really interesting to me. Some of the work I have done with photography was definitely inspired by that: to not give people something safe, giving them exactly what they want deep down, but making it so open and shoving it so far down their throats they choke a little, just a little though, as we need to smile too.[15]

In Schmidt's inimitable style, she draws from references as diverse as feminist art and old masters to so-called low culture to allude to a decisive moment in feminist activism. Schmidt's visual vocabulary employs beer cans, cigarette butts, condoms, and bloody tampons, much in the vein of feminist predecessors such as Judy Chicago and the *Womanhouse* project, who confronted what were taboo subjects at the time: vaginal imagery, sexual liberation of women, rape, and in general experiences specific to women. Schmidt's work has also been compared to Arcimboldo, the Italian Mannerist painter who made portraits out of plants.[16] As Grant has discussed, Schmidt may be considered as a fan of Benglis, with nostalgia playing an important role in this work. She, however, takes it into the twenty-first century with a punk aesthetic that owes as much to Pussy Riot as it does to second-wave feminism.

Rachel Mason's *Starseeds* (2014) may also be read in terms of the fan in a direct manner that owes much to fandom in popular culture. Born in 1978, Mason makes work across sculpture, performance, video, and installation as well as writing and performing music with her band Merry Band of Sailors. After completing her MFA at Yale, Mason was the assistant of Joan Jonas, a formative experience that influenced her work. Mason illustrates deference to an earlier generation of women artists quite literally with her large sculptural and video installation *Starseeds*.[17] Mason says Starseeds are "people from another planet who come to earth specifically to fulfill a mission", a wry definition of artists and creativity.[18] The main formation of this work includes 30 medium-sized dolls that personify artists across both visual arts and music including Joan Jonas, Missy Elliott and Lil' Kim, Yoko Ono, Ana Mendiata, Björk, Madonna, Frida Kahlo, and Marina Abramovic.[19] Mason made the work in homage to the artists that she felt most indebted to. The figures began as Victorian style, mid-sized dolls, with traditional, historical clothes. The heads, faces, and hairstyles were modified to resemble the artist: Frida Kahlo's prominent unibrow; Yayoi Kusama's pink wig; Lil' Kim's red bob haircut and cheeky sneer; Joan Jonas's similar short, fair-colored hair. Mason created dolls' outfits constructed from shards of mirrors that reflect their environment and create a constellation-like effect. The 30 dolls are exhibited throughout the gallery in a total installation, which includes colored geometric patches on the wall and floor. Some dolls are placed as if growing out of a geological formation; suspended from the ceiling as if floating through the sky; others rest on wall plinths and other crafted structures.

The reflective outfits of the dolls are admittedly part of the artist's projection of herself onto this feminist history:

> I was moving a piece in my studio which happened to have a mirror in it and the mirror shattered. I immediately took off the clothes of one of the dolls and placed some of the mirror shards on her and it just clicked. I saw myself reflected back in the dolls – and my own reflection was fragmented – and that is exactly when it hit me that I needed to make a mirrored uniform – and that this whole project was another kind of self-portrait.[20]

In an accompanying video installation, Mason dons a similar mirrored dress and sings to the doll audience, performing a tribute to her beloved icons and role models. Mason's iteration of fandom may be considered as close to the attachment that a teenager might have for a favorite singer. By becoming one of the dolls she integrates herself into the history of feminism that she is paying homage to, similar to Grant's concept of passionately reworking the past.

Dolls are typical products used by celebrities and film stars as spin off merchandising for fans. Dolls and their component parts, however, have long been a theme in the history of art, from Bellmer's dismembered figures to Cindy Sherman's macabre 1980s series that includes doll parts. The second-wave generation of feminist artists also used dolls as a symbol of both female innocence as well as the domestic situation. For example, Kate Walker's *Death of a Housewife* installation and accompanying performance from 1974 included a dresser full of doll parts. Interestingly, dolls still remain a toy marketed towards and used primarily by female children and adults. Mason's dolls are reminiscent of the imaginative, adolescent world of dolls that children – typically female – use to develop ideas. The artist discussed the use of dolls:

> for me they were more connected to the anxiety about being an artist. And about the final state that an art object attains as a collector's item. I thought about that in relation to my aunt's doll collection. I had often stared at these dolls in their fixed position in a vitrine in her house and thought of course about the horror movies where dolls come to life, but also simply in that strangeness of a grouping of individuals presenting themselves in a line. I wanted to delve into that experience with this project and the video in which I placed all the dolls in a single backdrop accomplished that image for me.[21]

Mason's admiration for female role models also recalls, Chicago's excavation of historical women for *The Dinner Party*. Both artists were concerned with the domestic and everyday as well as elevating female artists into icons for future generations.

Like Mason's multifaceted work, Lisa Kirk's *Revolution* is a multi-platform project that has unfolded over a decade, taking the form of a perfume, live action, sculpture, video, and photographic intervention. It is inspired by feminist predecessors, from Linder to Martha Rosler, who have commented on advertising and consumption. While working on an exhibition that the artist curated called *Bonds of Love*,[22] Kirk met a parfumer with whom she began an ongoing collaboration. Kirk, whose work has an abiding sensibility towards the ephemeral – she made cakes with slogans on them at art school – began to investigate the concept of what revolution would smell like. In today's world we are bombarded with products to buy that will make us feel, look, or smell better. This project is a comment on the rabid consumption of late capitalist society, as well as the political atmosphere of living in New York in the first years of the new millennium.

Kirk's decision to work on the theme of revolution was a response to the heavy policing in contemporary culture post-9/11. She spoke of

the government's insistence on going out shopping to avoid our misery over September 11 and the fact that we couldn't protest any more because any kind of political action was villainized and basically considered a threat in this new realm of terrorism and terrorist paranoia.[23]

Revolution was not possible if one wanted to remain a law-abiding citizen. You couldn't have a public gathering of protest without risking arrest.[24]

Kirk began to work with the parfumer Patrick Choux to create several options of scents that captured the smell of revolution. Interviewing living revolutionaries and activists, the artist identified the various smells associated with revolution, from blood and tear gas to burning rubber and decaying flesh. She also created, with the help of New York-based goldsmith Jelena Behrund, pipe bomb sculptures in silver, gold, and platinum that resembled Molotov cocktails. These became the boxes that hold the plain vessels for the scent that was developed, akin to the sculptural bottles of perfumes that are produced for the mass market. One of the first iterations of this project saw Kirk gather several artists and friends to dress in revolutionary clothes as part of a happening at SculptureCenter in Long Island City. The artist shot a video and constructed faux ads resembling a photo campaign for the perfume that eventually were shown on billboards and on buses in Baltimore as part of a public art project.

This ongoing series of projects also included an action at Participant, the longstanding non-profit space in New York City helmed by Lia Gagitano, a supporter of both avant-garde and performance art. At this 2008 event two interns dressed as revolutionaries with ski masks while they handed out perfume blotters with three versions of the scent on them. The artist describes it as "an informal consumer study" that involved the participation of the visitors at the opening. Kirk spoke of the power of the ski masks: "The blotters actually took on this life of looking like a knife because of the ski mask. It was strange that this would happen because it was just this pointy little white stick, but your subconscious would attach that shape to a weapon."[25] Visitors would make their choice as to which scent was most revolutionary and were then given the opportunity to write comments on the walls of the galleries. Eventually the perfume was made available for sale at various outlets including the shop at the Ace Hotel in New York and Quartier 206 in Berlin.

A commercial for the perfume is a disturbing and hilarious take on the perfume ads so ubiquitous in our culture. One cannot walk a block downtown or move through any large public space (think train stations, airports, malls) without being confronted by a billboard of a semi-clad or undressed[26] woman or man selling a fragrance. Kirk's commercial is quite the opposite: the

commercial begins with music set to iconic shots of New York City including the Brooklyn Bridge and the terrace-house fire escapes typical of lower Manhattan. A shot of a person in black boots and jeans running through the city cuts to a shot of a sniper with a gun. The sniper shoots, we hear sirens and see a briefcase thrown to the ground, as well as fire trucks and people looking stunned in the streets. Two figures in black from head to toe meet on a street sidewalk. One pulls off his ski mask to reveal a handsome man and the other reveals a beautiful female. She opens her hand and one sees Kirk's metal pipe bomb and the words "REVOLUTION a fragrance for men & women." The video uses the same absurd language of perfume campaigns (especially the 1990s Calvin Klein ads for Obsession) while signaling a much larger and disturbing issue: the media's manipulation of the threat of terrorism and the sense of "foreignness" that is cultivated when the mainstream press try to make sense of such threats. "America" is seen as a pure, law abiding, loyal entity with the xenophobic "other" as threat to moral integrity and peace.

Kirk's project also investigates the notion of women as consumers. Since the postwar period women have been the target of advertising, first as the gatekeepers of the household budgets, and then with the advent of feminism as individual consumers with their own disposable income. Kirk's perfume, which comes full-circle from an artwork to a luxury item that can be purchased at specific boutiques, both engages and critiques this consumptive tendency. While she is critical of the fact that our society relies on consumption, and obsolescence in particular when it comes to fashion, she also cannot escape its clutches. The commercial for REVOLUTION is disturbing in that it proves that even terrorism can be made to look seductive, through the use of camera work, professional models, and iconic architecture.

This recalls the work of a generation of feminist artists who critiqued the consumption of mass media imagery, for example, Martha Rosler's *Bringing the War Home* series (1967–72), where she juxtaposed images from mainstream interior design and architectural magazines with media images from the atrocities in Vietnam.[27] One image in the series shows a sleek modernist interior from the period with a young Vietnamese girl, her leg amputated and bound beneath her right knee. Another shows a well-dressed Western woman vacuuming her curtains. As she draws the curtains back we see soldiers in a hostile landscape collaged into the image. Still another shows an outdoor patio that looks out upon a devasted Vietnamese village after a US bombardment. Tanks roll through the dusty street and civilians lie charred and dead on the ground. Kirk borrows this notion of disruptive juxtaposition, seen in Rosler's

use of photomontage, as well as the realities of violence in our society. What is perhaps most telling is that in Rosler's era the enemies were more explicit: the United States versus Vietnam in a war that no one seemed to understand. Kirk captures what is so disturbing about the present threat: the enemy is unfixed, masked, and unknown. Kirk plays on the US fear, cultivated by the US media and government, of the fundamental Islamic terrorist. In reality, statistics show that homegrown racism has accounted for more deaths than Islamic terrorism. Kirk's work asks us to consider if late capitalism is the real enemy, because it is more pernicious in its infringement into our everyday lives. Barbara Kruger used the slogan "I shop therefore I am" in an iconic work from 1990, now in the MoMA NY collection. Her words were prescient of a world today where we are what we consume and there is still tremendous societal pressure for women to conform to media's standard of beauty.

The homage to earlier feminist artists that is evident in the work of the emerging artists discussed in this chapter is further evidence of a nostalgia for a history of women's practice. Carolee Schneemann had predicted this condition in a 1975 exhibition catalogue for a show organized by VALIE EXPORT. At the time she stated that, by 2000, younger generations of female artists wouldn't suffer as her generation had; they would be taught by women; they would learn about pioneering women artists; and they would no longer be the exceptions in the art world. Her idealistic text ended with, "these future young women who will have acquired all this knowledge, will never believe that our pioneering work immobilized and isolated us; that the belief in the importance of a female art history was despised and dismissed as heretical and false."[28] Younger artists, such as Kirk, Mason, Hinant, and Schmidt, do understand how hard their predecessors fought. This struggle is part of the reason for fan worship of the earlier feminist artists. I also affirm that these emerging artists are still struggling for a place at the table. While gender equality in the art world has improved, it is nowhere near resolved.

The Female Figure in Contemporary Practice

From VALIE EXPORT and Hannah Wilke's confrontational works to Karen Finley's abject performances, second-wave feminist artists sought to undermine the conception of woman as an idealized object of beauty and desire. Often these depictions forced viewers to acknowledge the abuse, exploitation, and misrepresentation of women. For these artists, the use of their bodies in confrontational poses or actions was the best way to express powerful

feminist statements. Today, younger artists based in New York are revisiting traditional media in work that acknowledges artists of previous movements and generations, especially painting and sculpture. In the 1960s through the 1980s, for many of the conceptual and feminist artists, figurative painting and sculpture were seen as regressive, traditional forms. Many artists of this era, however, repositioned their painting practice into a feminist stance. While the nude female figure was a consistent trope in the history of art, feminist artists of the second wave sought to challenge and interrupt the notion of the classical female nude. Audrey Flack, Sylvia Sleigh, Mira Schor, Joan Semmel, and Betty Tompkins in the United States and Margaret Harrison, Jacqueline Morreau, and Alexis Hunter in the United Kingdom challenged the notion of painting as a male-dominated field by introducing feminist content. The artists discussed below continue this trajectory. Today, a renewed interest in painting is often witnessed with a feminist agenda that builds upon this generation of feminist artists.

Anya Kielar's[29] practice is an ongoing investigation into the depiction of the female form. Kielar's work is representative of an emerging generation of female artists who use the female figure in their practice. She employs a range of media – pigment (International Klein Blue), sand, fabrics including linen, velvet, and burlap – to create works that reference earlier Surrealist artists. In her solo exhibition *Women* at Rachel Uffner Gallery in October 2012 Kielar showed large-scale works that depicted the female form in some manner; from a profile to a full-length nude, each of her works is reminiscent of iconic images from the earlier twentieth century including avant-garde stage design in addition to art. Kielar's *Women* were created in an intensive, handmade, immersive studio practice where she dyed fabric installed in wooden stretchers. Walking through the exhibition meant meandering through a range of female figures painted on these fabrics, which were hung from the ceiling, some transparent; it was like walking through a stage populated with female characters. When asked about her interest in depicting the female form, Kielar said,

> I think it's always been me trying to relate to myself as a woman in the universe and how complex that is. At the very base of it, I think it's all simplistically self-discovery or about the strangeness of what femininity is, and how women are depicted in art history and culture."[30]

The 2012 exhibition intersects this feminine exploration with an admittedly modernist style. The simplicity of her forms, combined with the color choices, recall earlier modernist paradigms as told through the eyes of a young female artist. In what would have seemed a regressive move in the 1970s, Kielar's work

looks innovative today. One may consider this as nostalgic. Like Schmidt or Hinant, Kielar's generation has had enough distance from the second wave of feminism to incorporate modern motifs, including Bauhaus shapes and colors, into her practice. Roberta Smith wrote of an earlier exhibition of Kielar's that it updated "aspects of early Dadaist and Surrealist photomontage, collage and assemblage with ad-agency sharpness and feminist, table-turning wit."[31] It also importantly reclaims the female as central subject matter, as did painters such as Sleigh, Semmel, and Tompkins.

Ella Kruglanskaya was born in 1978 in Latvia and earned a BFA from Cooper Union and an MFA from Yale University. She now lives and works in New York, using painting as her primary medium. Like Kielar, Kruglyanskaya prefers figurative painting that recalls art of the early twentieth century. Using oil on linen as her main practice, she has created a significant body of work that depicts strong, emboldened women who do not conform to societal convention. Pattern and color are important elements of her practice, which compares in places to the *Neue Sachlichkeit* movement in pre-Nazi Germany, from 1918 to early 1930s Weimar. In other aspects, her work owes more to cartoon and graphic culture than to the fine arts tradition of painting. The female body, rather than seen as an idealized nude or intentionally seductive, is seen in all its endomorphic splendor, typically jostling for space on the canvas; however, her characters entice with their confidence and strength of conviction.

Kruglyanskaya's work favors scenarios with two or more characters who often are engaged in some sort of activity. *Zip it* (2014) depicts two women whose shadows form cartoon-like shapes on the canvas. One woman, who wears a green dress that sports a face with eyes strategically placed on the breasts — a typically playful device used by the artist — holds her hands up while another behind is seen frantically trying to secure the zipper. A scenario familiar to anyone who has tried to squeeze into a smaller size, the painting depicts a daily reality in the world of body fanaticism, but with an animated sense of movement: frenetic brush strokes on the limbs of the characters and their facial expressions attest to this. The artist has acknowledged her interest in the "economy of expression" that, for example, mid-century cartoons have.[32]

Kruglyanskaya, who believes in feminism as a basic ideology, is deeply invested in the history of representation:

> Women have been the face of representation for so long. You can read so much about historical periods or create certain moods through the representation of women throughout history. You see a particular photograph and you know that it is from the 1940s…

I just felt like I needed to own up, to tap into that whole history that I'm playing with and coming out of. I wanted to own it and come to terms with it somehow...

I want to participate in this historical conversation so I want my work to have this weight that it would be hard to ignore.[33]

Indeed, her subject matter is confrontational in its exploration of a politically incorrect, heteronormative, popular tradition of female representation where breasts and bums are exaggerated for comical effect. Allison Gingeras writes of the female subjects: "With their high heels, pencil skirts and curve-hugging sweaters they both embrace the performance of femininity and conventional hetero-sexuality."[34] Indeed Kruglyanska challenges the history of representation of women, reclaiming the female subject matter as her own. Gingeras writes:

She deploys clever visual puns – for example painting cartoony lemons and oranges over her subjects' breasts or a bearded male face strategically placed on a woman's *maillot* – to parry centuries of sexist objectification. The mere annunciation of Kruglyanskaya's female centric subject matter is political enough. Separatism, hairy legs, splayed vulvas, and burning bras have given way to numerous "post" Feminist strategies: humour, performative posturing, ambiguity and ambivalence.[35]

The ambivalence of Kruglyanskaya's work, as well as those of her colleagues discussed above, furthers the discussion of feminism. In the 1970s, feminist artists had to stage a revolution with confrontational imagery, including Tompkins' *Fuck* paintings, Joan Semmel's nude self-portraits and Sylvia Sleigh's male nudes and new methods of making art. Today's artist engages with feminism in a more oblique way, combining it with other issues. In the case of Kruglyanskaya, another issue is the history of painting and how to continue to challenge and propel the medium forward in her practice.

The representation of women has changed since the first incarnation of the women's movement. Today, one is allowed the freedom to enjoy women's bodies in art rather than to resist against the notion of a female nude as a morally inept gesture. Kruglyanskaya's work may cause viewers to cringe when women are seen treated as cartoons; if so, this in itself represents a development since the early twentieth-century caricatures so typical of the *Neue Sachlichkeit*. These images confront the complexity of representing the female figure in the traditional medium of painting. For a feminist viewer these cartoonish images of women may be more controversial than the genital close-ups of Tompkins. Rather than avoiding difficult dialogue, Kruglyanskaya engages in it, forcing the viewer to confront her own preconceptions about female imagery.

Beyond Painting: Deconstructing the Figure

I have argued above that artists have used the female figure, especially as represented in earlier twentieth-century art, as the starting point for a new depiction of the female subject. Diana Al-Hadid has also made work that takes the figure, in this case a classical female nude, and deconstructs it, shattering notions of the idealized female form. Al-Hadid is an artist based in New York, whose family originally hails from Aleppo, Syria.[36] Her work most often takes a sculptural form and alludes to the history of architecture and art. Breakthrough pieces such as *Spun of the Limits of My Lonely Waltz* (2006) and *The Tower of Infinite Problems* (2008) were indebted to the history of architectural structures, both real and fantasized, especially that of gothic cathedrals and the elusive Tower of Babel.[37]

The female figure entered Al-Hadid's work in around 2010. *In Mortal Repose* (2011) incorporates a concrete, stepped plinth with a figure draped across its surface. Al-Hadid's female figure literally melts down the small steps of the plinth, suggesting a lyrical nod to the sensuousness of classical masters such as Michelangelo and Canova. It also implicates through the deconstruction of the female form. The figure, however, in opposition to classical sculpture, is not nude. She wears a contemporary-style tank top that one would see anywhere on the street today, thus conflating past and present, classical and contemporary, in one work.

A body of work shown at Marianne Boesky Gallery in New York in 2012[38] proved even more ambitious in scale as well as concept. In *Antonym* (2012) and *Suspended After Image* (2012), the artist morphs the architectural and the human figure. In *Antonym*, a female figure reminiscent of a classical Roman sculpture seems to grow out of a pedestal that yields to her physical weight. Here the figure is nude, but she is hollowed out, with patches of surface missing and paint dripping across her torso. This freedom of mark is reminiscent of abject figurative sculpture as seen in Kiki Smith's and Robert Gober's work. As in *In Mortal Repose*, the pedestal is part of the sculpture. Here the concrete of the earlier work is replaced with a fragile plaster structure, notable for its use of negative space. At the base of the pedestal, on which the figure rests, is the striated, attenuated structure seen in the artist's earlier works, an effect that the artist produces through plaster and paint. Al-Hadid has referenced her interest in magic and the notion of a perilously balanced house of cards, which are both evident in this work.[39] The figure echoes this in its uncanny balance of fragility and stability; the body is literally pieced away, and

yet it makes an indentation in the pedestal reminiscent of a Canova pillow, so exquisitely carved that it looks soft.

Suspended After Image occupied an entire gallery. The work is architectural in scale, resembling a temple or monumental structure with five steps leading towards to a central form. The artist attributed this as a "floating grid that is extracted into painted cubes" that trickled down in her trademark sculptural drips that suspend forms in space. A human figure which recedes into the steps, with only fragments of a prone body surfacing – a knee, a torso, an arm – reminds one of classical sculpture; like bodies found frozen in time after the eruption of Mount Vesuvius, this figure is suspended in a reclining position, arm poised above the head. The artist's trademark "dripping" is seen in the puddle that trickles to the ground beneath the figure and the pedestal. It is also seen in the cascading forms above the figure, like Frank Lloyd Wright's *Falling Water* in structure. The layering of references in this work are indicative of Al-Hadid's project: images are suspended just at their vanishing point and shapes defy gravity in a world teetering on collapse. Her work embodies the overarching argument of this book, that younger artists create works that are feminist in tone and format and increasingly appropriate earlier works from the history of art. In this case Al Hadid reclaims the classical nude female figure and brings it into a contemporary context.

Valerie Hegarty also takes earlier examples of canonical work by male artists and reinterprets them. Her abiding project may be considered the myth of America and its histories, from maritime paintings and ceramics to Abstract Expressionist canvases and Minimalist sculptures. In each of her works, Hegarty uses a sculptural approach to literally and conceptually deconstruct existing imagery. She creates installations and sculptures that riff on the history of painting. For example, her *Rothko Sunset* (2007) is a cross between a painting and sculpture, made from a foam core base, with canvas, paper, paint, glue, wire, and tape. It is executed in the restrained palette associated with the canonical artist and is nearly a direct copy of his use of blocks of shading. The title is reflected in the yellow and orange palette that at once suggests a sunset as well as the abstract composition. Hegarty's sun is literally ablaze, with the bottom of the work literally disintegrating, burnt out and barely held together. It is a post-apocalyptic reiteration of Rothko, that simultaneously honors and questions the legacy of the mythological male genius as well as its place within an art historical canon. Hegarty's work takes Rothko's seamlessness and creates a more haptic, sculptural form.

The handspun construction of Hegarty's artwork is notable in her feminist predecessors. Women artists made work from ephemeral materials – food, hair,

blood, and other non-art materials – in protest of the male-dominated history of art production. For example, Mary Kelly used her son's soiled nappies in her infamous *Post-Partum Document* (1973–6) and Carolee Schneemann used menstrual blood in *Blood Work Diary* (1973). Here, Hegarty distresses and disintegrates the painting into a barely cohesive object. Rather than being a straightforward critique of Rothko and a mythical generation of hard-living, tragically destined artists, Hegarty also gives it credence as a masterpiece of US art. She comments on the decline of the US myth, which is even more poignant given the 2016 election, which drew on a groundswell of unease and distress that has plagued the country.[40] Like Kruglyanskaya, Hegarty confronts the male-dominated history of painting with her deconstructive technique, commenting in a wry way and bringing a feminist critique of male art history that was prevalent in second-wave feminism into the twenty-first century.

British artist Rachel Garrard, born in 1984, living and working in New York, also chooses to expand the notion of painting through abstraction, which in her practice is always based on the body. Garrard uses her body as a map for geometric abstractions that result from self-imposed processes, with a sense of materiality as an abiding feature of the work. The artist's body, in a Pollockian imperative, is ever-present and always in motion, at the core of the work, which spans from performance and temporal actions to paintings and floor-based steel sculpture. While the materials and formal presentation may vary, each piece evolves from the figure – always that of the artist herself – and morphs towards abstraction, in places hard-edged while in other areas seeping out, untidily resisting their self-imposed margins.

Passage (2014) is a series of paintings created through a performative process. The artist places an untreated canvas on the floor, then lies on top of it. Plotting coordinates of her body as the corners of cubic shapes, she then creates geometric forms by taping these lengthwise and horizontally across the canvas. From there blue pigment is applied, which concentrates towards the middle and radiates out towards the edges of the canvas, creating a sense of depth that defies the inherent two-dimensional nature of the work. When the tape is removed the resulting canvas contains overlapping rectangular forms created from the blank sections where the tape was applied. Garrard's process recalls Yves Klein's *Anthropométries de l'époch bleue (Anthropometries of the Blue Epoch)* from 1960. While Klein used live nude models who would paint the canvases as "living brushes",[41] Garrard reclaims the female body as the artist in control of the process. Garrard's paintings resemble blueprints, with cyan blue pigment stains spread diaphanously across the surface, as well as the forms

that connote floor plans of sacred spaces. Garrard was conscious of this play between plan and architecture, figure versus abstraction, as well as the opposition between performance and the trace.

Luminous Volumes is another series formally related to the idea of the floorplan. Here the artist begins with a photograph of her body that she uses as a reference for the resulting composition on the canvas. Garrard uses bleach to rub away at the dark matte surface, creating a corresponding absence of color that by chance resembles a cruciferous form. Utilizing a Vitruvian scale, the canvases correspond to the artist's own bodily dimension, again leaving a trace of her existence on the surface. Here Garrard's work bears most correlation to Ana Mendieta's *Silhueta* series from the mid-1970s. Created in nature and intended to return to nature, these performance works, like Garrard's, varied in substance and physical manifestation and suggested the seamless existence between human existence and nature. They exist today only in documentation, a representation of the fragile temporality made so poignant by the artist's early death.[42]

Garrard's work reads as an extension of Mendieta's process: the material translation of the body onto a surface, existing only in a temporal interstice and captured here on canvas. While much of feminist art concentrated on the corporal manifestation of the female form, Garrard speaks instead to a universal existence where the female and male are intertwined and implicated within each other through the geometries created. Her work is concerned with the boundaries we encounter and that largely define our lives: gender, sexuality, class, and race are often seen as fixed existences rather than shifting conditions. As an expatriate artist based in New York, her work finds an appropriate context in a city where many young women artists are working through notions of gender in body-oriented practice.

Reconstructing Feminist Self-portraiture

Photography as a means of expression as well as a form of activism became an important genre in feminist art. Many feminists used photography to document live events; however, photography in itself became an important alternative to painting. Most often using their own bodies, they created imagery that reflected the ideology of feminism. From Jo Spence to Cindy Sherman, the self-portrait became an important vehicle for investigating female identity as well as the issues relevant to the female experience. And artists including

Wilke and Spence are exemplary for documenting their decline and ultimate demise through terminal illnesses.

British artist Jo Spence used photography as a form of opposition to tackle complex issues such as class, gender, and health. In the 1970s, she worked with the Hackney Flashers collective to produce community-based art and education projects. Developing what she would call "photo theater," Spence created everyday scenarios in which she was photographed, for example, doing domestic duties such as laundry. Her husband Terry Dennett and she collaborated on several series together, including in the late 1970s and early 1980s unflinching photographs of Spence, whose body did not conform to societal standards of slimness and beauty.[43] She wrote of her activity at that time:

> We were especially keen to provide a starting point for discussion between men and women in the controversial area of the representation of the female body where it is argued at one extreme that to even show the female body is problematic, while at the other some still seek to tinker with the dominant "stereotypes" of women without engaging with wider questions of cultural production."[44]

Take, for example, *The History Lesson* (also called *Remodelling Photo History*), a series of works made for the exhibition *Ten Contemporary British Photographers* at MIT in February 1982. *Colonization*, a work from this series, shows the artist wrapped in a towel, naked from the waist up except for a strand of beads, holding a broom at the entrance to a typical working-class home in the UK. The double entendre of the title can refer to England's colonizing within their empire, as well as the colonization of women's bodies through domestic confinement. Another work in the series, *Madonna and Child*, shows a man, Dennett, suckling on Spence's breast. While these images employ a dose of comedy and farce, they also attest to the struggles of feminists, who were debating issues over equal pay, housework as a form of unpaid labor, and other issues related to traditional family life.

Spence and Dennett, a supporter and activist for the Labor party, also used photography and Spence's body to comment on the changes in British society that were the result of a neoliberal, Thatcherite agenda. For example, *Industrialization 1 and 2* from the *The History Lesson* were shown three decades after their production, at *Dokumenta* 2007. Their inclusion is another example of the increasing interest and popularity of second-wave feminist art. *Industrialization 1* shows Spence from behind, laid out languidly on her side, on a field that has been literally scarred by industrialized farming; one sees where crops were grown and mechanically culled. *Industrialization 2*

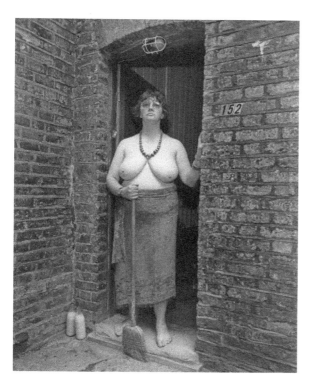

2.1 Jo Spence, *Remodelling Photo History: Colonization*, 1981. Stamped on reverse: "Photography Workshop, 152 Upper Street, London, N1", along with a stamp of "Photo Credit" and handwritten underneath "Jo Spence/ Terry Dennett, Remodelling Photo History, Colonization". Collaboration with Tony Dennett. © The Estate of Jo Spence. Courtesy Richard Saltoun Gallery.

juxtaposes Spence's thick unidealized body, seen from behind, standing in a field that is intersected by power lines; her body is bifurcated by the framing of the photograph, a metaphor for the landscape being carved up and privatized under Thatcher's government. Spence and Dennett's photographs, while made in the early 1980s, are as relevant today and were prescient of many current issues around factory farming in the US and the UK.

Despite keeping breast cancer at bay for eight years with naturopathy, which she documented in photographs, Spence was diagnosed with terminal leukemia in the early 1990s. Dennett and Spence collaborated on two series as she was struggling to survive. *Leukemia Diary* (1991–2) was made while the artist was still strong enough to pose for the work and to create scenarios both in and outside of her home: Spence ringing the bell at the Samaritans, doling out her many medications for each day, reading a book in a bathtub, and so on. *The Final Project: A Photofantasy and Phototherapeutic Exploration of Life and Death* (1991–2), the unfinished last series of photographs, was made

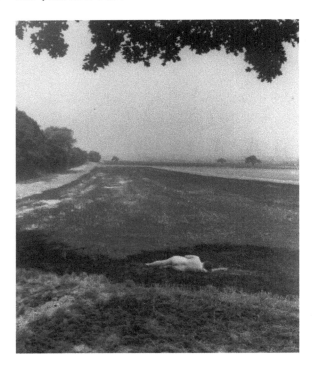

2.2 Jo Spence, *Industrialisation: Remodelling Photo History*, 1981–2. Collaboration with Terry Dennett. Black and white photograph, 58.5 x 45.5 cm. © The Estate of Jo Spence. Courtesy Richard Saltoun Gallery.

after the leukemia, when the disease created a lack of oxygen in the brain, making it impossible for her to continue her "photo theater" type of work. This last series was made with objects from her archive, for example, Day of the Dead skeletons from Mexico and a feminist tablecloth that read, "you start by sinking into his arms, and end up with your arms in his sink." Until her death, she used photography as a tool for her feminist activism. Spence's contribution to feminist art, as seen through unflinching photographs that documented her demise, is reflected today in the work of younger artists.

LaToya Ruby Frazier[45] has created a body of work that draws on the history of social activism and documentary photography.[46] Like Spence, Frazier collapses the body and the landscape in her work, as well as using themes of illness and economic deprivation. The artist was born and raised in Braddock, Pennsylvania, an industrial town just nine miles from Pittsburgh and home to Andrew Carnegie's first steel mill plant as well as his library.[47] Frazier creates black-and-white photographic images of three generations of her family: her late grandmother, her mother, and herself. She combines these with images of

the local landscape, decayed from industrial toxicity and disuse. Her body of work, like Spence's and Dennett's in the UK, is emblematic of the economic decline of rural America and its devastating impact on the citizens, in particular the female members of her family. The artist depicts the lives of these generations in photographs that are staunch representations of illness and deprivation.

Frazier comments on the generational decline of her hometown:

> Grandma Ruby, Mom and myself grew up in significantly different social and economic climates in Braddock. Grandma Ruby witnessed Braddock's prosperous days of department stores, theaters and restaurants. Mom witnessed the steel mills close and white flight to suburban developments. I witnessed the War on Drugs decimate my family and community. Between our three generations we not only witnessed, we experienced and internalized the end of industrialization and rise of deindustrialization.[48]

The internalization that Frazier refers to, in addition to the psychological effects of a declining area, is the ingestion of metals from the local environment, which have caused health problems for the community and, on a personal level, for the artist's family. Her grandmother Ruby suffered from pancreatic cancer and diabetes; her mother suffers from cancer and an undiagnosed neurological condition; and the artist suffers from lupus. Frazier said:

> We represent three generations of witnesses who can account for the way America was shaped and changed by three very different economic models. This implication becomes a residue on the actual people's bodies that are living in these environments.[49]

The artist was encouraged to show these photographs of her family by her teacher and mentor Kathe Kowalski, whose career was dedicated to photographing families living in rural poverty as well as her mother's decline.[50] Frazier's *Grandma Ruby Smoking Pall Malls* (2002) is an ominous predecessor to images of her deteriorating health and eventual death. Ruby is pictured as a commanding presence in her home, surrounded by her dolls, in a tender portrait of the artist's matriarchal family member.

While Frazier's relationship to Spence's work is my own ideation, the younger artist did draw upon the work of another female artist for inspiration: Dorothea Lange's *Migrant Mother* from 1936. Lange was a successful working photographer, decades ahead of when feminism would become a movement in art. Her iconic photograph depicts a young woman, only 32 years old at the time, with her two small children in a ramshackle tent. It is obvious from their appearance that they are suffering from malnutrition as well as

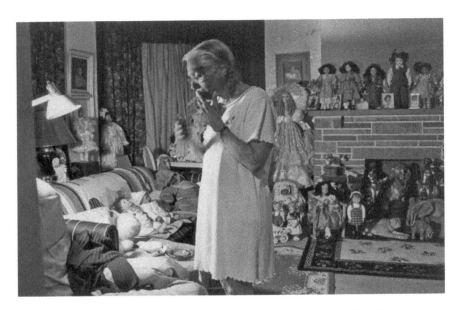

2.3 LaToya Ruby Frazier, *Grandma Ruby Smoking Pall Malls*, 2002. Gelatin Silver Print, 20 x 24 in. Courtesy the artist and Gavin Brown's enterprise, New York/Rome.

2.4 LaToya Ruby Frazier, *Self-portrait in the Bathroom*, 2002. Gelatin Silver Print, 20 x 24 in. Courtesy the artist and Gavin Brown's enterprise, New York/Rome.

exposure to the elements. The photograph was commissioned by the FSA (Farm Security Administration) as part of their campaign to document the deprivation in the agricultural world during the great depression. Frazier was interested in the subject of the photograph – Florence Owen Thompson – and why she is an anonymous person today as most viewers would not know her identity and particular story, although they would likely recognize her image. Frazier was interested in how Thompson might have told the story had she possessed a camera and made photographs herself. The younger artist therefore relates the story of her local community through the history of this US documentary tradition.

Frazier found an equivalent to the decaying farms of Lange's era in her hometown Braddock, a once-idyllic US town that has, like many other North American cities, struggled to cope in the past half century. Racial segregation and redlining (when a bank will not allow loans in certain areas) occurred in the 1950s and 60s after the GI Bill when Black service men returning from duty and their families suffered from racial discrimination. Braddock also suffered from white supremacy that did not want Black families living in white communities, which were beginning to form in sprawling suburbs outside of the industrial towns. In the 1980s drugs and concomitant crime became a dangerous blight in the community. Frazier has asserted, and it is commonly understood, that illegal drug trade was introduced into socially and economically abandoned Black communities by the state with an agenda to justify Reagan and the first lady's so called "War On Drugs".[51]

An early image from this series shows the artist seen from behind in her bathroom. *Self-Portrait in the Bathroom* (2002) is a seemingly simple composition with layers of complexity. The artist is seen leaning over the sink, her reflection only visible in the mirror above it. Beside her is a collapsed set of plastic shelves, strewn with personal toiletries, indicative of the artist's own collapsing health, having been diagnosed with lupus at a young age. This photograph is an important form of contemporary feminism for several reasons. First, it transposes the contemporary African American female identity in the place of the white subjects of the WSA era photographs or Spence's body in Thatcherite England. The US, once a bastion of immigration offering a chance at a better life for Afro-Caribbean expats, is seen as downtrodden as a third-world country. In addition, it implicitly questions the history of US documentary photography, which was another male-dominated genre. James Van Der Zee, Prentice H. Polk, and Gordon Parks were known for their documentary journalism, which narrated the fraught and evolving

state of race relations in the US.[52] Frazier, following in their footsteps as well as female African American artists including Carrie Mae Weems and Lorna Simpson, illustrates in this series that race and class continue to be barometers of health and wellness – both physically and economically – in the contemporary US.

Self-Portrait in the Bathroom also reminds a viewer of the tradition of feminist artists, particularly in the UK and US, who have used photography, and self-portraiture especially, to document illness and the fading of youth. Like Spence's work, Wilke's *Intra Venus* series from the early 1990s depicted the artist in the final stages of Hodgkins lymphoma, a pernicious cancer that eventually claimed her life. Spence documented her battle with terminal illness in a body of work that challenged both the representation of the idealized female as well as illness.[53] Nan Goldin turned her focus towards her friends' battles with the AIDs epidemic and Corinne Day directed her lens towards her demise from a brain tumor.[54] Like Spence and Wilke's later work, Frazier undermines the classical theme of the idealized female subject and challenges it with an unflinching rendering of her own coming to terms – literalized here through the use of her self-confrontation in the mirror – with illness. In this case, like Wilke and Spence, the illness strikes the artist in her prime. This

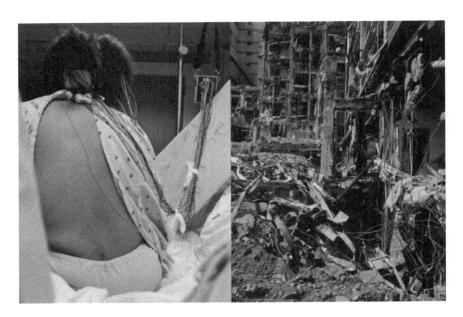

2.5　LaToya Ruby Frazier, *Landscape of the Body (Epilepsy Test)*, 2011. Gelatin Silver Print, 24 x 40in. Courtesy the artist and Gavin Brown's enterprise, New York/Rome.

presents the harrowing idea that things are getting worse, not better, in this first-world nation that prides itself on progress and innovation.

Landscape of the Body (Epilepsy Test) (2011) is a striking photographic diptych that may be compared to Spence and Dennett's *Industrialization* photographs. Here Frazier juxtaposes an image of her mother, seen from behind in a hospital gown, hooked to a machine that monitors her responses. The hospital gown that she wears is open at the back, suggesting vulnerability and also equating the flesh to the earth; the body becomes literal evidence of the misuse of the landscape. This is placed next to an image of the demolished UPMC Braddock hospital. Piles of rubble lie in the foreground and the exoskeleton of the former hospital in the background, where a framework of empty rooms now awaits final demolition. Frazier's work comments on the larger ills of post-industrial US culture and its lack of nationalized healthcare, and the specific, personal ramifications for the artist's family.

One of Frazier's most haunting images, called *Baggage in Grandma Ruby's Living Room (227 Holland Avenue)* (2009), is taken after the matriarch's death. Here one sees the artist in her grandmother's room. Once covered with Ruby's

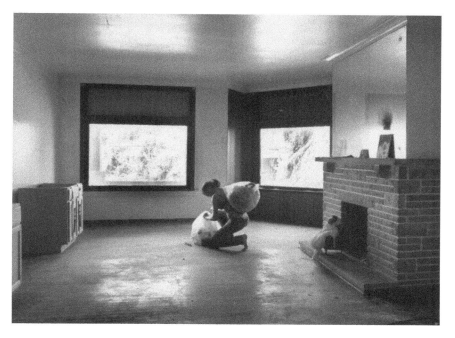

2.6 LaToya Ruby Frazier, *Baggage in Grandma Ruby's Living Room (227 Holland Avenue)*, 2009. Gelatin Silver Print, 20 x 24 in. Courtesy the artist and Gavin Brown's enterprise, New York/Rome.

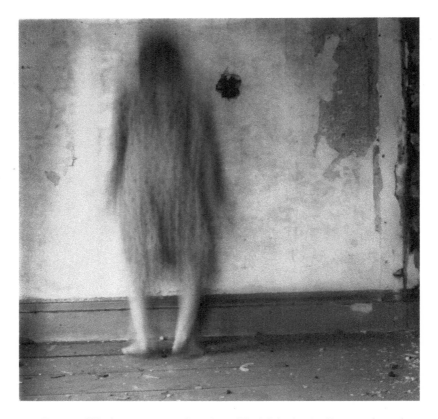

2.7 Francesca Woodman, *Polka Dots*, Providence, Rhode Island, 1976. Vintage gelatin silver print, 5 5/ 16 x 5 5/ 16. © Francesca Woodman. Courtesy of Betty Woodman.

dolls, now the mantel sits almost empty, save for one doll in a chair, symbolic of Ruby's absence. The artist, wearing only bra and knickers, holds a bag of garbage on her back, weighing her down. The work is reminiscent of Francesca Woodman's photographs, where the artist's body was immersed into the architecture of mostly empty rooms. Frazier's photograph has the same haunting quality and the same sense of the abandoned architecture, literally weighing upon her body and psyche. Woodman, whose untimely death has meant that she is mythologized for a small body of work made while she was very young, similarly focused on portraits of herself in architecture. *Polka Dots*, shot in Providence, Rhode Island in 1976, shows the artist crouched in an empty room with distressed walls, as if attempting to integrate herself into the infrastructure. Woodman's work was largely performative, and there is the same impulse in Frazier's haunting image. Both artists employ a confrontational, haunting approach to self-portraiture. Woodman is representative of women

artists and the feminist legacy of questioning the representation of women. Frazier carries on the legacy of second-wave feminist artists by highlighting illness and deprivation, both of bodies and landscapes.

Masquerade for the Digital Age

Cindy Sherman is known for using herself as subject matter for the duration of her career. One of her earliest series, *Untitled Film Stills*, shot in black and white between 1970 and 1980, was produced by Sherman adopting various costumes and accessories to create female personas based on stereotypical images of actresses from B-level Hollywood films: a frustrated housewife, a woman with long blonde hair lying on a bed in a white negligée, a woman lighting a cigarette. The viewer is given visual cues that allow them to create their own narrative for what is happening in each image. While these were largely ignored at the time, in the early 1990s they became iconic and celebrated in academic, institutional, circles for their original approach to critiquing the construction of female representation. In the ensuing decades, Sherman continued to use herself as subject matter, first in color images, eventually through digital imagery and more recently through a series of work that investigates the theme of the aging woman.

K8 Hardy's[55] *Positions* is a series with a direct nod to Cindy Sherman's practice. Hardy's images conflate the masquerade of the *Untitled Film Stills* with the mawkishness of Sherman's *America* series and the garish palette of the clown series. Hardy's work comes out of an earlier foray into fanzines. Her *Fashion Fashion* fanzine, a self-produced Xerox publication, was a successful venture for the artist. Having spent time styling the girl band Le Tigre and coming out of the Riot Grrrl generation, Hardy uses the do-it-yourself aesthetic popularized by this movement in the 1990s. The Riot Grrrl aesthetic was anti-consumerist glamor; young women wore thrift shop clothes, wrote on their bodies as a form of political statement, and took the ideology of feminism into the hands of a younger generation of teenagers and young adults; hence the appellation "grrrls." Their music was characterized by an amateurish approach coming out of the garage band movement in Seattle. Girls were frustrated with being shut out of punk rock and formed their own bands, such as Bikini Kill, Heavens to Betsy, and Bratmobile.[56] Their popularity traveled by word of mouth and by fanzines distributed free of cost or for very little expense. Riot Grrrl culture evinced a "girls to the front" anthem; previously it had been difficult for girls to get close to the stage at gigs because of the

violent mosh pit dancing that the boys engaged in. In Riot Grrrl gigs singers like Kathleen Hanna would ask girls to come to the front and boys to hang back during performances.

Hardy's work takes fashion as an abiding theme. Hardy says,

> [Fashion] deals with women, and is made by women, and claims to deal with their issues, and that's what is possibly fruitful. Images of women are fucked up. But if artists completely reject worlds just because they are fucked up, how are we going to get further along?[57]

Positions (2006–9) is a series that illustrates how fashion becomes a political statement about gender, sexuality, class, and politics. As in Sherman's earlier series, Hardy positions herself within each photograph, morphing into various personalities.[58] "Positions" also refers to the awkward physical positions in which the artist places herself, similar to fashion editorials that do so with no sense of irony. Hardy creates her own innovative fashion by resisting the mainstream world of glamor magazines and shoots. Most of the garments and accessories in these photographs are found in thrift shops. Curator Dean Daderko writes that Hardy illustrates how "conspicuous consumption wears thin when compared against personal, inventive and individual refinement."[59]

Like most of Sherman's works, Hardy's photographs are shot in her studio, with a few exceptions. As in Sherman's work, rather than appropriating a specific person – in the manner, for example, of Japanese appropriation artist Yasumasa Morimura who morphs into Frida Kahlo or Marlene Deitrich – Hardy instead evokes tropes of women. For example, in *Positions Series #13*, the artist is pictured outside, her foot propped on a stone structure with a log cabin in the background. She wears clothing traditionally associated with the masculine: work boots, oversized jeans with a button-up shirt, and a cap turned backwards on her head. Her purple hair is an indicator of her "alternative" persona, especially given the rural environment. Is she the only lesbian in the village? Is she a young man who looks effeminate and has no community in this rural setting? The identity oscillates and the viewer brings her own reading to the work, much like the narratives that one projects on Sherman's *Untitled Film Stills*. This recalls the feminist idea of masquerade and Butler's writing on gender as a construction.

Unlike Sherman's recent work, which has evolved into high-end large-scale printing production, Hardy's are hand-produced photograms that she develops in a darkroom. *Positions Series #26* (2009) shows a woman wearing a strange constellation of items – a black bandeau top, rolled up shorts, thigh boots, and

a wig and headpiece – smoking a cigarette in a nondescript interior setting. The figure is situated on the left side of the image; on the right, a photogram of a bra is situated alongside the human figure. Hardy puts the object, or on occasion one of her own body parts, on top of the image as it is developed in the dark room, resulting in a negative outline of that object on the image. This emphasizes the objectness of the photograph itself, each unique and printed by the artist, a technique that quickly became outdated in our digital world.

Hardy's series effortlessly continues the conversation about the representation of women and about the construction of the image, begun in the 1970s and carried on into the 1980s and 1990s. The series furthers the discussion begun by artists such as Spence, Wilke, Sherman, Laurie Simmons, and Carrie Mae Weems, who have used photography as an investigation into the representation of women in society. Hardy's images reflect the schizophrenic nature of twenty-first-century life. Rather than existing as clichéd images of female stereotypes, in the vein of Sherman or Simmons, Hardy's constructions are a mash-up of contemporary culture. They reflect both fashion trends as well as the sociological: young women as hipsters, defiant androgynous girls, and permutations of the twenty-first-century woman. Where Sherman drew her inspiration from classic Hollywood films, Hardy draws her inspiration from the streets.

Feminism and New Media

Juliana Huxtable's self-portraits may be considered alongside Hardy's work in their combination of attitude, street fashion, and youth culture. Born in 1987, in Bryan-College Station, Texas, and like Hardy, studied at Bard College in New York, Huxtable works fluidly across many mediums, from performance, poetry, and text to nightlife and music. Where in the *Positions* series Hardy uses analogue techniques of printing and composing the image, Huxtable uses digital technology to create a hallucinatory vision.[60] In one image, she is seen crouching on one leg, wearing knee-high white platform lace-up boots, printed trousers, a midriff-baring top, with hair wrapped into two buns, and her skin burgundy. In another, she is seen from behind, naked with long blonde braids trailing her back and her skin green-hued. As a trans artist who identifies as female, Huxtable's digitally altered photographs are the ultimate representation of gender politics today: gender is a socialized, pharmacological, and political construction that each individual has agency over. Never before have we lived in a time where gender was such a flexible and open state of being

rather than a binary determined by our biological lottery. While second-wave feminist theory discussed gender as a construction, it was much less prevalent in the actual world. This is a feminist ideal that is actually being embodied by many trans people. Today trans culture is exponentially more present, as is discussed in Chapter 4.

Huxtable's photographs and writing were featured in the New Museum's triennial, *Surround Sound* in 2015. Her brightly colored images were hung in a gallery that also featured a life-sized sculpture of the artist by the artist Frank Benson. *Juliana* (2015) is a hyper-realistic, 3D printed work that features the artist, nude and reclining in a pose reminiscent of classical figurative sculpture; the fingers of her left hand are pinched in a pose echoing Cleopatra.[61] From the back, she is an idealized and eroticized female figure; seen from the front, the inclusion of a flaccid penis reveals the figure to be a transgender person. Her skin is an iridescent green and her nails are blue, summoning a cyborg-type image of Huxtable, thus emphasizing the construction of her body as well as persona. Her braids, along with the fingernails, were painstakingly drawn by Benson in a digital drafting program. The combination of Benson's sculpture and Huxtable's photographs suggest that today's world is not bound by biological determinism and that "trans" culture is at the forefront of image-making and fashion. If the 1990s were the decade of the emergence of queer art, the early twenty-first century is the era of the dissolution of gender normativity and the celebration of trans culture. The fact that this work is seen in a major New York institution is a further indication of how far trans culture has progressed into the mainstream. Huxtable's work is indicative of what is called intersectional feminism today; she combines issues related to feminism, for example, the representation of women and self-portraiture with ideas around race and class.

In addition to digital production, digital space has become a site for young feminist artwork. Ange is a multi-disciplinary artist, born in Tajikistan and living in New York, whose recent body of work sees the artist using social media to post a daily self-portrait in a different guise. Using props and makeup to channel a Cindy Sherman-style constructed photography, Ange morphs into different characters each day, with a strapline featuring a witty aphorism on gender difference. For example, a post dated March 8, 2017 shows Ange, naked from the waist up, wearing a strawberry blonde wig, with a doll clutching her breasts, seemingly breastfeeding. The comment says NO WOMAN NO LIFE. Like Hardy's *Positions* series, these recall the masquerade of earlier feminist artists, albeit for a wider audience. Like Sherman or Spence, Ange uses her body as the raw material, to make improvisational characters that employ inexpensive

props and makeup. Her captions provide additional layers of meaning to the use of wigs and accessories. However, the immediacy of Instagram provides a new context for this practice as thousands of followers can see immediate, daily images. Many artists are now using social media platforms for testing ideas as well as documenting an ephemeral practice, as evinced most popularly in the work of internet sensation Amalia Ulman as well as Emma Sulkowicz, who carried her mattress around Columbia University for one year as a protest for the school's treatment of her accused rapist in the work called *Mattress Performance (Carry that Weight)* (2014–15). An open, democratic space, Instagram as a platform means that Ange's practice is not confined to the gallery setting, although the images are sometimes printed and shown in galleries. Like earlier feminist artists, for whom moving beyond a gallery setting was an important impulse, younger feminist artists find alternative sites today in the digital realm.

Leah Schrager also uses Instagram as one of several platforms for her multi-layered and challenging practice. Schrager, who was born in the US and completed her MFA at SVA in New York, uses various pseudonyms and websites for several projects. One such ongoing project is an Instagram feed called *Onaartist*. Schrager speaks of the meaning behind the name Onaartist:

> I was thinking about how we present ourselves online … Ona having a number of different meanings: Ona is a term as in masturbation so that is the first meaning; also Ona means woman in Japanese so I also see it as a very female centric, female powerful generation; and then owning as in "own it" so an entrepreneurial thing.[62]

Onaartist is an online personality with over one million followers. There are even fan sites dedicated to her in the same way that sites are dedicated to Beyoncé or Lady Gaga.[63] This feed shows daily self-portraits of the artist in various provocative and soft pornographic poses with humorous captions: Onaartist posed like a ballerina in a dance studio, but wearing only a bra, underwear and garter belt with a caption that reads, "Sisters that dance together take chances together"; Onaartist, using a selfie-stick to take an image of herself in only a bra and thong accompanied by a caption that reads "Here's a cinnamon bun to sweeten your New Year"; Onaartist standing on the arms of a leather chair, in front of a green wall, legs spread with a black leotard that reveals most of her posterior says, "My ass is the cherry on a bowl of green sherbet." Each of the locations, which is often reminiscent of a porn set in its quotidian domesticity, is found by the artist using Airbnb locations that she rents for the shoots. Schrager does extensive research both in New York and further afield to ensure each shot is in a new location.

Schrager's Onaartist feed relies entirely on the "selfie," a popular form of image-making that has become ubiquitous in the age of social media. From teenage girls to mature couples on holiday, the selfie has become a vernacular means of art production and dissemination. Onaartist intentionally mimics sensual selfies from young women that Schrager observed online. She says,

> I am basically copying girls… I am not naturally a selfie person. I really only started taking selfies of myself last year when I started school, because before I was so much more about hiding myself and the layers and the concepts. Once I got to school I was starting to take photos of myself and then I went with it.[64]

The artist is using an everyday format, like Ange; however, whereas Ange is an obvious construction, to her fans and viewers, Onaartist is a real person, albeit anonymous, objectifying herself for the camera. This twenty-first-century feminist response puts the artist in an especially tenuous position between commentator and objectified person. Johanna Fateman wrote in *Artforum* about Schrager and colleagues, including Ann Hirsch, who have an invitation-only Facebook group called Starware:

> This unruly collection of work from mostly little-known artists, many from overlapping feminist subsets of the male-dominated Net art and alt-lit worlds, addresses perennially contentious issues of representation (pornographic and otherwise). They take as a given that social media – as a platform for art, activism, and sexual expression, and as a potent facilitator of image appropriation and abuse – is the primary context for such investigations today.[65]

Where artists of earlier generations relied on mediated forms of self-portraiture including photographs and publications – and I would argue here that Hannah Wilke's, Martha Wilson's, Lynn Hershman Leeson's and Spence's photographs are prescient of selfie culture – today's young artists can have the immediate gratification and response of viewers seeing their work. In a society where everything is available on the web, including pornography at the touch of a keyboard, Schrager uses technology to push a sex-positive, female-empowered agenda.

Schrager sees this cultivation of her image into celebrity as an art project. She wants to create the first "celebrity as an art project" – a fascinating Warholesque response to reality television and social media cultures where people become famous with no particular talent or content. In this instance, the artist follows in the vein of Cosey Fanni Tutti, a British artist who in the

mid-1970s posed for soft pornographic glamor magazines as an art intervention, then showed the photographs at galleries, and was subsequently blacklisted by the photographers who shot the images.[66] Schrager, like Fanni Tutti, is a sex-positive artist who wants to both challenge and celebrate the female body and the act of looking at women. But like Fanni Tutti, and other artists discussed in this book such as Schnemann and Wilke, the fact that Schrager is an attractive young woman, a former model and dancer, means that her intention can get muddied in its reception. While four decades have spanned between the groundswell of second-wave feminist artists and Schrager, many of the same debates remain: is the artist's intention critical to the meaning of the work? How does objectifying the young female body create a complex and precarious practice for a feminist artist? How can technology further a feminist stance? And is it possible to create sex-positive work and still be considered a feminist? The artists discussed in this chapter, grapple with many of the same issues that their predecessors did. It is fitting, then, that they appropriate themes and techniques of earlier feminist artists. I have argued that they borrow motifs, but use twenty-first-century responses to further these themes and ideas. While these emerging artists have not found a solution to many of these questions, they have continued complex debates begun by second-wave feminist practitioners.

3

The Artist is Present: The Body in
Feminist Performance,
Then and Now

In this chapter I argue that feminist performance art in the 1970s has its legacy in the work of emerging artists, including Nadja Verena Marcin, Dawn Kasper, Tino Sehgal, Rachel Mason, Kate Gilmore, and Liz Magic Laser. This discussion is grouped around the following themes, which are crucial for drawing both comparisons and distinctions between the earlier period and today's practice: the importance and central role of the artist's body in performance, both live and performed for video; the concurrent trend away from the use of the artist's body and into the role of director in current performance practice; the shift of performance art from a marginalized practice to one in the center of the art world today in terms of institutional and market support. I argue that younger artists build upon the groundwork laid by second-wave feminist performance art, particularly but not exclusively of the 1970s, in terms of the body as a contested site. While some embrace their own presence in the artwork, others remove themselves. However, all the artists rely on feminist tactics or themes in the work. I will also argue that this type of work, both the radicalized practice from earlier generations as well as the more recent performance, has moved further into the mainstream in terms of the art market and major institutional support.

One of the most important legacies of feminist art is the use of the body and the prevalence of performance as a viable artistic medium. While performance has its roots in early twentieth-century Dada and mid-century Happenings, it became a dominant art form in the same era as the intersection of the women's movement and art practice. For feminist artists performance was a progressive

medium that rejected the white male canon of art history as evidenced in painting and sculpture; it was also an important alternative for feminist artists. Drawing on influences such as the protest culture of the 1960s and improvisational dance and non-traditional theater, feminist artists most often based performances on issues related to the women's movement: female sexuality, childbirth, rape, housework, race, and labor became important themes in feminist performance art, as evidenced in *Womanhouse* in the US, and *A Woman's Place* in the UK, to name just two collaborative projects that fostered such practice. One of the defining characteristics of feminist performance included the use of the artist's body – nude or clothed – in confrontational situations. The same could be said of an emergent generation today, discussed at length below.

Feminist Performance: From the Home to the Streets

Artists of the 1960s and 1970s, from Carolee Schneemann, VALIE EXPORT, and Joan Jonas, to male counterparts such as Robert Whitman, Vito Acconci, Bruce Nauman, and Dan Graham, used performance as an alternative practice that resisted commodification within a codified art system based on a modernist model of authorship and genius. This was a medium that avoided the pitfalls of the commodity economy of postwar art. The body as a politicized form was no longer engaged in making the art as prioritized in Greenbergian dominated action painting, it became the art. Growing alongside and concurrent with the protest culture of 1968, performance art was seen, for both male and female artists, as a medium with less weight of tradition than painting or sculpture, albeit with a different agenda for female artists. Barbara Smith spoke about how abiding characteristics of performance differed for female and male artists of her generation. Amelia Jones quotes Smith:

> When men like Acconci, Nauman, and Burden began to work with the body, it was with a focus on behavior and permutations. They used their bodies as tools for self-discovery with a kind of self-disengagement. It seemed to me that they were exploring things in a quasi-scientific way but not really exploring maleness."[1]

Feminist artists used performance to explore the female experience.

Smith is a West Coast-based artist who made early performance work based on ritualistic actions, female sexuality, food, and spirituality. *Feed Me* (1973) took place the same year as Vito Acconci's notorious *Seed Bed* at Sonnabend Gallery. These performances are representative of male/female approaches in

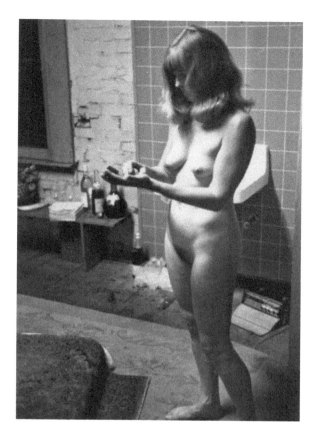

3.1 Barbara Smith, *Feed Me*, 1973. Courtesy of the artist and The Box, LA.

performance art, acknowledging the similarities as well as differences. Acconci hid under a floorboard and masturbated during gallery hours while visitors walked over him, their only connection to the artist through the sound of his action transmitted into the gallery. *Feed Me,* which took place in San Francisco at Tom Marioni's Museum of Conceptual Art throughout one night. Visitors could enter a room one at a time and would find Smith, naked on a divan, surrounded by various pleasurable items including bread and cheese, body oils, books, beads, perfumes, and marijuana, while a soundtrack repeated the words "Feed Me". At that point, the 16 men and three women who visited the performance were in direct contact with the artist, who dictated what she wanted to happen. Smith said the following about *Feed Me*:

> There has been a long history of misunderstanding of this piece. Many have felt I played right into the misogyny of patriarchy. However this was

not my experience. Of all the women who did pieces of this sort, making themselves available for the actions upon them by an audience, mine was the only one during which I had agency and control of the room. I made all the decisions. It was not a place of fear but of transcending expectations for all who entered. I forced the visitor to recognize that I am not an object but a person.[2]

Both works are iconic for their era. While Smith's employs the confrontational aspect of much feminist art, Acconci's work also uses his own body as object and material for the work. The similarities – both body-oriented, both dealing with sexuality – are equal to their dissonances. Smith's work leaves room for subtlety, with participants having to ask her what would please her, while Acconci's keeps total voyeuristic control in the hands (pun intended) of the artist. Smith's included direct confrontation whereas Acconci was safely removed from his viewers.

Some female performance artists were unrelenting in their provocation of viewers in what Amelia Jones has termed the "narcissism of feminist body art."[3] Jones discussed Hannah Wilke's posing, where she is seen topless or nude as a deliberate refutation of the male gaze, as symbolic of narcissism or the falling in love with one's image. Reclaiming female identity from an object to be looked at, which is evident throughout most of the history of art, and into an agent of that sexuality, was a hallmark of Wilke's work. Wilke's work is notable for her enacting a role of female objectification even as she was dying in her early 1990s series *Intra Venus*, shot in hospital beds as her body was being ravaged by lymphoma. In this series she figuratively spoke to her detractors who critiqued her for being a beautiful woman flaunting her body in her work.

Adrian Piper's *Catalysis* works are indicative of the feminist trend towards the use of the body in confrontational, role-playing situations in public spaces in New York City. In Europe VALIE EXPORT's performances also took place in public spaces and offered an element of danger for the artist.[4] EXPORT's *Tap and Touch Cinema*, performed in ten European cities between 1968 and 1971, saw the artist 'transform herself, through the use of a "cinema" or box around her upper torso, into a living embodiment of expanded cinema. The public was invited to touch rather than see the work through holes in the front of the box, thus eliminating the illusive quality of film and challenging them to encounter a real woman. Photo documentation shows a man reaching into the box, suggesting the fondling of the artist's breasts. Marina Abramovic also placed herself in potentially dangerous situations. In her work *Rhythm O* (1974) visitors to the gallery were invited to interact with the artist by choosing from 72 different objects placed on a table; these included sensuous things such as

3.2 Adrian Piper *Catalysis, IV,* 1970. Performance documentation notebook: 5 silver gelatin prints on baryta paper (prints ca. 1998), 1 typescript, 16 x 16" (40.6 x 40.6 cm), 9.5 x 11.5" (24.1 x 29.2 cm). Detail: Photography #4 of 5. Photo credit: Rosemary Mayer. Collection of the Generali Foundation, Vienna, permanent loan to the Museum der Moderne Salzburg ©Adrian Piper Research Archive Foundation Berlin and Generali Foundation.

olive oil, honey, and feathers to more menacing implements including scissors, a scalpel, and a gun with a single bullet. Yoko Ono's *Cut Piece* done a decade earlier in 1964 similarly left the artist in a vulnerable position. Here Ono sat in silence as the audience approached her, and cut a piece of her clothing. The potential for danger is obvious and these performances put the artists into vulnerable situations that relied on the trust in others. These artists often exhibited incredible endurance and courage in what could escalate into dangerous situations.

Feminist artists used their bodies to illustrate themes that were specific to the female experience, including centuries of objectification at the hands of male artists and society; the violence and objectification inflicted upon many women is evident in their performances. These themes, coupled with the

3.3 VALIE EXPORT *TAPP und TASTKINO (TAP and TOUCH Cinema)*, 1968. © VALIE
EXPORT, Bildrecht Wien, 2018, Photography: © Werner Schulz. Courtesy VALIE EXPORT.

insertion of the artist's body into the work, may be considered as criteria spe-
cific to feminist performance art. Suzanne Lacy discussed the importance of
the body in an interview with fellow artist Lynn Hershman [Leeson]:

> using the body as a primary site for work, a primary source of work, the
> physical manifestation of the body. That ran all the way from role-playing
> to the stuff that Cindy Sherman does now, which was done early on by
> feminists, which is adopting roles and distancing the self from the role.
> So it ran all the way from that to rape, to the impact of physical violence
> on the body. But the body is taken to be the underlying substrate, in the
> work that you did – the notion of shifting identities. All of that rests itself
> within the body of a woman and top of that body is the various interpret-
> ations of what happens. As you strip away the clothes, I think it was seen
> then, you come closer to some kind of reality. We had women performing
> nude in *Ablutions*. They dipped themselves in blood and eggs and clay. It
> was an incredibly physical experience the whole evening, and people were
> viscerally affected by arriving at that level of reality of women's experience
> within their body.[5]

Speaking in the early 1990s, Lacy was looking back at 1970s feminist art in her native Los Angeles, where performance and the body were important elements of a radical feminist practice that also included consciousness-raising and education.

Martha Rosler, well known for her early performance and video work, writes about feminist forms of art as a resistance to the elitism of the art world and a step closer to popular culture:

> Feminist reinterpretation of the most stringently formal mainstream art, combined with an assault on ideology and practice, was a further step in the process under way in pop of carrying high art into the wider cultural arena. The appearance of the female voice in the discourses of high art as something other than *lack* shattered, temporarily, the univocality of style. So did the struggle against commodity form and against dealer control of art world entry – but this process helped put the high-art world into even closer accord with the entertainment model of art, which was first centrally acknowledged by pop in the person of Andy Warhol.[6]

Rosler's *Semiotics of the Kitchen* is a short (six-and-a-half minute) perform-ance made for video in 1975. Set in a domestic kitchen, the artist is seen in a cramped space between a stove and refrigerator with a small wooden table with implements in front of her. Filmed in black and white with a fixed camera angle, the work begins with the artist holding a blackboard – typical of the kind that would be found in a household kitchen at that time – with the title, her name, and date written in chalk. The camera pans out and after placing the board to the side, the artist dons an apron then begins to read a script that unfolds alphabetically moving through different kitchen utensils, starting with "Apron". As she moves through the alphabet her actions become increasingly violent. For example, "Fork" sees the artist make jabbing actions and the "Ice pick" is stabbed into the tabletop. At the end of the video she uses her body to spell out U, V, W, X, and Y and then uses the knife to ominously carve a large "Z" in the air, which she refers to as a "zorro gesture" in her script notes.[7] The work subverts the notion of the happy homemaker as seen in 1950s instruc-tional videos or cooking shows. Using a deadpan humor, Rosler's connotation throughout is that of a housewife ready to revolt. This revolutionary video became an icon of feminist art that is often shown today and was re-enacted as a live event with younger women performing the actions under Rosler's dir-ection at the Whitechapel Gallery in London 2003.[8]

For Rosler and her US colleagues, many of whom were responding to the patriarchal order, performance represented a resistance to oppression and a

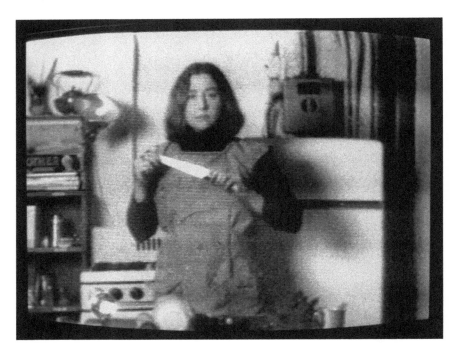

3.4 Martha Rosler, *Semiotics of the Kitchen* (still), 1975. Black-and-white video. Duration: 6 min. Courtesy of the artist.

possibility to raise awareness; and perhaps, to elicit changes in government policies, both domestic and foreign. It also closely reflected the wider society where protests against the Vietnam war were a common occurrence. The use of the live body as a political statement was a natural outgrowth for artists who witnessed widespread political protest. Martha Wilson commented on this:

> I saw feminism as projected against the backdrop of the Vietnam war… Feminism and the anti-war movement were in my mind linked because women are on the ground. They're the ones having the babies. They're the ones cleaning up the shit and the vomit. They're the ones on the front lines of actual, visceral, process.[9]

Wilson's connection between domesticity and war is an important and often overlooked position: women's labor is tedious, unacknowledged, and never done.

The relationship between feminist performance art and protest culture was illustrated in *Protest and Survive*, curated by Matthew Higgs and Paul Noble at the Whitechapel Art Gallery in London in 2000. This exhibition presented the connections between protest culture and art throughout the decades of

1960s to the new millennium. Feminist Artists included in this show were VALIE EXPORT, Jo Spence, Cosey Fanni Tutti, and Elke Krystufek, an Austrian artist who came of age in the 1990s. In the accompanying catalog, Higgs and Noble, both artists, wrote of the exhibition's nostalgic sentiment and their decision to include works that dealt with "gender, race, class, identity, sexuality, politics, economics, war, idealism, passion, resistance, boredom, frustration and pleasure."[10] These issues may be read as consistent with both protest culture and intergenerational feminist ideology. Today in the US, since the presidential election of 2016, we are again witnessing the popularity of protest culture, as seen in the January 2017 and 2018 women's marches. Most disturbing, freedoms that were won by feminist activity are being questioned, much to the dismay of many women and men alike.

Other reasons that feminist artists were almost always present in their performances included economic considerations and artistic control. Using themselves in the artwork eliminated the need for hiring a performer and meant that the artist could perform the action exactly as they envisioned it. Where today performance art is often supported by major institutions including public art agencies such as Creative Time or Public Art Fund in New York, in the 1970s feminist artists were largely working with little to no budget and with no chance of selling the work. Today documentation of these works is now being sold to both institutional and private collectors, but at the time of production the artists were not supported. Many younger artists have the advantage of institutional support, which allows for greater creative freedom, larger productions, and the hiring of performers.

The Body in Today's Practice: The Home as Disputed Site

Disruptive yet comical qualities of 1970s feminist artists are echoed in the contemporary practice of emerging artists who use their bodies in performances. Domestic themes, which were so prevalent in the 1970s feminist performance discussed above, from *Womanhouse* to Martha Rosler, are still an area for feminist critique today. Nadja Verena Marcin is a young artist of German/Slavic descent born in Germany whose work often explores representations of women in the media. After completing her MFA at Columbia University in New York, she now lives and works there. Marcin's *How to Undress In Front of Your Husband* (2016) is a short video that recreates a 1940s instructional film that was made to ostensibly help women remain seductive for their husbands. In the

3.5 Nadja Verena Marcin, *How to Undress in Front of Your Husband*, New York, 2016. © Courtesy of
Nadja Verena Marcin, New York, Thomas Jaeckel Gallery, New York & AK Art, San Francisco.

contemporary video, the artist performs four roles: the seductive, glamorous
Hollywood starlet called Elaine Barrie Barrymore; the awkward Hollywood
actress Trixie Friganza, who lives below Barrymore; and the two narrators Hal
Richardson and Albert van Antwerpt. The video opens with a text that relates
developments in society and purports that men have suffered enough and that
the video is a lesson for women to help with their husband's boredom: "We
have decided to do our bit toward the relief of marital boredom."

The narrator's voice describes the two neighboring women as they return
home from Hollywood parties and undress in very different manners: Marcin,
dressed in black as the glamorous actress, begins to undress in front of a mirror
as the narrator says, "Now Miss Barrie is unquestionably an authority on
undressing. Notice the ease and grace with which she slips out of things. That
truly is artistry." The camera then cuts to Marcin dressed entirely in white as
the unsexy actress downstairs pulling off her clothes in unladylike fashion. The
narrator says, "Trixie has been around and when it comes to undressing she
should be able to show us a thing or two." As Trixie awkwardly pulls up her
dress the male voice says, "Trixie, don't forget your bedroom manners." Cutting
back to Miss Barrie: "for Miss Barrie has excellent bedroom manners… she
not only knows how to get a husband, but how to keep him." The narrator
denigrates Trixie's disrobing technique as she rubs her toes then smells her
fingers, falls off a chaise lounge and passes gas: "How her husband must thrill
to such exotic charms. No wonder he has business at the office."

Marcin notes that instructional videos, which began with the prolifer-
ation of the camera in the 1930s, were made up of authorial male voices, who
literally controlled the gaze. Like Rosler's *Semiotics of the Kitchen*, or Helen

Chadwick's *Domestic Sanitation* (1976), where housewives dressed as furniture are seen smoking cigarettes while they perform household duties, or Catherine Elwe's *A Plain Woman's Guide to Performance* (1979), where the artist created a guidebook for performance artists who were not beautiful, Marcin's video uses deadpan humor to confront a serious issue for the 1970s that is still endemic today: women are socialized to be seductive and objectified rather than strong, confrontational, or argumentative. While societal and technological changes have democratized image-making, the artist notes that inherent sexism is still something that we see today. Marcin said in an interview,

> Women face so much oppression, whether it's violence or our represen-tation in the images we consume. It's all bad and I want to communicate how much we still encounter it every day. I try to have a little bit of a sense of humor around these topics because I feel like a certain amount of humor frees us. As a contemporary voice, this is how I want to invite people to open their hearts and open their eyes and think more. We can't just deny it. It's still happening.[11]

Marcin's work recalls the humor and role-playing of earlier feminist artists and also displays a nostalgia for historical documentation as typical of other artists of her generation discussed in this book.

The Limits of the Body in Performance Today

As several of the artists discussed above, younger artists push their bodies to physical limits of safety, performing risky actions that are indebted to the earlier practitioners. Rachel Mason and Kate Gilmore have created works of physical endurance that may be read in the continuum of earlier feminist artists. I argue that their work diverges from some of their predecessors, however, as they do not perform nude. Where that seemed essential as a reclamation of female sexuality for Schneemann or Wilke, it isn't necessary for Mason or Gilmore working in the context of the twenty-first century.

Mason's performance work adopts earlier feminist strategies, in particular the use of her body to create pieces that require extreme feats of stamina. While still a student at UCLA, Mason first performed *Terrestrial Being* in 2001, when she scaled the exterior façade of one of the school buildings. Dressed entirely in white and wearing a white helmet, the artist climbed the eight-story Dixon Art Building without any harness or support.[12] Mason explains that dressed

in this guise she adopted the character of the terrestrial being and was able to experience architecture in ways that she could not with her "normal physical body." This action had serious consequences for her, and almost resulted in her being expelled from the school.[13]

Mason has also developed a character called FutureClown where she dons a clown suit and makeup and performs in the street as well as to camera. *FutureClown's Filibuster* (2013) is a 13-hour durational performance and corresponding video in which Mason mimes the words to conservative US Republican senator Paul Rand's filibuster on the use of US drones for domestic terrorist targets. The artist used the YouTube version of Rand's rant, memorizing it and lip-syncing it in her FutureClown costume. Like Marcin, Mason performs all the parts, including interjections by Senators Ted Cruz, Mike Lee, Ron Wyden, Marco Rubio, Dick Durbin, Saxby Chambliss, Minority Leader Mitch McConnell, and Majority Leader Harry Reid.[14] The durational aspects of the performance recall many earlier performance artists, including Marina Abramovic. Mason's work transcends these earlier practices with the inclusion of humor and nonsense. It creates a distance between Mason and the character she is portraying rather than relying on narcissistic tendencies that were typical of neo-avant-garde performance. Dressed as FutureClown, Mason illuminates the theme of role-playing and masquerade that was central to feminist theory and art. The concepts of masquerade and farce are also central to comedy, another similarity with feminist artists such as Rosler, who combined serious critique with comedy in *Semiotics of the Kitchen*.

Kate Gilmore, an artist who combines sculpture, painting, performance, and video in works that always require physical duration, may also be seen in the continuum of feminist performance. Like *Semiotics of the Kitchen*, Gilmore performs in her studio to a camera that documents the action. Gilmore does not use editing, allowing herself only one take to perform each activity. For example, in *Walk This Way* (2008), a video opens with a shot of a dry wall installation with visible seams – a pounding, destructive noise is heard. The viewer realizes that the sound emanates from the artist, who eventually kicks her foot through the crudely constructed wall. As she uses her arms, fists, and legs to create a passageway large enough to escape through, the wall tears and crumbles, revealing a metallic pink interior, presumably symbolic of a female anatomy. If the opening may be considered vaginal, then her expulsion from it is a birth. Another wall behind the artist also needs to be bashed through in order for Gilmore to be able to worm her way out of this manmade corridor. Her head remains out of the shot, making this an anonymous, perhaps

universal, experience. The title of the work, *Walk This Way*, recalls an Aerosmith song about a cheerleader that leads a schoolboy on his first sexual experience. Gilmore seems to be bashing her way out of the objectification of women so rampant in our culture in this type of song.

In *Walk This Way*, Gilmore wears a black dress, black stockings, and black high-heeled shoes for the performance, suggestive of professional attire; a gendered uniform, it is also suggestive of role-play. The viewer does not see or understand her subjectivity but rather that of a performer enacting a task. When the heel kicks through the wall in the first penetrative action, one perceives a woman battling, against misogyny, the male-dominated workplace, and also her own biological confines. It is inspired by tropes of advertising campaigns, where a leg or shoe is mnemonic of a woman. It is also representative of a sculptural form that is deconstructed by the performance, a tautology that tests the understanding of traditional studio production in the same way Rosler's early actions did. Once the wall is destroyed, it is rendered useless as an object. It also may be considered as liberating: how many times have we as an audience, and particularly females, felt constrained by the representations of women? Gilmore's performances, which first used seemingly nonsensical exercises for herself, later transformed into works enacted by other participants. In their physical feats they hark back to feminist predecessors such as Abramovic and EXPORT, who placed their bodies in physically challenging circumstances in their early work.

The Body in Today's Practice: The Artist as Director

While the discussion above has focused on artists using their bodies within performances of their own devising, recently artists have removed themselves from live works, preferring to take the role of director rather than a participant. This is not a new phenomenon. Feminist artists, for example, Suzanne Lacy,[15] Martha Wilson,[16] and Judy Chicago, included other performers in their work. Mainstream artists such as Jim Dine and Robert Whitman also took a more directorial role.[17] Today there is a resurgence of this type of practice. Departing from the artist's body playing a central role in the performance action, I argue that younger artists take a directorial role in live and recorded performances, rejecting the narcissism of much of second-wave performance art.

Gilmore's practice evolved after 2010 when she began to remove herself from her work. *Walk the Walk* (2010) was one of the first performances where

the artist was not included in the central action. Commissioned by Public Art Fund and situated in the public realm, *Walk the Walk* took place in Bryant Park in midtown Manhattan, where the artist built a yellow plinth in the dimensions of the average office cubicle. As the park is centrally located near the Fashion District, the Bank of America headquarters, and the New York Public Library, it is a popular spot for office workers to meet for lunch or coffee when the weather is good. In Gilmore's performance seven female performers, dressed identically in yellow dresses and high-heeled shoes, similar to a typical female office worker, inhabited the small platform for ten hours a day from 8:30am to 6:30pm, the customary working hours of a New York City employee. The women, neither dancers nor performance artists, performed various actions, such as walking, shuffling, or stomping, but not in any particular pattern or order. These movements were not choreographed and may be considered as futile exercise. The performers derived from various races and nationalities, a microcosm of New York City's population. Visitors could partake fully by walking inside the cubicle, which was also painted yellow on the interior, to listen to the trampling footsteps above.

Gilmore's performance develops further her earlier durational work that acknowledged a direct lineage to second-wave feminist artists. Here again she confronted gender issues, and conflated the destructive tendencies of capitalism. The women performing on the podium, in all types of weather for ten hours a day, are emblematic of the tedium of the urban office worker, who spends more than a third of her life in a cubic space no bigger than a closet and then often returns home to perform domestic labor. Gilmore portrays the working woman as a liberated, self-sufficient entity, yet trapped in a confined area in a seemingly endless routine of repetitive action. Enclosed in a small circumference, the female performers attempt to avoid each other as they stumble through the day, a metaphor for women's position in corporate society.[18] The durational aspect of *Walk the Walk* is difficult to portray in video documentation, which is necessarily compressed to short fragments of ten-hour days. Thus, for an audience seeing the piece live is very different from understanding it via video documentation; this dilemma is reflective of how I understand feminist performance of the 1970s, which can only ever be experienced through abridged documentation.

Gilmore comments on the unpaid labor that women perform in everyday life, which might be read as of the legacy of Helen Chadwick's *Domestic Sanitation/Latex Rodeo* (1976), Merle Laderman Ukeles, *Sanitation Art* (ca 1979), and Janine Antoni's *Loving Care* (1993). In the last of these, the artist builds on the theme of domestic labor by "washing" a gallery floor. Dipping

her hair into a bucket of hair dye, the artist proceeds to use her ponytail to wash the floor, pushing the audience further out of the gallery. Remaining on her hands and knees for the duration of the performance, she reclaimed this vulnerable position into one of power by commandeering the gallery space. *Loving Care* incorporated identity politics and biological determinism with the collective state of women and all low-paid workers in late capitalist society, as Gilmore's works do. In the twenty-first century the production and reception of such work has evolved. Gilmore's projects were produced in collaboration with major non-profits Public Art Fund in New York and Parasol Unit in London, which exist to foster and support such activities and make them visible to a wide audience, including those outside of the art world. This is a far cry from second-wave feminist artists who needed to be entirely self-sufficient in the creation of their performances, which, if performed in the public space, were unauthorized and unprotected.

Another Gilmore performance, *Through the Claw*, took place at Pace Gallery in New York as part of *Soft Machines* 2011, a group show curated by Sarvia Jasso, Harmony Murphy, and Nicola Vassell.[19] In this performance, a group of five women dressed in identical pastel housedresses clawed at a giant slab of clay situated in the gallery. During the course of the show's opening reception, the women tore away at 7,500 pounds of wet clay, throwing it around a built structure that enclosed the performance, creating a mud painting with an installation that remained for the duration of the exhibition. The physical force required by the women was palpable. The violence of tearing apart the clay slab and throwing it against the walls of the structure also created what seemed like a liberating release for the performers, akin to a Reichian exercise to release anxiety or anger. One can cite Antoni's works, where she sculpted and molded materials such as lard and chocolate with her teeth as well as other body parts. The physical labor entailed is a metaphor for women's place in the domestic sphere or the larger framework of capitalist society. Unlike Antoni, Gilmore experienced the performance from the point of view of the audience while she took photographic documentation, leaving her out of the spotlight.

The stains and mess created by the event were left as an installation for the duration of the exhibition. These traces are notable for several reasons. First, they take what is essentially a white cube gallery space with a minimal clay structure and disrupt it to the point of chaos. This may be interpreted as a feminist challenge to the cube and to Minimalism in general, an admittedly male-dominated movement. Harry J. Weil writes, "Historically, women were not active in the creation of minimalist art; instead artists like Eva Hesse

and Lynda Benglis critiqued it by creating sculptures with organic textures. Gilmore's performance is a similar attack on high modernist taste."[20] It was not only women who dismantled the hard edge of Minimalism; male artists including Mike Kelley and William Pope.L have also used everyday soft materials such as stuffed toys and textiles to challenge a pristine aesthetic.[21]

In addition, the installation was for sale. Gilmore watched from the vantage point of the audience, documenting the performance with photographs that were sold in an edition of ten afterwards. The artist stepping outside of her performance also allowed her to control the documentation of the event, which in this instance entered the market. Performance, once a medium that artists used to resist commodification, and at times even resisted documentation of these events, has found its role in the mainstream art market. While not yet traded via auction,[22] artists have integrated performance into a mode of production that results in commodities that are bought and traded like objects. Sean Kelly Gallery began this trend with the creation of editions and essentially built a market for Marina Abramovic's work. Kelly said, "To no small extent we determined the way things would be formally presented and sold. Now there's a much more plural and formal environment, where you can buy a photo or a video of Marina, or you can buy an actual performance."[23] Earlier gallerists such as Ileana Sonnabend supported performance activity by artists, for example, Vito Acconci's *Seedbed* in 1972 and Gilbert and George's *Singing Sculpture* (1971), with slim chance of selling these works.

Video and photography, once seen as alternative genres, have become the tools by which the ephemeral is made manifest for the market. There is a history of recording performances for video works that can be traced to *Semiotics of the Kitchen*, as well as early Marina Abramovic, Hannah Wilke, and Bruce Nauman pieces. Even Chris Burden documented his perilous actions for posterity. Much of this documentation is now exchanged in the commercial art market, existing in multiple formats in the collections of institutions and private collectors. Also, there are artists, for example, Peter Moore or Babette Mangolte, whose work included documenting other artists' performances. Mangolte documented most of Yvonne Rainer's work as well as Silvia Palacios Whitman's performances.[24] These artists, once seen as photographers or documentarians, are now represented by commercial galleries and considered as artists alongside the peers they documented.[25]

More recently, Vanessa Beecroft, Patty Chang, and many others have used video as a means to both record and disseminate their performances. In Gilmore's case she first recorded herself in acts of physical and psychological

endurance and later moved behind the lens. I assert that removing oneself from the performance is a feminist action, displacing oneself from the objectified condition that many criticized Wilke and Schneemann for occupying. It resists the spectacle of the artist performer and morphs it into the traditionally male role of creator. It also removes the artist's body from the work, essentially democratizing and opening up the possibility of collaboration with other performers in the reenactment of such pieces.

For Gilmore there were practical as well as aesthetic reasons for removing herself from the live act. The artist became pregnant and could not perform the physically challenging and at times dangerous work that she had in the past. Also, her works became increasingly focused on groups of female participants who together perform some sort of task. Whereas the original wave of 1970s feminist performance art necessarily required the body of the artist as a political act, emerging artists increasingly step out of the action and into a directorial role, more often seen in theater than contemporary art. This witnesses a return to the generation of performers that congregated around the Judson Church in New York in the early 1960s. Here disciplines of dance, theater, and art merged in works that were both collective and experimental, chance becoming a key element in the work.[26] Rather than an artist who delivers a solo performance to her specifications, others are brought into the practice, thus leaving more room for interpretation. This is also evidenced in the institutional recreation of performances such as Abramovic's MoMA exhibition with younger artists.

Liz Magic Laser's *Chase* (2010) is a work where the artist shifts the performance space to a real-world setting as a metaphor for capitalism's pernicious effects. In *Chase*, nine actors read a Berthold Brecht play called *Man Equals Man* 1926 in the ATM vestibules of banks in New York City. Brecht's play is set in Colonial India and concerns soldiers who vandalize a temple and cajole a local man to take the blame. Both a comedy and a parable about relinquishing identity to the war machine, the post-World War I play finds its context in the present-day Western world, where individuality is ceded to corporate conglomerates, including banks such as Chase who track our every move through financial transactions. The actors each individually act out the entirety of the play in their local bank. The title *Chase* reflects the predominance of Laser's actors using this bank; however, it also has a double entendre that makes sense for the play – chasing for the identity of the offender.

These performances, while rehearsed, are played out in the public realm, complete with civilians who are using the bank machines as unwitting audiences.

This real-life engagement with the public harks back to feminist artists such as Suzanne Lacy, Betsy Damon, VALIE EXPORT Barbara Smith, and Adrian Piper, who in the 1970s interacted with non-gallery populations. In Laser's case, the work takes various formats: it exists in its original performance, as well as its edited documentation that is a video work in itself and collateral sculptures that create a gallery installation.

Chase, much like Gilmore's *Walk the Line*, employs strategies of earlier feminist art – direct confrontation with the public, adopting existing narrative for their own purpose, using collaborators in the productions – but moves the debate beyond issues of gender inequality. Gilmore and Laser confront the bleak realities of late capitalism. Both these works speak of containment: Gilmore's confinement is physical and psychological, stuck within the confines of a cubicle space. With the advent of women's supposed equality in the workplace[27] it also increased the amount of responsibility for women. More women had full-time jobs, in addition to domestic duties. Unfortunately, in many cases, while the woman became a so-called bread-winner, the division of domestic duties was not calibrated. In addition, Gilmore's performance, while utilizing female actors, also speaks to the plight of all workers in the corporate world. In this way, it is a universal indictment of corporate culture, which demands increasingly more from workers while giving less in return. Gilmore's work speaks to those that assert feminism as a human rights issue.

Laser's containment is one of identity, both physical and digital, and how it binds us to a history and stratified role in society. Brecht's play investigated social castes and the swapping of identities. In Laser's unconventional restaging of this, it becomes relevant to a time where our identities are defined by the digital realm that we inhabit; bank cards and social security numbers have become our new identities. We live in a world where individuals can be traced via their spending habits and internet searches; back-end data is cached and sold to other companies. The shifting of roles in *Chase* – from a balding male actor to a blonde female to yet another player – reads as metonymic for society's homogenization in this twenty-first-century culture. We are no longer individuals who know our bank managers and live in small towns, we are mostly urban dwellers who exist as numbers and figures in a vast global network.

K8 Hardy's performance in the 2012 Whitney Biennale provides another interesting example of the artist stepping beyond the role of performer. Hardy, who had often performed in the past, created a fashion show at the Whitney

Museum where models walked the runway and interacted with an infrastructural sculpture created by Oscar Tuazon. For the event, Hardy utilitzed a professional runway choreographer, hair stylist, and a celebrated female DJ (Venus X). The artist created each outfit using scraps and remnants from garments and objects found at thrift stores and junk shops. One dress was made entirely of bras sewn together while other outfits were made from children's bed sheets or disused curtains. Each outfit was a version of a runway trend, from midriff-baring tops to asymmetrical hems and deconstructed styles. What made the show so compelling was this combination of homemade clothes with a professional runway production. Feminist artist Cheryl Donegan,[28] who assisted Hardy backstage and has created her own catwalk shows as artworks, wrote about the show in publication that followed:

> K8's fashion show wasn't about the fashion business *per se*. By presenting one-off garments – nothing mass-produced or marketed – K8 created an authentic punk couture, its attitude playful and generous, more Michael's Crafts than Michael Kors.[29]

Hardy's work has always dealt with fashion and accessories as a representation, and particularly with the construction of female identity around such outfits. Rather than critique the fashion business, she engages in her own, alternative microcosm of it, employing real models, a runway manager, and a museum-going public. A runway show crosses the boundaries between the traditional notion of "high art" and the more accessible industry of fast fashion, which is particularly aimed at young female consumers. Hardy both mimics and subverts the fashion system by creating clothes that are made from unwanted items. She also illustrates the illusive nature of fashion.[30]

The performance was well received with positive press and sold-out attendance at both iterations. One journalist wrote:

> The irony, of course, is that by incorporating the form of the "fashion show" into her work, K8 Hardy delivers a performance that is essentially uncommodifiable. And because we are at an art event and not a fashion market, the inter-relational dynamic between those caught-up in this performance is altered. The attendees are there not for the clothes, but for the performance, and as a result, become part of the performance itself. The models are there not merely to present what they are wearing, but to play out their roles as a kind of unleashed feminine id. And the clothes, by subverting their own sense of fashion, call attention to the dynamic of the viewer-object relationship that is not unique to fashion,

but characterizes the very way we are most accustomed to experiencing works of art.[31]

A fashion show necessarily would require a line-up of models and hence the artist brings others into her work. However, it wasn't just for practical reasons that Hardy stepped out her performance work. She said:

> Well, I started to feel like an art clown. Some people might consider performance art pure entertainment. The requests got really bizarre – to show up one afternoon and perform in a tiny cage of an art installation and be filmed while doing it, for instance. Just for the coolness of it or for some fake economy of favors. Never for a fee. Performance art takes up so much attention that it can turn into a cloud of spectacle and take away from other work. It's a balancing act. That coupled with health reasons made me press the pause button, or maybe stop completely.[32]

Again, the notion of labor should be considered here. Performance artists are often invited into exhibitions and given a paltry fee or no fee for a live work that can take weeks or months to prepare. Similar to the mainstream corporate world, the art world exploits performance artists who are typically at the bottom of the economic food chain.[33]

Mika Rottenberg collaborated with Jon Kessler to create *SEVEN*, an extraordinary performance at Nicole Klagsbrun Project Space in Chelsea during Performa 11. In this work the audience, which was limited to a handful at each performance, entered to find seven participants in white bathrobes, who took turns sitting in a glass-walled sauna, which was powered by another performer who rides a stationary bike. The sweat of participants was gathered and placed into test tubes by a woman in a lab coat; eventually these tubes were placed in a cylinder and transported to an African savanna, as seen in a video where the same cylinder pops up through a chute and is removed by local African men, thus creating a system that connected wintry New York City to the African desert in Botswana.[34] While neither Kessler nor Rottenberg was present at the performance, which was repeated on a schedule over the course of three weeks, the trademarks of their work were there: for Kessler the cryptic use of new technology, machinery, and sculptural installation; for Rottenberg the use of female participants in absurd acts of production, which are based on the artist's abiding interest in Karl Marx's theories, but always lends a sense of humor and playfulness to the work.[35] Like Gilmore and Hardy's performances, this type of work would not be possible without institutional support and indicates a

divergence from earlier feminist art that was entirely self-funded. While some artists have found ways to commodify performance, it nevertheless is an expensive and time-consuming practice when delivered at this level. Institutional support now means such intricate and complex works can be produced and delivered to the public in an unmitigated way, encouraging artists who would hitherto have been unable to take such ambitious projects to fruition.

Indeed, it is here that we find the biggest disparity between live art of current women practitioners as compared to that of preceding feminist generations: the context and the audiences have changed. Institutions invest in performance because, although it can be costly, it keeps their programming vibrant and draws new audiences. Today, it is not unusual to stumble upon a performance at a museum opening or an institutional gala benefit. Take, for example, Alix Pearlstein's *Shoot in Twelve Shots* (2010), which was a performance on the occasion of the Independent Curators International (ICI) annual benefit. Pearlstein's twelve-minute live performance at the Park Avenue Armory included four participants who moved throughout the crowd and used innovative architectural elements of the landmark building. Two men and two women performed *tableaux vivants* (one can recall Bruce McLean's pose band *Nice Style* from 1970s UK) from a range of photographic sources, set to a soundtrack of rock music, including the seminal Nirvana track "Come As You Are" where Kurt Cobain sang the chorus "No, I don't have a gun."

Shoot in Twelve Shots is part of a larger series collectively titled *Shoot* where Pearlstein investigates the histories of photojournalism and performance documentation. Inspired by the Godard quote "all you need for a movie is a girl and a gun," Pearlstein investigates the concept of shooting in its various connotations, from shooting a gun to shooting a model or performer, with a camera. In this performance, hosted at a benefit for ICI in 2010, four performers – two male and two female – strike poses that are held for several seconds before changing to another. The poses range from the iconic image of a woman on her back being straddled by a fashion photographer from the film *BlowUp* to the pose of Elvis as a cowboy that was appropriated and repeated by Andy Warhol in his silver canvases. Shifting around the crowd without any warning or delivery of speech, the performers navigate the crowded rooms of the Park Avenue Armory uptown during a hectic social event.

The presence of cardboard props and cameras echoes the shifting relations between protagonist and adversary, artist and model, performer and audience. Pearlstein has spoken of her interest in this shifting relationship between

performer and audience and her admiration for works such as Dan Graham's *Performer Audience Mirror* (1975). In this performance, Graham stands in front of a mirror facing an audience describing every movement and action he makes. After a few minutes Graham begins to describe the small actions of people in the audience, who in turn see themselves in the mirror. By these actions, both ad lib and deadpan, the artist heightens the self-consciousness of the audience as well as the performer, breaking down the traditional remove between performer and audience.[36] Pearlstein found it interesting that Graham's piece originated the same year as *A Chorus Line*, once Broadway's longest-running show, debuted in New York. This musical also broke down the barrier between performer and audience, was set in a dance studio, where one could see the crew and performers indulged the audience in their insecurities and innermost thoughts.[37] Pearlstein was also interested in Yvonne Rainer's decision to create films rather than continue as a choreographer because she couldn't divorce the dancers from their lives.[38]

Like Gilmore's and Laser's works described above, *Shoot* exists in various formats, including live performance, photographs, and videos. As Anke Kempkes, a dealer with experience working with ephemeral practice and historical positions, has discussed, a package of these varying media could be offered to a collector.[39] *Shoot* is many things, but most of all it is a critique of performance as spectacle and an attempt to expose how performance is mediated through various situations including site, audience, and format. It is ironic, though, that its context was an art benefit, one of the mainstays of New York socialite calendars. Here one sees how performance art has moved from the margins into the center.

That Pearlstein, Hardy, Gilmore, and Laser are conspicuously not present in these performances is an important divergence from the second wave of feminist art discussed earlier where the presence of the artist was paramount: part of the impact of the work was Piper, O'Grady, EXPORT, or Damon interacting with the public. The trend today of artists staying behind the scenes is also the result of more institutional support for performance. Taking a directorial role is also related to our society's obsession with documentation. It is only seconds before a photograph from a performance is posted on Facebook, Tweeted, and recorded on Instagram for posterity. Today's generation of artists may be more interested in creating a work that lives on in diverse platforms, rather than one charged moment, or brief duration. By stepping outside of the performance they can control the documentation of their own work and thus control its legacy for future generations.

The development of digital video documentation of performance has also meant that younger artists can show the work in a broader spectrum of venues. Whereas earlier generations of artists discussed the issues around documentation, many claiming that it was imperative that the work be experienced live, increasingly younger generations of artists and audiences experience work on the internet, through their personal devices including laptops, tablets, and mobile phones. How this technology influences contemporary performance art will be an interesting trajectory to witness in the coming decades. Today, performance and video art is vastly more available than it was only 20 years ago, when the internet was just burgeoning. At that time, not only was less archival documentation and material available to scholars, there was also less performance art in general. The past decades have seen an exponential rise in performance by contemporary artists. This may be due to political and social upheaval – the Iraq wars, the Arab Spring, increased terrorism on a global scale, and a groundswell of protest culture, as well as the economic downturn in the US. However, there is also an increased awareness, through digital means, in earlier performance art. This had led to a correlative market interest in historical and contemporary performance art.

Performance Today: Institutional and Gallery Support

Performance has long been the medium of choice for a radicalized practice. In feminist history in particular, performance became a powerful tool for expressing ideas relevant to the women's movement, including disillusionment with the patriarchal order, the construction of female identity, and debates over domestic and professional parity. Performance is still considered an alternative practice to painting and sculpture, although the blending of all of these is now common. Live art and the moving image are particularly implicated as less definable, perhaps more challenging art forms given their inherent ephemeral nature. In terms of subject matter, and I speak here in terms of a radicalized practice, or one that uses live actions to express political ideology, the dialogue today echoes that of the past generations, including: what does it mean to for a female performance artist who is invested in debates around feminism? How is gender defined and used as a mechanism of control by society? How do we use our bodies to perform our identity, and can performance art still reject what might be seen as a more patriarchal order of traditional fine arts? These issues are also included

within a larger collective angst over the condition of the individual in late capitalist society.

Performance art has evolved in many aspects since the generation of artists that embraced this medium in the 1960s and 1970s.[40] The research, examination, and analysis of performance is an ongoing issue for a current generation of writers and curators who did not witness the groundbreaking performances of Carolee Schneemann, Robert Morris, Dan Graham, Adrian Piper, Yvonne Rainer, Joan Jonas, Robert Whitman, Simone Forti, Lorraine O'Grady, and many others in their original incarnations. My experience of performance has been largely mediated by documentation in the form of written scores and instructions, photography, film, video, and increasingly the internet. There is a plethora of online platforms dedicated to video art – Ubu, Vimeo, YouTube – as well as artists' personal websites. This has made the documentation of work from the formative period of performance art more accessible than ever before. While this is not the ideal way to experience this practice, it means one can see much more than was previously possible. It has also spawned a new generation of artists such as Ryan Trecartin and Lizzie Fitch, Jayson Musson aka Hennessy Youngman, and others, who make performance work for a web-based audience. My graduate research, which focused on feminist artists in 1970s, relied heavily on oral history and clouded memories as well as some photographic documentation and very little video evidence. To understand how performance has evolved in the past decades I am forced to do the same: to look back upon a secondary source – documentation – and make comparisons to the present state of performance.

During the advent of feminist art the performance medium was in its early stages, still on the margins, and its only audience a handful of insider, avant-garde art spectators.[41] Performance art had some support and connections to institutional spaces and communities, but they were rarely major museums; it was considered a radical practice that worked largely on a word-of-mouth basis.[42] Artists would invite friends, not only to witness the performance, but often to participate in the event. A collective spirit developed as so many artists participated in their colleague's pieces: Carolee Schneemann performed as Olympia in Robert Morris' *Site,* 1964; Frank Stella played tennis at the Park Avenue Armory in Robert Rauschenberg's renowned *Open Score* in 1966 as part of the seminal *9 Evenings: Theater & Engineering* festival; Lucas Samaras, Red Grooms, Jim Dine, Claes Oldenburg, Simone Forti, and Robert Whitman performed in each other's works in the early 1960s.

Today, performance has become accessible to a much wider audience. An example of its popularity was evidenced in the many sold-out performances at the 2012 Whitney Biennial, an exhibition curated by Elizabeth Sussman and Jay Saunders that was particularly invested in live performance. How and why has the audience for performance widened? First, institutions such as the Whitney, Tate, and MoMA have increased their support of live art through the establishment of departments dedicated to this field with expert curators; thus, the public has increased exposure to this type of practice. The notion of a printed, physical photograph, at least in a domestic sphere, has become antiquated in our culture, particularly for the generation born between 1980 and 1990 branded as the millennials, who came to maturity during the advent of the digital age. Today we are incessantly bombarded with digital images, popping up while we are on a news site or being sent to us via text messages or email. In addition, as a culture we have become accustomed to our own constant, daily, vernacular performance. Social media such as Instagram, Facebook, Snapchat, and other sites have provided platforms for everyone to both perform and witness performances. Teenagers give online tutorials about how to use eyeliner or how to straighten their hair; aspiring hopefuls make amateur porn; and the internet has produced a new genre of stars that are famous for quirky YouTube performances. Suddenly, it seems that everyone performs her way through life. However, feminist theorists such as Judith Butler have maintained that women have always performed their gender. The fluidity of gender that is socially constructed, rather than a biological determinism, was central to Butler's now-seminal writing.[43]

Undoubtedly, today's spectacle of daily life means that performance in a gallery or museum seems less radical, more acceptable, and even mandatory to engage a millennial audience. If the audience as both spectator and performer means that performance and the documentation of such have become ubiquitous in everyday life, what impact does this have on art production? Artists are always at the forefront of new technology. In the 1960s, Portapak video cameras enabled a new generation of artists – Joan Jonas, Nam June Paik, Michael Snow, Richard Serra, Jaime Davidovich, to name only a few – to utilize technology that was previously only available to film and television professionals.[44] As analog technology faded and digital technology expanded, artists increasingly became embedded into a global, transnational network. The use of the internet, as a performance space, for the documentation of work, or to host simultaneous performances, is widespread.

There is much discussion today about the "institutionalization" of perform-
ance. In 2010, Marina Abramovic's "The Artist is Present" was a retrospective
exhibition of her live actions (as well as those done with her former artistic
and life partner Ulay) with re-enactors, which featured a durational perform-
ance for the entirety of the exhibition, at MoMA New York; "Tino Sehgal"
at the Guggenheim in 2010 saw the iconic rotunda of the museum empty
except for performers who were given instructions by the artist; "Carsten
Holler: Experience" at the New Museum in 2011/12 included performative,
interactive works, which implicated the audience in the work.[45] Considered
retrospectively, this is both similar and divergent from a founding generation
of artists working in performance. For example, Merle Laderman Ukeles
performed one of her infamous sanitation pieces at the Aldrich Museum in
Hartford, Connecticut as early as 1973.[46] And progressive European institutions,
for example, the Kunsthalle Bern under the leadership of Harald Szeemann,
embraced ephemeral forms including performance, as did early iterations of
Documenta with, for example, the 1977 work of Joseph Beuys.[47] When viewed
retrospectively, the alternative spaces of feminist performance – *Womanhouse*
in America and *A Woman's Place* in London among many others[48] – became
institutions themselves, where the membership was defined by a self-selecting
group of people who were privy to such events. Today's institutionalization of
performance, with much wider popular appeal, is related to a vastly expanded
art market where almost any form of art can be commodified.

It is important to acknowledge that live art is not an autonomous medium
existing solely within the realm of visual art. Living in the age of "posts" as we
do (postmodernism, post-sexual, post-gender), it is at times difficult to separate
performance from dance, music, theater, sculpture, and even painting. Some of
the artists discussed below, like the feminist artists above, straddle disciplines,
a dominant characteristic of the age in which we live. Increasingly, popular cul-
ture has become more interdisciplinary as well; television shows like *Glee* and
Dancing with the Stars have embraced the previously unfashionable mediums
of the musical and ballroom dancing; reality television programs, such as *X
Factor* and *American Idol*, overlap with talent scouting; and increased inter-
activity means that the audience can now interact and guide the entertainment
through voting, polls, and social media.

Institutions in New York such as the Guggenheim Museum, MoMA/
PS1 and the Whitney have staged major exhibitions dedicated to perform-
ance. Where it once was a form of resistance, today it is inclusive and deemed
palatable for a general viewing public. There are varying types of exhibitions

that use performance as a main feature: those that include performance as an intrinsic aspect of the artist's practice; those that recreate performances, either by the artist or new interpreters, to place the work in a historical context; and those that include performance as part of a larger survey of an artist's work.

The first type is represented by the Tino Sehgal exhibition at the Guggenheim Museum in 2010, which included no physical objects. The performance consisted of a walk up the spiral architecture, with "guides," who were civilians ranging from children to octogenarians, and who would take you on a journey through the ages of life as well as the space of the unique building. Holland Cotter described the ephemeral aspect of Sehgal's work in his NYTimes review:

> Things are a problem for Mr. Sehgal, who lives in Berlin and studied political economy before he studied dance. He thinks the world has too many of them, that production is ceaseless and technology destructive. His art is a response to these perceived realities as they play out microcosmically in the context of the art industry. His goal is to create a countermodel: to make something (a situation) from virtually nothing (actions, words) and then let that something disappear, leaving no potentially marketable physical trace.[49]

Sehgal's work, which develops from a set of instructions given to his performers, evolves from the tradition of dance performance associated with the practitioners around the Judson Church scene: dancers such as Trisha Brown, Simone Forti, and Yvonne Rainer developed an informal, improvisational approach to dance that relied less on classical training than on notions of chance and the unexpected. Forti pioneered contact improvisation and merged the disciplines of dance, theater, and visual art with a feminist agenda.[50] Today these artists are currently being reassessed for their contributions to contemporary art and included in biennials and museum exhibitions, and Sehgal's project may be seen in this historical context.[51] Forti, Rainer, Brown, and Schneemann, all artists who directed performers and made works from a feminist perspective, are important predecessors for Sehgal. Sehgal's work would not be possible without these important forerunners; thus, his work may be read as advancing from the feminist tradition of challenging the legacy of the traditional artistic canon, through the use of the body, an ephemeral *oeuvre*, and the use of everyday actions, movement, and popular music, in performance.

Two recent biennials feature the live work of Dawn Kasper curated into the main gallery spaces of the exhibition. Kasper is a young artist who has worked

itinerantly since 2008 and is known for creating performance tableau.[52] For example, in one project, gallery-goers would enter the space to find a scene of her dead, face down on the ground, covered in blood, impaled by a pitchfork.[53] She references here the tradition of so many artists – Marina Abramovic, Chris Burden, Bob Flanagan – who enacted violence upon their bodies for their art, as well as Ana Mendieta, whose *Untitled (Rape Scene)* from 1973 confronted a much darker reality of violence aimed at women. Fellow artist Rachel Mason wrote about Kasper's work in 2011:

> But what seems to me to separate Dawn from other artists is that she doesn't invent a fantasy character, she actually performs as herself, albeit an exaggerated version of herself. But it is Dawn on display in her work. And it's scary. A lot of performers put versions of themselves out there – I know I do – but Dawn does the thing directly to herself, *with* herself, permanently, and it is forever inscribed on her. It's frightening, it's troubling, and it's heroic.[54]

Perhaps an onlooker to Burden's *Shoot*, where the artist instructed a collaborator to shoot him, or Mendieta's *Untitled (Rape Scene)* would have described it similarly as an unnerving experience. Over time, Kasper's work progressed from the confrontational death scenarios to a less contentious interaction with the viewer.

Nomadic Studio Experiment (2008–), in which she relocates to a host exhibition space, came as a necessity for the artist who gave up her studio for financial reasons after losing her job.[55] The performance is Kasper's studio life itself, which often includes her playing music and doing mundane studio chores (sorting cables, organizing her archive, etc.) as well as more creative tasks/activities. Kasper takes this show on the road wherever she is invited to exhibit. In 2012, she participated in the Whitney Biennial with *This Could be Something if I let It*, a performance that took place for the duration of the exhibition. Kasper packed up her studio, took residence at the Whitney Museum for opening hours (she wasn't allowed to stay overnight), made work and interacted with the public in an ongoing performance. Testing the limits of the museum in a similar vein to her predecessor Merle Laderman Ukeles, Kasper was not allowed to eat in the galleries and had to use the bathroom on the basement level.

The public's interaction with Kasper was an inversion of the typical museum visitor experience; rather than seeing a resolved artwork that was transported from a studio space, one stepped into an artist's studio and saw the mundane objects, the inspiration, the unfinished works, and most importantly, the artist's

working process. Working in the vein of Laderman, Ukeles, or Andrea Fraser, who are known for their interventions in museum spaces, Kasper follows in the footsteps of these artists who used the museum as both site and material to test the boundaries between the acceptable and the disruptive. The legacy of institutional critique, so central to the practice of artists Laderman, Ukeles, or Andrea Fraser, is continued through Kasper's project.

Kasper's work is also reminiscent of feminist tactics where artists sought to interact directly with the public, such as Bobby Baker's *Mobile Family in an Edible Home* in London,[56] VALIE EXPORT's *Tap and Touch Cinema*,[57] or Adrian Piper's *Catalysis* series, in which these artists sought unmitigated contact with the general public as an unwitting audience. It is also reminiscent of Marina Abramovic's *The House with the Ocean View* (2003), in which she lived on a raised platform at Sean Kelly Gallery in full view for twelve days, fasting in silence the entire time.[58] Kasper uses the legitimization of the museum institution itself, through a prestigious biennial, to conduct a durational, mostly banal performance, albeit less spectacular than many of her predecessors. Her daily activities, including eating, playing music, and even going to the bathroom, require permissions not normally associated with museum life. For example, one could hear her installation – music she played on vinyl or on her computer – before one saw it, a curatorial challenge for an institution like the Whitney. Kasper inverted the typical relationship between the audience and the work of art; traditionally an artist's studio is a private place, open only to friends and colleagues such as curators and art dealers who visit. The artist transforms her studio and her processes – even the quotidian daily events of organizing or eating – to the audience, demystifying the creative act. The direct interaction with the public is one of the most important tenets here, albeit a select museum-going audience.

There is another form of exhibition witnessed in recent years, which comprises the re-creation of earlier performances, either by the original artist or by new practitioners. It is worth noting that in London the Tate Modern and the Whitechapel Gallery of Art were important forerunners of this trend. In 2001, Whitechapel mounted a series of performances titled *A Short History of Performance* (Parts 1 and 2) where, among others, Rosler recreated her seminal video *Semiotics of the Kitchen* as a live performance using younger women, and Schneemann recreated *Meat Joy* (originally performed 1964) with herself as master of ceremonies and using a cast of young performers. In 2005, Abramovic's *7 Easy Pieces* at the Guggenheim saw the artist recreate five iconic works of other artists (Vito Acconci, Joseph Beuys, VALIE EXPORT, Bruce Nauman, and Gina

Pane) as well as two of her earlier performances, over a period of seven days. What were originally limited events with a limited audience, these performances were transformed into large-scale spectacles at one of the world's leading museums. This serves to glamorize and popularize earlier performance art. However, it adds little understanding or analysis of the original artists' intentions, and instead seems to further mythologize the post-war history of performance art.

Performance has also notably re-entered into large curated exhibitions. For example, several recent iterations of the Venice Biennale have featured performance integrated within the galleries on a daily basis. In 2013, Sehgal won the Golden Lion at Venice for a work that saw performers hum and beatbox while moving around the gallery floor for the duration of the exhibition.[59] Similarly, Sehgal's work was featured in Documenta 2012. Visitors were immersed in a dark space and surrounded by performers who sang and danced throughout, interacting with the public. In Okwui Enwezor's 2015 Venice Biennale, an entire gallery called the Arena and set up as a mini auditorium, was situated in the middle of the central pavilion's galleries. Here, performances rotated throughout the day, including daily live readings of Karl Marx's *Das Kapital* as well as a film program inspired by the book.[60] Dawn Kasper and Anne Imhof presented performance-based projects at Venice Biennale 2017. Documenta14, which opened in Athens in 2017 under the creative direction of Adam Szymczyk, also included performance as a main platform for the international exhibition.[61]

Sehgal, Abramovic, and others have brought performance art into a mainstream collector market, which begs the question of whether it nullifies its existence as a radical action.[62] At Frieze New York in 2013, Marian Goodman Gallery presented a booth with a single work by Sehgal called *Ann Lee*. The work consisted of an eleven-year-old child who acted as an *anime* character, engaging with the audience by asking, "Have you heard of Pierre Huyghe? Have you heard of Philippe Parreno?" Engagement with the audience is a trademark of Sehgal's; what made this work different was the story behind the Japanese character Ann Lee. Huyghe and Parreno purchased the rights to this character, then consigned this to artists that they thought could do something interesting with the concept as part of their *No Ghost Just a Shell* project.[63] Sehgal's *Ann Lee* performance was available for purchase in an edition of four; however, apart from the usual conventions for editioned works, Sehgal does not issue a certificate of ownership or written instructions.[64] He also never allows documentation of his work. The artist attempts to subvert the art market's established system of exchange

by challenging accepted protocol, but ultimately his work is nevertheless implicated within this system.

Performance during the women's liberation movement was an important form of political action in both protest and art-making. Performance is now a commodity acquired and exchanged as an object, yet it is still possible to be considered as an instrument of politics. As performance moves into the mainstream, it broadens the field of protagonists and opens up the dialogue to more practitioners and intersectional points of view. Contemporary feminism intersects with performance as well as issues around labor, capitalism, race and politics. Artists now – female and male – owe a debt to feminist forerunners of the 1970s in particular for their interpretation of the body and sexuality, their confrontational use of gender, as well as the use of the domestic as theme and site. As performance is increasingly institutionalized it begs the question: where does one locate the avant-garde?

4 Avant-Drag: The (Fe)male Body Reconsidered for the Twenty-first Century

In this chapter I argue that the legacy of feminist performance finds a new context today in artists who use drag and burlesque, genres that in the past were more often found in nightclubs rather than galleries, in their practice. As I have argued in the previous chapter, performance has become institutionalized and supported through a gallery system, and artists are pushing the boundaries even further. I have previously in this book discussed the debate over nudity in feminist art including that of VALIE EXPORT, Jo Spence, and Hannah Wilke and the fact that it is still problematic today. The artists in this section challenge by blurring the boundaries between burlesque, drag, and performance art. They use their cultural and personal heritage to challenge accepted norms, to celebrate difference, and to acknowledge a past feminist history. It is this celebration of difference that has its origins in feminist art practice. Building on a foundation set by forerunners, these artists carry on a legacy of questioning, agitating, and demanding societal adjustment, using their own bodies and identities to effect change.

The word burlesque comes from the Italian *burla* meaning joke or mockery; in the US, particularly in 1940s club life, it became associated with striptease and bawdy female comedy. Drag is an abbreviation for drag queen, or one who dresses in the clothing of the opposite sex. While this is seen in popular culture, from cult films such as the Monty Python series to television programs including Little Britain, it also refers to a specific

form of performance usually found in gay nightclubs where performers don makeup, wigs, dresses, and often use comical props. Each genre – performance art, drag, and burlesque – requires a significant amount of unseen labor that is focused on an effortless, comical performance. Unlike endurance-based performance art, the labor is not overt in any of these genres. Narcissister, Colin Self, Chez Deep, Martine Gutierrez, and Kalup Linzy borrow elements from these popular forms, including cross-gender dressing, humor, and popular music as well as homemade props and outfits. Their work has developed parallel to the rise of queer studies in the academy, where club culture became a topic for research and analysis.[1] In this chapter I argue that emerging artists are indebted to feminist predecessors, yet they also diverge from them by using depictions of womanhood that are non-normative and more typically associated with drag culture.

Queer studies flourished during the AIDs crisis, when issues around contamination and disease were conflated with a morality debate. The fear of gay people infected by the disease was prevalent in society and many artists made work in response to this irrational panic. Robert Gober's notorious installation at Dia Foundation in Chelsea in 1992 is an example of work that responded directly to this crisis. The centerpiece of the show was a gallery covered in walls that simulated a forest created by the artist. Gober attached his handmade sculptures, suggestive of urinals with anthropomorphic holes, on to the handpainted forest scene. Below the urinals, stacks of faux *New York Times* newspapers, painstakingly created by the artist, featured headlines about the AIDS epidemic. The installation was haunting for its suggestion of the US trying to cleanse the population from AIDS, often portrayed in the mass media as an immoral disease spread by lascivious people.[2] Artists such as General Idea, David Wojnarowicz, and Peter Hujar were important for adding voices to this debate over contamination and morality. Women artists also used the AIDS crisis as subject matter. While the virus devastated a predominantly male population, it nevertheless did spread among women and many artists lost several among their circles to the disease. Nan Goldin's photographs of Cookie Mueller withering from the disease, and subsequently dead in her coffin, are among the most powerful of this genre of work.[3] Today through the development of pharmacology, HIV is a manageable virus, and people are living with it for extended periods of time. The widespread panic that characterized the late 1980s and early 1990s has waned as the virus has become more manageable.

Labor, Humor and History

Trained as a professional dancer with the Alvin Ailey Dance company, Narcissister[4] is an artist who remains anonymous by creating an alter ego, which is female identified. As Narcissister, the artist is always masked, her identity never revealed.[5] Narcissister investigates gender, race, and society by morphing into hyperbolic manifestations of women. Her work takes various forms: live performances at clubs or galleries, which are often used to experiment and test ideas; recorded videos, shown in galleries and freely distributed on the internet; and artworks such as photographs and video installations that are shown and sold through the gallery system. Her art practice is financially supported by her work in the burlesque industry. At clubs such as The Box in lower Manhattan, Narcissister performs on a regular basis, earning income that supports her gallery-based work. Embraced by the burlesque industry, which allows her to continue to work on her art with complete freedom, she has also elicited some negative criticism from within the art establishment. The artist has said:

> This is an issue I struggle with, which may have to be resolved in the long term. I understand my project with its multi-facets and multiple platforms can be confusing or off-putting to some and resists the kind of containment that is perhaps required by the various "establishments."[6]

According to the artist, and in contradistinction to some of her peers, selling is not her main objective:

> Perhaps it's political, my anti-capitalist tendencies and my embracing of these more populist pursuits of making the work widely available. I want to share my work with as many people as possible. I don't have the interest in, or proclivity for, art world-type strategizing that might include making my work more exclusive, less available. This doesn't seem to make sense for my project and doesn't suit my creative aims or my larger vision of how I want to live in the world.[7]

Like many of the artists discussed in this book, Narcissister mines art of the past – especially feminist art – in the production of her work. She acknowledges her interest in Adrian Piper, Marina Abramovic, and Carolee Schneemann, in works that continue the legacy of challenging taboos and the mainstream art world. Take, for example, her video and performance work *Every Woman*. This is a short performance where the artist enacts a reverse striptease during the

course of a single pop song: Whitney Houston's *I'm Every Woman*. In this instance Narcissister begins the performance wearing only her typical mask, a merkin, and a large afro wig. She proceeds to pull her entire outfit from various orifices: a tube top, belt, and earrings from her mouth; stockings and a tube skirt from her vagina; platform shoes, wrist cuffs, and a handbag from her afro; and finally, a scarf from her anus.

"I'm Every Woman" also became the strapline for the Whitney Houston Biennial, an alternative, women-only exhibition, established in early 2014. Conceived as an alternative to the prestigious Whitney Biennial, artists C. Finley and Eddy Segal gathered over 75 artist colleagues of different generations, including Annie Sprinkle, Michelle Hebron, Body Double (Kathy Garcia), and many more.[8] Narcissister performed there to a festive crowd while one of her video works, *Burka Barbie* was also projected large-scale as part of the exhibition. The event took place at a studio complex in Brooklyn and crowds lined up in freezing temperatures around the block to see the show. Reflecting a new spirit of young, punk feminism, Narcissister's performance was a headliner event for this one-night-only exhibition.

Narcissister acknowledges the inspiration of several artists within this performance: she pays homage to Adrian Piper, whose *Catalysis* series included her riding the subway with a gag in her mouth.[9] Also, Carolee Schneemann's *Interior Scroll* (1973), during which she pulled a text on a scroll from her vagina as she read it, was a major touchstone for the younger artist, who liked the idea of using the interior parts of her body – so often taboo – in the performance.[10] Schneemann, Piper, and Narcissister's use of orifices of the body may be discussed in relation to the classical text by the anthropologist and cultural theorist Mary Douglas, *Purity and Danger: An Analysis of Concepts of Purity and Taboo*, from 1966. In this groundbreaking book Douglas looked at the concepts of purity and dirt and how cleanliness is used to enforce cultural norms, including religious customs such as a kosher diet. Orifices of the body are boundaries between the clean, acceptable exterior and the taboo interior, especially of women. If we think of the germs associated with orifices, especially in an era after the AIDS crisis and other communicable diseases, these artists are challenging social norms by suggesting contamination through their mouths, vaginas, or anuses. Cultural theorist Ben Campkin quotes Douglas: "The underlying feeling is that a system of values which is habitually expressed in a given arrangement of things has been violated."[11] Julia Kristeva's writing on abjection is also relevant here:

Does one write under any other condition than being possessed by abjection, in an indefinite catharsis? Leaving aside adherents of a feminism that is jealous of conserving its power – the last of the power-seeking ideologies – none will accuse of being a usurper the artist who, even if he does not know it, is an undoer of narcissism and of all imaginary identity as well, sexual included.[12]

The abjection in Narcissister pulling clothes from her orifices and then wearing them during the performance is shocking, even in relation to her feminist predecessors. Kristeva's abjection is also enacted with the artist's obscured identity, which means that we cannot place her, and thus rejects the narcissism of second-wave performance. She is an everywoman that challenges society, disrupting the visitor's expectations and encouraging one to think about how we view women in our society.

Using her orifices literally internalizes the performance, as the artist becomes one with the work. This corresponds to earlier practitioners who have used their bodies to test the endurance and to make a political statement with their art. Abramovic is most appropriately referenced here as she was an influence on the younger artist; Narcissister was one of the performers who re-enacted historical works of Abramovic at the MoMA retrospective in 2010. She commented on this experience in a discussion with the author:

> This was a great opportunity that I felt extremely fortunate to take part in. It was very interesting to witness the behind-the-scenes process. And of course it was a very different practice of performance than my work as Narcissister offers me. Re-performing Marina's work asked me to draw more on my previous experience as a professional dancer and on all the rigorous training of that period. I re-performed the *Luminosity* piece which demanded great physical and mental strength required to sit on that bicycle seat suspended in the air – withstanding discomfort in the pelvic area, keeping the arms outstretched, warding off waves of dizziness, not fidgeting – these are all challenges that my training as a dancer left me very prepared to deal with. I also practice meditation and those stretches of time on the seat offered me a great opportunity for practicing focusing on my breath staying in the present moment.[13]

Narcissister's work as a paid reenactor for Abramovic is labor for another artist. Again, the labor intrinsic in creating a performance is the same for art, drag, burlesque, or theater, and belies what the viewer sees as effortless. Here, though, is a twenty-first-century phenomenon: performance art in the form of reenactment where the performer is not author. This is a divergence from

the performance of earlier feminists such as Wilke whose narcissism is central to the meaning of the piece. It is also different from the collaborative spirit of the Judson group or Happenings, as they were not paid to participate in each other's performances. Narcissister does not assume authorship as a paid reenactor; however, working with Abramovic was clearly inspirational for her own practice, in particular in terms of endurance in withstanding discomfort.

For Narcissister's generation, the rich legacy of feminist artistic tradition, now better documented and exhibited, is easily referenced; this is a marked distinction from the generation of second-wave feminist artists that younger artists look to for inspiration. Catherine Grant's writing on fans of feminism, as discussed previously in this book, is again relevant. Rather than the idea of harking back to an idealized golden past, Grant argues that these artists share a more complex relationship to their predecessors: "rather than an appropriation strategy that privileges irony and distance, the action of a fan focuses on attachment and desire".[14] Grant continues:

> This may be a productive model through which to think about the tensions between different generations of feminist artists and historians, and how to relate to a feminist history in a way that moves beyond rejection or straightforward celebration. By approaching this work through the model of fandom, the engagement with feminism as a historical project also allows for a consideration of how feminism can continue in the present. Being a fan of feminism does not replace being a feminist, but articulates a particular relationship to histories of feminism.[15]

Narcissister's admiration for Abramovic, as well as her work, with its playful insertion of bawdiness and popular culture, may be considered in light of her position as a fan of her feminist predecessor.

Narcissister's choice of soundtrack for the performance is very different from Schneemann reading from a scroll, although perhaps as significant: a Chaka Khan track originally released in 1978, and rerecorded in 1992 by Whitney Houston, who sang back-up vocals on the original. Houston represents the fallen woman scenario in popular culture: having started as a gospel singer and descended into drug use and domestic abuse, eventually meeting her demise in a cliché of tabloid fodder, in a bath tub at the Beverly Hills Hotel. Narcissister, as Houston sings, is "every woman"; she is not an individual but rather an anonymous performer behind a mask. Houston's chorus "it's all in me" is literalized with Narcissister's props hidden in the interstices of her body.[16] The artist's incorporation of Whitney Houston is another form of

nostalgic fan worship. Houston was packaged to appear as a beautiful church girl with an angelic voice; indeed she developed a huge fan base starting in the 1980s, which would be familiar to Narcissister and likely what she would have listened to as a young girl. The choice of Houston is indicative of what Grant terms as "attachment and desire" as Narcissister is not keeping an ironic distance, but engaging Houston as an iconic, integral part of her work.

While the work is a homage to earlier second-wave feminist performance, it is very much of its time, a twenty-first-century version of feminism, where humor and sexual titillation move beyond one fixed political stance and owe more to drag and popular art forms. The boundaries are literally and physically transgressed using a costume, mask, props, and pop music. The artist celebrates the use of popular culture in both the accompanying soundtrack and her outfit. Fashion – in this case the afro hairstyle, the miniskirt, platform shoes, and tube top – becomes a political statement and a class indicator. The artist is not addressing a particular feminist audience but every woman, as the song suggests; however, one could argue that Narcissister, with her mask, is not a typical woman, but a vision of female that is highly constructed and has much in common with drag performance.

The body here becomes the tool in several ways. Most obviously it is that of the artist herself, a trained dancer, who applies the discipline and choreography of modern dance to this short performance; it is perfectly timed and cued to the music track. Also, her body is indeterminate in terms of race. As a light-skinned African American woman, with her face masked, the audience cannot determine a fixed racial profile. Is she Hispanic, light-skinned African American, Middle Eastern? This amplifies the "I'm Every Woman" theme. The artist acknowledges the viewer's inability to assign a racial profile saying, "I have realized, because of the sheer reality of my identity, that it is impossible for me to not address these issues on some level. These issues come into play in the work whether I directly intend it or not."[17] This indeterminacy is an interesting factor that the artist uses as a tool in her work. She extends the racial debate that overlaps with feminist enquiry; however, as her race and cultural background cannot be clearly identified, her position becomes more open to interpretation for a viewer. This openness is a trait typical of much of the new work presented in this book. I argue this is a progression, through intersectional feminist tactics, from second-wave feminism. Where artists such as Piper or later Renee Green or Kara Walker, have made work that emphasizes the African American female experience, Narcissister's identity is never fully divulged. It can be read as a universal message.

Burka Barbie is another work where the artist puts aside any notion of political correctness to interrogate the representation of women, including violence and subjugation. In this performance for video, Narcissister is seen with a blonde wig and prosthetic breast plate a la Cindy Sherman's *History* series entering a typical 99 cent shop in New York City, where she finds a Barbie dressed in a burka. While holding it she fantasizes a scenario that begins with her (and four other women) in life-sized Barbie packaging that may also be read as coffins. Narcissister wears one of her typical masks as well as a black burka, which means she is almost totally obscured by the costume. The four other women wear velvet blue burkas. Set to The Clash's 1982 hit *Rock The Casbah*[18] Narcissister dances and uses props from the Barbie box including a designer handbag, and undergoes several costume changes. This is typical of her other performances, including *Hot Lunch*, where the artist starts as a giant hot dog, morphs into a diner waitress, and finishes naked, and *Basket*, where she morphs into women from various time periods; in *Burka Barbie* she appears in various burka iterations. She and her cohorts dance in a style resembling Madonna's Vogue video, striking poses and repeating simple hand and arm gestures. At one point in the song, Narcissister takes off her burka to reveal a lingerie-clad woman, with short hair, and a row of bombs strapped to her midriff, suicide-bomber-style. When she pulls the release a bomb is detonated and she is violently transformed into a woman wearing a Western, modern dress and climbs back into the Barbie box. The next shot is back in the 99 cent shop, with Narcissister putting the Barbie box – with a tiny doppelganger of her in the modern, Westernized dress – back on the rack.

In *Burkha Barbie* Narcissister questions gender roles; she also interrogates the representation of women, as seen through a Barbie doll, as well as the representation of the Middle Eastern woman, who is often demonized in conservative US media and politics since the 9/11 attacks and expressed most recently in Trump's Muslim travel bans in the US. She breaks obvious taboos by featuring a woman in a Muslim garb dancing provocatively, at one point in a sheer red burka, smoking a cigarette, and prostrating herself in prayer with a designer handbag. As Martha Rosler and other artists used the war in Vietnam as source material, Narcissister here uses the post-9/11 era of media-fed hysteria over Muslim fundamentalism. However, her work, while acknowledging earlier feminist precedents, includes a sense of playfulness that she doesn't acknowledge as present in the 1970s practice. She says:

> I think the main element that separates my work from much of this [earlier feminist] work is my embrace of humor, and the deeply subversive

potential it carries. Also perhaps my unabashed embrace of pop forms, my commitment to the mask, and my brash aesthetic separates my work from this early feminist work. Worth considering also is my/our distance from pivotal movements – the women's liberation movement and civil rights movement. Perhaps this distance affords me more space to be more playful, less overtly serious? ... I still look to early feminist performance work for inspiration. I certainly aspire to be just as powerful as the best of it.[19]

Judy Chicago has reminded me of the use of humor in much second-wave feminist art. Perhaps Narcissister, and many of us who were not present for that era, don't immediately read humor in the works that we see through documentation.[20] It is significant that younger artists are embracing it as a central message.

Using the body as sculptural material, a trope of artists begun in the 1960s and 1970s, was embraced with fervor by feminist artists. Carolee Schneemann used her body for mark-making in performances such as *Up To and Including Her Limits*, in which she swung by a tree surgeon's knot to make crayon marks on the ground and adjacent walls of an installation space. Hannah Wilke and

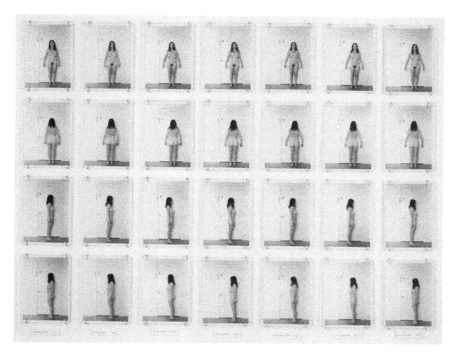

4.1 Eleanor Antin, *Carving: A Traditional Sculpture*, 1972. Installation view. 148 silver gelatin prints & text, 7 x 5 in each. Courtesy of the artist and Ronald Feldman Gallery, New York.

Eleanor Antin also used their bodies as sculptural material. Wilke attached miniature chewing gum sculptures to her face and body and documented it in works called *S.O.S. Starification Object Series* (1974–82). The tiny sculptures resembled labia and the title is an obvious play on scarification. Eleanor Antin's *Carving* (1972) involved morphing herself through radical dieting over a one-month period and documenting its effects on her body. The resulting documentation may be compared with a sculptor working in marble. The body as sculptural material in performance is not a genre solely occupied by female artists. In the wave of body-oriented art there were male artists who used their bodies in performative actions: Bruce Nauman, Stuart Brisley, and Chris Burden, among others, opted for performance as a medium that could challenge the traditional status quo of painting and sculpture. That both women and men were drawn to use their bodies in artworks at the time is not surprising. For all artists the body was a new medium that hadn't yet been claimed by the male-dominated history of art. For men and women alike, the coverage of the Vietnam war, with its eviscerated and flame-covered bodies, was a constant media presence. This focus on mortality, along with the protest culture of the time, surely had an effect on artistic content.

Zackary Drucker, a younger trans artist whose works have been critically acclaimed, and who featured in the 2012 Whitney Biennial, gave this explanation for the appeal of performance:

> I think live performance is such a powerful medium because it's inescapable. There is so much that is lost in the flattening of things and the creation of objects – the interactions that we have with humans and all of the sort of chemistry exchange. All of the primal lower level communication tools we can use are impossible in the creation of objects or on-line communication or anything.
>
> You're not safe when you're watching a performance. ... You get people's guards down. It's a wave that is completely outside of the norm. We are so guarded and we have so many kind of filters to protect us.[21]

This immediacy between performer and audience, which was so avowed by 1970s feminist performance artists, is even more relevant today. With the exponential increase in technology of the past two decades, devices have isolated us rather than bringing people together, as often promised. Drucker's words remind us that live performance has that primal connection between performer and audience that is so important in our society.

Between Male and Female: Drag and Transgender Performance

Through drag and transgender a new generation of artists is embracing feminist tropes. Colin Self[22] is one of this younger generation whose work acknowledges a debt to research on and artistic production around gender roles. Self works between disciplines, moving from performance to sound and music works, as well as organizing symposia and events. Coming from a queer perspective he has spoken of the importance of 1990s feminist activity, as well as earlier canonical feminist work, for his own work:

> I definitely feel a strong affinity with all waves of feminism in their differences in trying to destroy or deconstruct patriarchal systems, but I would say the core of my initial influences were women (most of which who were musicians or performers) in the Pacific Northwest. I grew up in Aloha, Oregon at a time where Riot Grrrl had sort of transformed into performance art and pop music. Susan Ploetz, Anna Jordan-Huff, Khaela Maricich, Wynne Greenwood, Kathleen Hanna, Miranda July, Beth Ditto, and so many other women in the Pacific Northwest were all approaching femininity and affect and rage and play in all of these different ways. I remember attending my first Sleater-Kinney show in eighth grade and telling my friend "This is what I am going to do with my life." …my awareness of earlier artists and feminists stemmed from building relationships with some of these women who showed me the history behind what they do, like Judy Chicago, Martha Rosler, Guerrilla Girls, Louise Bourgeois. A lot of these influences came into my life when I moved to Chicago in 2008 to study video art and performance.[23]

Self creates works as a sole author and as part of a collective, Chez Deep, which also includes Sam Banks, Hari Nef,[24] Alexys Penny, and Bailey Styles. Their work has been called avant-drag, post-drag, or drag beyond 2000.[25] As mentioned previously, the terminology for such practice is evolving and is not yet resolved. Chez Deep exist somewhere between burlesque, drag, and gallery-based performance art. However one identifies it, the collective occupies an interstitial space between contexts and genres. Their five-part philosophy is called "A Manifesto in Five Parts: Desire, Surrender, Labour, Power, Sacrifice."[26] Living in an era where gender is a fluid spectrum rather than a binary opposition, the group expresses the exultation and angst of existing in a time when they do not choose to identify with one gender in particular.

The definition of gender, as discussed by writers from Judith Butler to Parveen Adams and Donna Haraway, was one of the central debates of earlier

feminist art. Women artists and activists were beginning to congregate to articulate the problems with patriarchy in postwar society. They protested against a heteronormative restriction of gender roles – as vessels, mothers, domestic laborers – defined by biological assignation. Many women artists made work around this: Mary Kelly's investigation of the social construction of women through motherhood in *Post-Partum Document* 1973–6, a series-based work that centered around the artist's son's development from infancy to a toddler reflecting psychoanalytic concepts; Ana Mendieta's *Untitled (Rape Scene)* (1973) and Suzanne Lacy's *In Mourning and In Rage* (1977), which used confrontational tactics to suggest the violent nature of crimes against women.[27] These artists questioned the role of women as one defined by physiology and acknowledged it as a socialized, learned condition. Today's investigation into gender becomes even more blurred. With the massive increase in hormonal pharmacology and increased options for surgical enhancement or reassignation of sex, gender identity is no longer a fixed assignment. In addition, the spectrum between male and female is increasingly an option. Living as a woman, man or intersex person, taking hormones to accentuate female or male traits, or just dressing as a woman or a man, are all choices rather than pre-determined today.

The notion of the collective is important here and harks back to earlier feminist tactics. Collectives including Judy Chicago's *The Dinner Party* project in Los Angeles, as well as the *Feministo* project and the Berwick Street Filmmakers in the UK, came together in the spirit of activism to try to further the cause of women's or worker's liberation. Educating others, producing collectively, and using the concentrated efforts of a group meant that artists could share the labor rather than working alone. Chez Deep reactivates such collective spirit. Self discusses this:

> I think all of my work and my consciousness as software built collectively by my biological and queer (chosen) family. One of the reasons I work in so many varied forms of collaboration and immaterial relations is to hopefully inspire others to focus on these relationships with a little more effort. If I can demonstrate the power of gathering together with other people to exchange ideas to improve upon their goals through conversation, then I am doing my job!"[28]

Like their feminist predecessors, the goal of producing art is an embodiment of activism, including to raise consciousness, in this case, of queer and trans culture.

Common Visions is an event that Chez Deep hosted and performed at the Ace Hotel in New York in November 2013. An hour-long program that

included drag and dance started with the five members dancing on a catwalk-like stage, where the audience is seated on both sides. This platform calls to mind drag clubs, where the stage is often in close proximity to the audience. The choice of song for the first section – "The Age of Aquarius" – represents the Utopian nature of their project. It also is indicative of the free-form and sexually liberated nature of their performance: Sam Banks, a dancer seen in all white street clothes with heavy drag makeup, dances around the stage. His improvised movements compare more to the Judson Church contact improvisation of Steve Paxton or Yvonne Rainer than traditional drag. They are the controlled movements of someone evidently trained in dance. Bailey Styles is dressed as a woman from the waist up with full drag makeup and hair; Colin Self is dressed in a flesh-colored dress and cuffs; the artists make little attempt to disguise their assigned sex.

Hari Nef performs a hypnotic lip sync to Lana Del Rey's *Ride*[29] in a sequin evening gown; her chest hair, white contacts à la Marilyn Manson and shaved head undermine the artifice of femininity. Other artists lip sync the same voice, creating a confusion of roles and raising questions for the audience. Who is the emotional diva singing the melodramatic song? How is individual identity subsumed into a collective action? While this has the melodrama of a traditional drag performance, it transcends the earlier genre with these aspects. This is an interesting development from drag of the last decade of the previous century when New York drag artists such as Joey Arias, Raven O, Hedda Lettuce, and others would dress fully as women. Even the stage identities of Chez Deep are shifting: Sam Banks intervenes in the Lana Del Rey number and takes over the lip sync from Hari Nef. Indeed, identity shifts as fluidly as gender in these performances. Not only do artists assume different roles within the event, they also change roles within acts. In the video documentation of this event the artists have inserted moments of text against a blank screen. These include "How does her identity define the way she performs?" and "I'm tired of feeling like I'm fun not a female, but growing up gay or trans in middle America, where an increasingly fanatical right wing tries to diminish such lifestyles."[30] The lack of distinction between the self and the collective is something that Leo Bersani has written about in terms of gay culture. His words can be used here: "…allegiance to the gay subculture requires the subordination of the individual to the culture's self-defining traditions and practices."[31] While Bersani is referring to sexual promiscuity, the quote can be considered in terms of an activist art practice such as Chez Deep, where the individual performer is subsumed for the sake of the group.

Self performs a solo dance and lipsync number, bare-chested, long blonde hair flowing, full makeup and tattoos visible. A "feathered" cape worthy of a runway is actually constructed of black bin liners. Like Narcissister, Self and his colleagues use quotidian, cheap materials to construct costumes for performances, typical to the DIY nature of drag. The body is the cheapest material of all and is used effectively by Chez Deep to question gender roles. A vision between female and male, human and animal, transforms within the performance from something seductive to frenetic, and increasingly fervent, with Self's performance at times becoming almost shamanistic. Midway through Planningtorock's track "Living it Up" the artist grunts maniacally to the music and proceeds to enter a trance-like state, shaking his head and arms violently.

Another act in the event sees Nef in a college logo sweatshirt (that iron-ically reads Catholic Football) and sweatpants mouthing the words to serial killer Aileen Woronos' last statement prior to her execution. The monologue, which gives glimpses of her delusional personality ("God is going to be there, Jesus Christ is going to be there, and all the angels... did you know there was helicopters dropping out of the sky, deputy sheriff trying to pick me up?"), Woronos represents those that slip through the system in the States; from the lowest economic strata, working as a street prostitute, and the victim of rape and sexual abuse, Woronos's life became defined by her serial killing of men who raped and attacked prostitutes. In the rambling rant one glimpses a failed cul-tural and justice system, where women of marginalized communities are repeat-edly victimized. Nef mouthed aggressively, "You sabotaged my ass society, and the cops and the system. A raped woman got executed and was used for books and movies...". While these are ramblings of a serial killer, it is a haunting and sobering chastisement of US society, which does not protect its most vulnerable, including the mentally ill and sex workers.

The sheer variety of short performances within Common Vision is what makes it remarkable. Alexys Penny performs an erotic, retro-style striptease that owes much to burlesque culture. While Nef confronts a dark theme in her performance, the overall feeling is one of exuberant, life-affirming celebration. It has the feeling of a music video come to life, albeit one in which gender roles are blurred and oscillate in front of the viewer's eyes. It echoes the ad hoc nature of downtown New York City club life in the 1970s and 1980s as well as the theatrical downtown loft performances of Jack Smith.[32] Here the writing of Paul Preciado is useful. In today's twenty-first-century bodies, we have the capability of existing in transitional state, including between male and female gender. Existing in a transitional role can be seen as an act of resistance to

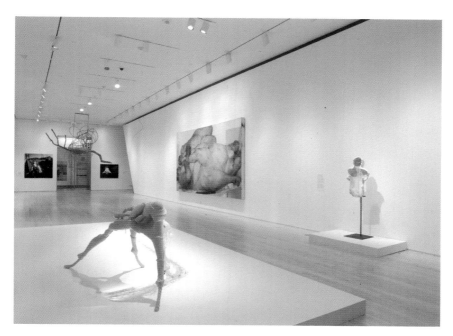

1 Global Feminisms, March 23, 2007 through July 1, 2007, Brooklyn Museum. Installation view.
Photography: Brooklyn Museum.

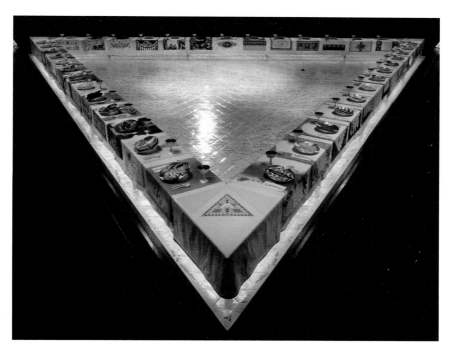

2 Judy Chicago, *The Dinner Party*, 1979. Collection of the Brooklyn Museum, gift of the Elizabeth
A. Sackler Foundation. Photography © Donald Woodman/ARS NY. © Judy Chicago/Artists Rights
Society (ARS) New York.

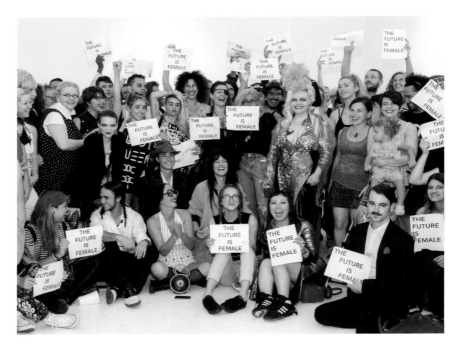

3 Future Feminism opening reception, The Hole, New York, September 11, 2014.
Photography: Walter Wlodarczyk. Courtesy of The Hole, New York.

4 Betty Tompkins, *Fuck Painting #15*, 2005. Courtesy of the artist and P.P.O.W.

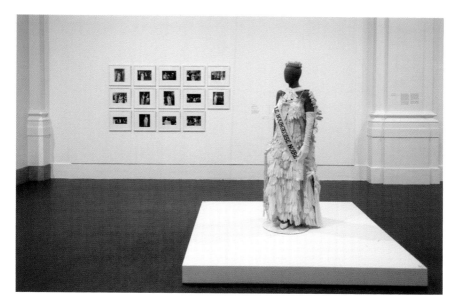

5 We Wanted a Revolution: Black Radical Women, 1965–85, April 21, 2017 through September 17, 2017, Brooklyn Museum. Installation view. © 2016 Lorraine O'Grady/Artist Rights Society (ARS), New York.

6 Cindy Hinant, *Women (Carolee)*, 2011. Courtesy of the artist.

7 Aurel Schmidt, *Lynda*, 2007. Courtesy of the artist.

8 Rachel Mason, *Starseeds*, 2014. Courtesy of the artist.

9 Rachel Mason, *Starseeds (Missy Elliot)*, 2014. Courtesy of the artist.

10 Lisa Kirk and Jelena Behrend, *Revolution (Revolution Pipe Bomb)*, 2008. Courtesy of the artist.

11 Martha Rosler, *House Beautiful: Bringing the War Home (Cleaning the Drapes)*, c. 1967–72. Photomontage. © Martha Rosler. Courtesy of the artist.

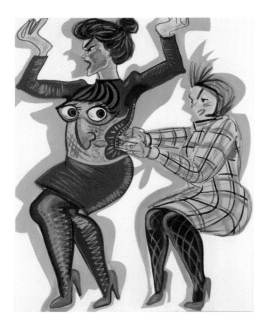

12 Ella Kruglyanskaya, *Zip It*, 2014. Oil and oil stick on linen, 84 x 66 in. © Ella Kruglyanskaya. Courtesy of the artist and Gavin Brown's enterprise, New York/Rome.

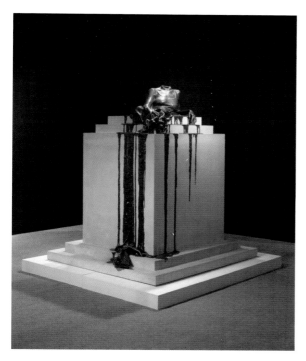

13　Diana Al-Hadid, *In Mortal Repose*, 2011. Courtesy of the artist and Marianne Boesky Gallery.

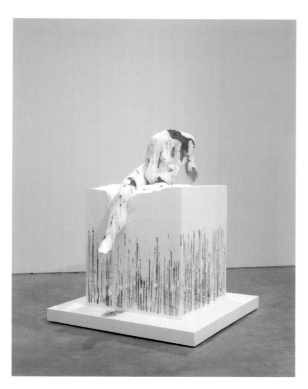

14　Diana Al-Hadid, *Antonym*, 2012. Courtesy of the artist and Marianne Boesky Gallery.

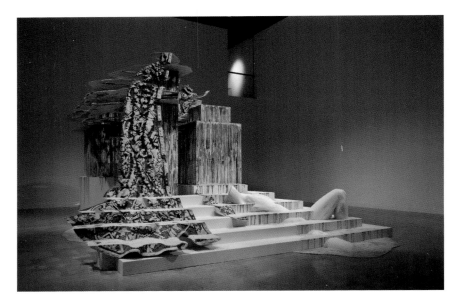

15 Diana Al-Hadid, *Suspended After Image*, 2012. Courtesy of the artist and Marianne Boesky Gallery.

16 Rachel Garrard, *Passage (Blue I)*, 2014. Courtesy of the artist.

17　Rachel Garrard, *Luminous Volumes (Float)*, 2014. Sodium hypochlorite on black canvas, 68 x 62 in. Courtesy of the artist.

18 Ana Mendieta, *Untitled: Silhueta Series*, Mexico, 1976. © The Estate of Ana Mendieta Collection, L.L.C. Courtesy of Galerie Lelong & Co.

19 K8 Hardy, *Positions Series #13*, 2009. Courtesy of the artist.

20 K8 Hardy, *Positions Series #26*, 2009. Courtesy of the artist.

21 Juliana Huxtable, *Untitled (Psychosocial Stuntin')*, 2015. Courtesy of the artist and JTT, New York.

22 Frank Benson, *Juliana*, 2015. Painted bronze with Corian pedestal. Sculpture: 23 x 48 x 22 in (58.4 x 121.9 x 55.9 cm); pedestal: 42 x 53 x 24 in (106.7 x 134.6 x 61 cm). Courtesy of the artist and Andrew Kreps Gallery, New York.

angelunaluna •••

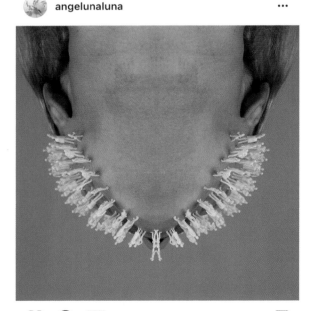

Liked by **threeasfour, adigabiange** and **348 others**

angelunaluna POPULATION CONTROL STARTS DOWN UNDER

23 Ange, Instagram post dated September 29, 2015. Courtesy of the artist.

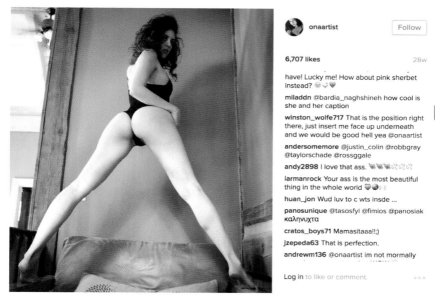

24 Leah Schrager, Onaartist Instagram screenshot, c. 2016. Courtesy of the artist.

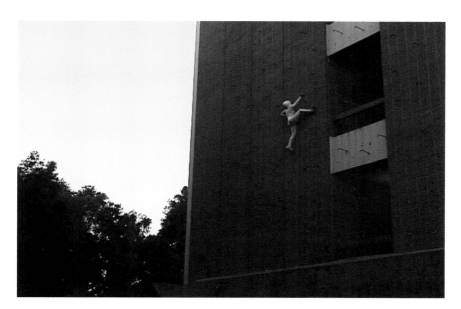

25 Rachel Mason, *Terrestrial Being*, 2001. Courtesy of the artist.

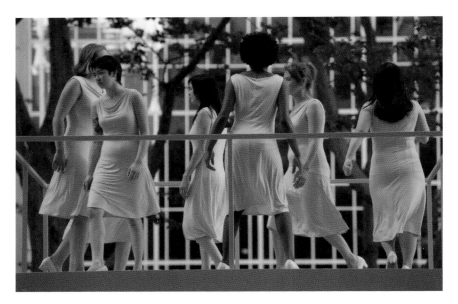

26 Kate Gilmore, *Walk This Way*, 2008. Courtesy of the artist.

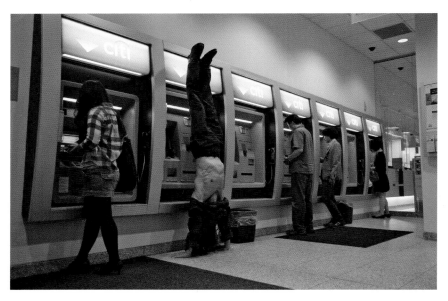

27 Liz Magic Laser, *Chase*, 2009–10. Still from performance and video installation, 145 min. With actors Annika Boras, Andra Eggleston, Gary Lai, Liz Micek, Justin Sayre, Doug Walter, Michael Wiener, Max Woertendyke, and Cat Yezbak. Courtesy of the artist.

28 Mika Rottenberg, *SEVEN (sculpture Variant)* in collaboration with Jon Kessler (2011–2016). Video Installation (36 min 08 s), mixed media. A Performa commission for Performa 11. Courtesy of the artists. Exhibition view, Palais de Tokyo, 2016. Photo credit: Aurélien Mole.

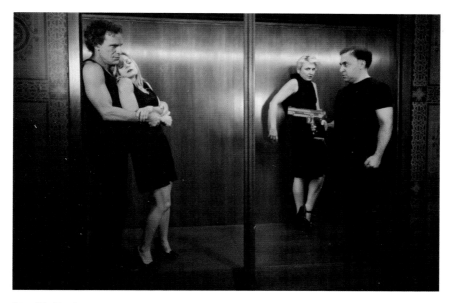

29 Alix Pearlstein, *Shoot in 12 Shots*, 2010. Performance, 12 min. Performance still. Courtesy of the artist.

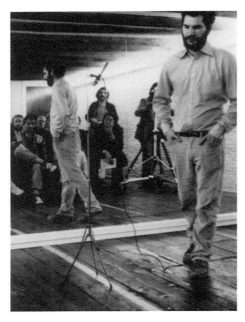

30 Dan Graham, *Performer/Audience/Mirror*, 1975. Single channel black-and-white video with sound, 22 min 52 s © Dan Graham. Courtesy Lisson Gallery.

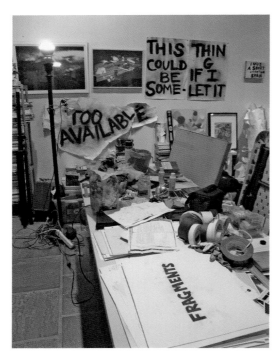

31 Dawn Kasper, *Nomadic Studio Practice Experiment (This Could Be Something If I Let It)*, 2008–12. Installation view. Courtesy of the artist and David Lewis, New York.

32 Narcissister, *Every Woman*, 2009. Production still. Photography: Tony Stamolis. Courtesy of the artist.

33 Narcissister, *Burka Barbie*, 2014. Video still. Courtesy of the artist.

34 Carolee Schneemann, *Up to and Including Her Limits*, 1973–6. Installation view. © Carolee Schneemann. Courtesy of Carolee Schneemann, P.P.O.W., and Galerie Lelong & Co., New York.

35 Chez Deep, *Common Visions*, 2014. Photography: Drew Bolton. Courtesy of the artist.

36 Kalup Linzy, *Romantic Loner (Crossing The Threshold)*, 2013. Courtesy of the artist.

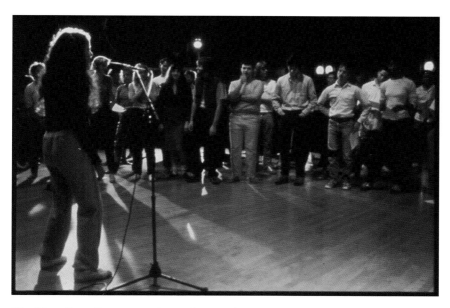

37 Adrian Piper, *Funk Lessons*, 1982–4. Group performance, University of California at Berkeley, 1983. Photograph documenting the performance. Photo credit: Courtesy of the University of California at Berkeley. Collection of the Adrian Piper Research Archive Foundation Berlin. ©Adrian Piper Research Archive Foundation Berlin.

38 Martine Gutierrez, *Clubbing*, 2012. © Martine Gutierrez. Courtesy of the artist and RYAN LEE Gallery, New York.

39 Martine Gutierrez, *Real Doll, Ebony 1*, 2013. © Martine Gutierrez. Courtesy of the artist and RYAN LEE Gallery, New York.

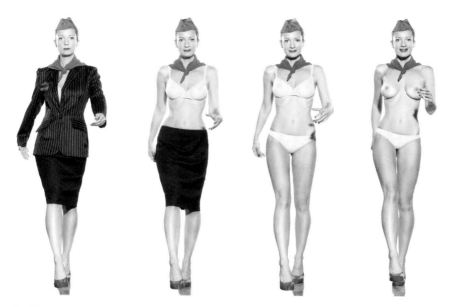

40 Marta Jovanovic, *Piornika*, 2011. Courtesy of the artist.

41 Samia Halaby, *The Brown One*, 2016. Acrylic on linen, 60 x 60 in (152 x 152 cm). Courtesy of the artist.

42 Alex McQuilkin, *Untitled (Pink Zip)*, 2016. Courtesy of the artist.

43 Alex McQuilkin, *Untitled (Purple Zip)*, 2016. Courtesy of the artist.

44 Cindy Hinant, *Kendra Exposed*, 2014. HD digital video, 26:54 min. Installation view at Interstitial. Courtesy of the artist.

45 Cindy Hinant, *Upskirt (Emma)*, 2016. Digital C-print, unique, 22.6 x 15 in. Courtesy of the artist.

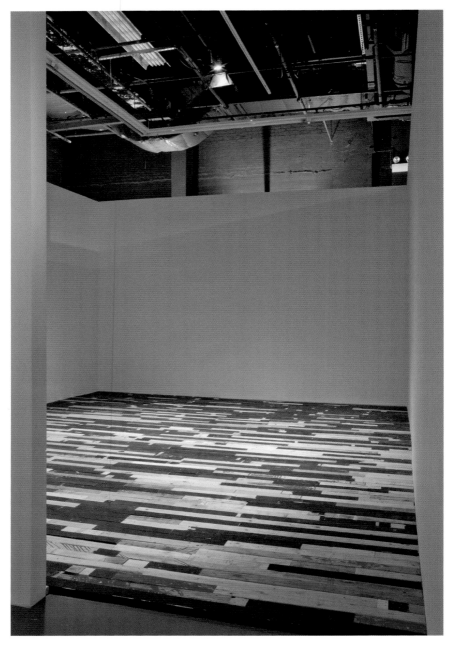

46 Virginia Overton, *Untitled (2x4 floor)*, 2012. Installation view at The Kitchen, New York.
© Virginia Overton. Photography: David Allison.

47 Virginia Overton, *Untitled (Waterfall)*, 2016. Installation view: Virginia Overton at the Whitney Museum of American Art, 2016, © Virginia Overton. Photography: Ron Amstutz.

48 Virginia Overton, *Untitled (Orb)*, 2015. Installation view: Escape Attempts, Shulamit Nazarian Gallery, Los Angeles, 2017 © Virginia Overton. Photography: Shulamit Nazarian Gallery.

49 Naama Tsabar, *Work On Felt (Variation 9 and 10) Bordeaux and Black*, 2016. Felt, carbon fiber, epoxy, wood, guitar tuning peg, piano string, piezo, amplifier. 71 1/2 x 55 1/2 in and 71 1/2 x 55/1/2 in. Photography: Tal Barel. Courtesy of the artist.

50 Naama Tsabar, *Closer*, 2014. Wood, metal, microphones, microphone stands, tuners,
guitar strings. 54.5" x 54.5" x 9'. Part of the performance series Blood Makes Noise, Solomon
R. Guggenheim Museum, New York, Nov. 22 – Dec. 22, 2014. Photography: Kristopher McKay
© Solomon R. Guggenheim Museum, New York. Courtesy of the artist.

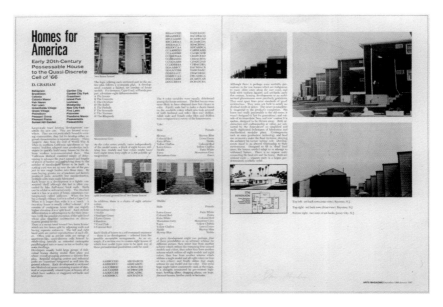

51 Dan Graham, *Homes of America,* Arts Magazine, 1966–7. Print 74 x 93 cm. © Dan Graham.
Courtesy Lisson Gallery.

52 Cindy Hinant, *Grids Next Door* series, 2011. Digital video, 22:28 min. Courtesy of the artist.

53 Cindy Hinant, *Makeup Painting*, 2011. Makeup on paper, 40 x 30 in. Courtesy of the artist.

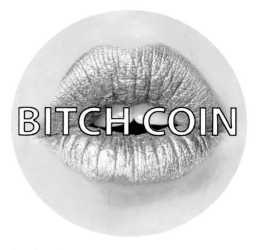

54 Sarah Meyohas, *Bitchcoin logo*. Courtesy of the artist.

55 Sarah Meyohas, *Canvas Speculation*, 2015. Courtesy of the artist.

political, artistic, or economic agendas. The proliferation of pronouns such as "zhi" and "they" indicating a trans person is indicative of this inbetweenness. A person with male sex organs may take female hormones to create a softer version of his body, while not opting to undergo a complete gender reallocation. Or he may have a breast augmentation but keep the genitals he was born with. Any of these variables may be seen as a resistance to heteronormativity and the dominance of the State. Preciado writes poignantly on this:

> The body no longer inhabits disciplinary spaces but is inhabited by them. The biomolecular and organic structure of the body is the last hiding place of these biopolitical systems of control. This moment contains all the horror and exaltation of the body's political potential.[33]

Self and Chez Deep are the aesthetic embodiment of this newly found freedom as well as long-contested issues. While in the US we live in a society with more flexibility than ever before, we are also at the mercy of a religious right-wing movement that threatens not only women's rights over their own bodies, but also the rights of gay and trans people. Self says:

> Chez Deep has really become an incredible outlet for demonstrating what I mentioned earlier about building a new attention economy and deconstructing the dualism / binaries through collective, plural forms of participation. ... The work / materiality of Chez Deep stems from the conversations and experiences we share together, taking care of ourselves and one another, and perpetually being asked to reify and recontextualize what those two things mean, because even within the group, we have very different ideas about what that means and how it should be demonstrated. Our rehearsing and choreographing comes from several different mediums and algorithms and rarely do we use the same algorithm twice. After finishing our second manifesto we are currently working on a script and two short films, so we can shift the attention and focus of our presence out of the privatized space of the nightclub / venue spaces, and think about de-centralizing ourselves and our communication to come from both physical and non-physical spaces. [34]

Chez Deep, like other collectives and collaborations working today – including Narcissister and AL Steiner; K8 Hardy and W.A.G.E.; Bruce High Quality Foundation, et al. – form an important alternative to the monographic art market where works by single known artists are commodified and sold to the highest bidder. They are also alternatives to traditional performance art and it will be interesting to see how they occupy "non-physical spaces." Chez Deep

intersects the impetus of feminist performance art in its resistance to the mainstream market with a conception of gender that resists easy categorization.

Female Avatars: Trans Culture and Contemporary Feminism

Kalup Linzy's[35] performance and video work features visions of feminine identity that highlight the absurdity of certain media representations of women. In particular Linzy is interested in the popular melodrama that is an integral part of daytime television. Outfitted most often in an obvious wig, crude makeup, and dress, Linzy creates music videos, short films, and mock soap operas in which he composes, acts, and sings. Linzy borrows themes from mass culture, including melodrama, clichéd notions of gender, as well as social and class stratifications. Drag is central to his work[36] and implicit throughout its various manifestations. Another theme common to his work is low production value, which resists the preceding era of slick, institutional video art, suggesting a more challenging and uneasy position of both the viewer and the audience. For example, the lighting and costumes are not on the level of actual televised productions; the music in the videos is obviously home-produced and the singing is off-tune; and at times the dialogue is off-sync with the actor speaking the lines.[37]

Linzy subverts the mainstream through the intentionally low production values. He said, "When things are a little off it gives a certain type of texture, a certain type of feel. It creates layers of tension. If you tell an interesting story it will make people forget about production values."[38] Linzy discusses his upbringing, living in the lower economic strata of the American South. He recalls the immersion in soap operas that was characterized by his childhood: "I grew up watching soap operas with my grandmother."[39] Soap operas are also typical of lower US culture, presenting a fantasy world that is heteronormative, class-transcendent, and aspirational.

Linzy's feature film *Romantic Loner* is a video essay where Linzy plays his alter ego Kaye. The action is strung together akin to the role of a typical female character in a music video; however, he is not attempting to pass as a woman. Despite his long hair, he is obviously male, with prominent facial hair, more akin to British farce than, for example, mainstream Hollywood culture. He climbs into bed to snuggle up to a male lover, sings in the shower, and lip syncs as one would expect from a female pop star. At one moment he asks the viewer, "What's in place? My nature? Gayness? Straightness?", resisting any fixed reading of his character.[40] Preciado's work on gender is relevant to Linzy's

practice and its resistance to abide by any rules regarding the representation of gender and race in the mass media. He writes:

> The technologies of gender, sex, sexuality, and race are the true economicopolitical sectors of pharmacopornism. They are technologies of production of somatic fictions. *Male* and *female* are terms without empirical content beyond the technologies that produce them. That being the case, the recent history of sexuality appears as a gigantic pharmacopornographic Disneyland in which the tropes of sexual naturalism are fabricated on a global scale as products of the endocrinological, surgical, agrifood and media industries.[41]

Linzy challenges the conception of a twenty-first-century body, which is formed as much through through the popular media as it is by pharmacology or biology. While he is not attempting to alter his body with hormones, his work plays on the notion of gender as a fixed perspective. It resembles aspects of popular drag culture, and is also a combination of several artistic genres: melodrama, performance, video installation, and painting are all part of his repertoire. As a queer, African American artist, he questions the stereotypical representation of gender in popular culture: are all women and gay men melodramatic? How does race intersect with gender and class? Linzy performs in an indeterminate space between and resisting gender allocation. He resists assigning his identity to either, oscillating between polarized gender norms. Much like artists before him who used role-playing to challenge a patriarchal society,[42] Linzy subverts our expectations through his ironic and unrepentant representations of melodramatic characters.

Adrian Piper and Lorraine O'Grady are important predecessors who resisted a patriarchal imperative of the representation of women in their work, using humor as well as pop culture. Piper's *Funk Lessons* (1983) is an interactive performance and corresponding video. In *Funk Lessons* she teaches the predominantly white audience to dance to black soul music; in the video, as white participants dance, text phrases such as "White people can't dance", "head nod", "shoulder shrug" appear as the artist explains these moves. Through this playful project she makes evident that working-class African American pop music, from Aretha Franklin to Little Richard and James Brown, is an integral part of US culture and points to the obvious appropriation of African American art forms into white culture, for example, into the music of The Clash and other white bands.[43]

During the same era in New York, Lorraine O'Grady created her *Mlle Bourgeoise Noire* performances in 1980–82, where she dressed up (in a dress

4.2 Lorraine O'Grady, *Untitled (Mlle Bourgeoise Noire leaves the safety of home)*, 1980–3/2009. Silver gelatin print, 9.31 x 7 in (23.65 x 17.78 cm). Courtesy of Alexander Gray Associates, New York © 2016 Lorraine O'Grady/Artist Rights Society (ARS), New York.

made entirely of white gloves) and disrupted art world events such as openings. She recited polemical poems about art and race, flagellated herself with a whip, and castigated black artists "for failing to assert themselves politically and for capitulating to the conservative standards of the art establishment."[44] By conservative standards O'Grady meant the safe abstract work that many African American artists were making to try to fit into a mainstream market. Uri McMillan writes eloquently on this performance series:

> O'Grady's satirical self-inflicted whipping was intended as a wake-up call to black artists, while her irate embodied double temporarily transformed the neutral white cube of the gallery into a black box – a kinetic theatrical experience. O'Grady exploited the great possibility of the avatar to transform herself into an art object. O'Grady's eccentric performance art hinted at the corporeal risks black artists could take: not the abandonment of representational art, but rather an amalgamation of self, a fashioning of oneself as both the subject and object of art.[45]

Linzy employs the humor and irony of these forerunners, along with the popular culture reference of soap operas in his work. Again, Grant's work on fandom may be useful here. Linzy's valorization of a low entertainment form may be read alongside Piper's *Funk Lessons*. While both are somewhat silly and involve the artist provoking their audience, they carry deeper messages about the homogenization of culture and the under-recognized position of artists of color within it. Linzy works in the vein of O'Grady, using the sense of farce as well as the "corporeal risks" that McMillan writes of. These intersecting issues – race, gender, class – are still relevant today. Linzy, Piper, and O'Grady are artists that use their agency to represent and disrupt expectations.

Martine Gutierrez[46] uses drag in the performative video work *Clubbing* (2010). Like Chez Deep and Linzy, Gutierrez uses her own body as material that is transformed into both female and male persona. Gutierrez employs former dance training in works that fuse movement, music, and fashion. *Clubbing* is a three-minute video that begins with a woman's back to the camera, her long hair pinned back in a retro mod-like style. As she turns to face the audience we see eyes painted on to the face to exaggerate them into a cartoonish look. The next shot is a male, with short hair and a giant quiff and sideburns, who does the same thing. They begin to dance, she with coquettish female moves, and he in a more forceful, male way. One minute into the video a second couple appears, dancing alongside the first. By two minutes into the work a third couple appears. Gutierrez shot the work against a green screen and layered the shots on top of each other, using careful calculations to be sure the dancing couples would not overlap but look as if they were dancing in the same ethereal space. They exist in a dream-like silvery-gray atmosphere that was created by the artist to enhance this effect. Gutierrez said:

> I made that out of paper and then filmed it while flashing lights knowing that this would be like a terrarium for them to like be sitting in. I wanted some kind of background wall for them to exist in, and then all of the things falling are actually glitter that I am sprinkling in front of the camera and taking out separately, there are probably 50–60 layers of glitter…[47]

Gutierrez, who was a printmaking major as an undergraduate, continues to use these skills in this background exterior.

Gutierrez in fact produces everything herself. From dancing and playing the roles, to styling the characters, creating backgrounds, shooting the scene, directing, and editing.[48] This comes out of a lifelong obsession with making films, since being given a digital camera as a child. Gutierrez says:

> I do everything myself because it's extremely important to me that I have full control. I guess that's the biggest difference between this being a campaign for something and then it being this piece that I have made that's not selling something.
>
> I always thought that I would be a model, which is partly where this work stems from … and then the reality was that this was before any transgender awareness or any talking about another kind of identity besides female and male that I was aware of. I thought, well that's not going to happen, if I am going to be a star I will just do it myself. So I have all these childhood videos of me, I was making movies, making my babysitters be in them, making my friends be in them and I have boxes and boxes of these tiny little dv tapes. I have this one recorder that went to Guatemala with me, it went on family vacations, it went to school … I was filming teachers, I was making movies without any kind of label or art content on them, it was just because I wanted to.[49]

Acting all the parts, the artist exists in oscillation between female and male genders. Gutierrez said, "I think of my work as documentations of transformation and performance. While gender is undoubtedly always a question in my work, I don't see it as a boundary."[50] Gutierrez, who identifies as a non-surgical female transgender woman, was born male but always identified with females. Her art practice moves between genders, but most often appears as female. *Clubbing* is an interesting work as it embodies the transgender experience; existing between male and female one can experience both genders and understand the challenges of each. It was also made while the artist was transitioning into total identification as a woman. *Clubbing* exemplifies this transformation in a celebratory and positive manner.

Transgender awareness has been increasing in the mass media in the past decades. As early as the 1975 Al Pacino starred in *Dog Day Afternoon*, a film about a man who robs a bank to pay for his lover's transition operation; curiously, one never sees a representation of a trans woman in the film. Further depictions of trans identity in popular culture include the mainstream films *Boys Don't Cry* (1999) and *Transamerica* (2005). Both of these films, though, focused on the thorny side of the transformation process; in *Boys Don't Cry*, which is based on a true story, the protagonist, Brandon Teena, born female and yearning to be male, dresses as such and tries to pass in rural Nebraska; she is ultimately killed by bullies, who after discovering the secret, brutally rape and beat her, resulting in an untimely death. In *Transamerica* the main character is a white man changing to the female sex, and as such suffers the

physical discomfort of this process while taking a road trip with a son she had previously not known of. *Boys Don't Cry* and *Transamerica* represent the sometimes-turbulent transition period of transgender people, even in the twenty-first-century US, where citizens pride themselves on freedom of expression. Recent debates in the US over transgender people serving in the military show that sadly there are still many prejudices against this demographic.

Television programs such as the series *Transparent*[51] (2014-) present these issues in a more mainstream manner. In this series the main character, a non-operative trans woman, and her dysfunctional family could be any other family in the US. The trans woman as patriarch, in itself an ironic nod, is a curious deconstruction of typical social constructs. She is accepted by her children, ex-wife, and friends, and the series focuses more on the everyday functional banalities and resists shock value. She is also a feminist character for her celebration of difference. Drucker, an executive producer of *Transparent*, comments on the evolving notion of gender and feminism today, "It will be a while before we really loosen up those rigid codes. It's definitely the future of feminism, to have less clearly defined gender."[52] This representation of trans life is more akin to Gutierrez's *Clubbing*, which may be read as a celebratory exploration of the iconography gender; indeed the artist plays both roles convincingly. As a female she is flirtatious and elegant, dressed in a very short dress, and as the male dancer she is suited, bold, and directing the action. Unlike Chez Deep and Linzy, Gutierrez as a female does not exaggerate or confuse gender structure. The female role, with the artist's impossibly long legs, slender frame, and thick dark hair, align more with a high fashion model than club culture. In other works, however, she does appear with, for example, makeup and a mustache, and confuses gender roles.

Gutierrez's *Real Doll* series adds to this discussion and owes much to the constructed photography of 1980s picture generation artists Cindy Sherman and Laurie Simmons. In this sumptuous photographic series the artist creates images shot in domestic spaces that reveal what appears to be a life-sized sex toy posed in doll-like configurations; however, it is the artist who models and painstakingly creates these scenarios; Gutierrez styles, does the makeup, sets the scenery, and uses all-natural lighting in this series. Each "doll" has four images per series, a serial format reminiscent of Sherman's *Untitled Film Stills* from the late 1970s. Gutierrez spoke about the process and its connection to the artist's personal and domestic history, speaking in particular about the *Raquel* series:

that is actually my childhood house in Vermont. ... I painted it a few
years before and we always call it the Pompeii room, and the house is
really small. How do I make this look really big? The dining room and the
kitchen are actually one room, and you can even see the cupboards from
the kitchen in the reflection.[53]

In the *Raquel* series the artist is posed in four locations with different outfits.
Gutierrez was inspired by the idea of the heteronormative male as the main
consumer of these dolls and thus developed different female characters,
including the high school beauty queen; a futurisitic S&M slave; the African
American woman; and the stereotypical submissive Asian woman. Raquel,
the white, WASPy character, is posed in a silver dress on the kitchen floor
in front of the dishwasher; wrapped in a plastic bag, wearing a green evening
dress, in the corner of a room; laying with legs open on the bed wearing a
black negligée; and sitting at the dining table in a formal gown. The latter is
the photograph that the artist speaks of as the Pompeii room; painted red and
featuring a chandelier, this is ostensibly the most formal room of the house
and her outfit reflects this formality. The convention of this room is part of
Gutierrez's unique cultural background; born to a Guatemalan father and
white mother, the artist always straddled both of these cultures, as embodied
by the childhood home as well as trips to the artist's father's native country.
Unlike Narcissister's *Burka Barbie*, these representations of females don't
break out of their packaging and break the rules; rather, they are inanimate
objects of men's fantasies, rendered mute and objectified. The artist took
great pains to art direct the *Real Doll* poses to appear stiff and inorganic as
if comprised of plastic or polyurethane instead of flesh and blood, painting
skin[54] and experimenting with light and composition of the photograph. In
this way they are reminiscent of Laurie Simmons' photographs of dolls and
miniature houses that express the claustrophobic quality and the stereotypical
roles assigned to the traditional domestic space.

There is a double confusion in *Real Dolls*: the eerie distinction between
doll and human, which is indeed difficult to discern, and the confusion of
Gutierrez's gender through the characters she plays. It is this condition of
indeterminacy that adds to the work. The artist says:

I think part of the power of the work is there is so much confusion about
it, which has been my life. I think that is where it is coming from, this
unclear gray area that I have consistently grown up in, and tried to hold
on to for so long that it is just inherent in the work...[55]

The lack of a definitive narrative aligns the work in particular with Sherman's *Untitled Film Stills* (1977–80). Sherman has acknowledged an intentional use of ambiguity in this series, and how it stemmed from an admiration of European cinema, "It was in European film stills that I found women who were more neutral and maybe the original films were harder to figure out as well. I found that more mysterious. I looked for it consciously."[56] This careful consideration to not give too much information, but to hint at a scenario, is what one sees reflected in the work of Gutierrez. The interpretation of both the *Untitled Film Stills* and *Real Dolls* is dependent upon a viewer's subjectivity and relationship to culture. Gutierrez progresses the projects of Sherman and Simmons, inserting a non-white as well as transgender identity into the debate over the objectification of women.

Linzy, Gutierrez, Chez Deep, and Narcissister each represent the utopian futurity, to borrow the concept of Jose Estaban Muñoz,[57] of emerging art practice. Muñoz was a queer theorist whose writing has been influential. Utopian futurity refers to his concept of looking to the past to see how queer artists have predicted the future. It is a utopian idea, suggesting that which is to come. Rather than taking a negative position, it suggests a "not-yet-here" moment of queer culture, a future possibility. Chez Deep, Narcissister, Gutierrez, and Linzy can be seen as representative of the not-yet-here in their resistance to mainstream categorization tactics such as highlighting mixed race, transgender, or gay identities as political positions. Their work corresponds in its resistance of an accepted norm or adherence to institutional or art market standards. It revels in the difference that feminism celebrated: bringing this concept into the twenty-first century where difference entails a plethora of positions – mixed ethnicity and transgender in particular.

5 Rewind/Repeat: Reconsidering the Postwar Male Canon in Contemporary Practice

Second-wave feminist artists often mined the history of art for subject matter, quoting from works by canonical artists, seeking to place their practice in the legacy of such history. In 1992, Lorraine O'Grady wrote the seminal article, "Olympia's Maid: Reclaiming Black Female Subjectivity" which traced the use of the black female nude in her work as a site of subjectivity.[1] Using the maid from Edouard Manet's *Olympia* as subject matter, O'Grady delved into a detailed and complex argument about race, gender, and the feminist artist. The article argues the black female's contradictory status as both the Jezebel and the mammy, two poles that are equally offensive. At first controversial, this has now become a classic work, which is still referenced today in debates around gender and race. Asked in a 2016 interview if the article was still relevant, O'Grady gave an equivocal response:

> I can sense that everything has changed and at the same time, nothing has changed. Or rather, I should say that the changes and lack of change have become so much more subtle, so much more to describe and to battle, that it's simultaneously hopeful and frustrating."[2]

O'Grady's position echoes the argument in this book: emerging artists are carrying on the feminist debate, which is still needed, relevant, and necessary; however, the complexity of the debate has only increased in the twenty-first century.

Judy Chicago, in her most ambitious work *The Dinner Party* (1974–79) took Leonardo DaVinci's iconic late fifteenth-century painting *The Last*

125

Supper as inspiration for an all-female version of important female histor-
ical figures. After conducting research to determine which females would
have a seat at her table, Chicago found so many women of importance that
she tripled the number of dinner guests, creating the triangular structure of
39 place settings. Each setting comprises an ecclesiastical runner marked
with the name of the woman, from the goddess Isis to Virginia Woolf
and Emily Dickinson, with an accompanying ceramic plate that features
Chicago's signature flower as abstracted vaginal imagery particular to the
great woman whom the plate is dedicated to. Undermining the European,
white, male hegemony of the Renaissance as well as the Catholic Church
who commissioned DaVinci's renowned painting, Chicago brought the role
of female achievement across ethnicities and geographies into the picture,
disrupting the canon with her now iconic work, which occupies a permanent
wing of the Brooklyn Museum of Art.[3]

Carolee Schneemann's *Cézanne, She Was a Great Painter (Unbroken Words
to Women – Sexuality Creativity Language Art Istory)* is an artist's book first
published in 1974 and then again in 1975 and 1976. As a 12-year-old budding
artist, Schneemann decided that Cézanne would be her "mascot." She wrote:

> I would assume Céz-anne was unquestionably a woman – after all, the
> {anne} in it was feminine. Were the bathers I studied in reproduction
> so awkward because painted by a woman? But {she} was famous and
> respected. If Cézanne could do it, I could do it."[4]

Schneemann's artist book, created as an adult, included correspondence,
notes, essays, and statements from the 1960s. For example, she included the
script from her infamous *Interior Scroll* (1975). The cover image for *Cézanne,
She Was a Great Painter (Unbroken Words to Women – Sexuality Creativity
Language Art Istory)* is a childhood drawing of two figures lying side by side
in a bed; clearly, the artist was challenging the accepted norms of art history
from a young age.

Emerging artists also look to the history of art as a resource for both con-
ceptual and formal precedents, and I have shown in previous chapters how, in
particular, they look to feminist artists for subject matter. The emerging artists
that I discuss in this chapter also look to postwar precedents, perhaps because
this is the art history they were taught at art school and the art they saw in
museums of modern art. I consider Dan Graham, Carl Andre, and Donald
Judd as canonical as their work has assumed a pivotal role in the postwar
history of art as well as in institutional and market status. It is also canonical

as it is part of the backbone of studio art education today. The question of what is included in the canon for twenty-first-century education is admittedly a matter for debate; however, the notion of who is included in these major movements, such as Conceptual and Minimal art, has expanded. Overlooked female artists of these movements (Rosemarie Castoro, Jo Baer, Agnes Martin, etc.) have been reconsidered and an attempt to insert them alongside their male peers has been observed.[5]

Recognizing the difficulty of freeing art practice from the legacy of art history, the emerging artists in this chapter use historical work from previously male-dominated movements, as a form of both homage and critique. In this chapter, I discuss how Marta Jovanovic refers to earlier forms of photography in her recent work; as well as how Naama Tsabar, Sarah Meyohas, Alex McQuilkin, Cindy Hinant, and Virginia Overton look to conceptual and minimal art paradigms for inspiration. I present several examples of emerging female artists who have unabashedly appropriated both specific artworks as well as a style or format male artists previously used in their work, inflecting it with a gendered position that reflects a feminist politic.

Since Pop Art emerged in the 1950s, artists have appropriated images from popular culture into their practice. Warhol's *Brillo Boxes*, as well as Peter Blake and Richard Hamilton's album covers, are examples of the symbiotic relationship between art, advertising, and the mass media. In 1980s New York this impulse was further examined by a generation of artists including Barbara Kruger, Sarah Charlesworth, Julia Wachtel, Richard Prince, Jeff Koons, and Haim Steinbach. Prince's iconic *Cowboys* series derived from images in mass-media advertisements. In the pre-digital era, Prince worked for a news clipping agency gathering articles for clients. He was interested in what was left at the end of the day after the noteworthy articles had been excised, namely the advertisements that became the inspiration for this series. Taking the iconic Marlboro cowboys and relinquishing all branding or text, Prince rendered a new context for the image. Retrospectively Prince and his contemporaries would be labeled the Pictures Generation, for their interest in the constructed image. In a similar manner, Cindy Sherman used the style of advertisements and cinematic language in her *Untitled Film Still* (1979–81) series. While these were not direct appropriations, they borrowed the syntactical structure of images, as well as the black-and-white format of Hollywood film stills, each showing a stereotypical female character: a bewildered young woman in a big city, the Hollywood siren, a young housewife, a jilted lover. Kruger used her

experience as a graphic designer to create imagery that looked closer to advertising than art by using bold text, a pared-down palette, and simple imagery. Her message, with pithy slogans, was overtly political in comparison to Sherman's more covert critique.[6]

Emerging artists are similarly mining from the past to create an "original statement" while acknowledging the practice that has come before. This takes several formats from artists who look back to the Conceptual and Minimal movements of the 1960s and 1970s to those who feel enough distance from the feminist pioneers to acknowledge that practice in their work. In the 1970s, as feminist artists gained momentum in New York and abroad, they developed a diverse aesthetic language specific to their concerns and issues. This necessarily rendered the male tradition of art history – steeped with painting and sculpture – mostly irrelevant to their needs. While there were notable exceptions to this rule, with painters including Betty Tompkins, Marilyn Minter, Sylvia Sleigh, Joan Semmel, Mira Schor, and Audrey Flack, these artists engaged the medium in a new way, using female or pornographic subject matter, male nudes and other previously unseen imagery; thus, even those using the traditional "male" fine arts of painting and sculpture subverted this heritage through a new focus on women's issues as worthy topics for aesthetic practice. And, as evinced in a previous chapter, a plethora of artists favored performance, body-oriented, and ephemeral work as a response to the "problem" of art history. In looking back at this period, Lucy Lippard wrote in the 1990s that the "concepts of body, pain, pleasure, and desire remain the vehicle of much feminist art, as they were in the seventies … from Lynda Benglis's *Artforum* ads and Hannah Wilke's willful narcissism to the Cyberpunkettes and Riot Grrrls".[7] As argued in previous chapters, feminist pioneers including Joan Jonas, Adrian Piper, Yvonne Rainer, Adrian Piper, and Carolee Schneemann avoided the pitfalls of the male tradition by using new forms of art-making that challenged the legacy of classical mediums.

Four decades later, we live in a world of unprecedented access to and layering of information. The notion of originality has subsided to an era of free appropriation and pastiche as an aesthetic practice in itself, a trajectory begun as early as Pop Art that continued with postmodernist artists like Koons and Steimbach. Before the age of the internet, artists in the 1980s – Barbara Kruger, Cindy Sherman, Jenny Holzer, Laurie Simmons – continued the feminist tradition of critique begun by a previous generation; however, this group of artists utilized both found and constructed imagery that borrowed from the history of depictions of women in Western society.

Today's emerging artists experiment even more freely with the language of appropriation and reference, which echoes the digital world they inhabit, with its memes and avatars as stand-ins for reality. Where in the founding moment of feminist art of the 1970s, borrowing from male imagery, unless critiquing it, may have been considered objectionable, today many artists look to the past for inspiration without feeling politically compromised. A new generation understands that subverting the legacy of art history is not as necessary or effective as it might have been considered four decades ago. This generation of artists grew up with the internet and have lived digital lives. The notion of authenticity is an evolved condition for them; the freedom to cut and paste is second nature. The artists discussed below appropriate from the history of art – particularly a male tradition – and reconfigure it through the use of their own bodies, deconstruction, feminist topics, and humor. It would be an underestimation of the work to consider it solely as a critique. In many cases it is equally homage to the work of male practitioners who came before. As their feminist predecessors did, these artists reference earlier male artists in work that incorporates issues around gender, sexuality, or race. Their work also includes such gendered topics as personal memories, domesticity, and the formal aspects associated with the female gender.

Women Warriors: Marta Jovanovic, Helmut Newton, and the Empowered Female Nude

Serbian-born Marta Jovanovic[8] has created a body of work that is concerned with the history of performance, as well as her identity as a post-Communist woman both inside and outside of the Soviet Bloc. While her practice is primarily engaged with performance, she works across media in video, photography, sculpture, and installation. Throughout these media, Jovanovic has an abiding concern with the paradox of her identity as a young woman brought up under a Communist regime, yet educated, living, and working in the capitalist West.[9] In *Piornika* (2011), the artist adopts the pose and gait of Helmut Newton's female models in his iconic *Here They Come* (1981). In Newton's series, a group of four women is seen in identical poses, both clothed and then naked, in large-scale black-and-white photographs. Part of Newton's *Big Nudes* series, these images were printed large, their seemingly gargantuan proportions symbolic of the power of female sexuality. They were claimed as among the first images that supposedly broke the stereotype of the objectified

feminine subject, although some feminist scholars still find them contentious for their objectification of women. These nude images, however, are intended to be seen in conjunction with Newton's shots of clothed models. In the latter, women were seen in the so-called "power dressing" of the early 1980s: the era of shoulder pads and almost militaristic austerity with accompanying severe makeup and big hairstyles.[10] As more women began entering the workforce and gaining more respect in the working world, professional women donned a female equivalent to male authoritarian suiting.

Jovanovic acknowledged Newton's progressive treatment of women in the *Here They Come* and how this inspired her series. She says:

> I love Newton's *Here They Come* as the women in the photographs look strong and free, dressed as well as undressed. They have the strength of Michelangelo's David; you notice their physical beauty but there is so much more than the simple male gaze satisfaction. It is absolutely an homage to Newton, a great artist who gave women in fashion a much different kind of representation then his predecessors, but above all an homage to the strong women who shaped and continue to shape my life, my grandmother first of all.[11]

Jovanovic was raised by her grandmother, the family matriarch, as well as her mother and aunt – all strong, independent women. Yugoslavia, a Communist country, was progressive in its treatment of women, giving them the right to vote in 1945. Women were included as equals in the working world, free to make their own decisions and enjoyed the same rights as men.[12]

In Jovanovic's reinterpretation she combines Newton's compositional structure with a traditional Yugoslavian *piornika* uniform, and translates his black-and-white austerity into a fully saturated color palette. It was important to the artist that her work is in color in order to depict the blues and reds of the Yugoslavian uniform as well as her blonde hair, which was dyed in tribute to her late grandmother. The *piornika* uniform is the national costume that all children wore on November 29, the national holiday when they were ceremoniously inducted as Tito's (Josep Broz Tito, President and later Prime Minister of the Socialist Federal Rebublic of Yugoslavia 1953–63) pioneers. The costume featured a navy skirt (or pants for boys), white shirt, red scarf, and a navy cap with a prominent central red star. This outfit is as familiar to any young person raised in the Soviet era, as a Girl Scouts outfit would be to a child in the US, or a Girl Guide uniform would be to a British child. While the school issued this standard uniform to all children, those from more

prestigious families might have special features, including an embroidered star or a more expensive silk scarf, illustrating that there is always hierarchy even in a Communist country.

The artist presents images of herself in stages of undress assuming the stance of a woman from Newton's *Here They Come* while wearing the *pionirka* uniform. As the artist sheds layers of clothing, revealing her body in various turns, she liberates her childhood memories and the embarrassment of wearing this traditional costume, and reveals her fully liberated mature female self. Yet nostalgia for the tradition is inherent in this series: the artist, unlike Newton's models, smiles for the camera and is fully engaged with the viewers, which is seemingly a cathartic experience. This nostalgia for a country that no longer exists – Yugoslavia – is enacted by the artist, who performs for the camera in the poses of Newton's liberated 1980s women.

The *Pironika* photographs were taken by one of the leading fashion photographers in Serbia, Petar Vujanic. For Jovanovic, it was of equal importance that the role of the male fashion photographer was fulfilled in the work. The relationship between artist and model, fashion and art – polar divides that Newton himself straddled – is seen in Jovanovic's *Piornika*. Yet, there is no editorial client for Jovanovic and the work evolves from her personal journey from Eastern Europe to America. The artist's words capture her thoughts so eloquently:

> Ashamed of being a child of divorced parents and of a broken and war torn Communist country, ashamed of living in the West while the West is bombing my country, ashamed of being a poor child in the rich countries and of having the opportunities of the rich in the poor country, ashamed of my Communist grandfather and a Democratic Jewish grandmother, ashamed of my "pionirka" photographs from primary school, ashamed of living in the West while my family is struggling in the East, ashamed for being misjudged as a trophy, capitalistic, consumeristic wife, ashamed for the Westerners that don't know where Serbia is, ashamed of classical education as a contemporary artist, ashamed of being an artist, ashamed of never being good enough (artist).[13]

Her ambivalence in the quotation above is played out in the work: proud to be from a former Communist country where women played strong roles, yet happy to have the advantages of living in New York. The seductive quality of the work – four larger-than-life color nude photographs of a beautiful

young woman – belie many of the serious issues at stake here over authorship, national heritage, and the role of women in both her native and adopted countries. Most significantly, her work as an acknowledged feminist engages with the work of an iconic male artist in a way that would not have been possible for a second-wave female artist.

Feminin/alism: Appropriation of Minimal Art by Emerging Feminist Artists

Although it was atypical for a feminist artist to use Minimal or purely conceptual practice in feminist work, there are important exceptions. Mary Kelly's *Post-Partum Document* borrowed conceptual strategies such as charts, graphs, and the predominance of language over image; however, her insertion of the trials of motherhood and issues around the division of labor within the family intersected the Conceptual tactics with a feminist agenda. Likewise, Judy Chicago's early "finish fetish" – style sculptures, while borrowing the notion of fabrication and large-scale abstract sculpture from her West Coast colleagues such as John McCracken, her candy-colored palette, and the choice of organic, orb-like forms predicted her later development into a fully fledged feminist practice. Miriam Schapiro's early paintings in the late 1960s and early 1970s featured pure geometric abstraction, and may be read today in the vein of Minimal colleagues; however, her insertion of more delicate, patterned areas of canvas was influenced by her activity within the women's movement.

There has been a reassessment of female artists associated with these male-dominated movements, in particular Minimal Art. Rosemarie Castoro, Jo Baer, Samia Halaby, and Agnes Martin, have led a resurgence of interest in the realms of the art market as well as curatorial practice. Although Agnes Martin was often included in prestigious private collections such as the Dia Foundation, her retrospective at the Guggenheim Museum, in 2017, signaled her insertion into a male-dominated history of Miminal practice. Martin's rejection of subject matter and her restrained palette, as well as her continued fixation with the grid, align her with male colleagues such as Sol LeWitt. Samia Halaby, a Palestinian artist who was the first woman to have a full-time teaching position in the Painting department at Yale University, was also a pioneer of abstraction. An abiding motif of her career has been the rejection of the figure and narrative as well as the use of geometric forms of color. Working in her downtown loft for the past four decades, her work has seen a market

resurgence in the early twenty-first century through Ayyam Gallery in the Middle East. Likewise, Broadway 1602's representation of Rosemarie Castoro has exposed her work, long under-recognized and undervalued, to a new generation of viewers. Her repetition of forms and lack of subject matter align her with Minimal artists, including Carl Andre, her first husband.[14] It is important to remember that in the case of Castoro, Halaby, Baer, and Martin, these artists were not aligned with feminist art and their work was not shown with other female artists of their generation. As female Minimalists, they were outliers in a time when male domination of the art world was about to be challenged. A new generation of artists is embracing the formal qualities of Minimalism but injecting this work with feminist agendas.

Today, in addition to the reassessment of overlooked female artists, younger artists invested in gender issues are adopting strategies from Minimal art and conceptual practice. These artists revisit earlier postwar movements, putting their own spin on new work that nevertheless engages with feminist issues. Virginia Overton's constructions use basic materials such as wood, mud, and fluorescent light fixtures to make sculptures and installations that call to mind earlier Minimalists like Sol LeWitt, Dan Flavin, and Carl Andre. Cindy Hinant uses diagrams that are in dialogue with earlier conceptual precedents. Sarah Meyohas has created her own currency that correlates to her value as an artist, a tactic used by artists including John Baldessari and Hans Haacke. The use of Minimal or conceptual formal strategies today doesn't constitute a rebuttal to the earlier feminist exclusion of this typically "male" work; rather, younger artists develop the concepts of Minimal and conceptual art further and infuse them with the irony, playfulness, and humor that was often lacking in their original iterations.

Alex McQuilkin's paintings interrogate the female space of the domestic interior. McQuilkin incorporates wallpaper motifs from 1980s suburban America, where home décor from designer brands like Laura Ashley and Ralph Lauren were seen as *de rigeur* for the upper-middle class. Growing up in the Northeast US, one would immediately recognize these floral motifs as status quo, representative of good taste and class aspirational for the lower-middle class. McQuilkin's paintings have, on close inspection, a handspun intimacy, which she combines with a nod to the girlish pink palette of teenage bedrooms. The paintings, although resembling wallpaper, are created entirely by the hand of the artist, using, for example, a complex palette of up to 20 hues of pink or lavender, that defies their seemingly mundane appearance.

McQuilkin's paintings may also be read as expansions of the Minimalist grid in terms of the repetition of patterns and formal structure. *Untitled (Purple Zip)* (2016) and *Untitled (Pink Zip)* (2016) are presented as grid formats, albeit rendered in confectionary palettes associated with feminine domestic space. In these paintings the artist inserts a zip line that disturbs the formal rigidity of the pattern. McQuilkin is interested in the idea of wallpaper that is applied improperly, resulting in a slight slippage of pattern or the revealing of wall colors from previous generations underneath. McQuilkin's zips grew out of her interest in Gordon Matta-Clark's "anarchitecture," as seen in *Splitting* (1974), where the artist intervened in domestic architecture by sawing a large splice into a suburban house in Englewood, New Jersey. McQuilkin, however, condenses this radical intervention into an intimate scale and feminine palette in her paintings, cleverly connecting the two formal interrogations into the tyranny of domestic architecture, an example of the concept that I term "feminin/alism".

Cindy Hinant's work equally embraces the relationship between gendered spaces and Minimal formats through the unexpected combination of gossip magazine images and makeup with the formal strategies of Minimal artists including Dan Flavin and Sol LeWitt. From their legacy, Hinant employs several formal mechanisms, most notably in her use of the monochrome and the notion of seriality. By both embracing and subverting the monochrome she acknowledges the utopian space of Minimalism, while at the same time commenting on the commodified female sexuality seen in celebrity gossip magazines and sex tapes that proliferate in US culture. The artist's interest in what she calls an aesthetics of violation is seen throughout several of her series of works. Three videos that embody this theme – *1 Night in Paris* (2014), *Kendra Exposed* (2014), and *Kim Kardashian Superstar* (2014) – each appropriate the sound from celebrity sex tapes, a genre of popular culture that has emerged in the past two decades. With rumors of leaked tapes used to bolster popularity, one is never certain how complicit the violation is with each subject. Hinant combines the dialogue with a monochrome screen of pink, blue, or black, colors that correspond to the DVD packaging of these sex tapes. The monochrome screens slowly fade to white over the course of the tapes, each approximately one hour in length.

Hinant's *Upskirt* series 2016 also resemble black monochromes arranged into a serial or grid-like display depending on the gallery space. The works appear to be completely black, but upon further viewing a faint photographic image emerges. Hinant, whose practice often examines the representation of

young women in the mass media, appropriated images of celebrities exiting the ubiquitous black car or limousine, a staple of the celebrity circuit. The found photograph is typical of another popular millennial genre termed "upskirt" where starlets or reality television personalities "mistakenly" flash their undergarments or their genitals. Like the sex tapes, their intentionality is beside the point; now an industry, there are websites and fan forums devoted to these lucrative images. Hinant appropriates the original image, rendering it upside down, a play on the term "upskirt," and almost completely obliterates it through a digital process of obfuscation. Typical of her practice, this edition combines conceptual strategies, popular culture and gender politics.

Virginia Overton[15] is a contemporary artist who similarly confounds any popular notion of "women's practice" as figurative, colorful, sensual, or body-oriented and yet makes an important statement on women's role in society. Her sculptural installation work embraces the use of everyday materials, space, and site specificity. Her practice is striking as it can be read in the trajectory of industrially sourced art, such as that of Carl Andre, Dan Flavin, and Richard Serra, but also embraces a feminist ideology in its use of the everyday, discarded materials as well as its relationship to domestic space. Overton's site-specific series of installations at The Kitchen in 2012, was critically lauded. In this project, the artist decided to use only material found on the site; hence she was given free rein to the cupboards, basement, backstage areas in this venue, known primarily for presenting performance and live art.[16] The artist discussed her process:

> I decided that the Kitchen exhibition needed to really be about the space and made in the space. I used trial and error the same way I do in my studio. … The activity I engaged myself in became a real part of the work – not a performance, but performance in a way. I spent days just moving piles of wood from one place to another, stacking and hanging cement blocks from my own ad hoc rigging, moving and setting up various lighting scenarios. I must have made a hundred sculptures in there that week. What you see in the show is the distillation of all those pieces.[17]

Overton created a series of room-sized installations where she turned refuse and overlooked objects into monumental sculptures. Take, for example, *Untitled (2x4 floor)* in which the artist created a floor comprising of mismatched found wood. The floorboards, ranging from light to reddish to dark, create a surface that covers the entirety of one gallery flush from wall to wall. It immediately recollects the work of Carl Andre and Richard Serra, where industrial materials were used to create trademark pieces of Minimal Art. While other artists of

Overton's generation have created responses to Andre,[18] hers is interesting in its ambivalence. Overton's uses of mismatched wood and an irregular pattern recalls the "do-it-yourself" aspect of early feminist art, when artists created works made of household materials including embroidery, knitting, and even cake. Many feminist artists of the 1970s used such materials that were not considered as "fine art" to make their work. To name just a few examples, Bobby Baker created life-sized figurative sculptures made of cake that were eventually eaten by the audience. Senga Nengundi created sculptures and installations made of women's pantyhose. Kate Walker made political quilts. Because of these forerunners, knitting, sewing, and craft were reconsidered as fine art practice. Overton uses the previously disregarded materials in The Kitchen's storerooms to create the work. This cooption of working-class "low" culture provides another level of reading to the work – construction materials traditionally carry a male association.[19] Overton subverts the male canon of art history through the use of materials that are found in any hardware or home repairs store and also challenges the pristine, white cube gallery space. It is in this respect where Overton's work both adheres and diverges from her Minimal predecessors; where prefabricated objects were vital to artists Donald Judd, Larry Bell, and others, there was a distinct fetishization of such objects. Flawless steel cubes such as Judd's *100 untitled works in mill aluminum* (1982–6) relied on an impeccable finish and are extremely fragile despite their heavy materiality. Overton's recycling of materials, preferring to use scraps and objects imbued with human use and existence, differs vastly from the fabricated sculptures of her predecessors.

Through her interest in reclaimed mass-market materials including lumber planks, doors, shelves, and industrial lighting, Overton wryly combines objects found in everyday life to create sculptures that investigate Platonic forms such as circles and squares, reconfiguring them in arrangements that are at once familiar and strange. *Untitled (Waterfall)* (2016) is made of three found elements: a cubic, mass-produced trunk that the artist found covered with a decal of a kitschy landscape; a sound machine inside the trunk; and a Kleenex box, with another cliched American landscape placed on top. An ironic nod to a Judd cube, Overton's is a metaphor for class aspiration. The landscape with waterfall is a cliché of the splendor and promise of the great American West, which is mirrored in the Kleenex box. The insertion of the ambient noise is, on one level, a reflection of the waterfall imagery. This is a reference to Robert Morris's *Box With the Sound of Its Own Making* (1961), where the artist recorded the sounds of constructing a simple wooden box and placed it inside the work.

Where Morris demystified the romantic idea of an artist's studio process by recording the labor expended in making the piece, Overton follows in his footsteps as she chose not to hide the electrical cord for the sound machine, preferring instead to reveal the actual process of making the sculpture from everyday, accessible materials.

In *Untitled (orb)* (2016), a discarded countertop is repositioned on the wall, with an industrial light inserted into the center of one surface. Overton's sculpture glows a pinkish hue, a reflection of the color of the cheap, mass-produced countertop lit by the bulb. Everyday industrial materials intended for domestic spaces take on a new ethereal presence, similar to the Light and Space movement. The work again plays on rational, Platonic forms: the light is a circle on top of the square of found countertop. *Untitled (landscape)* (2012/15), like *Untitled (orb)*, again combines basic materials: a slice of cedar (the artist transports fallen trees from her family farm in Tennessee to her studio in New York via truck) is combined with a pine plank, while a fluorescent light fixture with blue gel tops the sculpture. Like its counterpart, *Untitled (landscape)* may be read in the legacy of Dan Flavin's use of industrial fluorescent lighting. With simple dexterity, materials that can be found at any hardware shop, combined with a sheath of a tree from her hometown, together create a constructed landscape: the terrain created by the contrasting wood and the blue light simulating sky. Like Flavin's works, the use of light in Overton's sculptures extends their presence into the surrounding architecture of the gallery space.

Overton illustrates a complex relationship to Minimal Art and displays a decidedly new engagement with the simplicity of form. Far from the industrial, unemotional sculpture associated with their mostly male precursors, she embraces the subjective and revels in a self-consciously intimate approach to art marking. She subtly disrupts Minimal practice with the notion of found objects, personal history, and natural materials, exemplifying the concept of *feminin/alism* and heralding a new era of art practice.

Naama Tsabar's work displays the typical appearance of Minimal Art in terms of simplicity of form, materials, and scale. In her practice she conflates notions of gender with a reduction of formal vocabulary. Tsabar investigates the coded associations of both gender and music at various intersections, particularly in reference to the culture of nightlife and the freedom of that liminal space and time. Tsabar's sculptures, installations, and performances are discrete objects as well as instruments for live events with herself and other collaborators. They also present the possibility for viewer interaction, which

defies the sanctity of the Minimal Art object as well as most other art historical precedents and engages with the legacy of feminist art that celebrated collaboration and visitor interaction.

Tsabar's wall-based *Work on Felt (Variations 9 & 10) Bordeaux and Black (Diptych)* (2016) is part of the larger series *Work on Felt and Paper*. A large, seemingly pared-down diptych reminds one of the late 1960s "anti-form" felt pieces of Robert Morris. Two rectangular felt forms, vertically oriented, are lifted on one corner by a thin piano string attached by a guitar-tuning peg. Appearing weightless, the sculpture is actually formed around a carbon fiber core, which lends it solidity. In addition, the work is wired to a speaker, thus giving it a charged potential as a musical instrument. Tightening or loosening the string affects the sound that the sculpture emits. Tsabar creates performances with this and other sculptures in the series, which are played by the artist and her long-term collaborators, in particular the musician Fielded. The work then exists in two forms: as an integral object, and as a sensual experience for a viewer and/or performer. The sculpture's potential for interaction harks back to earlier works by Dan Graham (for example, *Performer/Audience/Mirror* (1975) and *Public Space/Two Audiences* (1976)) in which both the artist and the audience become active participants in the sculpture. As in Graham's works, to fully experience Tsabar's work properly, a viewer must implicate herself within the piece, either as a player or an observer.

Tsabar's *Closer* (2014) is a freestanding sculpture that resembles the architectural element of a room corner, in which the interior chamber of the sculpture doubles as a musical instrument. To play the instrument, one has to literally enfold the corner by wrapping one's arms around the sculpture to touch the strings and knobs located inside, like embracing a body. This intervention by the body of the artist or viewer is central to the conceptual potential of the work. Rather than a freestanding, monolithic form, *Closer* is an anthropomorphic invocation of intimacy on the artist's part, allowing the sculpture to exist on various planes: as an integral architectural object, as a charged artifact from the artist's performances, or still as potential spheres of intervention on the part of the viewer. Here Tsabar's body, or that of the performer or viewer, creates the "figurative incident" that Morris decried. Tsabar, similar to Overton, Hinant, and McQuilkin disrupts the original aesthetic and ethos of her Minimal predecessors, intersecting narrative and personal history into the work, thus cleverly disrupting the art historical predominance of male artists.

Reconsidering Conceptual Practice: Gender, the Grid, and System Works

Conceptual Art flourished in the US and globally during the postwar period. Often featuring charts, grids, instructions, and algorithms, these works placed concept, systems, and language above formal aesthetics. Dan Graham used categorization and charts in his seminal magazine works including *Homes for America* (1966), *Schema* (1966), and *Figurative* (1965). In addition to these acknowledged pioneers of conceptual art, there has been in recent years a rediscovery of women associated with conceptual art. Mary Kelly's work has been aligned with a global conceptual turn and has been included in major exhibitions on this theme. Also, take for example Sanja Ikevic, born in 1949 in Zagreb, Serbia. Her work combined issues around the female experience with conceptual strategy and has had solo presentations in museums, for example, in MoMA NY.

Cindy Hinant's work often references the male bastion of conceptual practice of the 1960s. Hinant's *Grids Next Door* 2011 is a video where a pink grid is computer-generated in response to audio from an US television series starring Hugh Hefner's girlfriends called *Girls Next Door*. The video is shown on a typical television monitor, a fitting format for such work. For Hinant, the grid is a homage to the late Minimal artist Sol LeWitt, while also suggesting a modernist paradigm of order and control (Agnes Martin is relevant to note here), which is dismantled by the chattering young women.[20] A younger female artist openly displaying her affinity for a male conceptual artist is a gesture that departs from earlier feminist tactics. Also, that she engages with such "low" subject matter as reality television is not surprising given her interest in the founding generation of conceptual artists.[21] Recall Victor Burgin's relationship to advertising, Dan Graham's magazine works, and Robert Smithson's essays. Hinant acknowledges her debt to Minimalism, explaining that while growing up in the Midwest and becoming interested in art in high school, contemporary art meant Minimalism. Before the advent of the internet and the growth of interest in contemporary art, most art books and classes would lead up to the postwar period circa 1960 and stop there. Hinant's visual language, therefore, was predicated on this generation of artist.

The playmates, whose job is to make public appearances and be kept as multiple girlfriends of the Playboy founder, are symbolic of both the triumph and failure of consumerism and popular culture, where softcore models and reality

television stars are revered and reviled in equal measure. The inane dialogue of these women, whose appearance and lifestyle epitomize the objectification of women, is heard in the background. Hinant used computer software called Incomptech Grid Generator to construct a grid through the trigger of sound from the television show. In the course of 22 minutes, a grid builds one line at a time and we understand the reality of television playmates through their words and voices rather than their appearances. Perhaps, in today's expanded notion of what feminism is, one might understand the playmates as women making the ultimate enlightened decision, using their feminine attributes as a source of income and notoriety; however, it is a far stretch to understand Playmate as a feminist career option as it is intrinsically linked to youth and beauty, both of which fade. In this work Hinant uses a Minimal format – the grid so revered through the work of Lewitt and his drawings. But she imbues it with another layer of meaning: the media's continued depiction of women as sexual objects and ciphers of male exploitation.

Hinant has also created a series of *MakeUp Painting*s that further on the legacy of minimal monochrome works and conceptual art's ritualistic processes. *MakeUp Painting* (2011) at first glance looks unremarkable, like a flesh-colored monochromatic work. Upon closer inspection, the viewer sees tonal variations and fluctuations in the opacity of the pigment. The artist creates these works by a daily ritual of blotting her made-up face against paper hanging on the wall of her studio. This daily act – one might say in the vein of masquerade that many women adhere to – while formally resulting in a Minimal aesthetic, also takes its cues from conceptual practice. One need only think of first-generation conceptual artists as diverse as On Kawara and Eleanor Antin who used daily rituals to create works of art. In Kawara's *I Got Up* (1970), the artist sent two postcards daily to colleagues and friends between the years of 1968 and 1979; each card was stamped with the words "I Got Up" and the time that he awoke in an intimate yet structured action. Some recipients got one postcard while others consecutively received hundreds.[22] During the same period, Antin produced the landmark feminist work *Carving: A Traditional Sculpture* (1973), where the artist was photographed in four views (front, left, back, right) over the course of 37 days while she intentionally lost ten pounds. The work is shown as 148 black-and-white images in a grid that reads from left to right, like the frames of film. Making reference to the male-dominated tradition of sculpting marble, where a reductive method is used to chisel the human form, Antin made this work in response to art history. It was also a retort to the Whitney Museum of Art's invitation

to participate in their biennial, whose guidelines stipulated that only painting and sculpture could be shown.[23]

Hinant's *MakeUp Painting*s are created with a similar ritual as both earlier precedents; the artist applies her own set of rules and constraints. While the twentieth-century works rely on strict formal and procedural documentation, the younger artist uses the notion of chance and performance. Seen in close proximity the works look almost expressionistic and embrace a controlled chaos. Like Kawara's work, the *MakeUp Painting*s form an intimate, existential diaristic presence. They also give credence to the daily ritual of studio practice in today's digitally entrenched world. While Hinant lives in a so-called "post-studio" era,[24] she acknowledges the importance of this designated space and time for creative production. She also acknowledges the discipline required to be a successful artist, something suggested by Antin's work, which so succinctly references many of the issues of being a female artist in the 1970s. Hinant reflects on these themes in her work: young women still struggle with many of the same issues that feminist artists of the 1970s were grappling with, including women's diminished role as objects of a male gaze; the notion of being a "woman" artist and therefore at a disadvantage to a male artist; and personally, the decision of whether to wear makeup and adhere to societal beauty norms. Coco Fusco has written about her "being looked upon with skepticism by the director of the women's center at my college (always clad, by the way, in grays, brown, and tans), who could not understand how I could be a budding feminist theorist in fishnets, pink mini-skirts, and purple hair."[25] Hinant's work seems to echo Fusco's in its refusal to adhere to any predetermined constraints of feminism.

Indeed, the use of makeup, and in general masquerade, was an integral component of feminist art practice, from Antin to Cindy Sherman and Lynn Hershman Leeson, and others. Hershman Leeson is known for a body of work in which she challenged mainstream ideology around beauty, using makeup as a medium for her work, and creating surrogate identities in a practice that can be considered as masquerade. The notion of masquerade dates back to Joan Riviere's 1929 essay "Womanliness as a Masquerade," which examined women and masks. Claude Cahun's work engaged with this as early as the 1920s. Judith Butler has also written on the notion of gender as a construction while many other feminist writers have discussed the subject of masquerade as uniquely feminine. If the feminine is something enacted by social codes rather than biological determinism, then feminist art can be created by any gender or material configuration. Today it is still a relevant topic for discussion. As

seen in the drag-influenced work in the previous chapter, playing with gender norms and clichés is a characteristic of some of the most exciting emerging art today.

Hinant's *Sephora* (2012) is a project, like Antin's and Hershman Leeson's, that combines performance, documentation, and conceptual practice. For this series she collected data from visits to various Manhattan branches of the cosmetics superstore. She recorded activities such as cosmetic application, personal and capital exchanges, in addition to logistics including store location, date, and time of day. Hinant also created a form that documented these exchanges in a manner similar to Conceptual art of the 1960s including Dan Graham's *Homes for America* (1966) and Hans Haacke's *Shapolsky et al Mahattan Real Estate Holdings, A Real Time Social System, as of May 1, 1971* (1971). Shown as an aggregation of these forms, Hinant's grid format also bears allegiance to the conceptual paradigm. Hinant acknowledges her debt to Dan Graham, saying that he "influences me in more ways than I can possibly identify now, and he often relates his work to middle-class experiences. I love his photos of roadside shops in New Jersey with plastic inflatable toys and swimming pools–these are very class specific."[26] Hinant's position as a young woman looking to an older male artist for inspiration is not typical of a second-wave feminist tradition and ideology; rather, it is an opening up of some preconceived feminist biases against male artists as a whole, as well as their strategies and processes.

Hinant's *Sephora* series has several layers. She critiques the idea of Relational Aethetics,[27] a key phrase of the early millennium, which saw artists including Rirkrit Tiravanija, Angela Bulloch, Liam Gillick, and Phillip Parreno create works that relied on participation to come to their full fruition. Hinant develops her work through the interaction with salespeople and other shoppers at Sephora, a chain that appeals to a mostly female and gay demographic. She became interested in the fact that although that demographic was represented on the sales floor, most of the managers are still white men.[28] This can be compared to the art world, where young attractive "gallery girls" are stationed at desks of commercial galleries, or indeed the art market itself, still dominated by white male artists.[29]

Hinant says:

> I think cosmetics are generally related to class. Beauty is associated with wealth and appearing more beautiful through cosmetic enhancements is a way to climb social ladders. It was my thesis that the Sephora store, with its interactive displays, encouraged people from different backgrounds

5.1 Cindy Hinant, *Sephora Project*, March 29- May 10, 2012. Edition of 10, 98 pages, 5.8 x 8.3 in. Courtesy of the artist.

and cultures to interact with one another more successfully than any Relational Aesthetic art project. I see Sephora as a democratic space where women from any social background can buy the same $34 Yves Saint Laurent lipstick without being intimidated by the exclusive luxury of the traditional department store counter. They do this by displaying all of their products in an "open sell" environment, which means that you can touch every product and sample things without having to interact with a salesperson. They also utilize no-pressure sales tactics and have an open return policy, this combined with special events, DJs, and welcoming product displays, creates a space where shoppers can spend an extended period of time with each other bonding over their shared interest in cosmetic products – I've given hugs to strangers in these stores. Cosmetic products are a way for the lower-middle class to participate in the same consumption of luxury brands as the upper-middle class. If you can't afford an Yves Saint Laurent handbag you can probably afford the $34.00 lipstick.[30]

Peggy Phelan has written about how feminists of the 1980s and 1990s looked back in dismay at the 1970s feminists overlooking differences of race, class, and sexuality.[31] Too often intellectual concerns of psychoanalytic and Marxist feminists precluded a higher-level education and the time to worry about such things. It is easy to fall into the trap of "good or bad" feminism, as Amelia Jones has written. She writes about contemporary artists "instinctively or explicitly working through intersectional identifications, producing work that navigates the complexities of identity in the contemporary world of highly technologized global capitalism".[32] For who is able to comment on feminism? Is it only women, lesbians, and gay men? Can male artists empathize and even embrace a feminist approach?[33]

While Hinant is critical of capitalism, she also acknowledges her implication – both financially and emotionally through the exchanges with others in the shop – in the *Sephora* work. On the form she has a category for "Notes and Observations" to convey to the viewer that these are not value judgments, but field observations akin to a sociologist's work. Taken as a whole, the *Sephora Project* is a contemporary feminist response to the earlier conceptual predecessors noted above. The subject matter is considered as typically female and rooted in popular culture and thus, more whimsical. It isn't real estate or statistics, but makeup and shopping, both subjects specific to female (and queer) consumers. In addition, Hinant's practice across these works deals with the theme of women, identity, and masquerade. Whereas female artists in the 1970s were derided for being too attractive (a criticism often aimed at Hannah Wilke and Carolee Schneemann) or for wearing makeup,[34] today's generation of women has a more pluralistic view of feminism. This is a positive development, but the debates still wage today on sites and blogs as diverse as *Sluttist*, *Feministing*, and *Lennyletter*. Hinant asks in this work how important is it for a woman to make herself desirable and how society conditions consumers to understand the definition of a woman.

Sarah Meyohas[35] is an emerging artist whose work investigates similar themes: the inherent value of the female artist, sexual politics, and a conceptual approach. Meyohas makes works that include painting, photography, sculpture, and performance. Her *BitchCoin* currency straddles all of her oeuvre. *Bitchcoin* is an alternative currency created by Meyohas and launched in New York at Where Gallery in February 2015. Inspired by the Bitcoin, hers is a cheeky pun on that system where investors can support her work and watch their investment grow in value as the artist's stature increases. Each *BitchCoin* purchased is equal to 25 square inches of a Meyohas photographic

work. There are only as many *BitchCoin*s as there are square footage of available Meyohas works.

BitchCoin certificates and corresponding artworks are stored in box #138 at the HSBC on William Street, near Wall Street in downtown New York. For every print locked in the vault or on a collector's wall, an equivalent number of *BitchCoin*s is released into circulation. *Speculation*, the first image to back *BitchCoin*, is a photograph in which Meyohas draws a connection between the female body and capitalism; the artist is seen nude, except for a band of flowers around her neck, repeated infinitely in a mirror held between her legs, against a vibrant yellow background. Its title, while referring to the act of speculating on a stock, also connotes seeing: the viewer's scopophilia is here undermined by the concept behind *BitchCoin*. As more people value the image, her stock literally rises. In true capitalist free market form, the collectors of the currency control the worth.

In the same vein as the Bitcoin logo plays on the dollar sign combined with a capital B, *BitchCoin* has its own logo: a female mouth, partially open to reveal two front teeth, with gold lips and the words BITCH COIN superimposed across the image. Investors in *BitchCoin* receive a certificate with two sets of numbers: one is a unique identification number, which can be used to determine the investor's balance and at a later date to claim back work made by the artist or its net worth in dollars or other currencies. The second number is a public key that allows one to send or receive *BitchCoins*. It is worth noting that Meyohas studied at the prestigious Wharton School of Business at The University of Pennsylvania before enrolling in a MFA in Photography at Yale. She combines the financial language of currencies and exchanges with her artistic practice, not only claiming her worth but setting it as she controls the dissemination of each stock certificate. The value increases as each new issuance of BitchCoins sells out. Meyohas has said, "BitchCoin asserts artistic agency as an economic claim … This is important for artists when art is viewed as cultural capital."[36] With the BitchCoin system, Meyohas can help fund work, a perennial problem for young artists, through the capital that is raised. The artist also ensures that as her work increases in value, not only collectors and auction houses, but the artist herself can reap rewards from that process. In the US, where artists do not have *droite de suite* laws to protect them, collectors can cash in and reap rewards on escalating prices while artists remain financially insolvent.

In *BitchCoin*, Meyohas furthers the institutional critique of artists such as Andrea Fraser's *Untitled* (2003), where she entered into a contract with a

collector, who for the reported sum of $20,000, was able to spend one night with the artist. This was documented in a video, shot at the Royalton Hotel in New York, where Fraser is seen having sex with an unidentified man, the collector. The video was eventually released in a limited edition, a tangible outcome of this exchange, which unapologetically aligned female prostitution and male power with the exchange between a female artist and male collector.[37] *BitchCoin* also recalls Duchamp's *Tzanck Check* 1919, which was created for the Parisian collector (and the artist's dentist) Daniel Tzanck. The check has the appearance of real currency but is actually hand-drawn on the account at "The Teeth's Loan & Trust Company Consolidated of New York" in the amount of $115, signed by Marcel Duchamp, with a stamp marked ORIGINAL across the face.[38] Meyohas furthers these conceptual strategies, ensuring that she retains power over her market, essentially investing in herself. Like other young women artists in this chapter, Meyohas uses strategies of earlier generations of both male and female artists; while acknowledging their debt to these strategies, they further the groundwork made by these artists by inserting their own issues into the practice.

Meyohas also comments on the exchange relationship of the art world in large-scale photographs from her *Speculations* series. These are constructed with props and a mirror in the artist's studio to suggest infinite space as defined through cubic forms. Following *Bitchcoin* (2015), ongoing, and *Stock Performance* (2015–16), these pieces interrogate rules of aesthetics and market value alongside the artist's role within such systems. This body of work recalls earlier artists Hans Haacke and Seth Siegelaub, in particular the latter's contract, which stipulated resale and loaning rights in perpetuity and allowed the artist to retain more control over the work post-sale. Like Haacke, who has actually upheld the contract in his practice, the work of Meyohas has implicated and intervened in the relationship between the artist and the market in her work.

In *Speculation* (2015) she presents a large-scale photograph whose scale has a visceral impact on the viewer. Using a cubic shape as its formal anchor, a mirror flanked by blue and yellow flowers reflects into a pink infinity. Meyohas chose the cube for its quality as a pure form: it is one of the most basic forms in existence and one of the five Platonic solids. A central trope of Minimal Art, the cube was evinced in the work of Larry Bell, Donald Judd, Sol LeWitt, Hans Haacke, Agnes Martin, and Eva Hesse. In this series she disrupts the sterility of its form through the use of various props and colors: the insertion of the delicate flowers and colors, and in other images from the series through

smoke, or with her own body. Meyohas adopts a gendered subjectivity through the hallucinogenic pink palette and flowers, both formal tropes typically, albeit controversially, associated with the female experience.

Canvas Speculation (2015) depicts a rolled canvas positioned into an arch-like, roughly cubic shape and then repeated into infinity in the photograph. Canvas here is representative of the longstanding tradition of painting, which the artist literally rolls up and subsumes into a lens-based work. The canvas, combined with the scale of the work, creates a sense that the photograph invites a viewer into the limbic space of her constructed image, creating an inherent dialogue. The implication of the viewer is typical of Minimal Art that demands a physical rather than emotional reaction on the part of the viewer, who would often walk around or peer through a work. Here Meyohas investigates the act of speculating – in terms of seeing as well as speculative market activity – through large-scale editioned photographs. She also cleverly inserts her own subjectivity into the work; although the viewer cannot see her she is in each work, hidden by the mirror placed strategically in her studio.

Meyohas, McQuilkin, and Hinant each coopt and further a conceptual strategy inherited from their artistic predecessors. They depart from second-wave feminist artists with their appropriation of male strategies and yet inject their works with gender concerns and feminist themes. They create works that are hybrids of various political and social issues, from gender, consumerism, objectification, and sexuality. These young practitioners represent a new wave of feminist inquiry and debate, as well as aesthetic values. Each embraces popular culture and new technology, a format that has seen a widespread resurgence of radical feminism. Today, it is once again fashionable to be a feminist. However, artists like these are still not what one would term mainstream art market players. It is significant that the market today still values formal painting and sculpture. Video and conceptual practice, even for luminaries including Haacke or Antin, is still a tiny slice of the market.[39] What this means for the trajectory of these artists careers, then, is uncertain. Similar to their predecessors, both male and female, they will likely need to pursue other related activities to art practice, including teaching or assisting mainstream artists.

In this book I have presented a new wave of artists based in New York who embrace the legacy of feminist practice. As explicated in the preceding chapters, second-wave feminist themes such as the use of the body, performance art, and self-portraiture span a variety of practices and approaches. From painting and sculpture to photography, video, installation and

performance the artists in this book acknowledge a large debt to their feminist predecessors. This diversity of production and distribution is in itself reflective of the wide array of second-wave feminist themes and tactics. The diversity and range of emerging practitioners is also exciting. Queer and trans artists embracing a feminist discourse is an important development of the past decades and represents a future where all people – male, female or gender fluid – can see the importance of feminism as a basic human right. The emerging artists presented here also admire systems of practice that are associated with male artists, as seen in this concluding chapter. This ability to embrace Minimal art, Conceptual art, and fashion photography, traditionally by male artists, is a new beginning for a twenty-first-century practice, which takes the best of all that art history has on offer and retains a strong feminist ideology. With artists now taking inspiration from both feminist and male predecessors, this is further evidence that feminist art has indeed become firmly established in the art history of postwar practice.

Notes

Introduction

1 See Parveen Adams and Elizabeth Cowie, *m/f: The Woman in Question*, London: Verso, 1990 for an excellent selection of articles from this feminist journal.

2 I am indebted to my colleague Kathleen Madden for a rich and engaging discussion on the contemporary art scene in London.

3 Take for example the Pussy Riot controversy and imprisonment and, more recently, the cancellation of a feminist art exhibition in China, to understand the lack of freedom to engage with such topics in certain cultures. See www.nytimes.com/2012/03/08/world/asia/08iht-letter08.html?_r=0 for a discussion on the crackdown of the *Bad girls* exhibition in Beijing.

4 For an excellent discussion of the postwar turn to performance see Paul Schimmel, 'Leap into the Void', *Out of Actions between performance and the object 1949–79*, Los Angeles: The Museum of Contemporary Art Los Angeles, 1998.

5 See Stephanie Dieckvoss, 'When Artists Take on the Market', *Apollo*, May 2017.

6 See Catherine Morris, *We Wanted a Revolution: Black Radical Women 1965–1985/A Sourcebook*, New York: The Brooklyn Museum, 2017 and Valerie Smith, 'Abundant Evidence: Black Women Artists of the 1960s and 1970s', in Jill Fields, ed., *Entering the Picture: Judy Chicago, The Fresno Feminist Art Program, and the Collective Vision of Women Artists*, New York: Routledge, 2012, pp. 119–31 for a discussion of African American artists whose work overlapped the civil rights and feminist causes.

7 One of the earliest feminist scholars to work on the importance of humor in feminism was JoAnna Isaak. See Isaak, *Feminism and Contemporary Art: The Revolutionary Power of Women's Laughter*, London: Routledge, 1996. I am also indebted to Judy Chicago for enlightenment on the role of humor in feminist art.

One Feminism: The New Wave

1 See Linda Nochlin, 'Why Have There Been No Great Women Artists', originally published 1971, excerpted in Amelia Jones, ed., *The Feminism and Visual Culture Reader*, London: Routledge, 2003, pp. 229–33 or Rozsika Parker and Griselda Pollock,

Old Mistresses: Women, Art and Ideology, London: Pandora, 1981 for a discussion on the feminist challenging of traditional art history.

2 Germaine Greer, *The Female Eunuch*, London: Flamingo Modern Classic, 1993 (1970), p. 17.

3 An important exception is Gustave Courbet's *L'Origin du Monde* 1866, now in the Musée D'Orsay, which is a close-up view of the torso and genitals of a woman. It was likely originally a commission for a Turkish Egyptian diplomat, who assembled a collection of works that celebrated the female body, but was ultimately ruined by gambling debts. D'Orsay acquired the work from the psychoanalyst Jacques Lacan.

4 For good discussions of Chicago's important program, see 'California Dreaming' in Judy Chicago, *Institutional Time: A Critique of Studio Art Education*, New York: Monacelli Press, 2014, pp. 19–47 and Laura Meyer, 'From Finish Fetish to Feminism: Judy Chicago's *Dinner Party* in California Art History', in Amelia Jones, ed., *Sexual Politics: Judy Chicago's "Dinner Party" in Feminist Art History*, Berkeley: University of California Press and Los Angeles: UCLA at the Armand Hammer Museum of Art and Cultural Center, 1996, pp. 46–74.

5 See Nancy Youdelman and Karen LeCocq, 'Reflections on the First Feminist Art Program', in Jill Fields, ed., *Entering the Picture: Judy Chicago, The Fresno Feminist Art Program, and the Collective Visions of Women Artists*, New York: Routledge, 2012, pp. 65–77; Chicago, 'California Dreaming', pp. 34–42; Meyer, 'From Finish Fetish to Feminism', pp. 56–61; see also womanhouse.net.

6 See Kathy Battista, *Renegotiating the Body: Feminist Art in 1970s London*, London: I.B.Tauris, 2012, p. 125–9 for a discussion of 'A Woman's Place' in Brixton, London.

7 I will not attempt to address this scenario on a global level as many have done so already. For the current state of women workers in the global economy see Barbara Ehrenreich and Arlie Hochschild, eds, *Global Woman: Nannies, Maids, and Sex Workers in the New Economy*, New York: Holt Paperbacks, 2004.

8 As of 2010 there were only 3 percent of companies in the Forbes 500 with female CEOs. See Mary Ellen Egan, 'Top Paid Female Executives', *Forbes.com*, www.forbes.com/2010/04/27/ceo-salaries-bonuses-global-companies-forbes-woman-leadership-boss-10-top-paid-female-chief-executives.html, accessed August 20, 2013. It is interesting to note as well that the highest-paid female executive, Martine Sundblatt, was born a man and has in fact had gender reallocation. See Lisa Miller, 'The Trans-Everything CEO', *New York*, September 7, 2014. See also See Olivia Morgan and Karen Skelton, eds, *The Shriver Report: A Woman's Nation Pushes Back from the Brink*, New York: Palgrave Macmillan, 2014, pp. 47–54.

9 Catherine Dunn, Beth Kowitt, Colleen Leahy and Anne Vandermey, 'The 50 Most Powerful Women', *Fortune*, October 28, 2013, pp. 59–67.

10 See https://nmwa.org/sites/default/files/shared/getthefacts_master-statistics_5womenartists.pdf

11 Carolee Schneemann, interview with the author, April 18, 2002.

12 There are exceptions to the lack of support for feminist artists in the gallery system. P.P.O.W. and Broadway 1602 (which closed in 2017) are important examples of women-led galleries whose abiding support of women artists is notable.

13 See 'Why Should Paintings by Women Artists Sell for Less', *Business Think*, published by UNSW Business School, June 2016, www.businessthink.unsw.edu.au/Pages/why-should-paintings-by-female-artists-sell-for-less.aspx.

14 Ibid.

15 Anna Heyward, 'The Price of Being a Woman Artist', *ArtNews*, December 22, 2014, www.artnews.com/2014/12/22/the-price-of-being-a-woman-artist/. See also Alexander Forbes, 'Women Artists Benefit from Art Market Woes', *Artsy*, October 5, 2016, www.artsy.net/article/artsy-editorial-at-frieze-women-artists-benefit-from-art-market-woes.

16 The Guerrilla Girls identified specific galleries and museums as not representing or showing enough women artists. In 2014 they recreated their statistics showing that galleries including Mary Boone, Pace, and Marlborough, where women artists represented only 10 percent of their roster, had only improved to 20 percent in the intervening three decades. Similarly, the museum statistics were bleak: the Guggenheim, Metropolitan, Whitney, and Modern (MoMA NY) each had zero or one solo show by a woman artist in 1985. In 2015 the numbers had increased to one or two shows in each institution. See www.guerrillagirls.com/projects/ for their projects and activism. Today there are some important NY galleries that are exceptions to this rule, showing a large percentage of successful female artists. In New York, Salon 94, Sean Kelly Gallery, P.P.O.W., Galerie Lelong, and Cheim and Read are notable exceptions to these statistics.

17 For example, Tracey Moffatt, an Australian artist who combines text and imagery, was featured, as well as videos by Sam Taylor Wood, Julia Loktev, Anna Baumgart, and Rebecca Belmore.

18 Peter Schjeldahl, 'Women's Work', *The New Yorker*, April 9, 2007, https://www.newyorker.com/magazine/2007/04/09/womens-work-3

19 Roberta Smith, 'They are Artists Who are Women: Hear them Roar', *New York Times*, March 23, 2007, www.nytimes.com/2007/03/23/arts/design/23glob.html?pagewanted=all&_r=0

20 See Carey Lovelace, 'A Feast of Feminist Art', *Ms Magazine*, Fall 2004, www.msmagazine.com/fall2004/feministart.asp.

21 Smith, 'They are Artists'.

22 For example, the work of Hannah Wilke, Anna Alina Szapocznikow, and Jo Spence, have posthumously entered the marketplace. It is not unusual to see work by these artists at major art fairs such as Frieze or Art Basel.

23 Jerry Saltz, 'Where are all the Women', *New York*, November 18, 2007, http://nymag.com/arts/art/features/40979/. It is perhaps interesting to note that Saltz is the husband of the *New York Times* critic Roberta Smith. His words are significant as they come from a voice outside the feminist demographic.

24 For a similar perspective from the UK see Jason Farago, 'Isa Genzken and Women Artists: Defying the Boys Club', *BBC Culture*, November 12, 2013, www.bbc.com/culture/story/20131112-the-art-worlds-glass-ceiling.

25 Born 1982 in Belgium, Goossens was previously a curator at PS1, Clocktower Galleries and Director of Envoy Enterprises, a gallery on New York's Lower East Side. He is now a freelance curator and academic.

26 Tim Goossens, interview with the author, September 3, 2014.

27 Ibid. It is worth noting that the recent incarnation of Pacific Standard Time initiative on the West Coast in 2017 focused on Latin American art and design.

28 This is a continuation from the 1970s eco-feminism. For example, as Judy Chicago has said (Judy Chicago gallery talk with the author at David Richard Gallery, Sante Fe, New Mexico, June 13, 2014), feminism is not just about resolving the oppression of women, it is concerned with the oppression of any underrepresented group, as well as our planet and nature itself.

29 Born 1971 in England, raised in San Francisco, and having studied experimental theater at NYU, Anohni is best known as lead vocalist for her former band Anthony and the Johnsons. She is also a visual artist with exhibitions at the Hammer Museum in Los Angeles and Sikkema Jenkins gallery in New York.

30 Born 1961 in Hermosa Beach, California, Pfahler is a filmmaker, performance artist, and film actress. She is best known for her role as lead singer in the glam punk band The Voluptuous Horror of Karen Black, where she often performs nude except for brightly colored body paint. Pfahler's unique brand of performance art that features nude musicians covered in bright body paint is known for its unique and unapologetic approach to disruption and fun. She has spoken in terms of artist research about using "symbols that I feel travel from generation to generation that are unavoidable to investigate what might not seem that original but are a place where we all have to go…" See *Next Time* media conference, November 17, 2013: www.next-time.info.

31 Johanna Constantine is a performance artist who has worked with Anohni since the early 1990s in their (the group also included Psychotic Eve) Backlips Performance Cult that that was based at the East Village Pyramid Club. Every Monday night they would perform a new play, including their "Bloodbags and Beauty."

32 Sierra and Bianca Casady are sisters best known for their band Coco Rosie, which has been described as "freak folk". The sisters had a non-traditional American upbringing, and never graduated high school. After being estranged for a number of years they came together in Paris in 2003 and formed Coco Rosie, named after their mother's pet names for them. See Fernanda Eberstadt, 'Twisted Sisters', *NY Times*, July 6, 2008, www.nytimes.com/2008/07/06/magazine/06cocorosie-t.html?pagewanted=all&_r=0.

33 Established by Kathy Grayson, former Director at Deitch Projects, The Hole may be as considered a spin-off and continues the cutting-edge work done by Jeffrey Deitch and his team before his departure to LA MoCA and then return to New York. Deitch is known for spotting young talent and in terms of emerging artists his support, in terms of exhibitions and projects, of Vanessa Beecroft and Bjork is important to note.

34 See Ann Powers, 'Anthony's Future Feminism: Stage Banter as Statement of Purpose', NPR, August 7, 2012, www.npr.org/blogs/therecord/2012/08/06/158237793/antonys-future-feminism-stage-banter-as-statement-of-purpose.

35 See Aviva Rahmani, 'Practical Ecofeminism', in Karen Frostig and Kathy A. Halamka, eds, *Blaze: Discourse on Art, Women and Feminism*, Newcastle Upon Tyne, Cambridge Scholars Association, 2009, pp. 315–32. The link between feminism and the green movement is understood as ecofeminism. The female body as a metonym for the landscape of our planet is a theme taken up by ecofeminists but goes back to the idea of primordial goddesses and classical mythology.

36 Schneemann was scheduled for a film screening, but could not attend because of illness.

37 The commodification of feminism, as seen in Beyoncé, Lady Gaga, and others, is a more recent development. In the past pop stars have seldom gone on record to support a feminist position. One can see how feminism as a concept can be exploited for commercial reasons with recording artists selling records and gaining credibility.

38 See Lorraine O'Grady, 'Olympia's Maid: Reclaiming Black Subjectivity', in Amelia Jones, ed., *The Feminism and Visual Culture Reader*, London: Routledge, 2010, pp. 174–86.

39 T-shirts reading THE FUTURE IS FEMALE were sold and quickly became ubiquitous fashion accessories for the liberal, artistically minded, in New York.

40 For example, Donna Haraway's notion of the cyborg, a theoretical position that emerged in the early 1990s, was an alternative to the more essentialist position of the construction of the female gender as solely connected to nature. Donna Haraway writes:

> The international women's movements have constructed "women's experience", as well as uncovered or discovered this crucial collective object. This experience is a fiction and fact of the most crucial, political kind. Liberation rests on the construction of the consciousness, the imaginative apprehension, of oppression, and so of possibility. The cyborg is a matter of fiction and lived experience that changes what counts as women's experience in the late twentieth century.

See Haraway, 'A Cyborg Manifesto: Science, Technology, and Socialist-Feminism in the Late Twentieth Century', in *Simians, Cyborgs and Women: The Reinvention of Nature*, New York: Routledge, 1991, pp. 149–81.

41 Kate Mondloch has written eloquently on the tendency to lump all theoretical feminist positions together, arguing for a more nuanced understanding of an internally diverse group of practitioners of that era. See Kate Mondloch, 'The *Difference* Problem: Art History and the Critical Legacy of 1980s Theoretical Feminism', *Art Journal*, Vol 71, No 2, Summer 2012, pp. 18–31.

42 Eleanor Heartley, 'Eco-Feminism Revisited', *The Brooklyn Rail*, November 5, 2015, http://brooklynrail.org/2015/11/criticspage/eco-feminism-revisited, accessed July 25, 2017.

43 Artists in the exhibition included Ange, Anne Sherwood Pundyk, Antonia Perez, Asha Cherian, Betty Tompkins, Bianca Casady, Elisa Garcia de la Huerta, India Salvor Menuez, Jemima Kirke, JK5, Katie Cercone, Kara Rooney, Kembra Pfahler, Leah Aron, Lola Montes, Marcia Jones, Mariko Passion, Michael Tousana, Nancy Azara, Virginija Babusyte-Venckuniene, as well as Dolle. Some artists, including Khembra Phaler and Bianca Cassidy, were also key participants in the *Future Feminism* project.

44 See more on Ange in Chapter 2 of this book.

45 Go! Push Pops interview with the author, January 29, 2015.

46 Kate Messinger, 'The Hole and Sensei Galleries Redefine the F-Word – Feminism', *Observer*, September 19, 2014. See also Alexis Clements, 'Past, Present and Future Feminism, *Hyperallergic*, September 19, 2014, http://hyperallergic.com/149699/past-present-and-future-feminism/, accessed December 15, 2015 and Katherine Brooks, 'Five Women are Setting the Stage for, *The Huffington Post*, September 5, 2014, www.huffingtonpost.com/2014/09/05/future-feminism_n_5769356.html, last accessed December 15, 2015.

47 Kate McNamara, interview with the author, June 2018.

48 See Susan Bolotin, 'Voices from the Post-Feminist Generation', *New York Times*, October 17, 1982. In this article Bolotin interviewed several younger women whose views on feminism at the time were depressingly negative.

49 Toril Moi, *Sexual/Textual Politics: Feminist Literary Theory*, London: Routledge, 2002.

50 Amelia Jones, 'Feminism Incorporated: Reading "postfeminism" in an anti-feminist age', in Jones, ed., *The Feminism and Visual Culture Reader*, London: Routledge, 2003, p. 324.

51 For an excellent discussion of the many uses of the term postfeminism see Misha Kavka, 'Feminism, Ethics, and History, or What is the "Post" in Postfeminism?', in *Tulsa Studies in Women's Literature*, Vol 21, No 1, University of Tulsa, Spring, 2002, pp. 29–44. For an earlier example, albeit more anecdotal, see Bolotin, 'Voices From the Post-Feminist Generation'.

52 Kavka, p. 33.

53 Marcia Tucker, interviewed by Lynn Hershman Leeson, July 2006, *!Women Art Revolution* pamphlet, 2010, p. 27.

54 In fact, many of the artists interviewed for this book acknowledge Riot Grrrl icons such as Kathleen Hanna as early influences.

55 Alison M. Gingeras, 'Ella Kruglyanskaya: Women's Studies', in *Ella Kruglyanskaya*, London: Studio Voltaire and Koenig Books, 2014, p. 10.

56 Moira Roth, 'Teaching Modern Art History from a Feminist Perspective: Challenging Conventions, my Own and Others' (1987), in Hilary Robinson, ed., *Feminism-Art-Theory*, Oxford: Blackwell Publishers, 2001, p. 140.

57 See Pheobe Hoban, 'The Feminist Evoluation', *ArtNews*, December 2009.

58 See Marco Poggio, 'Brooklyn Museum taps woman to head the cultural institution; first time in its 200-year history', *NY Daily News*, June 29, 2014, www.nydailynews.com/new-york/woman-head-brooklyn-museum-article-1.1847332 and Robin Pogrebin, 'Elizabeth A. Sackler to lead Brooklyn Museum Board', *New York Times*, June 26, 2014, http://artsbeat.blogs.nytimes.com/2014/06/26/elizabeth-a-sackler-to-lead-brooklyn-museum-board/?_php=true&_type=blogs&_r=0.

59 See Catherine Morris and Rujeko Hockley, *We Wanted a Revolution: Black Radical Women 1965–85 A Sourcebook*, New York: Brooklyn Museum of Art/Duke University Press, 2017.

60 Judy Chicago, email to the author, October 14, 2015.

61 See www.lib.stanford.edu/women-art-revolution and www.henry-moore.org/hmi/archive/turning-the-pages--helen-chadwick-notebooks.

62 One might also add Vito Acconci and Chris Burden's performance works here, which tested the limits of endurance. Feminist artists including Faith Wilding in her *Waiting* (1972), Marina Abramovic in many early works, and Carolee Schneemann all used endurance as a key factor in performance art.

63 Mike Kelley interviewed by Lynn Hershman Leeson, July 27, 2006, http://lib.stanford.edu/files/WAR_kelley.pdf.

64 One need only look at social media forums to see a backlash, by some women, against feminism. #notafeminist has become a trend in social media sites such as Facebook, Twitter, Instagram, and Tumblr. Unfortunately, many of these posts, which range from "I take care of my man. If I don't, someone else will" to "Feminism is no longer about equal

rights. It's about putting men down and making women victims." Regrettably these posts are retrogressive and oversimplified, filled with generalizations.

65 Aurel Schmidt, email to the author, 12 September, 2014.

66 See Chicago, *Institutional Time*.

67 Martha Rosler, *Decoys and Disruptions: Selected Writings, 1975–2001*, Cambridge: The MIT Press, 2004, p. 108.

68 See Amelia Jones, ed, *Sexual Politics: Judy Chicago's Dinner Party in Feminist Art History*, Los Angeles: University of California Press, 1996 for a thorough discussion of this project and the artists associated with the Feminist Art Program.

69 Jane Wark, *Radical Gestures, Feminism and Performance Art in North America*, McGill Queen's University Press, 2006, pp. 63–4.

70 See Maurice Berger, 'Styles of Radical Will: Adrian Piper and the Indexical Present', in *Adrian Piper A Retrospective*, Baltimore: Fine Arts Gallery University of Maryland, 1999, p. 17.

Two Revisiting Feminist Artworks and Re-envisioning a Feminist Practice for the Twenty-first Century

1 Suzanne Lacy interviewed by Lynn Hershman, May 9, 1990, *!Women Art Revolution* files, Stanford Libraries. See http://lib.stanford.edu/women-art-revolution.

2 Linda Nochlin in 'Feminism and Art: Nine Views', *Artforum*, October 2003, p. 141.

3 Louisa Elderton, 'Redressing the Balance: Women in the Art World', *The White Review*, www.thewhitereview.org/art/redressing-the-balance-women-in-the-art-world/, accessed August 16, 2013.

4 Lynn Hershman Leeson, 'Transcript of Interview with the Guerrilla Girl Kathe Kollwitz', Stanford Digital Files, July 27, 2006, http://lib.stanford.edu/women-art-revolution/ transcript-interview-kathe-kollwitz, accessed August 16, 2013.

5 See www.guerrillagirls.com and http://www.ggtakeover.com for more information on this important group of anonymous activist artists.

6 Brainstormers are an artist's group based in New York that consists of artists Elaine Kaufmann, Danielle Mysliwiec, Anne Polashenski, and Maria Dumlao. Their practice may be seen as evolving from the Guerrilla Girls in that they create works solely about the gender distribution in the art world. See www.brainstormersreport.net for samples of their work, press, and information on the group.

7 Although not included in this book, which centers on New York based activity, Los Angeles based artist Audrey Chan recreates herself as Judy Chicago, appearing alongside her at events, interviewing her, and even shopping with the feminist artist. As an aside, Chan was also part of the recreation of some of the earlier performance works for the Pacific Standard Time series of exhibitions. She and her collaborator Elana Mann worked with Suzanne Lacy and Lesley Labowicz-Starus to recreate their *Myths of Rape* performance from 1977. Thank you to Judy Chicago for introducing me to Audrey and her work. See audreychan.net and Audrey Chan, Alexandra Grant, and Elana Mann,

'Rupture and Continuity in Feminist Re-performance', *Afterall*, Issue 33, Summer 2013, pp. 38–45.

8 Catherine Grant, 'Fans of Feminism: Re-writing Histories of Second-wave Feminism in Contemporary Art', *Oxford Art Journal* 34.2, 2011, p. 271.

9 Grant, p. 286.

10 Hinant completed her MFA at the School of Visual Arts (SVA) in 2011.

11 Hinant usually publishes her books in a small edition (10) and distributes half of them for free to friends and colleagues, selling the other half. Exceptions include *Flav*, published in an edition of 60 and all freely distributed.

12 Cindy Hinant email to the author, July 27, 2013.

13 Born 1982, Kamloops, Canada, Aurel Schmidt now lives and works in New York.

14 Roberta Smith, 'Art or Ad or What? It caused a lot of fuss', *New York Times*, July 24, 2009, www.nytimes.com/2009/07/25/arts/design/25benglis.html?_r=0.

15 Aurel Schmidt email to the author, September 12, 2014.

16 Rachel Wolff, 'The Biennial's Breakout Star', *Daily Beast*, February 25, 2010, www.thedailybeast.com/articles/2010/02/25/the-biennials-breakout-star.html.

17 Starseeds (the exhibition) took place at Envoy Enterprises on the Lower East Side of New York, in February 2014.

18 Starseeds, *Artlog*, http://envoyenterprises.com/artists/mason/Press/RachelMason-Artlog.jpg.

19 Mason talks about the feelings of emotional exhaustion after spending seven years sculpting the faces of world leaders that she had such conflicting emotions about:

> After this process- I was simply mentally exhausted by staring into so many faces- as I sculpted – of people who I had such troubling feelings about. I would look at their pictures for hours and hours and silently sculpt them one by one and think about the bloodshed and the violence...
>
> (Mason email to the author, 21 August, 2014.)

20 Ibid.

21 Ibid.

22 *Bonds of Love* was a group exhibition of female artists whose work was not intentionally feminist; however, because it was an all-female roster the work was identified as a feminist project.

23 Lisa Kirk interview with the author, September 17, 2014.

24 This was before the Occupy Wall Street movement, a groundbreaking moment in public action where hundreds of people took residence in Zuccotti Park in Downtown Manhattan from September 17 to November 15, 2011. This was concurrent with the various uprisings in the Middle East, often referred to as the Arab Springs of 2010 and 2011.

25 Lisa Kirk interview with the author, September 17, 2014.

26 Kate Moss was the iconic example of an undressed model posing for Calvin Klein's Obsession perfume in the mid-1990s.

27 See Catherine de Zegher, ed., *Martha Rosler: Positions in the Life World*, Birmingham, England: Ikon Gallery, 1998, pp. 14–22.

28 Schneemann quoted in Mirjam Westen, '*Rebelle*, Introduction', *Rebelle Art & Feminism 1969–2009*, Arnhem: Museum voor Moderne Kunst Arnhem, 2009, p. 13.

29 Kielar was born in 1978 and completed her BFA at the Cooper Union School of Art and her MFA at Columbia University.

30 'Anya Kielar Shapes Art to Time', *Zing Magazine*, February 2014, www.zingmagazine. com/drupal/node/35956.

31 Roberta Smith, 'Art in Review: Anya Kielar', *New York Times*, April 6, 2007, http://query. nytimes.com/gst/fullpage.html?res=9C02E5DB173FF935A35757C0A9619C8B63, accessed July 22, 2013.

32 Ella Kruglyanskaya interview with the author, September 19, 2014.

33 Ibid.

34 Alison M. Gingeras, 'Ella Kruglyanskaya: Women's Studies', in *Ella Kruglyanskaya*, London: Studio Voltaire and Koenig Books, 2014, p. 10.

35 Ibid.

36 Al-Hadid was born in 1981 and studied at Kent State College for a BA/BFA in Art History/Fine Art, MFA at Virginia Commonwealth and then attended the prestigious Skowhegan School of Painting and Sculpture.

37 Al-Hadid also makes drawings and integrated, double-sided wall pieces.

38 Sadly, most of this work was destroyed when Hurricane Sandy hit New York in October, 2012.

39 Al-Hadid in conversation with the author, March 2011.

40 Hegarty grew up near Concord, Massachusetts, an area known for historic homes. She spoke of houses with plaques and vernacular 1970s housing made to look colonial. While this isn't her heritage, she was interested in how immigrants always try to assimilate into the culture they find themselves. The artist in discussion with the author, April 2012.

41 See Kerry Brougher and Philippe Vergne, *Yves Klein with the Void, Full Powers,* Washington: Hirshhorn Museum and Sculpture Garden & Minneapolis: Walker Center, 2010.

42 See Julia Bryan-Wilson, *Ana Mendieta, Traces*, London: Hayward Gallery, 2014 and Olga Viso, *Ana Mendieta: Earth Body*, Berlin: Hatje Cantz, 2004.

43 See The Jo Spence Memorial Library as an excellent source on her work and writing: www.bbk.ac.uk/arts/research/photography/the-jo-spence-memorial-library-terry-dennett-collection.

44 Jo Spence, *Putting Myself in the Picture*, referenced in Jo Spence, *Cultural Sniping: The Art of Transgression*, London: Routledge, 1995, p. 77.

45 Frazier was born in Braddock, Pennsylvania in 1982 and lives and works in Chicago. She received her BFA from Syracuse University and a MFA from Edinboro School of Art. She was Critic in Photography at Yale University and is now Associate Professor at School of the Art Institute of Chicago.

46 See Dean Daderko, 'Upside Down, Left to Right', in *LaToya Ruby Frazier: Witness*, Houston: Contemporary Arts Museum Houston, 2013, p. 6.

47 Thank you to LaToya Ruby Frazier for emailing important information regarding Braddock, PA in May 2018

48 LaToya Ruby Frazier, 'Statement', at www.latoyarubyfrazier.com/statement/, accessed July 23, 2013.

49 See LaToya Ruby Frazier with Greg Lindquist and Charles Schultz, *The Brooklyn Rail*, July 15, 2013.

50 Ibid.

51 Thank you to LaToya Ruby Frazier for correspondence about Braddock, PA in May 2018.

52 For a good resource on documentary American photography and race see Coco Fusco and Brian Wallis, eds, *Only Skin Deep: Changing Visions of the American Self*, New York: Abrams and the International Center of Photography, 2003.

53 See Spence, *Cultural Sniping*.

54 See Nan Goldin and Hans Werner Holzwarth, eds, *I'll Be Your Mirror*, New York: Scalo and the Whitney Museum of American Art, 1996 and Corinne Day, *Diary*, Munich: Kruse Verlag, 2000.

55 K8 Hardy was born in 1977 in Texas, and now lives and works in New York. She has a BA from Smith College, a MFA from the Milton Avery Graduate School for the Arts at Bard College and was a participant of the Whitney Museum of American Art Independent Study Program.

56 For a good introduction to this movement read Sara Marcus, *Girls to the Front: The True Story of the Riot Grrrl Revolution*, New York: HarperCollins, 2010.

57 Alex Frank, 'Interview with K8 Hardy', *The Fader*, www.thefader.com/2012/03/08/interview-k8-hardy/, accessed August 16, 2013.

58 Hardy has also used her sister in this series; however, they look very similar so she may be considered as a stand-in for the artist.

59 Dean Daderko, 'K8 Hardy: Positions Series', *Pastelegram*, September 23, 2011, http://pastelegram.org/reviews/54, accessed August 16, 2013.

60 Hardy has used digital technology in other series, for example for a body of work for the solo show *September Issues* at Dallas Contemporary in 2012.

61 Kevin McGarry, 'At the 2015 New Museum Triennial: A High Tech Take On Nude Sculpture', *New York Times magazine*, February 24, 2015, http://tmagazine.blogs.nytimes.com/2015/02/24/frank-benson-new-museum-triennial/?_r=0.

62 Leah Schrager interview with the author, January 7, 2015.

63 See "onaartistqueen," "onaartistfun," and "onaartis" on Instagram.com.

64 Leah Schrager interview with the author, January 7, 2015.

65 Johanna Fateman, 'Women on the Verge', *Artforum*, April 2015, p. 219.

66 See Kathy Battista, *Renegotiating the Body: Feminist Art in 1970s London*, London: I.B.Tauris, 2012, pp. 45–8 and Simon Ford, *Wreckers of Civilization: The Story of Coum Transmissions and Throbbing Gristle*, London: Black Dog Publishing, 1999, pp. 6.3–6.33 for discussions of Cosey Fanni Tutti's project and the Prostitution exhibition in 1976.

Three The Artist Is Present: The Body in Feminist Performance, Then and Now

1 Amelia Jones, *Body Art: Performing the Subject*, Minneapolis: University of Minnesota Press, 1998, p. 151.

2 Barbara Smith, 'Feed Me 1973', performance notes, unpaginated, 2012. I'm grateful to the artist for sharing this document with me.

3 See Jones, p. 151.

4　The artist changed her name from Walltraud Hollinger to VALIE EXPORT in 1968 in her emergence on to the Viennese art scene. Rejecting the name of her father and husband, EXPORT was a brand of cigarettes at the time.

5　Judith Baca and Suzanne Lacy interviewed by Lynn Hershman in 1990, *!Women Art Revolution*, Stanford Libraries, https://lib.stanford.edu/women-art-revolution/transcript-interview-judith-baca-suzanne-lacy.

6　Martha Rosler, *Decoys and Disruptions: Selected Writings 1975–2001*, Cambridge: The MIT Press, 2004, pp. 108–9.

7　A copy of her handwritten script notes may be found in Catherine de Zegher, ed., *Martha Rosler: Positions in the Life World*, Birmingham and Vienna: Ikon Gallery and the Generali Foundation, 1999, p. 202.

8　Whitechapel's *A Short History of Performance Part II* 2003 was curated by Andrea Tarsia and Chris Hammonds.

9　Martha Wilson interviewed by Lynn Hershman Leeson, February 15, 2008, http://lib.stanford.edu/women-art-revolution/martha-wilson-2008.

10　Matthew Higgs and Paul Noble, Protest & Survive, London: Whitechapel Gallery, 2000, p. 44.

11　Priscilla Frank, 'Feminist Artist's *How to Undress In Front Of Your Husband* skewers Retro Mansplaining', *Huffington Post*, March 24, 2017, www.huffingtonpost.com/entry/nadja-marcin-feminist-art_us_58d2cc4fe4b0b22b0d19448f, accessed May 29, 2017.

12　Another *Terrestrial Being* performance took place at the Swiss Institute in 2008. This was not a guerrilla event, but one sanctioned by the Institute with an invited audience.

13　From a discussion with the artist, July 2, 2013.

14　'Rachel Mason Performs Paul Rand's 13 Hour Filibuster As a FutureClown', *Huffington Post*, July 11, 2013, www.huffingtonpost.com/2013/07/11/rachel-mason-rand-paul-13-hour-filibuster-futureclown-video-interview_n_3573780.html?utm_hp_ref=arts.

15　See Suzanne Lacy, *Leaving Art: Writings on Performance, Politics, and Publics 1974–2007*, Duke University Press, 2010.

16　See Martha Wilson, ed., *Martha Wilson Sourcebook, 40 Years of Reconsidering Performance, Feminism, Alternative Spaces*, New York: Independent Curators International, 2011. Wilson's DISBAND, an all-women punk band who couldn't play instruments, was a forerunner of 1990s Riot Grrrl culture.

17　See David Joselit, *Robert Whitman, Playback*, New York, Dia Foundation, 2003 and Marco Livingstone, *Jim Dine, The Alchemy of Images*, New York: Monacelli Press, 1998.

18　Gilmore created another version of this work, called *Walk the Line*, in London in 2011. In this instance the platform was situated in the busy Broadgate area in the city of London, where most of the financial institutions are located. The women performed eight hours of the day, even in inclement weather. The composition in this iteration involved a red platform and red outfits although the actions were similar.

19　The title of this exhibition derives from a William Burroughs novel of the same name.

20　Harry J. Weil, 'Old Themes New Variations: The Work of Kate Gilmore', *Afterimage*, 39.3, 2011, p. 7. A notable exception to dearth of female Minimal artists is Rosemarie Castoro (1939–2015), whose work has recently been reassessed and introduced to the art market. See http://artforum.com/news/id=52212, accessed October 3, 2015.

21 The relationship of emerging female artists to their Minimal predecessors is further discussed in Chapter 5 of this book.

22 Phillips hosted their first auction of digital based art in. See Jennifer Maloney, 'Auction House Enters the Digital World', *Wall Street Journal*, September 23, 2013, http://online.wsj.com/article/SB10001424052702304713704579091192929676208.html. One can imagine that it is only a matter of time before an auction house hosts a performance-based sale.

23 Julie Baumgardner, 'How Performance Art Entered the Mainstream', *Artsy*, November 3, 2015, www.artsy.net/article/artsy-editorial-how-performance-art-entered-the-mainstream, accessed May 29, 2017.

24 Thank you to Anke Kempkes of Broadway 1602 for an enlightening discussion on the commercial exchange of performance art. Also, as cited above, thanks to Karina Daskolav at Marian Goodman Gallery.

25 Babette Mangolte was represented by Broadway 1602 Gallery, which has now closed, and Peter Moore's estate is handled by Paula Cooper Gallery.

26 See Wendy Perron, 'Simone Forti: bodynatureartmovementbody', in Ninotchka Bennahum, Wendy Perron, and Bruce Robertson, eds, *Radical Bodies: Anna Halprin, Simone Forti, and Yvonne Rainer in California and New York, 1955–1972*, Santa Barbara: Art, Design & Architecture Museum, University of California, 2017, pp. 107–11.

27 For statistics on the gender gap in the corporate workplace see: Emily Peck, 'The Pay Gap At The Top of Corporate America Is Not What You Think', *Huffington Post*, May 10, 2016, www.huffingtonpost.com/entry/women-ceo-gender-pay-gap_us_57322688e4b016f378974931, accessed July 26, 2017.

28 Donegan was known for confrontational video pieces in the 1990s. She recently created her own fashion/life drawing show at NADA New York art fair in May 2015. Her show was unique, with no runway but a stage area, and involved both men and women of all races and ages who posed for someone who sketched their outfit.

29 Cheryl Donegan, 'Backstage at K8 Hardy's Untitled Runway Show at the Whitney Museum of Art, 5/20/2012', K8 Hardy and Dorotheé Perret, eds, *K8 Hardy How To: Untitled Runway Show*, Paris: DoPe Press, 2013, p. 41.

30 John Bock and Rainer Ganahl have also created fashions shows using cast off materials. For a discussion of Rainer Ganahl's *Commes des Marxists* performance art/fashion show see Tracy Zwick, *Art in America*, November 4, 2013, www.artinamericamagazine.com/news-features/previews/comme-des-marxists-rainer-ganahls-runway-show/.

31 http://frontrow.dmagazine.com/2012/10/art-review-k8-hardys-failed-fashion-show-and-successful-performance-at-the-dallas-contempary/.

32 'K8 Hardy by Ariane Reines', *Bomb*, April 1, 2012, https://bombmagazine.org/articles/k8-hardy/.

33 W.A.G.E. or Working Artists for the Greater Economy was formed to lobby for better pay and treatment of artists, including performance artists. See www.wageforwork.com/home for more information on this activist organization.

34 See Jennifer Piejko, ed., *Performa 11 Staging Ideas*, New York: Performa Publications, 2013, p. 78–91 for more information on this project.

35 Rottenberg's video and installation *NoNoseKnows* was featured in the 2015 Venice Biennale. Viewers had to pass through a pearl factory to enter the video gallery. See Amanda Soroff, 'Mika Rottenberg', in Luz Gyalui, ed., *All the World's Futures*, Venice: Fondazione La Biennale de Venezia, 2015, p. 92–3.

36 See Bennett Simpson and Chrissie Iles, *Dan Graham: Beyond*, Los Angeles: Museum of Contemporary Art, 2009.

37 Pearlstein discussed this in a lecture at Sotheby's Institute of Art New York on October 10, 2012.

38 Pearlstein has acknowledged Yvonne Rainer's *Work 1961–1993* as a formative book for the development of her practice in terms of documentation and how it is preserved. See also Yvonne Rainer, *A Woman Who… Essays, Interviews, Scripts*, Baltimore: Johns Hopkins University Press, 1999 for a thorough review of Rainer's work.

39 I am indebted to Kempkes for several discussions about ephemeral art and the market.

40 Of course, performance art has a much earlier history, for example Dada events in the early twentieth century as well as the burgeoning of Happenings in 1950s New York. See Leah Dickerman, ed., *Dada*, Paris: Centre Pompidou, 2006. For an art historical survey of performance see RoseLee Goldberg, *Performance Art: From Futurism to Present*, London: Thames and Hudson, 2011 [1979]. Another useful source is Amelia Jones andTracey Warr, eds, *The Artist's Body*, London: Phaidon, 2006. Regarding 1950s New York see Mildred Glimcher, *New York: Happenings 1958–63*, New York: Monacelli Press, 2012 and Melissa Rachleff, *Inventing Downtown: Artist Run Galleries in New York 1952–65*, New York: Prestel, 2017.

41 Whitman has said about the audience for performance art in 1960s New York, "…the audience were people in the know, so they already had a feel for the work." See Roundtable discussion with Sabine Breitwieser, Julie Martin, Robert Whitman, Kathy Battista, in Breitwieser, ed., *E.A.T. Experiments in Art and Technology*, Salzburg: Museum der Moderne Salzburg, 2015, p. 206.

42 See Julie Ault, *Alternative Art New York 1965–1985*, Minneapolis and New York: University of Minnesota Press and The Drawing Center, 2002 for an excellent discussion of institutions and collectives that supported avant-garde work during this period.

43 See Judith Butler, *Gender Trouble, Feminism and the Subversion of Identity*, London: Routledge, 1990.

44 See Jon Burris, 'Did the Portapak Cause Video Art? Notes on the Formation of a New Medium', *Millennium Film Journal*, Volume 29, 1996.

45 In addition to these NY based examples, major exhibitions of the work of Yvonne Rainer and Simone Forti have been mounted in Europe. See Sabine Breitwieser, ed., *Simone Forti: Thinking with the Body*, Salzburg and Munich: Museum der Moderne and Hirmer, 2014. Joan Jonas represented the US at the Venice Biennale in 2015. This is a significant development in performance art studies and reception.

46 See Helena Reckitt and Peggy Phelan, eds, *Art and Feminism*, London: Phaidon, 2001, pp. 92–3.

47 See Hans-Joachim Müller, *Harald Szeemann Exhibition Maker*, London: Hatje Cantz, 2006; and *When Attitudes Become Form*, Milan: Prada Foundation, 2013.

48 See Kathy Battista, *Renegotiating the Body: Feminist Art in 1970s London*, London: I.B.Tauris, 2012 and Kathy Battista, 'Domestic Crisis: Women Artists and Derelict Houses in London 1974–1998', in Ken Ehrlich, Brandon LaBelle, and Steven Vitiello, eds, *Surface Tension: Problematics of Site*, Errant Bodies, 2007, for a discussion of *A Woman's Place*.

49 Holland Cotter, 'In the Naked Museum: Talking, Thinking, Encountering', *New York Times*, January 31, 2010.

50 See Brietweiser, *Thinking with the Body*.

51 For example, the exhibition *Yvonne Rainer Dances and Films* at the Getty in 2014 and the *Simone Forti Thinking with the Body* retrospective at the Museum der Moderne Salzburg in 2014.

52 Kasper was born 1977 and lives and works in Los Angeles. She did her BFA at Virginia Commonwealth University in Richmond and completed a MFA in New Genres at UCLA. She is currently represented by David Lewis Gallery in New York.

53 Rachel Mason, 'Dawn Kasper', *art21*, October 4, 2011, http://blog.art21.org/2011/10/04/dawn-kasper/#.U_I17pVFc20.

54 Ibid.

55 See Penelope Green, 'Please, Don't Feed the Artist: Dawn Kasper at the Whitney Biennial', *New York Times*, April 25, 2012 and Yasmine Mohseni, 'Beyond the White Cube: Dawn Kasper's Studio Within a Museum', *Huffington Post*, May 21, 2012, www.huffingtonpost.com/yasmine-mohseni/beyond-the-white-cube-cha_b_1456252.html.

56 See Battista, *Re-Negotiating the Body*, pp. 101–4.

57 EXPORT has said, "I didn't want to perform in a gallery or a museum, as they were too conservative for me, and would only give conventional responses to my experimental works." See Elizabeth Lebovici, 'Interview with VALIE EXPORT', in *VALIE EXPORT Summary*, Montreuil: Editions De L'Oeil, 2003, p. 148–9.

58 See James Westcott, 'Marina Abramovic's The House with the Ocean View', *Critical Acts*, MIT Press, Vol 47, No 3, Autumn 2003, pp. 129–36.

59 See David Batty, 'Tino Sehgal wins Golden Lion for best artist at Venice Biennale', *Guardian*, June 1, 2013, www.theguardian.com/artanddesign/2013/jun/01/tino-sehgal-golden-lion-best-artist.

60 The readings were directed by artist Isaac Julien, whose work *Capital* was also shown at the Biennale. See Mark Nash, 'Arena Film Program', in Luz Gyalui, ed., *All the World's Futures*, Venice, Fondazione La Biennale di Venezia, 2015, p. 124–125 and Charlotte Higgins, 'Das Kapital at the Arsenale: How Okwui Enwezor Invited Marx to the Biennale', *Guardian*, May 7, 2015, www.theguardian.com/artanddesign/2015/may/07/das-kapital-at-venice-biennale-okwui-enwezor-karl-marx.

61 See Adam Szymcyzk talks with Michelle Kuo, *Artforum*, April 2017, https://www.artforum.com/print/201704/documenta-14-67184.

62 See Kathy Battista, 'Other People and Their Ideas: RoseLee Goldberg', *ArtReview*, January 2016, for a further discussion of this debate.

63 www.mmparis.com/noghost.html.

64 I am indebted to Karina Daskalov, formerly of Marian Goodman Gallery, for an email correspondence about the commercial aspects of Sehgal's work.

Four Avant-Drag: The (Fe)male Body Reconsidered for the Twenty-first Century

1 See Janet Halley and Andrew Parker, ed., *After Sex? On Writing Since Queer Theory*, Durham and London: Duke University Press, 2011.

2 For more information on this landmark exhibition see Dave Hickey, 'In the Dancehall of the Dead', in Karen Marta, ed., *Robert Gober: Dia Center for the Arts*, New York: Dia Center for the Arts, 1993.

3 See Nan Goldin, David Armstrong, and Hans Werner Holzwarth, eds, *I'll be Your Mirror: Nan Goldin*, New York: Whitney Museum of American Art and Scalo, 1996, pp. 256–73.

4 Born 1972, Narcissister lives and works in New York.

5 The masks used by the artist are actually from vintage wig stays that the artist discovered. She researched into their designer, Verna Doran, who had a company with her husband called Plasti-personalities. Narcissister email to the author, August 16, 2014.

6 Narcissister email to the author, August 15, 2014.

7 Ibid.

8 The Whitney Houston Biennial took place again in March 2017 during the Armory Show art fair week. In this instance it was on view in Soho, in downtown New York, and had a longer run. The spirit of inclusivity was still the same. See the website for information: www.whitneyhoustonbiennial.com.

9 See Maurice Berger, *Adrian Piper: A Retrospective*, Baltimore: UMBC, 1999.

10 It is worth noting Los Angeles-based artist Micol Hebron, who riffed on Schneemann's piece with her performance *Roll Call* 2013. In this performance as part of the exhibition Pretty Vacant, she pulled a scroll out of her vagina in homage to Schneemann, and read the statistics for women artists represented by 88 Los Angeles galleries. Over 70 percent of the artists were male. Hebron said that *Interior Scroll*, "resonated with me, as a female artist who constantly experiences, through body and mind, myriad inequities in the systems of the art world." Using words as her soundtrack, this piece confronts a serious issue in the art world today. See http://micolhebron.com for further information.

11 See Mary Douglas, *Purity and Danger: An Analysis of the Concepts of Pollution and Taboo*, London, Routledge, 1966, and Ben Campkin, 'Placing Matter Out of Place: Purity and Danger as Essence for Architecture and Urbanism', *Architectural Theory Review* 18:1, 2013, pp. 46–61.

12 Julia Kristeva, 'Powers of Horror', in Charles Harrison and Paul Wood, eds, *Art in Theory 1900–2000 An Anthology of Changing Ideas*, Malden, MA: Blackwell Publishing, 1993, p. 1138.

13 Narcissister email to the author, August 15, 2014.

14 Catherine Grant, 'Fans of Feminism, Re-writing Histories of Second-Wave Feminism in Contemporary Art', *Oxford Art Journal*, 2011, p. 269.

15 Ibid, p. 271.

16 Indeed, the props and sets that Narcissister constructs for each performance are considered as sculptures by the artist. In an email to the author, August 15, 2014, she said:

> I am primarily a studio-based artist. I make most of the sets, costumes, and props myself. I love this aspect of the project, being alone in my studio fabricating,

working with many different materials, working with my hands. I still use my mother's Kenmore sewing machine that I taught myself to sew on as a child. I only get help when a piece is too unwieldy for me to handle alone or if I am on a deadline I need help meeting. The props and costumes can be quite elaborate, and it often takes quite a bit of time to figure out how to make the costume or prop perform in my intended way, however for me this is the easiest part of the process of making Narcissister work. There is always a practical solution which, with enough trial and error in the studio, can be found.

17 Ibid.

18 The video for the original hit by The Clash was also invested in cross-cultural themes. Its main protagonists are a Hasidic Jew and a Middle Eastern man wearing traditional head covering who maraud around an American town in a convertible, listening to music, drinking beer and carousing.

19 Narcissister email to the author, August 15, 2014.

20 Jo Anna Isaak has written at length about this theme. See Jo Anna Issak, *Feminism and Contemporary Art: The Revolutionary Power of Women's Laughter*, London: Routledge, 1996 and Jo Anna Isaak and Marcia Tucker, *Laughter Ten Years After*, Geneva, New York: Hobart and William Smith Colleges Press, 1995.

21 Zackary Drucker, interview with the author, September 24, 2014.

22 Self, born 1987, lives and works in New York.

23 Colin Self email to the author, August 14, 2014.

24 Nef is also an actor in the Emmy and Golden Globe winning *Transparent* series and part of the feminist collective Milk and Night discussed in Chapter 1 of this book. See www.milkandnight.com/artist-directory/

25 'Post-Drag Collective Chez Deep Present Their Manifesto', *Dazed*, www.dazeddigital.com/artsandculture/article/20993/1/post-drag-collective-chez-deep-present-their-manifesto.

26 *Dazed*, www.dazeddigital.com/artsandculture/article/20993/1/post-drag-collective-chez-deep-present-their-manifesto.

27 See Mary Kelly, *Post-Partum Document Mary Kelly*, London: Routledge & Kegan Paul, 1983 and Sabine Breitwieser, ed., *Rereading Post-Partum Document Mary Kelly*, Vienna: Generali Foundation, 1999; Julia Bryon-Wilson in Stephanie Rosenthal, ed., *Ana Mendiata Traces*, London: Hayward Publishing, 2014; Sharon Irish, *Suzanne Lacy: Spaces Between*, Minneapolis, Univeristy of Minnesota Press, 2010.

28 Colin Self email to the author, August 14, 2014.

29 Del Rey's song is an ode to an Easy Rider-type of lifestyle, with the words "just ride" repeated. The music video shows with her several older men in motel rooms, truck stops, and gas stations. It features groups of Harley riders and the singer being suggestively pushed over a pinball machine from behind.

30 Indeed, one of the members of Chez Deep, Bailey Stiles, speaks of being from Carthage, Missouri, during *Common Vision*.

31 Leo Bersani, 'Shame on You', in Janet Halley and Andrew Parker, ed., *After Sex? On Writing Since Queer Theory*, Durham and London: Duke University Press, 2011, pp. 91–109.

32 For a good discussion of Jack Smith's work see J. Hoberman and Jay O. Sanders, *Rituals of Rented Island: Object Theater, Loft Performance, and the New Psychodrama – Manhatta, 1970–1980*, New York, Whitney Museum of Art, 2013.

33 *Paul Preciado, Testo Junkie: Sex, Drugs, and Biopolitics in the Pharmacopornograhic Era*, New York, The Feminist Press, 2008, p. 79.

34 Colin Self, email to the author, August 14, 2014.

35 Born 1977, Kalup Linzy lives and works in New York.

36 Linzy has spoken of growing up in a trailer in the South and performing a Tina Turner drag at a family party when he was young.

37 Although Linzy's work exists predominately in the art world, he did appear on the soap opera *General Hospital* with collaborator James Franco.

38 'Kalup Linzy Likes It a Little Bit Off', in 'New York Close Up', *Art 21*, http://blog.art21. org/2012/12/21/nycu-kalup-linzy-likes-it-a-little-bit-off/#.U-kSm5VFc20.

39 Ibid.

40 Kalup Linzy, *Romantic Loner*, www.youtube.com, www.youtube.com/watch?v= Pg0ddH3WL8A, accessed December 13, 2015.

41 Preciado, *Testo Junkie*, p. 101.

42 I am thinking here of the Womanhouse practitioners who used themes around the domestic and gendered violence in their work.

43 See Sarah Aranha, 'Funkaesthetics', *C Magazine* no 106, Summer 2010.

44 See Valerie Smith, 'Abundant Evidence: Black Women Artists of the 1960s and 1970s', in Jill Fields, ed., *Entering the Picture: Judy Chicago, The Fresno Feminist Art Program, and the Collective Vision of Women Artists*, New York: Routledge, 2012, pp. 128–129.

45 Uri McMillan, *Embodied Avatars: Genealogies of Black Feminist Art and Performance*, New York: New York University Press, 2015, pp. 2–3.

46 Born Berkeley, CA, Martine Gutierrez obtained BFA 2012, Rhode Island School of Design.

47 Martine Gutierrez in discussion with the author, December 16, 2014.

48 The artist's incredible vision and multi-disciplinary talent doesn't just apply to the visual realm. Guiterrez also makes music and accompanying videos. See the website: www. martine.tv, accessed July 27, 2017.

49 Gutierrez in discussion with the author, December 16, 2014. Recently Gutierrez has become a model, alongside Hari Nef, in a short fashion film for the Spanish brand Camper.

50 http://www.martinegutierrez.com, accessed January 14, 2015.

51 Zackary Drucker is an executive producer on this series while Hari Nef of Chez Deep appears as an actor in season two.

52 Zackary Drucker, interview with the author, September 24, 2014.

53 Martine Gutierrez interview with the author, December 18, 2014.

54 She paints her skin no matter which ethnicity she is posing as: white in *Raquel* and *Luxx*; African American in *Ebony*; Asian in *Mimi*.

55 Gutierrez in discussion with the author, December 18, 2014.

56 Cindy Sherman, 'The Making of Untitled', in David Frankel, ed., *The Complete Untitled Film Stills, Cindy Sherman*, New York: The Museum of Modern Art, 2003, p. 8. For more on Sherman's work see Eva Respini et al., *Cindy Sherman*, New York, The

Museum of Modern Art, 2012; Arthur Danto and Cindy Sherman, *Untitled Film Stills*, New York: Rizzoli, 1990.

57 See José Estaban Muñoz, *Cruising Utopia: The Then and There of Queer Futurity*, New York: New York University Press, 2009.

Five Rewind/Repeat: Reconsidering the Postwar Male Canon in Contemporary Practice

1 This was first published in *Afterimage 20* (Summer 1992) but has since been republished on several occasions: the revised version, including "Postscript," originally appeared in *New Feminist Criticism: Art, Identity, Action,* edited by Joanna Frueh, Cassandra L. Langer, and Arlene Raven, New York: Icon, 1994 and has subsequently been reprinted in *Art, Activism, and Oppositionality: Essays from Afterimage*, edited by Grant Kester, Durham and London: Duke University Press, 1998 and *The Feminism and Visual Cultural Reader*, edited by Amelia Jones, London and New York: Routledge Press, 2003.

2 'In Conversation: Lorraine O'Grady with Jarrett Earnest', *The Brooklyn Rail*, February 3, 2016, http://lorraineogrady.com/wp-content/uploads/2016/02/Brooklyn_Rail_Lorraine_OGrady_with_Jarrett_Earnest.pdf.

3 For original documentation of the work see Judy Chicago, *The Dinner Party, a Symbol of our Heritage*, New York: Doubleday/Anchor Books, 1979.

4 See Sabine Breitwieser, *Carolee Schneemann, Kinetic Painting*, Salzburg: Museum der Moderne/Prestel, 2016, pp. 240–3.

5 Initiatives such as Wiki Project Women are concerned with adding more women artists to Wikipedia have become popular as of late. See https://en.wikipedia.org/wiki/Wikipedia:WikiProject_Women_artists, accessed July 31, 2017.

6 See Douglas Eklund, *The Pictures Generation 1974–1984*, New York: Metropolitan Museum of Art, 2009 for a discussion of these artists.

7 Lucy Lippard, 'Introduction: Moving Targets/Concentric Circles: Notes from the Radical Whirlwind', in *The Pink Glass Swan: Selected Feminist Essays on Art*, New York: The New Press, 1995, p. 17.

8 Jovanovic was born in Belgrade in 1978 and lived in New York between 2005 and 2015. She received her Bachelor of Arts from Tulane University and attended Scuola de Medici in Florence, Italy.

9 Jovanovic returned to Belgrade in 2016; however, the work discussed here was made during her decade of residence in New York City.

10 For a good discussion of 1980s power dressing see Rebecca Arnold, *Fashion, Desire and Anxiety*, London: I.B.Tauris, 2001 and Joanne Entwistle, *The Fashioned Body: Fashion, Dress and Social Theory*, London: John Wiley and Sons, 2015.

11 Marta Jovanovic interview with the author, August 16, 2013.

12 Ibid.

13 Marta Jovanovic website: www.m-art-a.net, accessed August 24, 2013.

14 See 'Rosemarie Castoro In Conversation with Alex Bacon', *The Brooklyn Rail*, October 5, 2015, www.brooklynrail.org/2015/10/art/rosemarie-castoro-with-alex-bacon.

15 Overton was born in Nashville, Tennessee in 1971 and completed her BFA and MFA at the University of Tennessee. She has worked as assistant to Wade Guyton and lives and works in Brooklyn, New York.

16 The Kitchen, located on 19th Street in Chelsea, is a non-profit interdisciplinary organization originally founded as an artist collective in 1971 by Woody and Steina Vasulka. It was originally focused on experimental filmmakers, composers, and performance artists.

17 Mai-Thu Perret and Virginia Overton, 'In Conversation', in *Virginia Overton Deluxe*, Dallas: the Power Station, 2012, pp. 65–6.

18 I'm referring here to works such as Sylvie Fleurie's *Walking on Carl Andre* 1998 and more recently in the exhibition *It Might as Well Rain Until September* 2013, where visitors were invited to don high heels and walk on a Carl Andre floor. Fleury's work looks at the seduction and fetishization of artworks and injects a feminine viewpoint. Overton's is so effective because her viewpoint is equivocal.

19 Marianne Vitale is another artist whose work uses construction and found materials, though with more of a narrative twist than Overton's.

20 Cindy Hinant in discussion with the author, July 27, 2012.

21 On the relationship between television and conceptual art, see Dan Graham, TV Producer as Conceptual Artist (2018), an installation at Greene Naftali gallery from May 19 to June 16, 2018.

22 In the exhibition *Materializing Six Years: Lucy R. Lippard and the Emergence of Conceptual Art* at the Brooklyn Museum of Art (September 14, 2012–February 17, 2013) there was a vitrine with several of these cards that were sent to the art critic during this period. See Catherine Morris, ed., *Materializing Six Years: Lucy R. Lippard and the Emergence of Conceptual Art*, Cambridge: MIT Press, 2012. I am also indebted to Dan Graham for a conversation about the humor in Kawara's postcard series.

23 See Peggy Phelan, 'Survey', in Helena Rickett and Phelan, eds, *Art and Feminism*, London: Phaidon, pp. 29–30.

24 See Wouter Davidts & Kim Paice (eds), *The Fall of the Studio: Artist at Work*, Amsterdam: Valiz, 2009; Mary Jane Jacob and Michelle Grabner (eds), 'Introduction' in *The Studio Reader: On the Space of Artists*, Chicago; London: University of Chicago Press, 2010, pp. 1–14; Daniel Buren, 'The Function of the Studio', *October*, no. 10, Fall 1979; Caroline Jones, A. *Machine in the Studio: Constructing the Postwar American Artist*, Chicago: University of Chicago Press, 1996.

25 Coco Fusco, 'We Wear the Mask' (1998), in Hilary Robinson, ed., *Feminism-Art-Theory*, Oxford: Blackwell Publishers, 2001, p. 432.

26 Hinant email to the author, July 27, 2013. Hinant worked as Dan Graham's assistant for several years.

27 See Nicholas Bourriaud, *Relational Aesthetics*, Paris: Presse du reels, 2002. Hinant titled her solo show at Joe Sheftel Gallery in New York Aesthetic Relations as a pun on this so-called movement.

28 Hinant in conversation with the author, July 27, 2012.

29 See www.thewhitereview.org/art/redressing-the-balance-women-in-the-art-world/, accessed July 29, 2013.

30 Cindy Hinant, email to the author, July 27, 2013.

31 See Phelan, 'Art & Feminism', p. 149.

32 Amelia Jones, in 'Art & Feminism, Nine Views', *Artforum*, October 2003, p. 143.

33 An interesting example of this is the F-Word, a documentary directed by Robert Adanto, which features the work of what he terms Fourth-Wave feminists, including many of Hinant's generation. When screened at the SVA cinema in New York, much discussion revolved around the director, a straight white male, presenting his view of radical feminist aesthetics today. See www.thef-wordflick.com for trailer and press response to this film.

34 Catherine Elwes made a work about this called *A Plain Woman's Guide to Her First Performance* in 1979 in London. See Kathy Battista, 'Catherine Elwes', *Luxonline.org.uk*, www.luxonline.org.uk/artists/catherine_elwes/(printversion).html.

35 Meyohas, born 1991, graduated from Yale with a MFA in Photography in 2015.

36 Katie Booth, 'New York City Artist Launches BitchCoin, a Virtual Currency', *Women In The World in association with New York Times*, March 17, 2015, http://nytlive.nytimes.com/womenintheworld/2015/03/17/bitchcoin-the-new-crypto-currency-backed-by-the-artist-herself/, accessed October 10, 2015.

37 See Sabine Breitwieser, ed., *Andrea Fraser*, Osfildern: Hatje Cantz Verlag, 2015.

38 See David Joselit, *Infinite Regress: Marcel Duchamp 1910–1941*, Camridge: Massachusetts Institute of Technology, 1998, pp. 97–8.

39 See Noah Horowitz, *The Art of the Deal: Contemporary Art in a Global Financial Market*, Princeton: Princeton University Press, 2014 (2011) for an excellent discussion on video and conceptual art and the market.

Bibliography

Adams, Parveen and Elizabeth Cowie. *m/f: The Woman in Question*. London: Verso, 1990.

'Anya Kielar Shapes Art to Time', *Zing Magazine*, February 2014, www.zingmagazine.com/drupal/node/35956.

Arnold, Rebecca. *Fashion, Desire and Anxiety*. London: I.B.Tauris, 2001.

Ault, Julie. *Alternative Art New York 1965–1985*. Minneapolis: University of Minnesota Press and New York: The Drawing Center, 2002.

Baca, Judith and Suzanne Lacy interviewed by Lynn Hershman in 1990, *!Women Art Revolution*, Stanford Libraries, https://lib.stanford.edu/women-art-revolution/transcript-interview-judith-baca-suzanne-lacy.

Battista, Kathy. *Renegotiating the Body: Feminist Art in 1970s London*. I.B.Tauris: 2012.

———. 'Other People and Their Ideas: RoseLee Goldberg', *ArtReview*, January 2016, pp. 60–3.

———. 'Domestic Crisis: Women Artists and Derelict Houses in London 1974–1998', in Ken Ehrlich, Brandon LaBelle, Steven Vitiello, eds. *Surface Tension: Problematics of Site*, Errant Bodies, 2007, pp. 107–16.

———. 'Catherine Elwes', *Luxonline.org.uk,* www.luxonline.org.uk/artists/catherine_elwes/(printversion).html.

Batty, David. 'Tino Sehgal Wins Golden Lion for Best Artist at Venice Biennale', *Guardian*, June 1, 2013, www.theguardian.com/artanddesign/2013/jun/01/tino-sehgal-golden-lion- best-artist.

Baumgardner, Julie. 'How Performance Art Entered the Mainstream', *Artsy*, November 3, 2015, www.artsy.net/article/artsy-editorial-how-performance-art-entered-the-mainstream, accessed May 29, 2017.

Berger, Maurice. *Adrian Piper: A Retrospective*, Baltimore: UMBC, 1999.

Bersani, Leo. 'Shame on You', in Janet Halley and Andrew Parker, eds, *After Sex? On Writing Since Queer Theory*, Durham and London: Duke University Press, 2011, pp. 91–109.

Bolotin, Susan. 'Voices from the Post-Feminist Generation', *New York Times*, October 17, 1982.

Booth, Katie. 'New York City Artist Launches BitchCoin, a Virtual Currency', *Women In The World in association with New York Times*, March 17, 2015, http://nytlive.nytimes.com/womenintheworld/2015/03/17/bitchcoin-the-new-crypto-currency-backed-by-the-artist-herself/.

Bourriaud, Nicholas. *Relational Aesthetics*. Paris: Presse du reels, 2002.

Breitwieser, Sabine, ed. *Simone Forti: Thinking With the Body*. Salzburg: Museum der Moderne and Hirmer, 2014.

————. *Carolee Schneemann, Kinetic Painting*. Salzburg: Museum der Moderne/Prestel, 2016.

————. *Rereading Post-Partum Document Mary Kelly*. Vienna: Generali Foundation, 1999.

————. *Andrea Fraser*. Osfildern: Hatje Cantz Verlag, 2015.

Brooks, Katherine. 'Five Women are Setting the Stage for A Future Feminism', *The Huffington Post*, September 5, 2014, www.huffingtonpost.com/2014/09/05/future-feminism_n_5769356.html.

Brougher, Kerry and Philippe Vergne. *Yves Klein with the Void, Full Powers*. Washington: Hirshhorn Museum and Sculpture Garden and Minneapolis: Walker Center, 2010.

Burris, John. 'Did the Portapak Cause Video Art? Notes on the Formation of a New Medium', *Millennium Film Journal*, Volume 29, 1996, pp. 3–28.

Buren, Daniel. 'The Function of the Studio', *October*, no. 10, Fall 1979, pp. 51–58.

Butler, Judith. *Gender Trouble, Feminism and the Subversion of Identity*, London: Routledge, 1990.

Calirman, Claudia. *Art Under the Dictatorship: Antonio Manual, Artur Barrio, Cildo Meirieles*. Durham: Duke University Press, 2012.

Campkin, Ben. 'Placing Matter Out of Place: Purity and Danger as Essence for Architecture and Urbanism', *Architectural Theory Review* 18:1, 2013, pp. 46–61.

Chan, Audrey, Alexandra Grant, and Elana Mann. 'Rupture and Continuity in Feminist Re-performance', *Afterall*, Issue 33, Summer 2013: 38–45.

Chicago, Judy. *Institutional Time: A Critique of Studio Art Education*. New York: Monacelli Press, 2014.

————. *The Dinner Party, a Symbol of our Heritage*. New York: Doubleday/Anchor Books, 1979.

Clements, Alexis. 'Past, Present and Future Feminism', *Hyperallergic*, September 19, 2014, http://hyperallergic.com/149699/past-present-and-future-feminism/.

Cotter, Holland. 'In the Naked Museum: Talking, Thinking, Encountering', *New York Times*, January 31, 2010, C1.

Daderko, Dean. 'K8 Hardy: Positions Series', *Pastelegram*, September 23, 2011, http://pastelegram.org/reviews/54.

————. 'Upside Down, Left to Right', in *LaToya Ruby Frazier: Witness*, Houston: Contemporary Arts Museum Houston, 2013: 6.

Danto, Arthur and Cindy Sherman, *Untitled Film Stills*. New York: Rizzoli, 1990.

Davidts, Wouter and Kim Paice, eds. *The Fall of the Studio: Artist at Work*. Amsterdam: Valiz, 2009.

Day, Corinne. *Diary* , Munich: Kruse Verlag, 2000.

de Zegher, Catherine, ed., *Martha Rosler: Positions in the Life World*, Birmingham, England: Ikon Gallery, 1998.

Dickerman, Leah, ed., *Dada*. Paris: Centre Pompidou, 2006.

Dieckvoss, Stephanie. 'When Artists Take on the Market', *Apollo*, May 2017, www.apollo-magazine.com/when-artists-take-on-the-art-market/.

Donegan, Cheryl, 'Backstage at K8 Hardy's Untitled Runway Show at the Whitney Museum of Art, 5/20/2012', in K8 Hardy and Dorotheé Perret, eds. *K8 Hardy How To: Untitled Runway Show*. Paris: DoPe Press, 2013, p. 41.

Douglas Mary. *Purity and Danger, An Analysis of the Concepts of Pollution and Taboo*. London: Routledge, 1966 (2003).

Dunn, Catherine, Beth Kowitt, Colleen Leahy, and Anne Vandermey. 'The 50 Most Powerful Women', *Fortune,* October 28, 2013, pp. 59–67.

Eberstadt, Fernanda. 'Twisted Sisters', *New York Times*, July 6, 2008, www.nytimes.com/2008/07/06/magazine/06cocorosie-t.html?pagewanted=all&_r=0.

Egan, Mary Ellen. 'Top Paid Female Executives', *Forbes.com*, www.forbes.com/2010/04/27/
ceo-salaries-bonuses-global-companies-forbes-woman-leadership-boss-10-top-paid-
female-chief-executives.html, accessed August 20, 2013.

Ehrenreich, Barbara and Arlie Hochschild, eds. *Global Woman: Nannies, Maids, and Sex Workers
in the New Economy*. New York: Holt Paperbacks, 2004.

Eklund, Douglas. *The Pictures Generation 1974–1984*. New York: Metropolitan Museum of
Art, 2009.

Elderton, Louisa. 'Redressing the Balance: Women in the Art World', *The White Review*,
www.thewhitereview.org/art/redressing-the-balance-women-in-the-art-world/.

Entwistle, Joanne. *The Fashioned Body: Fashion, Dress and Social Theory*. London: John Wiley and
Sons, 2015.

Farago, Jason. 'Isa Genzken and Women Artists: Defying the Boys Club', *BBC Culture*, 12
November, 2013, www.bbc.com/culture/story/20131112-the-art-worlds-glass-ceiling.

Fateman, Johanna. 'Women on the Verge', *Artforum*, April 2015, p. 219.

Forbes, Alexander. 'Women Artists Benefit from Art Market
Woes', *Artsy*, October 5, 2016, www.artsy.net/article/
artsy-editorial-at-frieze-women-artists-benefit-from-art-market-woes.

Ford, Simon. *Wreckers of Civilization: The Story of Coum Transmissions and Throbbing Gristle*.
London: Black Dog Publishing, 1999.

Frank, Alex. 'Interview with K8 Hardy', *The Fader*, www.thefader.com/2012/03/08/
interview-k8-hardy/.

Frank, Priscilla. 'Feminist Artist's *How to Undress In Front Of Your Husband* Skewers Retro
Mansplaining', *Huffington Post*, March 24, 2017, www.huffingtonpost.com/entry/nadja-
marcin-feminist-art_us_58d2cc4fe4b0b22b0d19448f, accessed May 29, 2017.

Frazier, LaToya Ruby. 'Statement', at www.latoyarubyfrazier.com/statement/

Frazier, LaToya Ruby, Lindquist, Greg, and Schultz, Charles, *The Brooklyn Rail*, July 15, 2013.

Frueh, Joanna, Cassandra L. Langer, and Arlene Raven, eds. *New Feminist Criticism: Art,
Identity, Action*. New York: Icon, 1994

Fusco, Coco, 'We Wear the Mask' (1998), in Hilary Robinson, ed., *Feminism-Art-Theory*,
Oxford: Blackwell Publishers, 2001, pp. 430–2.

Fusco, Coco and Brian Wallis, eds. *Only Skin Deep: Changing Visions of the American Self*.
New York: Abrams and the International Center of Photography, 2003.

Gingeras, Alison M. 'Ella Kruglyanskaya: Women's Studies', in *Ella Kruglyanskaya*, London: Studio
Voltaire and Koenig Books, 2014, p. 10.

Glimcher, Mildred. *New York: Happenings 1958–63*. New York: Monacelli Press, 2012.

Goldberg, RoseLee. *Performance Art: From Futurism to Present*. London: Thames and Hudson,
2011 [1979].

Goldin, Nan, David Armstrong and Hans Werner Holzwarth, eds. *I'll Be Your Mirror: Nan Goldin*.
New York: Scalo and New York: The Whitney Museum of American Art, 1996.

Grant, Catherine. 'Fans of Feminism: Re-writing Histories of Second-wave Feminism in
Contemporary Art', *Oxford Art Journal* 34.2, 2011, pp. 265–286.

Green, Penelope. 'Please, Don't Feed the Artist: Dawn Kasper at the Whitney Biennial',
New York Times, April 25, 2012, D1.

Greer, Germaine. *The Female Eunuch*. London: Flamingo Modern Classic, 1993 [1970].

Halley, Janet and Andrew Parker, eds. *After Sex? On Writing Since Queer Theory*. Durham and
London: Duke University Press, 2011.

Haraway, Donna. 'A Cyborg Manifesto: Science, Technology, and Socialist-Feminism in the Late Twentieth Century', in *Simians, Cyborgs and Women: The Reinvention of Nature*, New York: Routledge, 1991, pp. 149–181.

Heartley, Eleanor. 'Eco-Feminism Revisited', *The Brooklyn Rail*, November 5, 2015, http://brooklynrail.org/2015/11/criticspage/eco-feminism-revisited.

Hershman Leeson, Lynn. 'Transcript of Interview with the Guerrilla Girl Kathe Kollwitz', Stanford Digital Files, July 27, 2006, http://lib.stanford.edu/women-art-revolution/transcript-interview-kathe-kollwitz.

Heyward, Anna. 'The Price of Being a Woman Artist', *ArtNews*, December 22, 2014, www.artnews.com/2014/12/22/the-price-of-being-a-woman-artist/.

Hickey, Dave. 'In the Dancehall of the Dead', in Karen Marta, ed. *Robert Gober: Dia Center for the Arts*. New York: Dia Center for the Arts, 1993, pp. 7–61.

Higgins, Charlotte. 'Das Kapital at the Arsenale: How Okwui Enwezor Invited Marx to the Biennale', *Guardian*, May 7, 2015, www.theguardian.com/artanddesign/2015/may/07/das-kapital-at-venice-biennale-okwui-enwezor-karl-marx.

Higgs, Matthew and Paul Noble. *Protest & Survive*. London: Whitechapel Gallery, 2000.

Hoban, Phoebe. 'The Feminist Evolution', *ArtNews*, December 2009, pp. 84–89.

Hoberman, J. and Jay O. Sanders. *Rituals of Rented Island: Object Theater, Loft Performance, and the New Psychodrama—Manhattan, 1970–1980*. New York: Whitney Museum of Art, 2013.

Irish, Sharon. *Suzanne Lacy: Spaces Between*. Minneapolis: University of Minnesota Press, 2010.

Isaak, Jo Anna. *Feminism and Contemporary Art: The Revolutionary Power of Women's Laughter*. London: Routledge, 1996.

Isaak, Jo Anna and Marcia Tucker. *Laughter Ten Years After*. Geneva, New York: Hobart and William Smith Colleges Press, 1995.

Jacob, Mary Jane and Michelle Grabner, eds. *The Studio Reader: On the Space of Artists*. Chicago: University of Chicago Press, 2010.

Jones, Caroline A. *Machine in the Studio: Constructing the Postwar American artist*. Chicago: University of Chicago Press, 1996.

Jones, Amelia, ed. *The Feminism and Visual Culture Reader*. London: Routledge, 2003.

———. *Body Art: Performing the Subject*. Minneapolis: University of Minnesota Press, 1998.

———. *Sexual Politics: Judy Chicago's "Dinner Party" in Feminist Art History*. Berkeley: University of California Press and Los Angeles: UCLA at the Armand Hammer Museum of Art and Cultural Center, 1996.

———. 'Art & Feminism, Nine Views', *Artforum*, October 2003: 143.

Joselit, David, Baker, George, Portis, Ben, and Cooke, Lynne. *Robert Whitman, Playback*. New York: Dia Foundation, 2003.

———. *Infinite Regress: Marcel Duchamp 1910–1941*. Cambridge: Massachusetts Institute of Technology, 1998.

'K8 Hardy by Ariane Reines', *Bomb*, April 1, 2012, https://bombmagazine.org/articles/k8-hardy/.

'Kalup Linzy Likes It a Little Bit Off', in 'New York Close Up', *Art 21*, http://blog.art21.org/2012/12/21/nycu-kalup-linzy-likes-it-a-little-bit-off/#.U-kSm5VFc20.

Kavka, Misha. 'Feminism, Ethics, and History, or What is the "Post" in Postfeminism?', in *Tulsa Studies in Women's Literature*, Vol 21, No 1, University of Tulsa, Spring, 2002, pp. 29–44.

Kelley, Mike, interviewed by Lynn Hershman Leeson, July 27, 2006, http://lib.stanford.edu/ files/WAR_kelley.pdf.

Kelly, Mary. *Post-Partum Document Mary Kelly*. London: Routledge & Kegan Paul, 1983.

Kester, Grant, ed. *Art, Activism, and Oppositionality: Essays from Afterimage*. Durham and London: Duke University Press, 1998

Kristeva, Julia. 'Powers of Horror', in Charles Harrison and Paul Wood, eds. *Art in Theory 1900–2000 An Anthology of Changing Ideas*. Malden, MA: Blackwell Publishing, 1993, p. 1138.

Lacy, Suzanne. *Leaving Art: Writings on Performance, Politics, and Publics 1974–2007*. Duke University Press, 2010.

Lebovici, Elisabeth. 'Interview with VALIE EXPORT', in *VALIE EXPORT Summary*. Montreuil: Editions De L'Oeil, 2003, pp. 148–149.

Leeson, Lynn Hershman. 'Transcript of Interview with the Guerrilla Girl Kathe Kollwitz', Stanford Digital Files, July 27, 2006, http://lib.stanford.edu/women-art-revolution/ transcript-interview-kathe-kollwitz, accessed August 16, 2013.

Livingstone, Marco. *Jim Dine, The Alchemy of Images*. New York: Monacelli Press, 1998.

Linzy, Kalup. *Romantic Loner*, www.youtube.com, www.youtube.com/watch?v=Pg0ddH3WL8A.

Lippard, Lucy. *The Pink Glass Swan: Selected Feminist Essays on Art*. New York: The New Press, 1995.

Lovelace, Carey. 'A Feast of Feminist Art', *Ms Magazine*, Fall 2004, www.msmagazine.com/ fall2004/feministart.asp.

Maloney, Jennifer. 'Auction House Enters the Digital World', *Wall Street Journal*, September 23, 2013, http://online.wsj.com/article/SB10001424052702304713704579091192929676 208.html.

Marcus, Sara. *Girls to the Front: The True Story of the Riot Grrrl Revolution*. New York: Harper Collins, 2010.

Mason, Rachel. 'Dawn Kasper', *art21*, October 4, 2011, http://blog.art21.org/2011/10/04/ dawn-kasper/#.U_I17pVFc20.

McGarry, Kevin. 'At the 2015 New Museum Triennial: A High Tech Take On Nude Sculpture', *The New York Times magazine*, February 24, 2015, http://tmagazine.blogs. nytimes.com/2015/02/24/frank-benson-new-museum-triennial/?_r=0

McMillan, Uri. *Embodied Avatars: Genealogies of Black Feminist Art and Performance*. New York: New York University Press, 2015.

Messinger, Kate. 'The Hole and Sensei Galleries Redefine the F-Word—Feminism', *Observer*, September 19, 2014, http://observer.com/2014/09/ the-hole-and-sensei-galleries-redefine-the-f-word-feminism/.

Meyer, Laura. 'From Finish Fetish to Feminism: Judy Chicago's *Dinner Party* in California Art History', in Amelia Jones, ed., *Sexual Politics: Judy Chicago's "Dinner Party" in Feminist Art History*. Berkeley: University of California Press and Los Angeles: UCLA at the Armand Hammer Museum of Art and Cultural Center, 1996, pp. 46–74.

Miller, Lisa. 'The Trans-Everything CEO', *New York*, September 7, 2014, pp. 8–21.

Mohseni, Yasmine. 'Beyond the White Cube: Dawn Kasper's Studio Within a Museum', *Huffington Post*, May 21, 2012, www.huffingtonpost.com/yasmine-mohseni/beyond-the-white-cube-cha_b_1456252.html.

Moi, Toril. *Sexual/Textual Politics: Feminist Literary Theory*. London: Routledge, 2002.

Mondloch, Kate. 'The *Difference* Problem: Art History and the Critical Legacy of 1980s Theoretical Feminism', *Art Journal*, Vol 71, No 2, Summer 2012: 18–31.

Morgan, Olivia and Karen Skelton, eds. *The Shriver Report: A Woman's Nation Pushes Back from the Brink*. New York: Palgrave Macmillan, 2014.

Morris, Catherine, *We Wanted a Revolution: Black Radical Women 1965–1985/A Sourcebook*. New York: The Brooklyn Museum, 2017.

———, *Materializing Six Years: Lucy R. Lippard and the Emergence of Conceptual Art*. Cambridge: MIT Press, 2012.

Morris, Catherine and Rujeko Hockley. *We Wanted a Revolution: Black Radical Women 1965–85 A Sourcebook*. New York: Brooklyn Museum of Art/Duke University Press, 2017.

Müller, Hans-Joachim. *Harald Szeemann Exhibition Maker*. London: Hatje Cantz, 2006.

———, *When Attitudes Become Form*, Milan: Prada Foundation, 2013.

Muñoz, José Estaban. *Cruising Utopia: The Then and There of Queer Futurity*. New York: New York University Press, 2009.

Nash, Mark. 'Arena Film Program', in Luz Gyalui, ed. *All the World's Futures*. Venice: Fondazione La Biennale di Venezia, 2015: 124–5.

Next Time media conference, November 17, 2013: www.next-time.info.

Nochlin, Linda. 'Why Have There Been No Great Women Artists', (1971), in Amelia Jones, ed. *The Feminism and Visual Culture Reader*. London: Routledge, 2003, pp. 229–33.

———. 'Feminism and Art: Nine Views', *Artforum*, October 2003, p. 141–9.

O'Grady, Lorraine. 'Olympia's Maid: Reclaiming Black Subjectivity', in Amelia Jones, ed., *The Feminism and Visual Culture Reader*, London: Routledge, 2010, pp. 174–186.

Parker, Rozsika and Griselda Pollock. *Old Mistresses: Women, Art and Ideology*. London: Pandora, 1981.

Peck, Emily. 'The Pay Gap At The Top of Corporate America Is Not What You Think', *Huffington Post*, May 10, 2016, www.huffingtonpost.com/entry/women-ceo-gender-pay-gap_us_57322688e4b016f378974931.

Perret, Mai-Thu and Virginia Overton. 'In Conversation', in *Virginia Overton Deluxe*, Dallas: The Power Station, 2012, pp. 65–66.

Perron, Wendy. 'Simone Forti: bodynatureartmovementbody', in Ninotchka Bennahum, Wendy Perron, and Bruce Robertson, eds. *Radical Bodies: Anna Halprin, Simone Forti, and Yvonne Rainer in California and New York, 1955–1972*. Santa Barbara: Art, Design & Architecture Museum, University of California, 2017, pp. 107–11.

Phelan, Peggy. 'Art & Feminism, Nine Views', *Artforum*, October 2003, p. 149.

Piejko, Jennifer, ed., *Performa 11 Staging Ideas*. New York: Performa Publications, 2013.

Poggio, Marco. 'Brooklyn Museum Taps Woman To Head The Cultural Institution; First Time In Its 200-Year History', *NY Daily News*, June 29, 2014, www.nydailynews.com/new-york/woman-head-brooklyn-museum-article-1.1847332.

Pogrebin, Robin. 'Elizabeth A. Sackler to lead Brooklyn Museum Board', *New York Times*, June 26, 2014, http://artsbeat.blogs.nytimes.com/2014/06/26/elizabeth-a-sackler-to-lead-brooklyn-museum-board/?_php=true&_type=blogs&_r=0.

'Post-drag Collective Chez Deep Present Their Manifesto', *Dazed*, www.dazeddigital.com/artsandculture/article/20993/1/post-drag-collective-chez-deep-present-their-manifesto.

Powers, Ann. 'Anthony's Future Feminism: Stage Banter as Statement of Purpose', NPR, August 7, 2012, www.npr.org/blogs/therecord/2012/08/06/158237793/antonys-future-feminism-stage-banter-as-statement-of-purpose.

Preciado, Paul. *Testo Junkie: Sex, Drugs, and Biopolitics in the Pharmacopornograhic Era.* New York: The Feminist Press, 2008.

Princenthal, Nancy. *Hannah Wilke*, Munich: Prestel, 2010.

'Rachel Mason Performs Paul Rand's 13 Hour Filibuster As a FutureClown', *Huffington Post*, July 11, 2013. www.huffingtonpost.com/2013/07/11/rachel-mason-rand-paul-13-hour-filibuster-futureclown-video-interview_n_3573780.html?utm_hp_ref=arts.

Rachleff, Melissa. *Inventing Downtown: Artist Run Galleries in New York 1952–65.* New York: Prestel, 2017.

Rahmani, Aviva. 'Practical Ecofeminism', in Karen Frostig and Kathy A. Halamka, eds. *Blaze: Discourse on Art, Women and Feminism.* Newcastle Upon Tyne: Cambridge Scholars Association, 2009, pp. 315–332.

Rainer, Yvonne. *A Woman Who… Essays, Interviews, Scripts.* Baltimore: Johns Hopkins University Press, 1999.

Reckitt, Helena and Peggy Phelan, eds. *Art and Feminism.* London: Phaidon, 2001.

Respini, Eva, Sherman, Cindy, and Burton, Johanna. *Cindy Sherman.* New York: The Museum of Modern Art, 2012.

'Rosemarie Castoro In Conversation with Alex Bacon', *The Brooklyn Rail*, October 5, 2015, www.brooklynrail.org/2015/10/art/rosemarie-castoro-with-alex-bacon.

Rosenthal, Stephanie, ed. *Ana Mendieta, Traces*, London: Hayward Gallery, 2014.

Rosler, Martha. *Decoys and Disruptions: Selected Writings, 1975–2001.* Cambridge: The MIT Press, 2004.

Roth, Moira. 'Teaching Modern Art History from a Feminist Perspective: Challenging Conventions, my Own and Others' (1987), in Hilary Robinson, ed. *Feminism-Art-Theory.* Oxford: Blackwell Publishers, 2001, pp. 139–46.

Roundtable discussion with Sabine Breitwieser, Julie Martin, Robert Whitman, Kathy Battista, in Breitwieser, ed., *E.A.T. Experiments in Art and Technology.* Salzburg: Museum der Moderne Salzburg, 2015.

Saltz, Jerry. 'Where are all the Women?', *New York*, November 18, 2007, http://nymag.com/arts/art/features/40979/

Schimmel, Paul. 'Leap into the Void', in *Out of Actions Between Performance and the Object 1949–79.* Los Angeles: The Museum of Contemporary Art Los Angeles, 1998.

Schjeldahl, Peter. 'Women's Work', *The New Yorker*, April 9, 2007.

Sherman, Cindy. 'The Making of Untitled', in David Frankel, ed. *The Complete Untitled Film Stills, Cindy Sherman.* New York: The Museum of Modern Art, 2003, pp. 4–16.

Simpson, Bennett and Chrissie Iles. *Dan Graham: Beyond.* Los Angeles: Museum of Contemporary Art, 2009.

Smith, Barbara. 'Feed Me 1973', performance notes, unpaginated, 2012.

Smith, Roberta. 'Art or Ad or What? It caused a lot of fuss', *New York Times*, July 24, 2009, www.nytimes.com/2009/07/25/arts/design/25benglis.html?_r=.

———. 'Art in Review: Anya Kielar', *New York Times*, April 6, 2007, http://query.nytimes.com/gst/fullpage.html?res=9C02E5DB173FF935A35757C0A9619C8B63, accessed July 22, 2013.

————. 'They are Artists Who are Women: Hear them Roar', *New York Times*, March 23, 2007, www.nytimes.com/2007/03/23/arts/design/23glob.html?pagewanted=all&_r=0.

Smith, Valerie. 'Abundant Evidence: Black Women Artists of the 1960s and 1970s', in Jill Fields, ed., *Entering the Picture: Judy Chicago, The Fresno Feminist Art Program, and the Collective Vision of Women Artists*. New York: Routledge, 2012, pp. 119–31.

Soroff, Amanda. 'Mika Rottenberg', in Luz Gyalui, ed. *All the World's Futures*. Venice: Fondazione La Biennale de Venezia, 2015, pp. 92–3.

Spence, Jo. *Cultural Sniping: The Art of Transgression*. London: Routledge, 1995.

Tucker, Marcia, interviewed by Lynn Hershman Leeson, July 2006,*!Women Art Revolution* pamphlet, 2010, p. 27.

Viso, Olga. *Ana Mendieta: Earth Body*. Berlin: Hatje Cantz, 2004.

Wark, Jane. *Radical Gestures, Feminism and Performance Art in North America*. McGill: Queen's University Press, 2006.

Warr, Tracey, ed. *The Artist's Body*. London: Phaidon, 2006.

Weil, Harry J. 'Old Themes New Variations: The Work of Kate Gilmore', *Afterimage*, 39.3, p. 7.

Westcott, James. 'Marina Abramovic's The House with the Ocean View', *Critical Acts*, MIT Press, Vol 47, No 3, Autumn 2003, pp. 129–136.

Westen, Mirjam. '*Rebelle*, Introduction', in *Rebelle Art & Feminism 1969–2009*. Arnhem: Museum voor Moderne Kunst Arnhem, 2009, p. 13.

'Why Should Paintings by Women Artists Sell for Less', *Business Think*, published by UNSW Business School, June 2016, www.businessthink.unsw.edu.au/Pages/why-should-paintings-by-female-artists-sell-for-less.aspx.

Wilson, Martha, ed., *Martha Wilson Sourcebook, 40 Years of Reconsidering Performance, Feminism, Alternative Spaces*, New York: Independent Curators International, 2011.

Wolff, Rachel. 'The Biennial's Breakout Star', *The Daily Beast*, February 25, 2010, www.thedailybeast.com/articles/2010/02/25/the-biennials-breakout-star.html.

Youdelman, Nancy and Karen LeCocq. 'Reflections on the First Feminist Art Program', in Jill Fields, ed. *Entering the Picture: Judy Chicago, The Fresno Feminist Art Program and the Collective Visions of Women Artists*. New York: Routledge, 2012, pp. 65–77.

Websites

www.bbk.ac.uk/arts/research/photography/the-jo-spence-memorial-library-terry-dennett-collection.

www.brainstormersreport.net.

www.ggtakeover.com.

www.guerrillagirls.com.

www.m-art-a.net.

www.martinegutierrez.com.

www.whitneyhoustonbiennial.com.

https://en.wikipedia.org/wiki/Wikipedia:WikiProject_Women_artists.

Index

Numbers in **bold** refer to figures.

THE ART OF
FULLMETAL ALCHEMIST™

Hiromu Arakawa

2001
2002
2003

VIZ Media
San Francisco

Hiromu Arakawa

0'3 0'2 0'1

THE ART OF FULLMETAL ALCHEMIST™

CONTENTS

ALCHEMIST
2002.3

Chapter 1

FULLMETAL 2001.5

Hiromu Arakawa

This chapter focuses on the beginning of the manga series, from its first appearance in Square Enix's monthly magazine **Shonen Gangan** in August 2001 through March 2002. These illustrations were produced roughly around the same time as manga volumes 1-2.

at all when it was printed.

カラー　2P.3P.　見開き

I mixed pepper into the paint to achieve the texture of the bricks, but I was disappointed to see that the bumpiness did not come through

表紙 カラー

2001.05.25 あらかわ

I was asked to just do something in color, so I did this one in a rush with some 12-color acrylic paints that I had lying around.

Al's loincloth was really deep blue in the beginning, wasn't it?

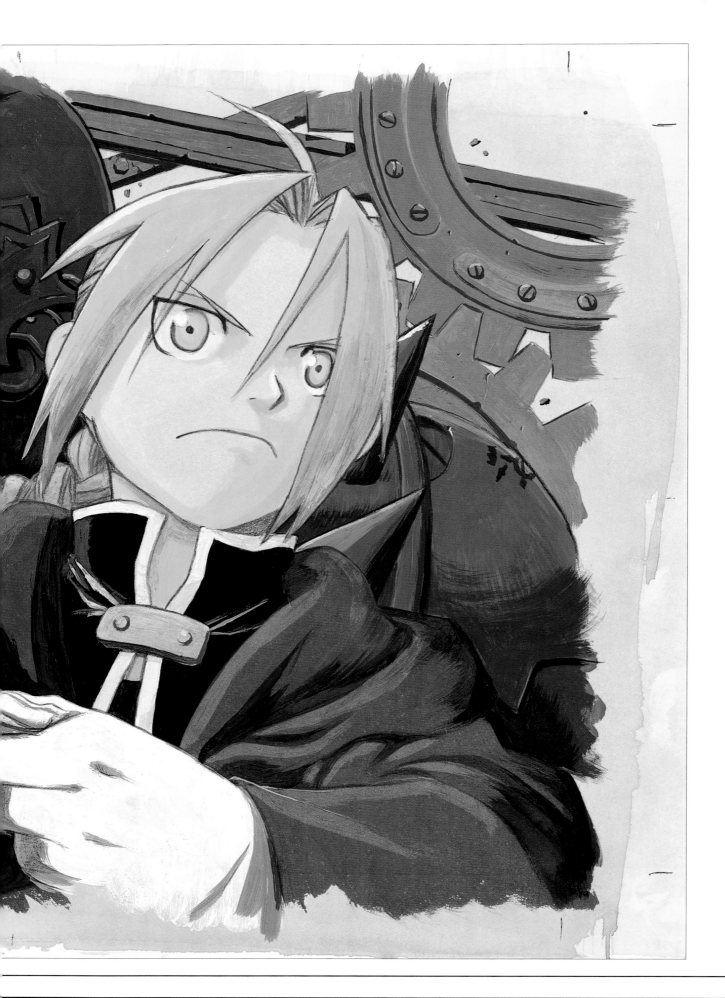

カバー

2001.12

Apparently there were some people who saw the cover for volume 1 and bought it because they thought it was a "mecha" comic.

I like the way Al was painted. Actually, after I finished painting Al I was already completely worn out.

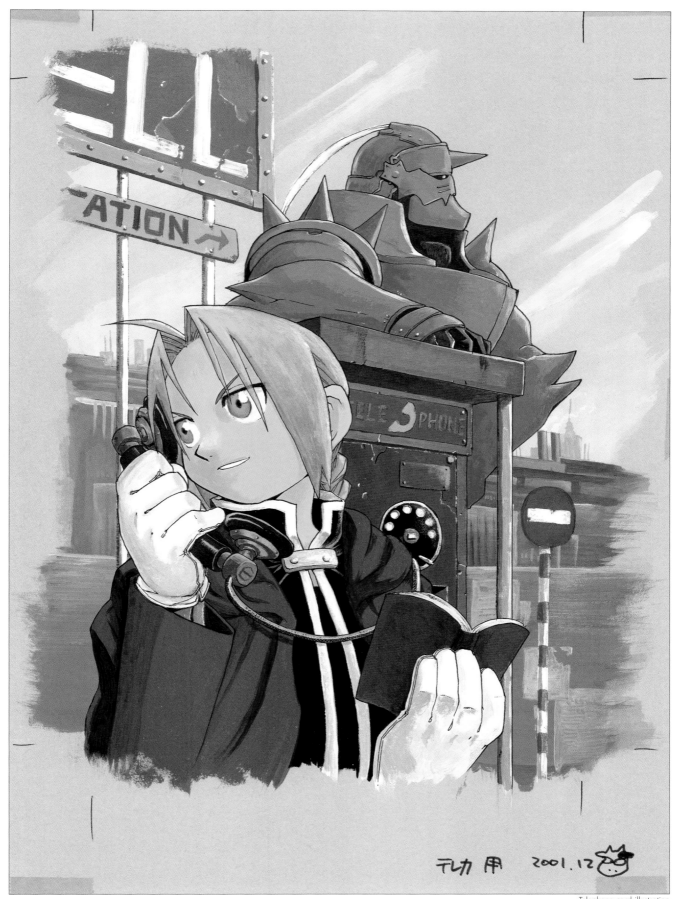

Telephone card illustration

This was for a telephone card, so I decided to use a telephone theme. Ed's outline expanded as I layered the colors.

So this was the final result.

2巻カバー

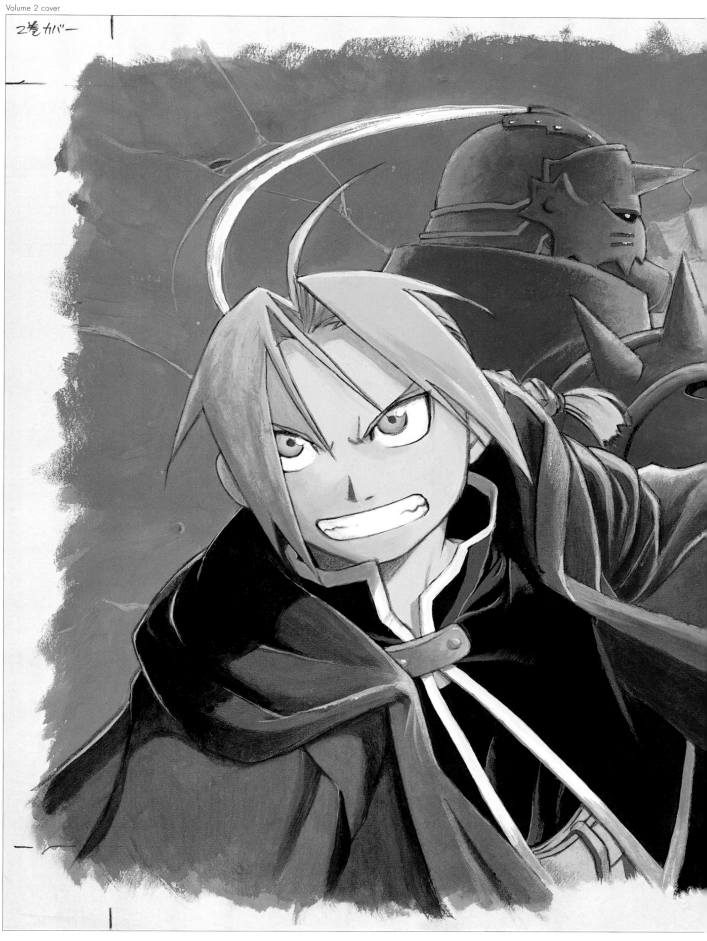

I had planned to put Al by himself on the cover of volume 2, but my editor said, "No one's gonna know what kind of manga it is...."

2巻 おまけ ポストカード用

2002.4.8

For the special postcard for volume 2

They sent this one back to me because I made some English spelling mistakes. But somehow I was able to fix it.

There are a lot of mistakes on this one.

Oil can (left): **One wipe is all it takes!** (right): **Even polishes armor!**

2002.3.3 Arakawa

2002.3.3

Red and blue. Hot and cold.

I always forget to paint the string that ties Ed's hair.

ALCHEMIST
2003.3

Chapter 2
FULLMETAL
2002.4
Hiromu Arakawa

This chapter focuses on the illustrations drawn from Spring 2002 to March 2003.
This is roughly the same time as manga volumes 3-4.
At this time a number of products were produced, such as novels, CDs and calendars.

2002.4.8

I think it was around this time that I was unable to continue with the basic 12-color acrylic paints, so I started to use Liquitex.

25 FULLMETAL ALCHEMIST ✛ Hiromu Arakawa
2002.4 — 2003.3

2002. 5

Blue.

Telephone card illustration

I love the phrase *yuruginai shinrai* (unbreakable bonds). Friends, comrades in arms, partners, lovers, family, etc....There are certain bonds between people that can't be expressed in words.

I like group pictures because they're fun to do.

3巻カバー　　　2002.8

Volume 3 cover

It's hard to paint the texture of the military uniforms...

I wanted to draw a typical shonen manga pose of a character about to shoot a "Kamehameha." (But it was impossible...)

I wanted to paint a dog.

I drew the artificial limb slightly larger in scale, in order to accentuate it. This piece is one of my favorites.

My old oil painting habits are hard to break. I'm satisfied with this piece because I was able to paint the wall the way I wanted.

Hiromu Arakawa ✢ FULLMETAL ALCHEMIST **36**
2002.4 — 2003.3

I think Second Lieutenant Havoc would look good in a flight jacket. Where is Granny Pinako?

Gangan Center

When this piece was published in the magazine, I detected a certain "maleness" in the way my editor put the title on top of the main character rather than cover up Winry's bare legs. My editor and myself are both members of the "dresses, bare legs and sandals are the greatest" club.

A postcard for the magazine. There were two volumes of **Shonen Gangan,** and Winry wasn't in either one...
(Now that I think about it, Ed's never been in **Gangan Versus** either.)

39 FULLMETAL ALCHEMIST ✝ Hiromu Arakawa
2002.4 — 2003.3

4巻カバー　　2002.11

At first Scar-san was looking towards the center of the piece, but by the time I finished painting him, his attention had shifted.

Aah, I forgot to paint the whites of Al's eyes. ◀━━

Novel illustration

The Phantom of Warehouse 13, the bonus story in the back of the first **Fullmetal Alchemist** novel, was a humorous story, so I decided to change the mood by painting with Copic markers. Doggy...!

Big text: **Letters** Small text: **Write, write.**

This illustration was for a postcard for the magazine, so I decided to do a four-panel manga with a postal theme.

I remember watching TV at my parents' house while I painted this.

がんがん 巻頭 見開き 2003.1 啓

Spread illustration for Shonen Gangan

afraid that I would miss my deadline (but in the end I did make it).

I painted this at my parents' house, but because of heavy snowfall, the airlines and the post office were both shut down. I was really

Arakawa

I drew Russell with River Phoenix in mind.

Drama CD illustration

Tarot card illustration

This was for the card "The Emperor," so I wanted to make him look conceited. He ended up looking too conceited.

I wondered why the red wasn't printing as well as it usually does, and then I found out that the way I paint is too bumpy. Argh.

It took me ten minutes to paint Major Armstrong... He's so easy to paint. And I forgot Lieutenant Hawkeye's earrings.

ALCHEMIST

Chapter 3
FULLMETAL
2003.4
Hiromu Arakawa

This chapter focuses on the illustrations from Spring 2003 to November of the same year. This is roughly the same time as comic volumes 5-6. The TV anime began production around this time, and the world of **Fullmetal Alchemist** was introduced to a larger audience.

5巻カバー用　2003.4

Volume 5 cover

Winry gets mad a lot, cries a lot and laughs a lot.

I decided to line up the main characters for the "Favorite Character Contest" in celebration of the second year of the series.

Everyone's looking in a different direction. They have no team spirit!

The rough sketch was much better because it had more feeling of movement.

6巻おまけ用　2003.5

The "Flame Alchemist" was supposed to be a joke, but they really put it out! Are they also going to put out the "Strong Arm Alchemist" as well?　[NOTE: The Japanese **Fullmetal Alchemist** vol.6 was published with a special "Flame Alchemist" mini-book.]

61　FULLMETAL ALCHEMIST ✝ Hiromu Arakawa
2003.4

Every time I've painted the covers for the novels, I've been able to make it close to what I imagine, so I'm satisfied.

The colonel got fat.

Edward Elric |||||||||||||||||||||||||||||||||||||

I made some mistakes on the artificial limb. I guess someone tampered with it while he was asleep (sob).

Alphonse Elric ||

Al strikes a tough pose, but on the inside he's just an easygoing 14-year-old... It's funny when you think about it.

Roy Mustang| |

There's no deep meaning to the colonel's cape. It just improved the composition and made him look more dignified. That's all.

Scar ||

He turned out a little too skinny.

Riza Hawkeye

Everyone told me "the lieutenant's chest is too big!" I think they might be right.

Winry Rockbell

Yup, she looks best in her work clothes.

2003. 8

Everyone asked me, "Is that blood?" But it's not. It's red ginger juice. After this, his cheek is going to get itchy.

ガンガー10月号　表紙用

2003.8

Shonen Gangan, October issue

I reverted to the style I was using in the beginning, and I put three different whites in the eyes.

半行本 6巻用　2003.9 [signature]

took the most time.

I put too much paint on this one, and the paper became really bumpy. Out of all the pieces in this illustration book, this one probably

2003.9

My editor was sitting next to me, waiting for me to finish. Brrrr.

Hiromu Arakawa ✠ FULLMETAL ALCHEMIST **74**
2003.4

For a *Shitajiki* [NOTE: A shitajiki is a sheet of plastic used to slide under your paper to make a solid surface to write on.]

When the major is in the picture he widens out the surface area of the composition, which is very handy.

Shonen Gangan, November issue (title page)

My themes for this piece were "fists" and "brotherly synchronicity."

Purse: Mustang

2003.10

In group pictures it's fun to make the characters interact with one another to create a whole.
By the way, the number of characters has sure gone up...

Little kids still tell me "Al's a robot!"

All of a sudden I had the urge to paint some sheep. ▬◀

2003.12

After this he's going to get punched by Winry.

ALCHEMIST

Chapter 4
FULLMETAL
Character
Hiromu Arakawa

This chapter focuses on the character sketches for the PS2 game *Hagane no Renkinjutsushi: Tobenai Tenshi* (**Fullmetal Alchemist and the Broken Angel**) which came out in Japan in December 2003.
Also included are a list of the illustrations and where they were first printed.

Left hand version

Front

Eyes are blue-gray 目玉 ブルーグレー

茶色に近い くすんだ 黄味 かかった色。

Hair is a brownish-yellow color

Left hand version

Angry 怒

Smokes a cigar

ハマキ

・鬼矢服は黒
・ボタン・ベルト・ふち えり章は うすいグレー

・His clothes are black.
・His buttons, belt and collar are light gray.

Back うしろ

Side よこ

Sullen むっつり

Full body version 全身ver.

Full body version 全身ver.

Back うしろ

後頭部の穴から鎖 出てます (この図では 省略)

The chain comes out of the hole in the back of his head. (You can't see it in this diagram.)

The back of the legs is the "Aldo" arms and legs version.

足 後部は 「アルド両手足 ver.」 参照

Front

Back

ホークアイ中尉より
こころもち アゴのライン
細目。

Her jawline is a little less
prominent than Lieutenant
Hawkeye's.

×:地味化粧
Plain version

スーツ↗
やわらかい
オレンジ色

Her suit is
a soft
orange color.

Front

Back

Side

皮っぽい服が
いいかも？

Leather clothing might
be good?

What did you
just say?!

なんですと！

ナイトスコープ…までも言わんが
夜用レンズ付？

I wouldn't go as far as a
night scope...but it might have
a built-in night-vision lens?

Wilhelm

Hawkeye

① (Kintaro is a character from Japanese folklore.)

Selene

Nemda

This version has brown shoes and a brown hat. I don't know whether this or the light blue version is better.

This version has brown shoes and a brown hat.

Armony's hair is red. This girl's hair is a dark orange.

White apron

Waagh--!

Front

Back

Flower Girl

Collar

Beard is white with black streaks

Hmm...

The side of his pants

Pastor

C H A P T E R 1
I l l u s t r a t i o n L i s t

C H A P T E R 2
I l l u s t r a t i o n L i s t

C H A P T E R 3
I l l u s t r a t i o n L i s t

I l l u s t r a t i o n L i s t

■ Another thing that I noticed was "Boy, the main character sure takes off his clothes a lot." Of course, if I want to draw his auto-mail, then I have to make him take off his clothes. But maybe he strips more often than Major Armstrong? Is Edward a stripper? No, guys always walk around their room wearing only their underwear. My dad will even go outside to the cow shed in the middle of winter after taking a bath. (I don't think I can ever win against a guy like that.) Huh? Are we still talking about underwear? I like talking about underwear. Eh? Is this all there is to the climax of this ground-breaking, historical illustration book? Am I done? No need to check with the editorial department? Seriously?

She wanted to include only the girls in this spread but there aren't enough female characters in this manga...

Hiromu Arakawa • January 2004

Girl?

Girl!

Church of Leto • Cakes

■ I'm just a manga artist, so it's really embarrassing for me to put out an art book. But I guess I should accept it as the natural course of events. Hello, this is Arakawa. My feelings about this book are that if I'm going to be embarrassed anyway, why not let people go behind the scenes and see some things that they wouldn't usually be able to see? It may be hard to bear at some points, but please think of it as the crust at the very edge of a loaf of bread and enjoy it in that way because even the crust has its own taste and can be enjoyed. I know / like it. (The crust, I mean.) It's all been arranged chronologically so I can really see my own development as an artist. It's like a scientific study charting the growth of some rare animal. Waagggh...but I'm still really embarrassed.

■ It's been two and a half years since I've begun this series. When I see it all lined up like this it makes me think to myself, "Arakawa, you've really drawn a lot of stuff." That's how I feel. Before I became a manga artist, I used to consider myself lucky if I completed one oil painting a year, so the speed at which I'm working now is nothing less than a miracle.

"Touching"?

うるおい？

THE ART OF
FULLMETAL ALCHEMIST
Hiromu Arakawa

[Original Japanese Edition]
Planning/ SQUARE ENIX CO., LTD.
Editing/Yuichi Shimomura, Yuko Nomoto (Shonen Gangan)
Design/Yumi Tanaka (D3)

[English Edition]
Translation/Akira Watanabe
Layout/Yoko Iwasa
Editor/Jason Thompson

Editor in Chief, Books/Alvin Lu
Editor in Chief, Magazines/Marc Weidenbaum
VP of Publishing Licensing/Rika Inouye
VP of Sales/Gonzalo Ferreyra
Sr. VP of Marketing/Liza Coppola
Publisher/Hyoe Narita

FULLMETAL ALCHEMIST Hiromu Arakawa Art Book

Printed in Singapore.

Published by VIZ Media, LLC
P.O. Box 77010
San Francisco, CA 94107

10 9 8 7 6 5 4 3 2
First printing, October 2005
Second printing, July 2007

INTRODUCTION TO
DICKENS

By the same author

INTRODUCTION TO
DICKENS

by

PETER ACKROYD

SINCLAIR-STEVENSON

First published in Great Britain by
Sinclair-Stevenson Limited
7/8 Kendrick Mews
London SW7 3HG, England

Copyright © 1991 by Peter Ackroyd

British Library Cataloguing in Publication Data
A CIP catalogue record for this book is available from the British Library.

ISBN 1 85619 060 9

Typeset by Rowland Phototypesetting Limited
Bury St Edmunds, Suffolk
Printed in Great Britain by
Clays Limited, St Ives plc

Contents

Introduction

OVER THE last one hundred and fifty years Charles Dickens has often been accused of purveying nothing but melodrama or sensationalism; his plots have been criticised for their reliance upon sudden reversals of fortune or upon the no less sudden access of wealth and happiness. Could a child like Oliver Twist really suffer such a fall from grace, at the hands of Fagin, and such an eventual redemption? Could the Dorrit family really leave the Marshalsea Prison in such an unexpected fashion? Could David Copperfield really have become so renowned an author with such little apparent effort? We need only look at some of the salient facts of Dickens's own life to answer these questions.

As a small child he had been brought up in a comfortable household, in Chatham, but at the age of ten that happiness was suddenly taken away from him. He and his family moved to a house on the fringes of London, in Camden Town, and the young Dickens, who even then had hopes of becoming 'a learned and distinguished man', was sent to work in a blacking factory. 'No words,' Dickens later wrote in a fragment of autobiography, 'can express the secret agony of my soul. . . .' Then he went on to describe his sense '. . . of being utterly neglected and hopeless; of the shame I felt in my position; of the misery it was to my young heart . . .' A further catastrophe destroyed whatever happiness the family still possessed: his father, who had until then led a relatively prosperous middle-class existence as a clerk in the Naval Pay Office, was incarcerated in the Marshalsea Prison as a debtor. So it was that Dickens's childhood was torn in half.

But then, once more, everything changed. His father was suddenly freed from gaol and, a few months later, Dickens was himself released from the blacking factory. While working as a 'labouring hind' all the hopes he had harboured of becoming a famous man had counted for less than nothing; but now he was enrolled in a reputable school and once more became a cheerful and vivacious child. That in itself is sufficiently remarkable a transition to justify (if not necessarily to explain) all the sudden changes of fortune which animate his fiction, but then at a later date something of momentous significance occurred; he left school and took a variety of jobs as law clerk, shorthand reporter and journalist before he realised that he could write essays or fictions which moved and delighted all those who read them. It was at the age of twenty-four, with the publication of *The Pickwick Papers*, that Charles Dickens fulfilled all of his childhood ambitions. Within a very short time, just fourteen years after he had been consigned to the darkness of a crumbling warehouse by the Thames, he became the most famous novelist in the country. When critics accused him of melodrama and sentimentality he would characteristically reply that everything he wrote was true – that these surprising reversals of fortune, these sudden conversions, were not simply the material of fiction. They represented the way of the world. Indeed for him, as we can see, they were the breath of reality itself.

It has in the past been a matter for some speculation why Dickens, as a schoolboy and as a young man, took delight in the more sensational periodicals (like the *Terrible Register*, which he devoured as a child) and in the cheaper melodramas of the period. It has often been excused as the means by which he came into close contact with the popular culture of the period, but it was also the means by which he could confirm and strengthen that vision of the world which was vouchsafed to him as a child. It was a way of reaffirming his own unique and bewildering identity, and there is no doubt that the tone and method of these popular romances entered the spirit of

his own later fiction. That in a sense is the theme of this introduction to Charles Dickens; there will be no attempt to provide a simple biography or a foreshortened exercise in literary criticism, but rather to outline the ways in which the very texture of Dickens's life affected the nature of his fiction. The 'life' and the 'work' are all of a piece; the shape and movement of his novels are as much a part of his being in the world as his social manner or his private behaviour, and they were directed by the same imperatives.

Two small examples may, in Dickensian fashion, set the scene. When he was courting his future wife, Catherine Hogarth, he once arrived outside the small villa in Fulham where she lived with her family – or, rather, he burst in through an open window. He was dressed in a sailor's suit and proceeded to dance a hornpipe in the middle of the drawing room where the family were sitting; he then leapt out through the window but, a few minutes later, knocked on the front door. He was wearing his usual clothes and conducted himself in an ordinary manner, making no allusion to his previous extraordinary behaviour except for a sudden 'roar of laughter'. A few years later he was sitting at dinner with some acquaintances when a woman turned to her husband and called him 'Darling'. This was not a customary endearment in the period and at once Dickens slid off his chair, lay on the floor, put one leg in the air and addressed no-one in particular with 'Did she call him darling?' Then he got up from the floor, resumed his seat, and carried on as if nothing whatever had occurred.

These incidents are trivial in themselves but they do nevertheless throw an interesting light upon the procedures of Dickens's own fiction; here he has been shown to act in a dramatic and striking manner for a very brief period before resuming his customary relations with the world, like some irruption of overt theatricality in a cooler and more controlled environment. In that sense it is highly reminiscent of the way in which the more eccentric characters are displayed in his novels: they spring out with their theatrical mannerisms and

verbal convolutions before subsiding once more into the background of the narrative. There is a larger point here also, since Dickens could not conceive of a character without attaching some particle of himself to its progress through the story; the more 'extreme' the character, the more he was able to provide fantastic variants of his own extreme behaviour. But if Dickens's characters in certain respects resemble their creator, so that creator came also to resemble them. Dickens was changed by his novels and by the creatures who stalk through them, because in the act of creating them he came to realise more of his own possibilities; it was only while inventing Oliver Twist that he became fully aware of his own sufferings as a child, for example, and in the process of creating Ebenezer Scrooge he began to understand the springs of his own mercenary preoccupations. In order to fashion them coherently he had to become 'like' them, and as a result he became more like himself.

There are other, and perhaps more easily observable, connections between the man and the novelist – perhaps the best example being the continuous presence of his extraordinary and capacious memory. He was on one occasion at a party when he became engaged in conversation with a woman who had just moved to the country; she complained of the fact that they had no neighbours, except for a certain Mr Maddison who lived a few miles distant. Some years later Dickens and the woman saw each other again at an evening party; he came towards her and said, 'Well, and *how's Maddison*?' It was an extraordinary gift: well into middle age he could remember the details of his schoolfriends' lives and appearance, and this gift was itself effortlessly transplanted into his fiction. When he read to his sister the description of the grim Mrs Pipchin from *Dombey and Son*, she exclaimed, 'Good heavens! What does this mean? You have painted our lodging-house keeper and you were but two years old at the time.' He was only a little older when he witnessed an incident at his family's house in Chatham when a man with a wooden leg got that appendage

stuck among some small coals in the basement: the incident recurred almost fifty years later when, in Dickens's last completed novel, Silas Wegg finds '. . . his self-willed leg sticking into the ashes about half-way down'. So the memory which he exercised in life was also one which helped to shape and animate his fiction.

There is another aspect of that same principle, since his friends were often astonished to note how at a first glance Dickens was able to assimilate and remember all the details of even a complicated scene. He knew as much himself and recalled on many occasions how as a child he noted and retained everything even without realising that he was doing so. It was a gift that remained with him always; it was often remarked how he could walk down a street and then afterwards remember perfectly the name of every shop as well as the nature and position of the goods which were on display in the front-windows. All this is intriguing in itself but it is, in addition, strangely reminiscent of that power of detail which fills the pages of Dickens's novels – the way in which a room, or a character, is so completely described that it rises up in front of the reader like an hallucination. And how expertly, also, Dickens was able to maintain the appearance and characteristics of even the most minor personage for the entire length of his lengthy narratives; in later life he began to keep memoranda to assist him in the composition of his novels but, even so, the ability to maintain so large an assemblage of characters within such elaborate fictions must itself be related to those powers of recollection which he exhibited in ordinary life.

Of course that power of memory is related to his other extraordinary powers of mental organisation since, if there is one characteristic of genius, it rests in precisely that heightened use of all human faculties. Just as in life there was no neater or more disciplined person, so it seems that he was able to control and refine the more obscure aspects of his consciousness. He often compared his brain to a number of compart-

ments, which he kept carefully labelled, and in all his activities – whether in the making of speeches, or the learning of dramatic parts – Dickens exhibited the same concentration and the same capacity for strict organisation. But memory was for him more significant than any other cognitive power, and indeed in many of his works it is seen to be the very spirit of imagination itself. In *The Haunted Man and the Ghost's Bargain*, one of the Christmas fables which he wrote after the success of *The Christmas Carol*, he ends his narrative with the sentiment, 'Lord, Keep My Memory Green'. For him the phrase had an acutely private application, since he always believed that it was his own memory of childhood misery and privation that opened his heart and imagination to the sufferings of others; but it had a wider reference than the wholly personal, since from that essential belief sprang Dickens's conviction that memory itself was the surest path towards imaginative sympathy and thus the act of creation itself. Memory was a form of inspiration, therefore, which linked past and present, unified humankind with the shared recollection of sorrow, and imparted to life a meaning and purpose which might not otherwise be discernible in what he once called the mere 'checking off of days'. The finest expression of this belief is to be found in *David Copperfield*, a novel which in a very real sense is about the nature and significance of memory, but we can see it operating throughout Dickens's life – both in his ability to recall even the most fleeting incidents of past years and in his constant preoccupation with his own childhood. The work in that sense acts as an elaborate and symbolic re-enactment of the life, a purified expression of all the preoccupations which drove him forward through the world.

Drove him forward literally, also, since one of the most significant images of Dickens is to be found in his energetic movement. He walked everywhere – from his house in London to his house in Kent after his fortieth year, over the Alps, to the top of Vesuvius to look into its cone, through the countryside, and of course endlessly through the streets of London.

One contemporary noted that he was to be seen at '. . . lodging houses, station houses, cottages, hovels, Cheap Jacks' caravans, workhouses, prisons, barbers' shops, schoolrooms, chandlers' shops, back attics, areas, backyards, dark entries, public houses, rag-shops, police courts, markets . . .' His chosen theory was that he ought to exercise for precisely the same amount of time as he worked at his desk, so it was customary for him to spend some three or four hours each afternoon striding through the lanes of Kent or through the alleys of London at a steady pace of five miles per hour. He thought nothing of walking twenty or thirty miles in a day. It is a perfect image of the energy and momentum which characterised all aspects of Dickens's career in the world, and indeed it can be glimpsed within the structure of his novels also; for what is it that leads the reader forward through them but the steady momentum of the narrative, complete with that sense of direction and control that were so much the characteristics of Dickens's other journeys? To walk so far and so fast – to write so much and so quickly. In both cases the same stamina and exuberance are manifested, together with the same measured pace and the same exercise of the energetic will. The life and the work are, once more, all of a piece.

Yet there is no need to curtail the analysis at that point, since the life and the work are also sustained by the age itself. Of course Dickens was not the only person to walk far and fast in the nineteenth century; indeed in the early decades of that century, at a time of expensive transport, distances of twenty and thirty miles were regularly traversed on foot. But there is a much more significant connection to be made, since Dickens's energy and sense of forward progress were very much in the spirit of his time. Much of the force of the period, for example, was concentrated on the need for quicker and more varied forms of transport – the railway was the central symbol of the nineteenth century and, with its own steady development across the face of England, it came to embody all the progress and spirited optimism which fuelled the momentum of the

age. The discoveries of the period are also concerned with unlocking the principles of energy, and the focus of scientific attention was largely upon the workings of electro-magnetism and thermodynamics. It is no coincidence, either, that in biological science the theory of evolution (again exhibiting some kind of forward momentum) should be at the centre of the most interesting research. In that sense Dickens himself becomes a truly representative figure – not just because he walked so far and wrote so much, but rather because in the very structure of his work it is possible to recognise the force and elaboration of the nineteenth century.

There were occasions when he described his own sensations upon these long pedestrian expeditions and during one night walk, as he explained later, he found himself making up verses as he continued on his way; quite instinctively in his exhausted state his expressions took on the shape and cadence of poetry, just as, in his own fiction, the long passages of prose themselves begin to adopt the movement and diction of poetry. It would be too much to claim that this transformation of his narrative also occurred at moments of stress or exhaustion – art does not necessarily copy life in such minute particulars – but it is worth noting that, at times of high feeling or high drama in his work, Dickens seems naturally to have reached for poetic cadence in order fully to express himself. That is perhaps why many critics have outlined the novelist's debt to Shakespeare, since blank verse is the pre-eminent medium which Dickens uses on such occasions; it was not that he necessarily read much Shakespeare and used him as a conventional literary source, more likely that he imbibed the sound and the movement of Shakespearean verse on his innumerable visits to the theatre. His favourite actor was William Macready, after all, and Macready specialised in Shakespearean roles.

The death of Little Nell in *The Old Curiosity Shop* is perhaps the most famous example of Dickens reaching towards poetry to lend substance to his vision, although the examples

of such transitions are to be found everywhere within his work. In fact it was in *Oliver Twist* that he first engaged in poetic elaboration on a large scale, as if the very contemplation of the poor boy's fate (a fate which to Dickens seemed very much like his own) elicited all the poetry of his own nature: '. . . some pleasant dream of a love and affection he had never known; as a strain of gentle music, or the rippling of water in a silent place, or the odour of a flower, or even the mention of a familiar word, will sometimes call up sudden dim remembrances of scenes that never were, in this life; which vanish like a breath; and which some brief memory of a happier existence, long gone by, would seem to have awakened . . .' There is a subdued echo of Wordsworth in this passage, and that affiliation suggests what is indeed one of the most important aspects of Dickens's genius.

He was in a true sense the heir to the great Romantic movement of poetry which characterised the decades before his own work came to prominence. It is unlikely that this was a deliberate or even conscious procedure on Dickens's part; it is just that he was filled with the spirit of the language which he employed, and indeed he possessed so receptive and capacious an imagination that his writing came to embody that spirit in all of its aspects. Certainly he was the first English novelist to introduce poetry into fiction, and thereby to transform it. Instead of the bright, hard language of the eighteenth century, so concerned with plot and material detail, Dickens conveyed a sense within his narratives of symbolic movement, of thematic unity, of meaning conveyed through images as well as dialogue or events; in the same manner the cadences of his prose transmitted the very being of his protagonists, no longer concerned only with expressing the principles of the conscious world but also intimating the inchoate and secret forces which lay beyond it. In his work, as a result, fiction became capable of larger and subtler effects than had been apparent in Smollett or in Fielding, and at the same time it was able to enter certain recesses of human personality and of human behaviour

than had not been readily available to Walter Scott or to Jane Austen. One could put the point differently by noting that he was the last of the great eighteenth-century novelists and the first of the great symbolic novelists, a writer for whom the over-used term 'magic realist' can truly be employed, since, by echoing the mannerisms of English poetry in his narratives, he was able to create new patterns of symbol and imagery that recreated the world in grandiloquent and even mythic terms.

Of course it would be unwise to neglect the eighteenth-century roots from which he sprang; his constant visits to the theatre have just been mentioned, and there is no doubt that in the melodramas and burlettas of the period Dickens was taken back into a more violent and more cynical period from which Smollett, Sterne and Fielding found the sources of their own art. Dickens was in the same way entranced by the engravings of Hogarth, and there are as many references by him to the work of that quintessentially eighteenth-century artist as there are to *Tom Jones* or to *Peregrine Pickle*. Dickens loved the Augustan world of sententiousness and brutality, of periphrasis and licence; shorn of its more explicit elements it was the source for much of his comedy, and there is no doubt that in the more melodramatic or pantomimic aspects of his own fiction he was reaching back towards the favourite reading of his youth. Yet the boy who could *see* the characters of *Tom Jones* in front of him even as he read that novel was also the boy weighed down by the sense of his own suffering and isolation; so it was that he became the writer who aligned the Augustan tradition of comedy or satire with the Romantic fascination for the lonely or melancholy hero haunted by the visions of his childhood.

So patterns begin to emerge and one of the purposes of an introduction such as this, in which the life and the work are seen in active cooperation, is to elucidate all the affiliations and resemblances which bring together Dickens the man and Dickens the novelist. These may even include patterns which

were not visible to his contemporaries, or even to Dickens himself, since it is only in the act of posthumous recognition that they become fully apparent. His nurse remembered him bursting into the kitchen when he was a young boy, for example, and exclaiming, 'Clear the kitchen, Mary, we're going to have *such* a game.' Fifteen years later, in *The Pickwick Papers*, Sam Weller's father declares, 'I've got *sitch* a game for you, Sammy.' And then some years afterwards, in *A Christmas Carol*, the Cratchit children announce that 'There's *such* a goose, Martha!' A small echo, perhaps, but it is one in which we seem to hear the voice of Dickens himself – the voice of the child vanishing into the air but then moving upon the page where it will live forever.

There are other respects in which that child lives on within the adult man and writer, bringing them both within the same distant perspective. Many critics have dwelt upon those occasions when the actual content of Dickens's fiction is affected by the events of his youth and infancy, for example, and indeed there are many parallels or resemblances which suggest the extent to which the traumatic incidents of his early life are constantly being replayed within his work. But the critic or biographer can also pursue what might turn out to be a more interesting path, since it is possible to see how certain aspects of his childhood materially affected the form and the manner of his fiction as well as its explicit content. For when he was a small child in Chatham, 'reading as if for life' as he once described it, he eagerly turned the pages of *Tom Jones* and *Roderick Random*, and saw the characters springing to life all around him; it was an experience which he later gave to the infant Scrooge, who cries out in delight, 'Why, it's Ali Baba! . . . It's dear old honest Ali Baba! . . . when yonder solitary child was left here all alone, he *did* come, for the first time, just like that.' So the child saw the characters of the novels which he read, standing there in front of him. But this was only the beginning of his visionary endeavours, since the mature Dickens saw his own characters also. 'I can very well re-

member his describing their flocking around the table in the quiet hours of a summer morning,' his son, Charley, once wrote. And Dickens himself often confessed that, while writing *Oliver Twist* or *The Old Curiosity Shop*, the figures of Fagin or of Little Nell would appear beside him, and would not let him rest until he had attended to their destinies. But it was not simply a visitation, or haunting, since it materially affected the manner in which he composed his narrative. 'I can as distinctly see with my own eyes,' he told one friend, 'any scene which I am describing as I see you now.' This almost hallucinatory recognition of the scenes which he was expounding accounts in part both for the extraordinary power with which he invests his narrative and for the permanent hold which they have had upon his readers' imaginations. He was himself an adept mesmerist, who on many occasions healed the sick or the disturbed, and in his novels themselves it is almost as if he were a hypnotist who impressed his scenes upon the minds of his readers in the same vivid manner in which they affected him. Does this not also account for the extraordinary way in which characters like Ebenezer Scrooge, Mr Micawber and Uriah Heep have entered the national consciousness? They have remained so real for us because they were always so real to him – more real, sometimes, than the flesh-and-blood creatures who surrounded him. His son, Charley, remembers the occasion when he saw his father for the last time. He found his father writing *The Mystery of Edwin Drood* 'very earnestly . . . I said, "If you don't want anything more, sir, I shall be off now", but he continued his writing with the same intensity as before, and gave no sign of being aware of my presence. Again I spoke – louder, perhaps, this time – and he raised his head and looked at me long and fixedly. But I soon found that, although his eyes were bent upon me and he seemed to be looking at me earnestly, he did not see me, and that he was, in fact, unconscious of my very existence. He was in dreamland with *Edwin Drood*, and I left him – for the last time.' It is an extraordinary and somewhat

disturbing anecdote. But in this image of the prematurely aged novelist, seeing only the characters and scenes of his novel in front of him, we can glimpse the presence of the child once again – the child who saw the characters of his reading come to life before him. 'Why, it's Ali Baba!'

There are other features of his childhood, which bear a darker aspect. The boy who worked in a crumbling warehouse beside the Thames became the novelist who insistently and deliberately recorded the presence of dark and crumbling buildings which haunt his fiction like a stain. The boy whose family was incarcerated in the Marshalsea became the novelist who continually introduces into his fiction images of prisons and of prisoners. A prison appears in his first novel, *The Pickwick Papers*, where Mr Pickwick learns the meaning of suffering, and it was to emerge in his last, *The Mystery of Edwin Drood*, before the death of Dickens himself preempted an ending in which John Jasper would discover the nature of his guilt in the condemned cell. Between those novels the gaol looms everywhere – in *Nicholas Nickleby, Oliver Twist, Barnaby Rudge, The Tale of Two Cities* – and of course it reaches its apotheosis in *Little Dorrit* where the prison becomes a symbol of the human condition itself. It should not be forgotten, in this context, that as a journalist and 'public man' Dickens was equally preoccupied with the theme of prisons and of prisoners – whenever he travelled to a foreign city the penitentiary was one of the first things which he wished to visit, and he never tired of discussing the nature and value of penal reform in articles and speeches. The traumatic events of his early life formed certain of his adult preoccupations, therefore, and through that connection it may be possible to find some clue to Dickens's general political and social beliefs. It would be difficult to provide a concise or coherent summary of his ideas, because those ideas were neither concise nor coherent in themselves, but this much can be said: in matters that directly touched upon the experiences of his own early life (such as the exploitation of children) he became a convincing and

vociferous radical whereas, in those areas which did not so directly touch him, he characteristically adopted the stance of a conservative or moralistic disciplinarian. He took the world personally, in other words, and his most public concerns are reflections of his own private and sorrowful understanding. The point could be made another way by noting that on those occasions when he could imaginatively identify with the plight of victims, all the powerful sympathy of his nature was poured upon them; when he could not embark upon that act of identification, he became the stern man of his age. His politics and social beliefs are in that sense very much part of his own divided nature, and when claims are made for Dickens the 'radical' or the 'social humanitarian' it is as well to remember from what troubled origins those concerns spring.

In fact there are many aspects of his mature character which, in small matters as in large, are to be seen stretching from the shadow of his childhood. There is his extraordinary cleanliness as a man, for example, which may be related to the horror of all the dirt and (literally) blacking that surrounded him when he worked in the warehouse as a child. And then there is his wonderful neatness, which may indeed be some reflection of the disorder and even squalor which invaded his early homes; his parents were often forced to pawn items of household furniture in order to pay for their ever-increasing bills, and in that light it is possible to view with some sympathy the adult man who, on his journeys away from home, instructed his wife and relatives never to move any item of furniture from its accustomed position. He used to explain this on the grounds that he needed to visualise everything exactly as it was, but it is hard not to feel here the presence of some childhood sense of dispossession. Many biographers have of course stressed the depth and significance of that trauma, although it ought also to be emphasised that Dickens successfully and even triumphantly came through the experiences of his childhood. It would not be going too far to say, in fact, that in many important respects the strength and

energy of the man were actually formed in the fire of his sufferings. Never has anyone been as persistent, as systematic, as industrious and as thorough as Charles Dickens; in addition, few writers have been as determined or as ambitious. These were precisely the qualities which saved him during his childhood tribulations, of course, and he learnt at that time a lesson he was never to forget – the world, and the human being, can be transformed by the power of the will. Always perform every task as if it were the most important thing in the world. Never *say* die. Never give up. These were the elements of his personal philosophy and, although it might not seem a very grand one, it successfully steered him through life while others clung to the wreckage of their hopes.

More significant matters can also be adduced here. His boundless need for public love and admiration may stem from those childhood feelings of being unwanted and rejected by his parents when they took away any hopes of education he harboured and instead consigned him to the blacking factory. Similar forces were at work in his lifelong efforts to transform his friends into one extended family; they always became surrogate brothers and sisters who joined the genuine Dickens family (so to speak) on their travels and their seaside holidays. It is as if he could not get enough affection or love, as if he had continually to recreate some image of a happy family which was so signally lacking in his own childhood. And yet his fiction tells its own story: his happy families belong to the world of fable and wish-fulfilment, as in his Christmas stories, but when he is most deeply engaged in his narratives the characteristic image of familial life is one of dissension, rivalry, and even hatred. Another image also recurs continually, since all the energy and thoroughness in the world could not disguise a different personality which Dickens brought everywhere into his fiction: it is that of the starved, mistreated or simply frail child.

This in turn leads to one of the strangest aspects of Dickens's own life. For despite all his fame, and his success,

there is a real possibility that at the end of his life he reverted to that solemn aspect of his own childhood; in his last years he seemed helplessly to re-enact the conditions of the first. He became sickly again; he felt himself to be unwanted and unloved; he became in many respects isolated, a man apart from his contemporaries just as the child had been apart from any companions of his own age. The vision of the world which visited him in childhood was for him the true one, and it was as if all the fame of the great English novelist had been a kind of dream from which he finally awoke to confront once more the terrors of his infancy. No doubt this is true of more people than Dickens alone, in which case some words from *A Tale of Two Cities* have more than a private import: 'For, as I draw closer and closer to the end, I travel in the circle, nearer and nearer to the beginning.' Perhaps this is to stray too far from the theme of this preface, which is to reinstate and to explore the affiliations between the life and the art. Yet even the need to understand the very source of that art takes us back indirectly to his childhood, since it was during the period when he was working in the blacking factory that he first started to tell stories. He declared in a passage from the short autobiography which he wrote in middle life that, when he was working alongside those 'common' men and boys who were to haunt his later fiction, 'I made some efforts to entertain them over our work with the results of some of the old readings, which were fast perishing out of my mind.' It is perhaps important to note here that he started telling stories precisely in order to evoke the old atmosphere of his childhood readings, and can we not see in his own later story-telling the same desire to return to the order and security of his earlier life in Chatham? But we must move back again with him to London for, when he was lounging on London Bridge waiting for the gates of the Marshalsea Prison to open and admit him to the company of his incarcerated family, he would stand with a maid and occupy himself 'by telling her quite astonishing fictions about the wharves and the tower'. So in this most un-

happy period of his life he told stories, both to entertain others and to comfort himself.

And he also told lies. He did not want his fellow workers to know that his father was actually in gaol – they did call him 'the young gentleman', after all – and so on one occasion, when he was being escorted 'home' by one of his young working companions, Bob Fagin, he 'shook hands with him on the steps of a house near Southwark Bridge on the Surrey side, making believe that I lived there. As a finishing piece of reality in case of his looking back, I knocked at the door, I recollect, and asked, when the woman opened it, if that was Mr Robert Fagin's house.' He was an astute and enterprising liar, and it is not hard to imagine that he told similar untruths on other occasions. Stories and lies. Stories and lies by which he hoped to control the world, to keep at bay a threatening reality, to render himself powerful and popular, to disguise the truth about himself. It is possible to see, somewhere in that amalgam of motives and desires, the first springs of the mature novelist.

But there are also signs and intimations of the work to come in the years immediately after Dickens's release from the blacking factory. His father managed to enrol him in a relatively good school, Wellington House Academy, and at once he shook off the shame and horror of his working life; indeed to his contemporaries at that school he seemed to be the son of a 'gentleman' and 'rather aristocratic than otherwise', which suggests how quickly the young Dickens rose into a new image of himself. It is as if he emerged from his ordeal almost fully formed, and there is much in the descriptions of him as a schoolboy which throws an interesting light on the work he was soon to create. He had, one of his friends said, 'a more than usual flow of spirits'; and another commented upon the fact that he was 'given to laugh immoderately without any apparent sufficient reason'. There is something here which corresponds with later descriptions of Dickens the novelist: the extravagant hilarity, the immoderation of his laughter. And

why should the child not have manifested such 'spirits'? He had, after all, been freed from a nightmare. The fairy-tale wish had come true. And in the high spirits of the child, as well as of the man, it is possible to see some trace of the rich unforced comedy of his novels; the energy and the sense of freedom which are true aspects of his comic genius emerge from someone who has himself escaped from his own prison. In some respects that may even be the root of his comedy – the shout of the child who has been freed at last, and who can now see the world as a gigantic game which at last he has learned how to play.

There are other sources of his comedy. As a child and young man he was particularly impressed by all the forms of 'low' humour available in the theatres of the period – much of the comedy, at least in his earlier fiction, is established upon the variety of theatrical routines which he witnessed. Indeed, in any account of the way in which the nature of his life affected the form of his novels, it is important to note how deep theatricality runs throughout his character and his work – it might even be said that it runs *from* his character *into* his fiction, since there is no doubt that from the beginning Dickens, the young boy of immoderate high spirits, was always in part a theatrical creation. He was, in other words, self-created. As a young man he dressed in the very spirit of fashion, and all his life he preferred brightly coloured clothes. Even in the 1850s and 1860s, when most Victorian males preferred the dark colours of the dress-coat or the stove-pipe hat, Dickens wore check trousers, 'loud' waistcoats and brightly coloured coats. In manner, too, he was often innately theatrical – one contemporary believed that he acted as if he were always on an 'imaginary stage', which is perhaps another way of saying that he acted in the manner of some of his own fictional creations. He never lost his early love for the theatre itself, and in fact he was himself a highly skilled amateur actor who on more than one occasion took his own company of players all over the United Kingdom. It is hardly worth referring to the

fact that he wrote plays before he wrote novels in order to make the salient point: just as Dickens's temperament and behaviour were deeply rooted in his appreciation of the stage, so his novels themselves were animated by the spirit of theatrical comedy and by the nature of theatrical illusion.

It is often said, however, that his humour altered over the years: that it became a darker and more intense force, somehow implicated in the sea-change which is supposed to overtake his 'mature' novels. But there is little truth in this. There are passages in *The Pickwick Papers*, his first novel, which are as dark (and indeed as tragic) as anything to be found in his last completed work, *Our Mutual Friend*. In similar fashion the humour of *Our Mutual Friend* or even *The Mystery of Edwin Drood*, the uncompleted novel which was published posthumously, is not in any significant respect different from that contained within his earlier writing. Mr Venus is as theatrical a creation as Sam Weller, just as Mr Sapsea is as much a stage buffoon as Serjeant Buzfuz. If there is a distinction to be drawn between the earlier and the later novels, it is not in terms of prevailing 'darkness' or 'light' (the preferred vocabulary of certain Dickens critics) but rather in terms of relative complexity. The more famous a writer he became, the more conscious he grew of his own art; the more he developed as a novelist, the more he sensed the possibilities within himself. As a result the later novels are far more elaborately structured, and more carefully composed, than those which had come before: the change can probably be marked at the time of *Martin Chuzzlewit*, and is undoubtedly in evidence by the time Dickens reached *Dombey and Son*. It is in fact that very complexity and elaboration which make these later fictions seem 'darker' when really they are only more intricate. The humour remains precisely the same, just as Dickens's own personal humour did not materially alter over the years: he always liked pantomimic tricks, puns, mimicry and farce. There is always present the boy who sang 'The Cat's Meat Man' to his schoolfellows and who would worry old ladies and then 'explode with

laughter and take to his heels'. It is that same explosive laughter which animates Mr Pecksniff and Mrs Gamp, Bob Sawyer and Mrs Nickleby.

Other connections can also be made from this period of his life. In the work and personality of the older man, for example, there are also traces of the schoolboy who read a periodical entitled the *Terrific Register* which, with its panoply of melodramatic and terrifying events, presage some of the more incandescent aspects of Dickens's fiction. He was also the schoolboy who read Addison's *Spectator* and Goldsmith's *Bee*. He devoured periodicals, in other words, and that childhood habit seems materially to have affected his own decision in later life to edit one himself. As a writer in the first years of his fame he assumed the editorship of *Bentley's Miscellany* but soon realised that he could only work efficiently and effectively when he was in complete command of his own newspaper. That is why he started his own weekly journal, *Master Humphrey's Clock*, which in spirit is not very different from the eighteenth-century periodicals he so admired. But these were only preliminary ventures, compared with the labour which he would eventually expend upon *Household Words* and *All The Year Round*. In fact he edited a weekly periodical continuously for the last twenty years of his life; this would be for most men a full-time occupation, but for Dickens it was only one of many and multifarious activities. But he loved journalism, and in his own life never ceased acting as a journalist as well as an editor; in the image of the middle-aged man sitting down to write an essay for *All The Year Round* we can also see the schoolboy who inaugurated a somewhat shorter periodical known as *Our Newspaper*. In that earlier journal had appeared short comic items under the denomination 'Lost'; more than thirty years later Dickens used precisely the same device in the grander journal. The connections can be made, the pattern seen.

If we move on, to Dickens as he appeared in his mid-twenties, it is possible to find incidents of other kinds which

affected both the form and texture of his fiction. When he was in the first full flight of his fame at the time of *The Pickwick Papers* and of *Oliver Twist*, for example, his own sense of progress and optimism were suddenly destroyed by the death of his sister-in-law, Mary Hogarth, at the age of seventeen. It was the profoundest grief he would ever experience, and this primarily because in his affection for that young girl he had managed to recapture the happiness of his infantile relationship with his sister and with his mother. That is why he became distraught, and indeed hysterical, at the time of her death. He had at the time been chronicling the fate of Oliver Twist, the orphan boy whose unhappy career bears a marked resemblance to Dickens's own sense of his wounded and betrayed little self, but in the death of Miss Hogarth all the happiness of his childhood seems once more to have been destroyed. On her grave he inscribed the phrase 'Young, Beautiful, and Good', which in turn leads us forward to the centre of his fiction. For it was shortly afterwards that there emerged in the pages of *Oliver Twist* the figure of Rose Maylie, who is herself described in the same words. In fact after this time these three adjectives inform the very pattern of the young Dickensian heroine, whether she takes the shape of Rose Maylie or of Rosa Budd, of Agnes Wickfield or of Little Nell, of Little Dorrit or of Florence Dombey. It can be said without exaggeration, in fact, that it was the figure of Mary Hogarth which Dickens was continually reviving throughout his fiction in an act of mournfulness and commemoration.

In the process the actual figure of Mary Hogarth becomes obscured and, in a way, unimportant; instead she becomes an image of Dickens's deepest wishes and predilections, and it would not be going too far to state that his own real relationships with women were as complex and as muddled as his fictional representation of them was clear and unambiguous. It is often assumed by biographers that the life of a writer deeply informs the art, but there are often occasions when the art

itself explicates the process. It is necessary at this point to retrieve something of his emotional history in order to make sense of that process, for there is no doubt that from the beginning there was some deep and abiding sense in which he felt himself to be abandoned, vulnerable, unloved or simply not loved enough. That is evident as much in his continual craving for public affection as in his constant attempts to create an extended family out of his friends or acquaintances. But the whole history of his relationships with women is also couched in those terms – clearly he felt himself to have been abandoned by his mother and his older sister at that perfidious time of his life when he was consigned to the blacking factory (he intimates as much in his passages of autobiography on the subject) and, in addition, he was rejected by his first and greatest adolescent love, Maria Beadnell. He never forgot those experiences, and indeed they became the guiding stars of his whole amatory or emotional career.

He married Catherine Hogarth but after a short time it is clear that he was haunted by what on more than one occasion he called a '. . . vague unhappy loss or want of something . . .' He seems in his married years to have engaged in obsessive but sexless friendships with two or three young women who, on the available evidence, in part recreated for him the image of Mary Hogarth but of whom he also quickly grew tired – until, that is, he became deeply involved with a young actress, Ellen Ternan, with whom he settled down into a strange form of domesticity after publicly repudiating his wife. But that new relationship did not in itself forestall or dissolve the pain which he carried with him everywhere, and his explicit comments upon his relationship with Miss Ternan are generally couched in mournful and even despairing terms. This does not suggest the happiest of emotional states, in other words, and it seems as if he were continually engaged in a search for an idealised woman while at the same time he found himself in a state of constant dissatisfaction or unhappiness with the real women amongst whom he lived.

Here the evidence of his fiction itself becomes central, for what do we find in his novels but the constant oscillation between the portrayal of absurd and garrulous (or cold and selfish) women and idealised, virginal young girls? This might in turn be the material for a case study of the way that the terms of art reflect the conditions of life, were it not for the fact that a much more interesting transference is also at work. For there is good reason to believe that, at moments of crisis or change in his own life, he instinctively or intuitively reached for the images from his fiction in order to impose order upon the world. One could put the point another way by noting that he was not a reflective or self-analytical man; there is in fact some reason to believe that he never really understood himself at all, and that his inner life was a fruitful chaos out of which he plucked the various selves which inhabit his novels. So it is that he had to go back to that fiction in order to understand the world. In the weeks leading up to the separation from his wife, for example, he publicly branded her as a cold and unfit mother. She was nothing of the sort, but it seems that he simply had to see her as one of the characters of his own work in order to deal with her effectively. Otherwise, he did not see her at all. The same was true of the young woman with whom eventually he entered a most peculiar relationship; it is generally assumed that the 'affair' with Ellen Ternan was sexual in character, but the truth may have been much stranger than that. For all the evidence suggests that with Miss Ternan he acted out one of the enduring fantasies of his fiction – that of an idealised marriage with a young and sexless virgin. He was an imaginative genius who held on to his creative imperatives against all the odds.

Had he not been doing that in a variety of guises all his life? We have already explored the ways in which the history of his own early life suggests a natural belief in melodrama as the principal agent of change in the world, and there is no doubt that he came to understand everything in those absolutist terms. With Charles Dickens everything was the best, or the

worst. 'The best audience I have ever had,' he would say with almost monotonous regularity. 'I have never seen a face like it!' 'The most extraordinary thing that has ever happened to me!' Everything in his own life veered from one extreme to another, and that same perpetual momentum can be observed in the very texture of his own fiction where the characters are always, in one sense or another, *in extremis*. One has only to think of Quilp or Miss Havisham, of Mrs Gamp or Silas Wegg, to understand that the 'grotesques' of his fiction are nothing more than the extensions of his instinctive vision of the world. The same process is also at work in the very heart of those extravagant and elaborate plots by means of which he twisted the world into the shape with which he himself was most familiar. Of course such matters are also intimately related to the very nature of his being in the world; he was a man of phenomenal and furious energy who was continually being swept forward by the forces of his temperament, and the world around him was often very like a dream or a phantasmagoria. At times of happiness the world became for him a wonderful stage, bathed in bright light and passion and laughter; at times of crisis or extremity, it became the anguished world of his childhood where once more he was abandoned and isolated. These are precisely the conditions which he recreated in his novels, and that evident affinity returns this preface to its originally stated aim – to suggest how it was that Dickens' very bearing in the world, his conversational mannerisms no less than his physical activities, press down upon his fiction and lend it its characteristic shape.

In that sense his own temperament must also play its part in the shaping of his fiction for he was, in almost all respects, a mercurial man. He once described the contrasts of comedy and pathos in his fiction as resembling streaky bacon, but we do not need to use any such metaphor to understand how that same need for contrast and paradox resides in the very nature of Dickens himself. He could be filled with high spirits at one moment only to sink into nervous anxieties and agonies of de-

pression. He was often described as the most cheerful and sociable man in the world, but there are just as many descriptions of his reticence and silence. He was sometimes the very epitome of gentleness and mildness; nevertheless he could also be both caustic and sarcastic. More significantly, it is as a result of these polarities of temperament that we understand more easily something about his fiction: the sorrows of young Oliver followed by the high comedy of Bumble, the miseries of Little Nell succeeded by the pantomimic farce of Quilp, the death of Paul Dombey contrasted with the comedy of Toots and Mrs Skewton, the agonies of Jo beside the ridiculous antics of the Smallweeds. So it is that the 'cheerfullest man of his age' (to quote one description of him) was also the man who brooded apart, who was filled with a sense of emptiness and of that one thing 'missing' in his life which he could never find. The man of farcical high spirits and endless imitations of his friends was also the man who was perpetually susceptible to slights and who in some deep sense felt himself to be unwanted and vulnerable. It is precisely because of these two interlocking selves that he seemed so 'odd' to his contemporaries, but the same polarity works throughout the texture of his fiction: what is the most common path within his novels but that of a solitary and sorrowful protagonist making his or her way through comic turns and theatricalities and endless vivacity?

By all accounts Dickens was also a very restless and 'driven' man, always attempting to do the impossible and, as it were, continually beating violently against the gates of the world. Is there not something about the length, and the pace, and the momentum of his novels which furnishes proof of the workings of just such a temperament? Henry James once described Dickens as possessing a 'military' bearing and indeed, throughout his life, contemporaries noted his upright stance, his brisk demeanour and the precision of his movements. But the Jamesian adjective has another connotation also, since everyone who met him realised at once that he was also imperi-

ous and even wilful. One friend said that his 'whims' were 'laws' and that he had 'a rod of iron in his soul'; certainly, in all the events of his life, from his roles as newspaper editor and stage manager to his more private duties as husband and father, he was a man who found it necessary to manage everyone and everything. No force could withstand the power of his will, as those who 'crossed' him found to their cost. But in that act of extrapolation which has been so much the purpose of this preface, we can view the same imperiousness in the fiction he created – even in the manner with which he manages to create an entire world, rich in symbolic movement and in thematic pattern. It was an elaborate, artificial, complex, vast world which he controlled absolutely – and in the process controlled the reader also, who is helplessly drawn into the very heart of Dickens's imaginative scheme. It was his earnest wish in the novels to impress his own world so vividly upon the reader that it became more real than the real world itself. Is there not something imperious, almost wilful, about that?

The same characteristics are to be seen during his progress around the United Kingdom and the United States as a public reader. Everything in his life led up to the unique phenomenon of the greatest writer of his age going from hall to hall, killing himself with exhaustion as he read dramatic episodes from his novels, performing all the characters, dying with Little Nell and dancing with Mr Pickwick. Of course he needed an audience and, as his private life grew more troubled, he seems to have craved the applause and enthusiasm with which he was greeted everywhere. The child who had entertained his father's friends in the Mitre Inn at Rochester had become the middle-aged novelist upon the stage, 'cooked', as he put it, by the heat and the gas-light. He was a wonderful amateur actor also, as we have seen, and he needed the stimulus and excitement of a hundred different characters to remove the burden of his own self. In addition he thought of himself as a public figure who could not only

entertain the nation but also, in an act of fictional resolution and reconciliation, bring all the classes together and recharge England with the vision of optimism and happiness which suffuses his earlier novels. But then other forces came to work upon him; he began to re-enact the murder of Nancy by Sikes, and he grew both more intense and more frightening. Once more we see that essential imperiousness: he was an expert mesmerist in private life, and while he stood upon the stage he seems to have been able to hypnotise his audience. The effects of his readings were altogether remarkable as a result. Men and women would weep uncontrollably at the death of Paul Dombey or Little Nell, and they would break out in hysterial laughter at the scenes involving Sam Weller or Tommy Traddles. People would faint, and have to be taken out. Here again is the need to control and to manage, to stamp his image upon the world and to impose his fictions so forcefully upon the people around him that they were quite literally under his command. This is an image of the novelist as the man of will.

Perhaps that is why so many of his contemporaries were nervous of meeting him. Some were simply frightened of him and there were times when, it was said, his eyes were like 'danger lamps'. Some merely thought that he was too famous, or too important, to be in their company; so they hid from him. Others were afraid of him because he seemed to be able to read their characters, and indeed even their thoughts, at a glance. He had created so many characters, after all, so finely observed, so meticulously organised, so much *seen through*, that they were ashamed of his vision of their own selves. There is a more curious aspect to this fear, also, since it seems more than likely that certain people behaved differently when they were in the company of Charles Dickens: they acted in a Dickensian manner, as it were living up to his image of what they ought to be like and becoming unwritten characters from one of his imaginary novels. Just as at moments of crisis he turned to his own fiction in order to make sense of the world,

so others used his fiction as a device for making themselves more interesting or more comprehensible.

That might even stand as characteristic of Dickens's entire relationship with the world. It is possible to define a genius as one who stands in symbolic relationship to his time, who in his temperament and career manifests the guiding principles or obsessions of the period. Indeed it can be said that the whole passage of Charles Dickens's life represented the course of the nineteenth century in emblematic form – the rural happiness of the child succeeded by urban deprivation of the boy mimics the very progress of what we have come to call the 'industrial revolution', and his sudden reduction to manual labour is very like the entire descent of the nineteenth century into the maelstrom of urban industrialism. Then we witness Dickens's battle against circumstances and, in the course of that battle, we recognise his ambition combined with hard work, his energy compounded by his will: all these features are so close to the lineaments of the nineteenth century that in examining the life of Dickens we are also coming close to the most powerful forces of his time. He was as brazenly optimistic and as anxiously doubtful as any of his contemporaries; he shared with them the same violence and the same energy, and in his earnestness as well as in his sentimentality, in his enthusiasm and in his theatricality, in his sense of duty and in his sense of the ridiculous, we see the Victorian era as it truly was.

Yet Charles Dickens is also a larger figure than that, because he has come to represent the English genius itself – both in his broad humour and in his brooding melancholy, in his theatricality and in his poetry, in his yearning for pantomime and his aspirations towards some kind of spiritual transcendence. All the melodrama and the horror, combined with the romance and the extraordinarily subtle delineation of character, exemplify a writer who stayed close to the English tradition from which he came but who at the same time immeasurably widened its possibilities and its significance.

These are difficult matters to describe. Perhaps it is best to say only that he was as English as Smollett and Sterne, as English as Blake and Turner. Without exaggeration, in fact, it can be affirmed that in his novels there is to be found the soul of the English people. It is to those novels that we must now turn our attention.

Sketches By Boz

IT IS generally assumed that Charles Dickens became famous, practically overnight, with *The Pickwick Papers*; and yet the true, first engine of his reputation was his earliest journalistic sketches and stories. At the time he wrote the first of these, 'Mr Minns and His Cousin', he was only twenty-one years old, unknown to name and fame, a short-hand reporter in the parliamentary press gallery of the House of Commons. By the time a second volume of those sketches had been published three years later, in 1836, he was arguably the most famous and successful novelist in England. *Sketches By Boz* marks, therefore, the extraordinary *rite de passage* of a writer who was to dominate the nineteenth century.

How did it begin? He had written that first story as a sort of exercise: it concerns the misadventures of a family too intent upon receiving a legacy from a relation and, although it is essentially a farce very much of the kind Dickens would himself have seen on the stage, it shows the care and assiduity of a young man intent on proving himself to be a writer. He transcribed a fair copy in neat and legible long-hand, and then put it through the letter-box of an obscure periodical entitled the *Monthly Magazine*. That journal has therefore the honour of being the first to print the work of Charles Dickens (albeit anonymously) and, when Dickens later purchased a copy and saw his story in all the glory of letterpress, '. . . my eyes were so dimmed with joy and pride that they could not bear the street'. So he escaped into the relative seclusion of Westminster Hall in order to understand his own new sense of himself as a published writer. It was a turning point in his life,

for it was now that he discovered his vocation – all the ambition which he had nourished through a traumatic childhood, through the drudgery of work in a blacking factory, through the humiliation of his father's incarceration for debt in the Marshalsea Prison, was about to be released in one of the most animated, inventive and energetic periods of his life.

He wrote another eight stories for the *Monthly Magazine*, most of them of a theatrical or farcical nature, but already he was looking ahead to a series of sketches which he wanted to call 'The Parish' and also to a 'proposed Novel'. It is rare for a young writer to have such purpose and direction but, as is so often the case, external circumstances began to match his own internal self-confidence: in 1834, just one year after the publication of his first story, he was employed as a parliamentary journalist, reporter and theatre reviewer on the *Morning Chronicle*. He rapidly attained a certain eminence among his journalistic contemporaries – one of the aspects of Dickens's genius lying in the evident fact that whatever he did he did *well* – but, more importantly, he was soon writing sketches of a descriptive and social nature for that newspaper. Even as he travelled all over the country to attend election meetings, even as he visited the theatres of the metropolis to see the latest melodrama or burletta, he was observing everything around him and widening his range. That is why, late in the same year, he found his most enduring theme in a series entitled 'Sketches of London' which he published in the *Evening Chronicle* – this was a tri-weekly offshoot of the *Morning Chronicle*, and was edited by a certain George Hogarth, whose daughter was in fact later to marry the young and rising author.

Everything was coming together, therefore, as Dickens was engaged in the most pressing and formative stage in any writer's development: he was learning about the resources and possibilities of his own style, literally finding out about his own creativity as he went along. The sketches he wrote for both the morning and evening editions of the *Chronicle* were

couched in a very different tone from his more stylised and more conventional stories: they were filled with precise observation and with urban detail, and they tended to be written in a much more impassioned manner; where the stories had been enlivened by ironical and sometimes acidic wit, the sketches are both more benign and more purposeful. In the stories he is transfiguring the world in the light of his own theatrical preoccupations: in the sketches he is more concerned with interpreting it. And so he worked on, often writing until dawn after spending the larger part of the night transcribing parliamentary speeches in short-hand, sometimes ill and almost always exhausted. He was at the same time courting Catherine Hogarth, and yet he never allowed his amatory preoccupations to interfere with his real work: he knew what it was necessary to do in order to achieve the fame he so assiduously sought. He never gave up.

Within a relatively short period, his efforts were rewarded. His stories and sketches had already been favourably received (he even achieved the unwelcome distinction of being 'pirated' by periodicals in the United States) and, in the autumn of 1835, he was approached by a publisher with the idea of collecting his various journalistic works into a two-volume set — with engravings by George Cruikshank, the most famous illustrator of his day. It was to be entitled *Sketches By Boz*, after the pseudonym which Dickens had given himself the year before. Of course Dickens accepted the offer; it was what he had always wanted, and he was soon editing and amending these occasional pieces in order to render them fit for publication in more permanent form. That is why the essays and stories in modern editions are not quite as they were originally written: there were in fact several editions of the *Sketches* during Dickens's lifetime, and he took the opportunity of revising them in accordance with the demands of the time as well as of his own changing taste. He removed topical allusions, softened the occasional harshness and amended the more tasteless jokes. And yet one thing did not change: they were a great success on

their first appearance, and they have remained so ever since.

Yet what kind of success was it, that has lasted so long? What accounts for that strange energy which seems to vibrate through them, and which makes them so much a record of Dickens's own momentum through the world at this triumphal period of his life? He was, for one thing, working very close to home; he was working very close to his own experience, in other words, and finding there the first lightning rod of his genius. Many of his stories and sketches, for example, take as their theme the vanities and hypocrisies of semi-genteel social life or the perils involved in trying to clamber across the ordinarily well-determined class boundaries: these were precisely the problems which beset him and his frequently impoverished family. But, more strikingly, he was ready to use material which simply, to use Mr Micawber's famous phrase, 'turned up'. One example may suffice. His father, John Dickens, was placed in a detention house for debtors on one of the many occasions when he could not pay for what he had so readily purchased or borrowed: his son went to great lengths to release him from his unfortunate circumstances, but then only two months later used the same scene and setting for 'A Passage in the Life of Mr Watkins Tottle'. He was grabbing almost blindly at the material which was closest to hand: this may have been because he was in urgent need of ideas and stories for what was fast becoming routinely hard labour but, perhaps most importantly, it suggests the creative self-confidence of a writer who knew that in such scenes and among such circumstances he had found his true theme.

Indeed in this earliest volume of Dickens's published work there can be seen in embryo almost all of the novelist's more mature characteristics. There is first of all the comedy; there is no funnier writer in English than Dickens, and in many of the urban sketches, as well as in most of the stories, there is that sharp and sometimes even hysterical humour which is so typical of him. There is the comedy of shiftless street life – 'Niver mind . . . niver mind; *you* go home, and, ven you're

quite sober, mend your stockings' – and the comedy of dom-
estic existence. But there are more specific resemblances with
his later work. In one of the first stories, 'The Bloomsbury
Christening', first published in April 1834, Dickens evokes an
early version of Ebenezer Scrooge in a certain Nicodemus
Dumps as well as an embryonic happy family of appropriately
Dickensian nature in the Kitterbells. But it is not only the
comedy of his mature novels which is prefigured in these
sketches: there are also the same great waves of pathos and of
melancholy. So it is that, at one point in his description of
Christmas time, he alludes to the fact that 'One little seat may
be empty . . .' and raises the early ghost of Tiny Tim. And
that is the most important characteristic of Dickens's writing
from the beginning: where there is comedy there is also sor-
row, where there is farce there is also pathos. They come to
meet us in a thousand shapes, in that veritable stage army of
characters which populates Dickens's imagination – in the
simpering young women and acid-visaged old ones, in the
priggish men and the oafish men, in the wide-awake children
of the streets and in pathetic orphans, in the reckless and the
cowardly, the shabby genteel and the virtuous poor. And this
is the most extraordinary thing of all – at the age of twenty-one
and twenty-two Dickens was already creating the world which
would live for ever in his fictions.

At the time it was described as a world of 'every-day life'
and 'every-day people', which on one level was true enough –
even if the full force of that truth may now escape us. For the
salient point is that the great success of these stories and
sketches sprang from the fact that, for the first time in English
fiction and English journalism, the morals and manners of
what we might term the 'lower-middle-class' had been brought
brilliantly to life. Whether it is the clerk struggling to maintain
a large and growing family, whether it is the householder liv-
ing in Poplar with marigolds in his garden and 'Beware of the
Dog' hanging on an adjacent gate, a whole class of English
social life was being explored. Dickens's 'startling fidelity' –

that was how one newspaper review described it. And yet it went further than the transcription of one class, however 'startling' that might seem, since Dickens observed and remembered everything. He heard the voices in the London streets and transcribed them directly, down to the employment of the 'w' instead of the 'v'; to read these urban sketches is to eavesdrop upon a now forgotten race. In addition he *saw* directly in front of him whatever he described – this was the claim he made throughout his writing life, and we can see its workings here in the graphic and immediate detail of the sketches themselves, even in the smallest trifle, like that 'solemn lifting of the little finger of the right hand' with which London cab-drivers greeted each other.

How are we to visualise Dickens himself in the midst of all this activity? He was a young man, smartly and colourfully dressed in the latest fashion, with long dark hair, and dark, lustrous eyes. He is a wanderer, and one who can never resist joining a crowd and watching what is *going on*. He cannot observe a scene without imaginatively participating in it; he cannot see characters without seeming to be almost literally possessed by their emotions. For him a thought becomes an impression, an impression an hallucinatory reality. He perfectly understood the vigour and disorder of the city, therefore, and indeed he has so much energy that he is able to live through a thousand imagined existences and incidents. He wanders through Vauxhall Gardens, or the Seven Dials; he visits Greenwich, or Newgate. He listens to the conversations of solemn men in public houses, and then walks through Monmouth Street and meditates upon the lost features of those who once inhabited the second-hand clothes on sale there. And what are the subjects that move him? The condemned men in prison, the poor, the vagrants, the outcasts, the forgotten children – forgotten as he once had been when he worked in the blacking factory of Hungerford Stairs . . .

That is the other aspect of the sketches and stories, and one which may in large part account for their power still to move

us. For it is in these earliest writings that Dickens, as if by instinct, reworks the entire course of his life up to this point. In essays such as 'Doctor's Commons' and 'A Parliamentary Sketch' he provides some evidence of his own work as a short-hand reporter, for example, just as in 'Private Theatres' he takes us on a tour of the urban entertainments which amused him as a youth. But there are darker shadows, also, and harsher tones – in 'The Streets', he recollects his own observations of London when he seemed to have been cast away into its very depths. He recalls what it is like to be poor amidst the prosperity of others, to be houseless in front of the homes of the more fortunate, to be alone in a city filled with crowds. In fact there are stories here which are tragic in their intensity, and if there is one line which seems to echo through all of Dickens's novels it is that of the small child: 'Mother! dear, dear mother, bury me in the open fields – anywhere but in these dreadful streets . . . they have killed me.' Here, then, are the very beginnings of his genius; it is recognisably and memorably the world of the 1830s but it is also Dickens's own private world, filled with characters and incidents and phrases which will survive as long as the English language itself survives.

The Pickwick Papers

T HE NOVEL which was to make Charles Dickens immortal was initiated almost by chance. In February 1836, in the month of his twenty-fourth birthday, he had published his first book. His debut has been successful enough to warrant a visit two days later from a certain publisher, William Hall, who wanted to put a suggestion to the rising author. He called upon Dickens in his lodgings in Furnivals Inn and found a young man, to use another contemporary's description, with 'eyes wonderfully beaming with intellect and running over with humour and cheerfulness' and with an energy 'that seemed to tell so little of a student or writer of books, and so much of a man of action and business in the world'. And what did Dickens see? He saw the man who, two years before, had sold him over the counter a copy of the *Monthly Magazine* in which his first published story had appeared. The omens, then, were propitious.

Hall then proposed his idea. He wanted Dickens to write a story in monthly serial parts – or rather he wanted the young author to provide the commentary, or letterpress, for the illustrations of a certain Robert Seymour. Each monthly episode was to narrate the exploits of a group of Cockney sportsmen (a popular theme at the time) who were to be called the Nimrod Club. Dickens was asked to write some twelve thousand words each month, for which he would be paid approximately thirteen guineas. He accepted immediately, not least because he needed the money. He was about to get married, and to move into larger lodgings, and, as he told his fiancée, '. . . the emolument is too tempting to resist'. But that cannot have

been the only reason for the alacrity of his response: he had a shrewd notion of his own possibilities, just as he had an instinctive sense of his own destiny, and it is hard not to believe he knew that at last he was coming into his own. There comes a moment in the life of any young writer when, suddenly, everything is changed; Dickens realised that moment had arrived.

Certainly he was confident enough to promise to deliver the first episode at the beginning of March, only three weeks away, and the second at the end of the same month – and this despite the fact that he was also writing plays, sketches, and working full-time as a parliamentary reporter for the *Morning Chronicle*. Indeed his self-confidence was such that, even before he began, he decided drastically to change the scope and nature of the project: he told his publisher that he had decided to range more widely than their original idea and would not, in any case, work directly from Seymour's drawings. He declared, instead, that the illustrator should take subjects from the text itself: it was Dickens, after all, who would decide the characters and the story of this new venture. Throughout his career, in fact, he never played a subsidiary role towards anyone. He insisted always on being preeminent.

After he had successfully asserted himself he was ready to begin but, first, he needed a title and a hero. He thought of the name of a coaching proprietor from Bath which he had seen on his frequent reporting excursions for the *Morning Chronicle* – that name was Moses Pickwick, and so *The Pickwick Papers* was born. Dickens sat down at his desk, on 18 February 1836, and wrote 'The first ray of light which illumines the gloom, and converts into a dazzling brilliancy that obscurity . . .' It was the first morning of *The Pickwick Papers*, and the first morning of what we can without exaggeration term Dickens's new life. He introduced Mr Pickwick and the associates of his club, and almost at once thought of Mr Jingle, the first and still one of the funniest of his comic creations – Mr Jingle whose 'air of jaunty impudence and perfect

self-possession' so attracted Dickens's warmest sympathy and approbation. By the time he had introduced this gentleman, in the second chapter, he had also brought his narrative to Rochester – the site of his own happy childhood before he was removed to London and the blacking factory. Everything was coming together in a story which would associate, in miraculous combination, his own history and temperament with those of his age.

He was working quickly because of his own 'perfect self-possession'. *The Pickwick Papers* had been commissioned as a result of the reputation he had acquired for his previous stories and sketches, and there is no doubt that he saw this latest work as an extension of his occasional journalism and fiction. So he worked on instinctively, happily, almost unself-consciously, enlarging upon the stray associations and ideas which had first occurred to him, fashioning a firm narrative from the threads of his original nebulous design. It was not yet quite a novel, but it was already the most sustained and comprehensive work he had attempted. In fact he was buoyed up by all the life around him now – he was married at the beginning of April and allowed himself an unusual break from his work to make way for his honeymoon – until an unexpected eventuality seemed about to ruin everything. His illustrator, Robert Seymour, shot himself.

Without an illustrator there could be no monthly series – and, without a monthly series, perhaps no more Dickens . . . So a desperate search was undertaken for a replacement. Robert Buss was chosen for a few weeks and then abruptly dismissed. And then the author found his true companion – Hablot Knight Browne, a young man of shy demeanour and quiet manners, an unassuming artist who could be relied upon to accede to Dickens's demands in almost every particular. He seemed the ideal choice, and indeed over the next thirty years he proved to be precisely that – as 'Phiz' (the name he chose to complement Dickens's pseudonym, 'Boz'), he was to illustrate most of Dickens's novels and to lend them that

particular visual flavour which has always been part of their appeal.

It was in these spring and summer months of 1836, then, that we see the first outlines of the author who was to dominate the English novel. He knew that this was the work for which he was destined, and his energy and exuberance (not to mention his inventiveness) were such that, in this same period, while he was still working as a reporter for the *Morning Chronicle*, he committed himself to five more books as well as two stage plays. The manuscript of *The Pickwick Papers* tells its own story: written in a clear, confident, large hand it has few corrections or second thoughts. It flows on magnificently, as the adventures of Mr Pickwick move on through Dingley Dell and Eatanswill and Bath. If there is one remarkable characteristic of the novel, it is that energy, that momentum, so much expressing the vitality of a young man who walked gladly towards his fame.

He was engaged upon quite a new thing in literature although, as is often the case, very few seemed to notice that fact at the time. For although there was a tradition of publishing old or established novels in monthly parts, this was the first time that a new work had been issued in such a manner. The novelty of the format is reflected also in the novelty of the enterprise: it was not a novel in the familiar three-volume style, and it certainly was not occasional journalism. It was a new and intriguing hybrid, and the fact that Dickens did not feel himself to be in any sense oppressed by the weight of literary tradition actually liberated his genius: he was not writing 'up to' any particular model and felt free to experiment, invent, or modify as he went along. He started to include short stories (generally of a horrific nature) within the narrative, and he introduced topical detail – the latest trial, and the latest scientific invention, were both exploited as part of his design. That is why *The Pickwick Papers* is filled with the spirit of the age, as if all the energy and optimism of those first decades of the nineteenth century had infused it with life. And yet, as

we shall see, the life is also that of Charles Dickens – who, as he progressed with the narrative, began to discover precisely what he was capable of. Just as a character like Mr Pickwick is enlarged and refined as the book proceeds, so that he ceases to be a mere object of fun and becomes something like a figure of universal benevolence, so Dickens's own sense of his powers is extended and enlarged.

His confidence grew, of course, when he began to realise the extent of his success. The printing of the first number was something close to four hundred copies: by the time of the last, it had reached forty thousand. The popularity of the serial (for this was how it seemed to its first audience) could be measured from the fourth number – a number, perhaps coincidentally, which first introduced Sam Weller and which first contained the illustrations of Hablot Browne. The appearance of Sam Weller was, in the short term, the more important of the two fresh aspects of the novel because Weller, with his Cockney wit and the sometimes arch peremptoriness of his manner, brought a new range of humour into English writing. There had been elements of it on the stage before, in the work of such impersonators as Charles Mathews (whom Dickens always admired), but it had never been employed on quite this scale and with this elaboration. It can be said with some justice that Dickens recreated the urban world for a new urban readership.

And, as a result, what a success it turned out to be: *The Pickwick Papers*, according to one contemporary, '. . . secured far more attention than was given to the ordinary politics of the day'. Fashionable doctors read it in their carriages, on their journeys between patients, and judges read it on the bench as jurors deliberated: the less affluent admirers of Dickens's work would press up against the booksellers' windows in order to see the latest instalment. In 1840 the name 'Pickwick' was found inscribed upon one of the great pyramids, and there is the famous story of the dying man who exclaimed, 'Well, thank God, Pickwick will be out in ten days, anyway.' Soon manufacturers put on sale the Pickwick cigar,

the Pickwick coat, the Pickwick hat. It was read by upper-class young ladies in drawing rooms, and by middle-class families in parlours: an early biographer of Dickens remembered visiting a locksmith in Liverpool and found him reading Pickwick '. . . to an audience of twenty persons, literally, men, women and children' who could not possibly have afforded the shilling for each monthly part. So these monthly parts were finding their way everywhere – it was part of Dickens's genius to ride the tide of his times, and it is not simply accident that he was able to inspire and amuse a truly national audience in an epoch when new methods of transportation and distribution meant that this national audience could be reached for the first time.

And yet why was it that *The Pickwick Papers* achieved such national renown, and seemed so signally to entertain and delight the nation? There was the novelty of the enterprise, of course, and the fact that it seemed to contain within its pages the moving spirit of the age itself. And there was also its wonderful and ubiquitous comedy, a comedy in which, characteristically, disaster is averted at the last moment: it was the comedy of the pantomime, which Dickens had loved as a child, but it had never before become the animating principle of a novel. It is also an enduring comedy: the comedy of Dodson and Fogg, of Serjeant Buzfuz, of Mrs Bardell, of the Fat Boy, of Bob Sawyer and Augustus Snodgrass, let alone that of Sam Weller and Alfred Jingle; this novel is as funny now as it was to our ancestors. Its characters are the first inhabitants of Dickens's comic kingdom, a gallery of creations which has never been surpassed or even equalled.

But that comedy was also implicated in a larger theme, for there is in the pilgrimage of Mr Pickwick some echo of that myth of innocence and peace, of ease and reconciliation, which is one of the enduring features of Western literature. Yet that mood of fullness and reconciliation could not help but have a specific relevance also, since in the very pattern and design of the narrative there was a strong and emphatic

yearning for the reconciliation of classes, for the reconciliation of families, for the nation itself to be characterised by union and brotherhood. These themes – so timely in an age when the 'condition of England question' was about to become of paramount concern and when industrialism was provoking its own forms of unrest – were couched within a narrative that also seemed to exemplify all of the energy and optimism of the early Victorian period: not just its vitality but its extravagance and its theatricality, its belief in progress and the possibility of change, its triumph over the past.

And yet none of this would have been of any account were it not for the strange alchemy of Dickens's genius. He recreated himself in *The Pickwick Papers* just as the age itself was re-created within his own life, for all the energy and optimism were also Dickens's characteristics at this time of great progress and creativity in his own career. He stood in symbolic relationship to his time, not least because the very vitality of his prose marked his own rise out of difficult circumstances and his triumph over his own past. In the pages of the novel itself there are echoes and intimations of his unhappy childhood – the scenes in the debtors' prison can be taken as a reflection of his visits to the Marshalsea Prison where his father was incarcerated for debt, and the memories of Lant Street in the novel are Dickens's own memories of the time when he took lodgings there to be close to his imprisoned family. There are other associations, too: his account of the clerks in the legal offices of London are a direct link to his experience as just such a clerk in just such an office. So Dickens's life is mirrored here, too, but within a narrative that triumphs over his own frustrated childhood just as surely as Pickwick himself triumphs over all the tribulations and defeats which at one stage seemed to hem him round. And, in that collaboration of author and hero, we see the nation itself: in Dickens's imagination, and no doubt in the imagination of his readers, is a story moving forward ineluctably to a time of fullness and prosperity. Thus a great novel is created.

It was in recent years fashionable to decry *The Pickwick Papers*, at least in comparison with such triumphs of Dickens's later style as *Our Mutual Friend* and *Little Dorrit*: this in turn neatly reversed the common Victorian opinion that all of Dickens's later novels represented his 'dotage' and that his purest spirit – what used to be called the spirit of his 'fun' – is to be found *in excelsis* in Pickwick. There is a partial truth in both attitudes – certainly *The Pickwick Papers* marks the first dominant stage of Dickens's achievement, and as a 'picaresque' novel it was not surpassed by anything which he subsequently wrote. It represents a triumph of the comic spirit and, even if it is not as carefully constructed or as elaborately plotted as his later novels, it has a warmth and vivacity which the passage of time will never dim. It is like a shout of laughter, ringing forever in our ears.

Oliver Twist

O LIVER TWIST, the novel which perhaps more than any other was in later years to be associated with Charles Dickens's name, began almost by accident. The circumstances were these: he had already written some eight monthly instalments of *The Pickwick Papers* when a publisher, Richard Bentley, approached him with the offer to edit *Bentley's Miscellany*; this was to be a monthly magazine which would publish the best of contemporary writing and, since Dickens was now widely regarded as the most promising novelist of his day, he was in a sense the most obvious choice. He had no real experience of editing but, as usual, nothing hindered his self-confidence or his energy; he readily agreed, and almost at once resigned from his post as a newspaper reporter on the *Morning Chronicle*. He was always very practical in financial matters, and no doubt he calculated that his income as an editor would be a reasonable substitute for his income as a journalist. He was not at this point banking, literally or otherwise, on his reputation as a creative writer.

Nevertheless he had also agreed to contribute to the new magazine he was about to edit and in its first number, published in January 1837, there appeared a sketch with the title, 'The Public Life of Mr Tulrumble'; it is an entertaining satire on the idiocies of those who wish to set themselves up in 'authority', and showed Dickens's usual command of idiom as well as his gift for satire at the expense of pride and hypocrisy. It was set in the fictional town of Mudfog which, to all appearances, is a veiled version of Chatham – the naval town where Dickens himself grew up. It was in Mudfog, too, that the

second story began in the next month's issue of *Bentley's Miscellany*; more specifically it began in the workhouse at Mudfog, with the birth of an infant boy, and this similarly short sketch was entitled 'Oliver Twist'. And so it began. The famous novel started life as one of a series of fictions, although almost at once it occurred to Dickens that he had hit upon a 'capital notion' in his picture of Oliver himself – the workhouse boy who is farmed out to a disagreeable employer before running off to London and unwillingly entering the life of Fagin's den.

George Cruikshank was the illustrator of *Bentley's Miscellany*, and was in later years to claim that it was he who originated the idea of little Oliver and who suggested the plot of this parish boy's 'progress' through all the wickedness of London before his eventual rescue and redemption. In fact this is highly unlikely – Dickens, of all writers, was not the kind to take ideas from other people, however distinguished they might be, and in any case all the forces of his own life would have prompted him into the creation of just such a novel and just such a hero. He hardly needed the advice of anyone else – for he was set to write a parable out of his own childhood.

It has been well said that *Oliver Twist* is the first novel in the English language to take a child as its central character – and how could it not be so, when the author's own childhood still simmered just below the surface of his adult career, and was to remain his most prominent memory? It may be as well to remember a few facts about that childhood in order properly to understand the adventures of little Oliver in his search for love and security.

Dickens had been brought up in Chatham (the birthplace of Oliver Twist himself, as we have seen), and his early life seemed as stable and as peaceful as that of any other child from a 'respectable' family; he went to a local school with his sister, was devoted to such books as *The Arabian Nights* and *Roderick Random*, and by his own account harboured dreams of growing up to be a famous and successful man. Then every-

thing was taken away from him, and at the age of ten his happy childhood was torn in half. His father was compelled to move to London, in order to take up a new post in the Navy Pay Office where he worked, and the young boy found himself in a narrow house beside the straggling fields of Camden Town. There was no longer any chance of an education for him and he spent his time acting as a sort of unpaid servant for a household which now contained some five children. But worse was to follow: his father was always notoriously impecunious and, when the opportunity came for the young boy to earn a salary of six or seven shillings in a blacking factory, it was taken at once. So it was that the young Dickens went to work at Warren's Blacking just off the Strand – a decrepit and crumbling warehouse beside the dirty river at Hungerford Stairs, filled with rats, which was later transformed into Fagin's own house in *Oliver Twist*. But the shillings which the boy earned were not enough to save his father from impending bankruptcy, and only a few days after his arrival at Warren's Blacking John Dickens was incarcerated for debt in the Marshalsea Prison beside Borough High Street. Lodgings were found for Charles Dickens close by, while the rest of the family stayed with the father in the gaol itself. Now Dickens's young life took on a new and sombre pattern: he had his breakfast with the family within the very walls of the prison and then walked to work in the crumbling warehouse. In the evening he returned to the prison for his evening meal. How great a change it was from his happy and relatively prosperous childhood at Chatham and, indeed, Dickens was to write in his autobiographical account of these dolorous London experiences that 'my old way home by the Borough made me cry, after my eldest child could speak'.

It is not hard to understand, therefore, why the sudden creation of the workhouse boy, Oliver Twist, should at once appeal to Dickens as a 'capital notion', for all the sorrows of his own childhood could be placed somewhere in the history of this sad child, reduced to beggary and want in London be-

fore being rescued by Mr Brownlow – and then (in perhaps the most painful episode of the novel) lost again and consigned to Fagin and darkness before being finally redeemed. It is as if Dickens could not conceive of this fictional infant without letting loose upon him in exaggerated form all the indignities and injustices which he believed to have been heaped upon his own younger self.

There are closer associations, too. The insidious and avaricious Fagin, one of the author's greatest monsters, took his name from a certain Bob Fagin – a boy of Dickens's age who was one of his working companions in the warehouse. But the real Bob Fagin was in Dickens's own account a kindly and sympathetic child – and that is the point. He was turned into the hideous Fagin precisely because his kindness and fellow-feeling threatened to bring the young Dickens down to the level of what he called 'common men and boys', towards the disorder and the dirt and the darkness which he spent the rest of life trying to escape. It might be remembered here that, throughout his ordeals, young Oliver Twist behaves and sounds like the little gentleman he seems implicitly to have believed himself to be – and indeed, by the end of the novel, in a dénouement which was as difficult for Dickens to arrange as it is for the unwary reader to unravel, he is proved to be a gentleman after all.

It is not at all clear, however, that Dickens realised that he was working through the memories and fantasies of his own childhood; in many ways, despite the great self-control he exerted within his art, he always remained on one level an instinctive and fluent writer – a novelist who had to work himself up into a kind of passion before he could compose effectively, who could no more have stopped himself from creating Fagin than he could have stopped breathing, who in fact at a later date explained how that character plucked at his sleeve and would not let him rest. That is why *Oliver Twist* has the clarity yet lack of definition which is customarily associated with the fairy-tale. It is the strangest amalgam of dream and reality,

fantasy and truth, in part a reworking of his childhood fears and in part a direct transcription of them, that is why it is also so peculiar and yet seductive a combination of the theatrical and the real – precisely because Dickens could scarcely, at this stage in his life, recognise the difference between them. In his waking life there was no more practical and realistic person, and yet he was always intensely theatrical in his dress and manner: he was always busy, active, business-like, and yet he was often helplessly ensnared in his memories of the past and willingly cast himself into a dream-like state of writing when all the buried fantasies and fears of his life return in powerful form. All these things were blended together, to make him what he was and to make *Oliver Twist* so wonderfully hetero-geneous an achievement.

And yet it would be wrong to suggest that this novel was a wholly private or self-communing statement. It was in fact caught up in the most pressing issues of the day, and indeed was seen by many of its first readers (especially the newspaper reviewers) as a direct assault upon the provisions of the New Poor Law – specifically in the attempt of that legislation to break up poor families in order to discourage them from claim-ing relief. Oliver Twist's request, 'Please, Sir . . . I want some more', was in fact a direct satire upon the dietary provisions for the inmates of workhouses, and suggests that Dickens was deliberately attacking what *The Times* called 'BENTHAM-ITE cant'; that was also why the same newspaper published extracts of the novel alongside its editorial comments. So Charles Dickens was working both as a journalist and as a novelist, just as he had in *The Pickwick Papers*, but perhaps most importantly he was for the first time adopting a role as a social commentator who through his fiction might help to alleviate the nation's ills.

He knew of these ills at first hand, and not just through the medium of his own unhappy childhood. Soon after beginning *Oliver Twist* he had moved to Doughty Street, with his wife and first child; it was an imposing house in a fashionable street

and was very much in keeping with Dickens's own astonishing rise to public prominence, but its relative grandeur did not militate against the fact that it was only three or four minutes' walk away from Field Lane and Saffron Hill – one of the very worst spots in all of London, and the precise area where Dickens had located Fagin's den. Everything was close to him: his own childhood in his imagination, and the doomed children of the urban poor all around him. He saw all the misery and disease like a miasma in the streets so close to his own; then he sat in his study in Doughty Street and fashioned out of them the London scenes of *Oliver Twist*. Yet he was not only working on that novel (or, rather, what at this stage we should still call a series for his magazine). Even as he composed *Oliver Twist*, he was also writing his monthly instalments of *The Pickwick Papers*, and one of the most astonishing features of this astonishing writer is the fact that, so early in his writing career, he should have been able to produce two novels at once – one of them broadly tragic or melodramatic, one of them essentially comic (although of course the moods interpenetrate each other, and cannot really be separated), and both of them among the most famous novels in the English language. And he was still only twenty-five years old.

But then something happened within the walls of his house in Doughty Street, something which was to change everything – change, even, the shape of *Oliver Twist* as Dickens continued upon it. His marriage to Catherine was by all accounts a happy one, and that happiness had been materially increased by the frequent presence of Catherine's younger sister, Mary Hogarth, as a guest in the house. She was seventeen years old at this time, and Dickens seems to have lavished all the affection and playfulness of his nature upon her: she had become something like a second sister, in whose company he could revive the happiness of his earliest childhood. But then, quite suddenly, in a small bedroom in Doughty Street, she died from heart failure. Dickens was devastated by the event, and it can fairly be said that he never fully recovered from the

shock of this loss. Indeed in his almost hysterical reaction to his sister-in-law's death one can sense something of his essential oddness. He put her clothes in a wardrobe and over the years took them out from time to time in order to look at them; he expressed the passionate desire eventually to be buried in her grave (in fact he ended up in Westminster Abbey); he dreamed of her every night for almost a year; and even after that dream image had disappeared, her spirit still haunted his fiction. The words 'Young, Beautiful, and Good', which he inscribed on her tombstone, were the very words he used about Rose Maylie, who was to become the heroine of *Oliver Twist*.

But he could not embark again upon that story, not yet: the shock of Mary Hogarth's death had been so great that, for the first and last time in his life, he postponed his work. No episode of *The Pickwick Papers* or of *Oliver Twist* appeared that month. Instead he went with Catherine to Hampstead, in order to rest in those rural surroundings; and when eventually he returned to his desk, his whole conception of *Oliver Twist* seems to have changed. He recreated Rose Maylie in the image of his dead sister-in-law, of course, but even before that happy resurrection much of the topical and polemical intent of the novel is abandoned and Dickens introduces a slower, more melancholy note which comes to pervade most of its subsequent pages. In fact it can be said that Dickens now introduces something of English Romantic poetry – Wordsworthian, in particular – into his fiction, and it has often been claimed that it is precisely this new presence which marks the true distinction of *Oliver Twist*. Dickens brings into his novel ideas of innate beauty, of childhood innocence, of some previous state of blessedness from which we come and to which we may eventually return. It is in these passages that his prose seems instinctively to move with poetic cadence and diction. It is as if the death of Mary Hogarth had broken him open, and the real music of his being had been released – and how powerful it becomes when it is aligned both with his helpless

memories of his own childhood and with the greatest extant tradition in English poetry.

These elements constitute the power of *Oliver Twist* but, by themselves, they do not account for its entire appeal – there is also the hysterical humour of Mr Bumble, the high spirits of the Artful Dodger, the horror of Fagin, and the brutality of Sikes. That is what Dickens meant when, in one chapter, he described the mingling of 'the tragic and the comic scenes' as resembling layers in 'streaky well-cured bacon'.

He wrote these words when he was working very rapidly indeed – it was in October of 1837, some six months after the death of Mary Hogarth; by then he seems to have recovered his verve, and the fact that he had just finished *The Pickwick Papers* seems to have added extra energy to his quill-pen. It was in this period, too, that he decided to alter the shape of *Oliver Twist*. He transformed what had been essentially a monthly series into a proper novel with a circular and, some would say, circuitous plot: it may well be that the new poetry of the narrative, as well as the care he was taking over the portraits of Rose Maylie and of the prostitute, Nancy, convinced him that it was worth reformulating the story in more serious terms. Certainly he decided that it would no longer be simply a parish boy's 'progress' but would instead be a more complex narrative which could hold together all the fears and fantasies and desires which he had been elaborating. In fact he did not finish the book until late in 1838 (characteristically by then he had started working on his next novel, *Nicholas Nickleby*), and wrote its last words only after exhausting himself over the extraordinary scenes in which Nancy is clubbed to death by Sikes. He pretended to be out of town in order to work in a continuous fashion upon these closing chapters, and he informed Richard Bentley that '. . . I am doing it with greater care, and I think with greater power than I have been able to bring to bear on anything yet . . .' Nancy is killed; Sikes flees; Fagin spends his last hours in the condemned cell.

Dickens wrote the final six chapters in three weeks and, at

the close, he did not want to leave behind any of the characters whom he had created and who had so entranced him. 'I would fain,' he wrote, 'linger yet with a few of those among whom I have so long moved . . .' In a sense he did linger with them – towards the end of his life he recreated in dramatic form the murder of Nancy by Sikes, enacting both parts himself, and many people believed that it was the effort of dramatising that murder which in fact killed him. Perhaps it could be said that *Oliver Twist*, the novel of its creator's first youthful and enthusiastic creativity, eventually caused his death. Yet this was far off, in a future more mysterious and extraordinary than anything which Dickens could have imagined for himself. At this stage he was aware only of the powers he harboured within himself, and of the direction in which he ought to travel. '. . . This marvellous tale . . .' he said of *Oliver Twist* after he had completed it. For the first time he put his own name on the title page (*The Pickwick Papers* had been simply 'edited' by 'Boz') and in later years he was to revise it more often than any of his other works. He realised that the orphan boy's adventures in the world elicited all that was most powerful in his nature and his writing – his buried memories of his own childhood, his poetry, his satirical and savage humour. These are still the qualities which are to be found within it, and which ensure its permanence.

Nicholas Nickleby

I T IS appropriate that *Nicholas Nickleby*, a novel so much concerned with journeys, with rushing forward, with energetic hurry, should itself have been initiated by a journey. It was at the close of January 1838 that Charles Dickens and Hablot Browne travelled by coach to Yorkshire on a trip which took the better part of two days. It was not a whimsical or haphazard journey, not one of Dickens's 'jaunts' with the sole motive of letting off a supply of his always extravagant energy; this was a journey with a destination, and a purpose. He had for some weeks been contemplating a new novel; he was still composing *Oliver Twist* but in October 1837 the final monthly instalment of *The Pickwick Papers* had appeared and Dickens had promised its publishers, Chapman and Hall, a new work which could also be issued in monthly parts. The fact that he would once again be working on two novels at the same time did not seem to affect his calculations: he was only in his twenty-sixth year and no task, no expenditure of energy, seemed beyond him. And he was also filled with youthful ambition – ambition for himself, naturally, but also ambition for his own art. That is why, despite the extraordinary success of *The Pickwick Papers*, he had no intention of simply following the same pattern. No doubt his publishers, and his audience, would have been happy with a reprise of the familiar manner; but Dickens was a true artist from the beginning, and knew instinctively that in his fiction he could never stand still – that he had to develop, move on, hurry forward just as he was now hurrying forward with Hablot Browne to the north of England.

Their destination was the small Yorkshire village of Bowes;

it was on the moors, near the River Greta, but more importantly it was the site of a school or 'Academy' run by one William Shaw. Dickens wrote a note in his diary that evening: 'Shaw the schoolmaster we saw to-day, is the man in whose school several boys went blind sometime since, from gross neglect . . . Look this out in the Newspapers.' In fact he had hardly any need to look in the 'Newspapers' at all, since he had already found precisely what he was looking for. The point was that he had come up to Yorkshire specifically to discover something about the notorious 'schools' of this region, where unwanted children were consigned (or, rather, abandoned) by parents or relations. It was an old scandal and, as Dickens eventually wrote in his preface to the first Cheap Edition of *Nicholas Nickleby*, he '. . . came to hear about Yorkshire schools when I was a not very robust child, sitting in bye-places near Rochester Castle, with a head full of Partridge, Strap, Tom Pipes and Sancho Panza': the fact that Dickens dates his knowledge of these schools to his own infancy suggests at once the association which comes fully to life in the novel itself. Dickens was so obsessed with his own difficult and often unhappy childhood that the full force of his pathos was always poured into the presentation of miserable or afflicted children – that is why, at the thought of Yorkshire schools in which the 'scholars' were little more than prisoners, all the alarm bells of his nature rang out.

But his was not simply a nostalgic or pathetic interest in the subject; he had realised from his attack upon the New Poor Laws in *Oliver Twist* that he was already being taken seriously as a novelist of topical and even propagandist intent. Indeed, portions of *Oliver Twist* had even been reprinted in *The Times*. '. . . what a thing it is to have Power', he was on a later occasion to say, and there seems little doubt that he realised even now the possibilities of that 'Power', in attracting public attention and channelling public outrage. So it is that he inspected Bowes, talked to the local people about the various scholarly establishments in the neighbourhood (with especial

attention to that of William Shaw), took his own impressions of the area, and even wandered around the local churchyard where he found the graves of no less than thirty-four boys who had died while attending the various cheap schools of the district. It was while looking upon the tomb of George Ashton Taylor, he said later, that 'his ghost put Smike into my head, upon the spot'. He had seen enough, in other words, and little more than a week later he and Browne were back in London. He returned to his study in Doughty Street and, after a fitful and uneasy start upon the first chapter, soon found that he was working as easily upon this new novel as he had upon *The Pickwick Papers* and upon *Oliver Twist*. Those who are interested in seeing first-hand evidence for the facts adduced here might care to visit the Dickens House Museum, in Doughty Street, and inspect there certain manuscript pages of *Nicholas Nickleby*: they contain the letter written by Fanny Squeers, in which she complains about Nicholas Nickleby's behaviour in attacking her father before the boys of Dotheboys Hall. It is perhaps the funniest letter written in the English language – certainly one of the funniest passages in English fiction – and yet it is clear from these manuscript pages that the young Dickens simply wrote it out without emendation or second thoughts. The humour emerges from him without impediment.

The same facility had marked *The Pickwick Papers* and *Oliver Twist*, but with this difference – both of those novels had evolved almost accidentally, or fortuitously, but their success meant that Dickens was now more certain of what he could achieve and more sure of the means by which he could achieve it. That is why *Nicholas Nickleby* seems to begin in the same picaresque, freewheeling mode as *Pickwick* while all the time he was holding in reserve, as it were, the full force of his assault upon the iniquities of the Yorkshire schools. He was attaching the humour of *Pickwick* to the topical seriousness of *Oliver Twist*, and it was without doubt an effective combination: the first number of *Nicholas Nickleby*, pub-

lished in March 1838, sold fifty thousand copies and the sales
did not noticeably decline for any of its twenty monthly instal-
ments. The extent of its popularity may also be measured by
Dickens's success in attacking the abuses of the Yorkshire
schools themselves. For although it can hardly be said that his
strictures against the New Poor Law in *Oliver Twist* had any
effect upon that legislation, it can fairly be argued that his
exposure of educational privation and abuse in *Nicholas Nick-
leby* led directly to the closure of the more notorious of the
Yorkshire schools. William Shaw's own school eventually
closed down – it was reported that his caricature as Squeers
destroyed the man, both personally and professionally – and
by 1848 only one such establishment still remained. A school
commissioner reported in 1864 that 'I have wholly failed to
discover an example of the typical Yorkshire school with
which Dickens made us familiar . . .' It was an example of his
influence that the novelist never forgot, and throughout the
rest of his career we will find him launching fiercely satirical
attacks against a variety of social abuses. It was part of his
genius to create something akin to 'magic realism' – powerfully
symbolic novels which move easily within the realms of fan-
tasy and mystery – and yet at the same time to include within
it a range of immediate and topical references.

It would be wrong, however, to over-emphasise at this late
date the propagandistic elements of *Nicholas Nickleby* for it is
primarily, and essentially, a comic work. Indeed it has some
claim to being Dickens's funniest novel, with the Crummles
family, and the Mantalinis, and the Snevelliccis, and the
Squeers family, not to mention Mrs Nickleby and Mrs Julia
Wititterly, adding their own illimitable and idiosyncratic
voices to the general tumult. It is worth remarking here, also,
that he was writing the most comic passages in the novel
at precisely the time he was writing the most poignant and
violent chapters of *Oliver Twist*; his general routine was to
write the month's episode of *Oliver* before embarking on the
next instalment of *Nickleby*, surely another example of that

extraordinarily fine *organisation* which was also part of his genius.

It is worth remarking on this, too, in order to emphasise what in an ideal world would not need emphasising – that Dickens himself is primarily a comic novelist. In recent years it has become fashionable to emphasise the 'darker' aspects of his genius and of his character, as if only a difficult writer can also be a great one. But this is to misrepresent a man whose stated philosophy might best be summed up in his own phrase – 'never *say* die'. Indeed he was described on more than one occasion as the 'cheerfullest' man of his age and, although it would be true to say that he was also marked by melancholy and even anguish, there was scarcely an occasion when he could not be found breaking out in laughter. There are many reports of his 'inimitably funny way' and his 'strangely grotesque glances'; he loved to improvise upon the performances of the clown (once, when quite a middle-aged man, accidentally slipping into the bathtub fully-clothed when engaged in a pantomime routine); he was a wonderful mimic and constantly impersonated the conversational foibles of his closest friends; in his high spirits he would sometimes dance the sailor's hornpipe; when engaged in amateur theatricals, he loved to 'gag' or improvise upon the stage.

It could be said that all of these elements of his comedy enter *Nicholas Nickleby* in one form or another, and indeed in this novel he found humour even in the spectacle of misery itself; of the pitiable starved children of Dotheboys Hall, for example, he observed an element of grotesquerie which '. . . might have provoked a smile'. But there is another important aspect of his humour here, since this is by far the most theatrical of all his novels – which is perhaps why it has been staged so successfully in recent years. Of course there is the constantly amusing spectacle of Vincent Crummles and his company, testifying to Dickens's own intense delight in bad acting of every kind. We also move from the prospect of real starvation in Dotheboys Hall to the description of the

wretched Smike by Crummles: '. . . he'd make such an actor for the starved business as was never seen in this country'. In Dickens's fiction the most pathetic realities can at any moment be parodied or ridiculed. But, in addition, most of the characters here are also conceived in terms of performance and the dialogue has all the grandiloquence and stylistic self-consciousness which are associated with the stage. Those who mock at such stereotypes as the innocent Madeline Bray and the miserly Arthur Gride, however, must try to explain the particular, compelling power which Dickens brings to those scenes which contain them. And how could it not be so, in a young novelist whose first and greatest love was the theatre, who had already written stage-plays, and who was himself in later life to become an outstanding amateur actor? Even as a child his instincts were the same: he recalled with delight the times that he stood upon a table in a Rochester inn and sang to his father's friends. All his life, in fact, he wanted to entertain: and it is in continuation of such a spirit that he announced in an advertisement for this novel that '. . . in our new work, as in our preceding one, it will be our aim to amuse, by producing a rapid succession of characters and incidents, and describing them as cheerfully and pleasantly as in us lies . . .' We may think of *Nicholas Nickleby* as the natural successor of the great eighteenth-century novels, of Smollett or of Fielding, but we may also see it as the fullest possible realisation of the English theatrical tradition.

The 'preceding' work which Dickens mentioned in his preface was of course *The Pickwick Papers*, but in many ways *Nicholas Nickleby* bears a closer relation to *Oliver Twist*. In both novels, after all, a young hero is forced to prove his true status as a gentleman while opposing any number of villains who wish to keep him down, to blacken his name, to relegate him to an inferior status. It is not hard to understand how Dickens himself, truly a self-made man forged in what he liked to call 'the battle of life', might view his own struggles in just such a light; and there is indeed in the characterisation of

Nicholas a certain amount of self-identification and implicit self-congratulation. This may also give added point to the general belief that, in the absurd and garrulous Mrs Nickleby, Dickens was attempting a portrait of his own mother – although any such resemblance, as with all so-called 'originals' for Dickens's characters, must be viewed with a degree of scepticism.

But more specifically the hero, and the narrative itself, are filled with Dickens's own determination and wild haste – what he calls 'the extraordinary energy and precipitation of Nicholas' as he embarks upon his adventures in the world. And, in the process, as Dickens wrote so fluently and freely in his study in Doughty Street, we feel the pulsing energy of London itself as it is described in this novel: 'Streams of people apparently without end poured on and on, jostling each other in the crowd and hurrying forward . . .' In *Nicholas Nickleby* it is a city of coincidence and of chance meetings, too, a conjunction of individual fates which emphasises the contrast and variety which the novel displays – a world both real and feigning, where the pathetic and the grotesque, the sentimental and the comic, exist side by side. He was a young novelist who had already enjoyed enormous success: like his hero, Nicholas, the world lay before him. Clearly he believed that he could achieve almost anything; that is why in this novel he introduced romance as well as melodrama, farce as well as tragedy. Some of these elements may now seem a little dated, but the most important of them has survived the passing of the years. It is the sheer comedy of *Nicholas Nickleby* which renders it immortal.

The Old Curiosity Shop

C HARLES DICKENS originally called it 'the little child-story' and, as is peculiarly fitting for a novelist who was also always a journalist, *The Old Curiosity Shop* began life simply as a short piece designed for a weekly magazine he was about to edit. He had been planning to start a new periodical even while he was working on *Nicholas Nickleby*; he proclaimed himself to his readers in the preface to that novel as 'one who wished their happiness, and contributed to their amusement' and it was precisely that role as benign public entertainer which he wished to extend with his new journalistic venture. His idea was a weekly magazine in which a club of characters would tell various stories to one another; there would also be essays and sketches of a more topical nature but essentially Dickens wanted to recreate the kind of magazine he had read as a child and to produce something akin to the eighteenth-century *Bee* or *Spectator*. There would be stories about old London, stories about the past. His childhood reading always haunted him in one fashion or another, and it is appropriate that such an effort of nostalgia and sentiment should eventually lead to the story of doomed Little Nell and her grandfather. Dickens wanted to create a quite different magazine from the wholly topical and modern venture with which he had previously been associated, *Bentley's Miscellany*, and it is important for any understanding of *The Old Curiosity Shop* to realise that in this period of his life he was preoccupied both with his own past and with the past of the city in which he dwelt.

He called his new magazine *Master Humphrey's Clock* and

in his first sketches for it he cast himself in the curious role of Master Humphrey, an old, crippled gentleman who spends his time dreaming of his unhappy childhood – '. . . now my heart aches for that child as if I had never been he, when I think how often he awoke from some fairy change to his own old form, and sobbed himself to sleep again'. There is a powerful vein of self-pity here which is very much Dickens's own, and becomes in that sense the perfect prelude to the wanderings of Little Nell herself. But this misshapen narrator reflects Dickens's own preoccupations in another sense: he is a wanderer who likes nothing better than to walk through the streets of London, lingering upon 'bygone times' or losing his 'sense of my own loneliness' by imagining various scenes and creating stories out of the characters whom he passes during his perambulations. This is similar to Dickens's descriptions of his own behaviour during his many walks through the city, and of course Little Nell is first seen to be lost in the very same streets. She must in fact have been very much like the kind of young girl he would have glimpsed during his solitary wanderings, one of the characteristic Londoners who were brought to life by this first truly urban novelist. It may also be appropriate to note, given the buried sexuality of the novel itself, that such a poor and unprotected girl would either have worked as a prostitute or have been in imminent danger of having prostitution forced upon her. This is not the story of Little Nell, of course, but the highly charged air around her may issue from that source.

But Little Nell had not yet been born. At the end of February 1840, just after he had first propounded the idea of a magazine to his publishers (who, as always, acceded to his wishes), he went down to Bath with his friend, John Forster, in order to stay at the house of Walter Savage Landor – Landor himself being one of those survivors of a previous generation of writers whom Dickens seemed to respect if not necessarily to read. It was while staying here that the picture of the girl first flashed upon him; at a later date Landor himself was to state that he

wished he had set fire to his house so that '. . . no meaner association should ever desecrate the birthplace of Little Nell' – a typical overstatement from a gentleman who was later to be satirised by Dickens as Lawrence Boythorn in *Bleak House*.

Yet at this stage Dickens decided to compose 'the little child-story' simply as one tale among many to be narrated by Master Humphrey in the course of his periodical effusions. But almost as soon as the magazine actually began to appear, in April of the same year, Dickens knew that something had gone wrong. He had thought he could make his fortune from the new venture, and told one friend that he expected to earn ten thousand pounds a year – Dickens's interest in making as much money as he could may come as a surprise to those of a sensitive temperament, but there is no law which prohibits good writers from also being good businessmen. Certainly Dickens was always acutely aware of the financial aspect of his genius. But his great expectations were not being fulfilled on this occasion – the sales of *Master Humphrey's Clock* slumped dramatically after the first two weekly numbers, and Dickens realised at once that his readers had been disappointed. They had, in fact, wanted and expected another novel from him. A collection of heterogeneous stories, even from the pen of Charles Dickens, was no substitute for another *Nicholas Nickleby* or *Oliver Twist*. And, since he never lightly under-estimated the demands or tastes of his audience, he at once changed his plans. He abandoned his original scheme for *Master Humphrey's Clock*, and decided that the story of Little Nell would be transformed into a continuous weekly narrative (he learned fast, and was never to make the same mistake again). So it was that, as Forster put it, *The Old Curiosity Shop* emerged 'with less direct consciousness of design on his own part than I can remember in any other instance throughout his career' (although in fact *Oliver Twist* had a similar gestation), yet it was this same story of Little Nell which made 'the bond between himself and his readers one of personal attachment'.

The strangest accidents of fortune were, in that sense, propelling Charles Dickens onward.

Yet there was also a sense in which it was no accident: Dickens knew instinctively, deeply, what he needed to do. His genius had a momentum which obeyed its own laws. That is why it would be wrong to believe that *The Old Curiosity Shop* became a novel purely by chance – as soon as he had conceived of the character of the girl wandering lost through the streets of London he realised that he had found as rich a vein as that which he had recently mined in Oliver Twist. He told friends that Little Nell soon 'followed him everywhere' and gave him no peace: it is almost as if she demanded her story from her creator, and in the spectacle of Dickens being pursued by the phantom girl we may understand one of the more curious aspects of his imagination. For he used to say that he literally *saw* his characters, and *heard* them, even as he created them; there were times, too, when they seemed to take over the narrative from him and pursue their own directions and their own ends. And so *The Old Curiosity Shop* was begun. The first episode appeared in the fourth issue of *Master Humphrey's Clock* and, after a short interval during which Dickens used up all the other material he had prepared for the periodical, the 'child-story' took over entirely. (In fact the magazine became merely a vehicle for its appearance and, by the end of its run in February 1841 after forty weekly episodes, its circulation had reached one hundred thousand.) Throughout the spring and summer of 1840 he worked assiduously upon it, creating in rapid succession the extraordinary characters who populate this most extraordinary of Dickens's novels – Quilp, Dick Swiveller, Sally Brass, the Marchioness. Once more it is a novel of journeying, of travel, of restless wandering as the divagatory imagination of Dickens himself spurs his characters forward through a world which is in turn grotesque and sentimental, pathetic and farcical, the saddest themes of the novel being relentlessly caricatured by Dickens almost as soon as he has envisioned them. As befits a novel of journeying, he and

his family themselves moved down to Broadstairs from Lon-
don while he was engaged upon it: it was a quiet resort where
he could work undisturbed. He sat down at his desk from 8.30
and did not leave it until two, all the time thinking and con-
triving and planning his way ahead: the novel appeared in
weekly parts but it was also being issued in monthly instal-
ments, so he had to maintain a double focus upon his work.
The weekly instalments sometimes constricted his always
ebullient imagination – 'I hadn't room to turn,' he told Forster
on one occasion – but, as ever, his self-discipline and habitual
routine of composition meant that he soon developed a rhythm
of work which is reflected in the rhythm of the narrative itself,
one long chapter being characteristically followed by a shorter.
It was also a strict routine, since on most occasions he was
only working two weeks ahead of the printer. Then, after the
day's work, he left his desk and began an equally arduous regi-
men of 'relaxation' – games, walks, expeditions, with Dickens
always the leader and instigator, gathering up his family and
his friends within the fierce hurricane of his progress through
the world. Yet he never stopped thinking of the next 'turn'
in his narrative. One night he was walking along the cliffs at
Broadstairs, for example, when he saw the stars reflected in
the water and had a sudden vision of 'dead mankind a million
fathoms deep' after the Flood. It was an image which he trans-
ferred to *The Old Curiosity Shop* where Little Nell sees the
stars reflected in a river and then '. . . found new stars burst
upon her view, and more beyond, and more beyond again,
until the whole great expanse sparkled with shining
spheres . . .' But this was also the imagination which was
creating such earth-bound creatures as Mrs Jarley and Short
Trotters.

Perhaps such disparities, such paradoxes and contradic-
tions, account for the general critical belief that this is his most
'fantastic' or 'surreal' novel – and nowhere is that atmosphere
thicker than around the character of the malevolent dwarf,
Daniel Quilp, who drinks boiling liquids and swallows eggs

whole. Yet the curious thing is that this grotesque creature on occasions behaves, and sounds, very much like Dickens himself; in fact the novelist himself seems almost to have revelled in the resemblance, and made a point of giving the dwarf a shower-bath in exactly the manner which he himself enjoyed (a detail which he took out at proof stage). Indeed there were times when he even seemed like Quilp to those who knew him, and one visitor to the Dickens family during this Broadstairs holiday noticed how the famous young novelist would indulge in 'most amusing but merciless criticisms' and how at times, when he was involved in his own creativity, his eyes were like 'danger lamps' and 'I confess I was horribly afraid of him'. But if he sometimes resembled Quilp, he also resembled Dick Swiveller, the cheerful and wayward young man who sings snatches of songs to himself. In truth, Dickens exists everywhere within his own creation: he is part of the circus freaks who populate the novel, he is part of the warm-hearted Kit Nubbles, he is even part of Little Nell. And he exists, too, within the wonderful figure of the fire-watcher who takes in the girl and her grandfather during the course of their wanderings – 'It's my memory, that fire, and shows me all my life . . .' So many people, in Dickens's novels, see pictures in the glowing coals that it is hard not to believe the novelist did also – looking into the fire, and picturing Little Nell's journey towards death.

At the beginning of October he returned to London from Broadstairs, and almost at once he had to begin planning the demise of his heroine. 'I am breaking my heart over this story,' he told one friend, 'and cannot bear to finish it.' And to another friend he confided, 'I am slowly murdering that poor child . . .' But indeed Little Nell had been foredoomed from the beginning, and there was nothing Dickens now could do to avert her fate: it is as if he could not imagine innocence without at the same time imagining all the harm that must eventually destroy it. And, in a novel which is in part about the blessed state of childhood, there are also terrible parodies

of childishness in the old men and the fairground freaks. Even Quilp himself is, in his dwarfish state, like some prematurely addled child. It is often noted how at moments of great tenderness in this story Dickens instinctively slides into blank verse, but it is not so often recalled that the principal comic character, Dick Swiveller, also breaks into blank verse at the most inopportune moments. Nothing exists in Dickens's world without being ridiculed, or parodied, or even destroyed. That is why the innocent girl must die.

He had to do it – '. . . it is as much as I can do to keep moving at all,' he said. But he did it. Little Nell was dead. The public reaction to that death was just as severe as Dickens's own. Lord Jeffrey was found in tears after reading that scene, and Dickens's great friend, the actor William Macready, was prostrated with grief. Daniel O'Connell threw the periodical out of the carriage of a railway train, exclaiming, 'He should not have killed her!' Crowds gathered at New York harbour to ask the English passengers on their arrival, 'Is Little Nell dead?' Dickens had, not for the first and not for the last time, created a sensation. The enormous public reaction to the death of Little Nell might seem as absurd to contemporary readers as it did to Oscar Wilde at the end of the nineteenth century – 'It would take a heart of stone,' he said, 'not to laugh at the death of Little Nell.' She was killed, Wilde added, 'for the market, as a butcher kills a lamb'.

Yet there were reasons for that tide of sentiment unleashed by Dickens's own sometimes morbid and nostalgic imagination. The deaths of children were, for one thing, by no means confined to fiction: in 1839, for example, half of the funerals in London were for children under ten years of age. Child mortality was one of the great evils of the early nineteenth century; but it was also an avoidable evil, if proper sanitation had been introduced, and no doubt there was a sense of guilt and even complicity among the readers of *The Old Curiosity Shop* which led them to mourn over the death of so exemplary a young spirit. It was a hard age but, just as the cruellest

people are often the most sentimental, it was also a mournful and nostalgic one – forever implicitly lamenting the loss of its own innocence, nineteenth-century industrial civilisation found a ready vehicle for such atavistic piety in the shape of Little Nell. Of course a modern audience would not lament in any such fashion, but that in itself illuminates another great truth about the Victorian age – quite unlike the normal caricature of the period and its inhabitants as somehow stiff, restrained and undemonstrative, it was quite common for men to weep openly in public, for whole audiences to be incited to terrible fits of grief, even for a nation to be caught up in the distress of a fictional heroine.

Of course not everyone was moved by this spectacle, and even at the time there were certain critics who accused Dickens of mawkish sentimentality. He himself was quite aware of what he was doing, however, and nothing is more appropriate for a proper understanding of him than the fact that even though he was rendering himself desperately miserable over the fate of Little Nell he was nevertheless dancing and playing charades until five-thirty in the morning just after he had 'killed' her. That same heady ambiguity of mood is evident in the novel itself: great sadness and pathos are immediately followed by the wildest humour, and many years later a friend found Dickens 'laughing immoderately' at the novel because of the associations it aroused in him. At funerals Dickens often broke down in hysterical laughter and, in his fiction also, death often provokes in him something close to hilarity. But it is that very conflation of mood and atmosphere which makes *The Old Curiosity Shop* so strange and wonderful an achievement: it is part fairy-tale and part farce, part religious parable and part pantomime. No one but Charles Dickens could possibly have written it, and more than any other of his novels it bears all the marks of his striated, wilful, complicated and perhaps ultimately baffling personality.

Barnaby Rudge

O F ALL Dickens's novels, *Barnaby Rudge* was the longest
delayed and the one with the most troubled beginnings.
He composed it in 1841, although in fact he had signed a
contract for it five years before under the title of *Gabriel
Vardon, The Locksmith of London*: it is even possible that this
was the novel he had been proposing to write ever since he
began his career, and indeed in some ways it is the most
elaborately planned and carefully structured of his earliest
fiction. It had such a long period of gestation in part because
Dickens committed himself to too many projects and too
many books; such was his self-confidence and energy that
he believed he could do almost anything, and indeed every
aspect of his extraordinary early success would have con-
firmed that opinion. But there were penalties involved in
such enthusiastic production – he had signed one contract
for *Barnaby Rudge* only to scrap it, he had begun the novel
and then broken off when he quarrelled with one of his
publishers, and then he had become too involved in his new
journal, *Master Humphrey's Clock*, to start work upon it in
earnest.

Indeed it was the fate of this periodical which finally per-
suaded him properly to settle down to *Barnaby Rudge*. He
had been serialising *The Old Curiosity Shop* in *Master Humph-
rey's Clock* and had seen sales mount to some one hundred
thousand; he knew well enough that only another continuous
story would maintain such popularity, and so he decided to
begin his new novel immediately after the wanderings of Little
Nell had come to an end. *Barnaby Rudge*, fortunately, was

ready to hand – he had written two chapters some months before, and with some judicious enlargements he was able to prepare three chapters without undue difficulty and thus provide enough material for the next two issues of his magazine. He was on his way again.

Nothing in fact is more surprising in Dickens's career than the energy and instinctive skill with which he could turn immediately from one novel to the next, and only eight days after completing *The Old Curiosity Shop* he set to work upon *Barnaby Rudge*. 'I imaged forth a good deal of *Barnaby*,' he told one friend, 'by keeping my mind steadily upon him.' That was Dickens's way – to hold his character in his mind's eye, watching him move through the story, hearing him converse, observing his gestures, all the time creating the pattern of the narrative in which that character might be seen to best advantage. Certain other aspects of that narrative, however, had been prepared in advance. Even when he had signed the original contract for it, five years before, he knew that it was going to be an historical novel and that it would in large part be concerned with the Gordon Riots of 1780 (these were anti-Catholic riots which led to some of the most savage and bloody scenes in the history of London) and Dickens had already done a certain amount of historical research into the subject. Not all of that research needed to be historical, however, for it was in the late 1830s that the Chartist struggles focused attention on what was then called 'the condition of England question'. There had been battles between mobs and the police in Birmingham in May 1839, and in November of that year there had been an 'uprising' in Newport. Of course the Chartist demands, primarily for universal male suffrage and the secret ballot, were not directly linked to the 'No Popery' riots of sixty years before; nevertheless the fears of mob rule and internecine strife were precisely the same, and not for the first time Dickens showed an exquisite sense of timing in writing a novel about urban revolt in a period when his readers would have every reason to be interested in it. Like all good

historical novels, *Barnaby Rudge* was as much about the present as the past.

There were other contemporary influences upon it, too, although perhaps of a more private nature. Dickens was fascinated by the behaviour of the mob, and had taken the opportunity a few months earlier of witnessing one of the many public executions which took place outside Newgate Prison. It is of course of some interest that, in the novel he was about to write, Newgate itself would be burned and stormed, but in particular Dickens was both obsessed and horrified by the behaviour of the crowds of men, women and children who flocked around the gallows. On this occasion a murderer, Benjamin Courvoisier, was to be executed, and at a later date Dickens described the conduct of the mob which watched his death as comprising '. . . nothing but ribaldry, debauchery, levity, drunkenness and flaunting vice in fifty other shapes'. This was a spectacle he would put to good use in *Barnaby Rudge*. And then there was his raven, Grip, a pet bird that fascinated him and which he would also put into the novel – as Barnaby Rudge's companion. It is as if a new fiction magnetised the world around Dickens, so that everything came to be fashioned in the image of the reality he was about to create.

It was apposite, for example, that a novel which is in large part concerned with the relationship between fathers and sons should have been preceded by a veritable explosion by Dickens against his own father. Ever since the time when John Dickens's debts had consigned him to the Marshalsea Prison, and the young Dickens to a blacking factory, the problem of insolvency had haunted the family. John Dickens was always getting into what he might euphemistically have termed financial 'difficulties', and his son's astonishing rise to eminence only compounded the problem: for it seems that the father was now literally trading on his son's name, and at this point Dickens had had enough. He placed an advertisement in several newspapers, disclaiming any debts which anyone

bearing his surname might run up, and then demanded that his father leave the country. It is perhaps not altogether surprising, therefore, that the theme of fathers and sons runs through the novel he was even now preparing to write: thoughtless fathers, like John Willet; unnatural fathers, like John Chester. How appropriate, too, that they should both bear the name of John. And how strange that, introduced into this theme, there are other more perplexing ideas: how a son, like Barnaby himself, may bear the taint of the father's crime; how another son, like Hugh, will run wild if he is neglected by the father and indeed exhibit all the characteristics which the father has successfully repressed in himself. But these are not simply Dickens's private preoccupations issuing unchecked into his fiction – part of his genius was to turn what might seem wholly individual concerns into metaphors of a universal kind. Thus in *Barnaby Rudge* the theme of fathers and sons is part of a much larger enquiry into the nature of power and dependency, of authority and subversion.

Perhaps it is the very compulsiveness of the private vision, however, which makes *Barnaby Rudge* a much more complicated narrative than at first it might appear. For Dickens displays himself throughout its pages as both an authoritarian and a revolutionary: his central characters are the respectable locksmith, Gabriel Varden, and the poor mad boy, Barnaby Rudge, as if in creating both he was also recreating the twin poles of his own temperament. Dickens hated the mob, as we have already had occasion to notice, but in this novel he seems to revel in the violence for which it is responsible. The most powerful scenes here are in fact those concerned with the burning and storming of Newgate Prison: 'I have just burnt into Newgate,' he said at the time of writing these passages '. . . I feel quite smoky when I am at work.' In fact throughout *Barnaby Rudge* there is both the fear of disorder and the need for it, the horror of, and the desire for, insurrection, the heady pleasure taken in the fever even as he diagnoses its painful effects. It should not be forgotten that his own father had

once been imprisoned, and in the scenes of riot it may be poss-
ible to trace his old childish impulses to tear down the insti-
tutions which had destroyed his family and blighted his
childhood.

That is also why Dickens himself seems so close to Barnaby,
for he depicts him in terms that he would also sometimes use
about himself – in particular he describes his 'terrible restless-
ness', precisely the condition from which he himself always
suffered. That wild and restless energy, that excess of imagin-
ative excitement – in a way Barnaby is like the dwarf, Quilp,
in *The Old Curiosity Shop* and in that conjunction we may see
how Dickens pours himself into his ostensible 'villains' as well
as his heroes. And, when Barnaby sees 'shadowy people' in
the outline of clothes hanging upon a line, he is precisely like
the young Charles Dickens who in an essay on the old clothes
market of Monmouth Street volunteered the same observa-
tion. In fact there were even people who considered Dickens
himself to be as insane as the character he created – it was
Landseer who said of his affection for his pet bird, Grip, that
he was 'raven mad'. Somehow this became transformed into
the phrase 'raving mad' but, even, before that time, even when
he was writing *The Pickwick Papers* and *Oliver Twist*, his
creativity was so astounding that it was popularly believed
that he was about to be consigned to an asylum. Dickens
himself was quite aware of these reports, and there may be
a certain harsh irony in his depiction of the mad young man
here.

He did not rely upon introspection alone, however: as soon
as he began seriously to write *Barnaby Rudge*, he made a point
of visiting at least two prisoners who were considered to be of
'unsound mind'. For similar reasons he was wandering
through the older streets of London, attempting to conjure up
for this narrative all the reeking atmosphere of the city's past.
He wanted, after all, to write a serious historical novel: he was
implicitly attempting to set himself up against Sir Walter
Scott, whose own historical works had been the single most

important fictional phenomenon in the years immediately before Dickens. And indeed *Barnaby Rudge* is the most carefully planned, the most consistently structured, of Dickens's fiction to date. All of his previous novels had emerged accidentally, out of stories or sketches, or had carried all the marks of brilliant improvisation on the author's part. This was the first novel which had originally been conceived as a unified whole.

That was one of the reasons why he was able to work so rapidly upon it, despite the fact that he suffered a number of egregious interruptions. He visited Scotland with his wife, Catherine, while he was deep in the middle of his narrative: he was away for a month but even while travelling he contemplated the bloody riots he was just about to recreate (one might almost say, to celebrate). Indeed in the very torrents of the Highlands he seemed to see the rioters of eighteenth-century London – 'They were rushing down every hill and mountain side, and tearing like devils across the path . . .' He had already explained in the first page of *Barnaby Rudge* how those bent upon great or violent designs 'feel a mysterious sympathy with the tumult of nature', and surely Dickens found in the wildness of the Scottish landscape some corroboration of his own wild imaginings. There were other interruptions of a less inspiring kind, however, and it was soon after his return to London that he began to suffer the pains of a fistula – agonising enough, certainly, but not so searing as the operation he was forced to undergo without anaesthetic in order to remedy the problem. The room would have been awash with blood as his posterior was forced open and carved up, but his hardiness and resilience were even then extraordinary; a few days later he was back to his composition of *Barnaby Rudge* while lying painfully upon a sofa in his new house in Devonshire Terrace.

In fact the novel was directly responsible for a longer interruption to his writing than either the operation or the Scottish journey, for even as he was composing it Dickens began to realise the perils of over-production. He had received advance

warning of a kind when he had visited the home of Sir Walter Scott, and remembered the last weary and defeated years of a great novelist forced to write more and more without respite. *Barnaby Rudge* was Dickens's fifth novel in as many years and, for the first time in his career, sales were disappointing: this in itself would have been enough to perturb him, dependent as he always was upon what he considered an affectionate and even familial relationship with his audience, but he understood at once the dangers of being too prolific, of flooding the market and thereby suffering all the penalties of his readers' over-familiarity with his work. He decided almost at once to stop after he had completed *Barnaby Rudge*, and write nothing else for at least a year – in fact he planned to travel to the United States, and there refresh both himself and his imagination with new scenes and new people.

We have here, perhaps, an explanation for the fact that this novel concludes on a slightly weary or even mechanical note. It is almost as if the violence and energy which Dickens expended upon the scenes of riot, as well as the great imaginative empathy with which he invested the portrait of Barnaby Rudge's madness, had reached a necessary quietus in the final chapters of the book. Certain elements of the novel also have echoes in Dickens's previous fiction, for once more he is preoccupied with the theme of private loneliness, with the necessity for restless wandering, with the image of the city as a place of darkness: '. . . to feel, by the wretched contrast with everything on every hand, more utterly alone and cast away than in a trackless desert . . .' This is the city which Dickens knew as a child, and in *Barnaby Rudge* his own old sense of privation and despair is lent a fantastic existence with the notion of London as 'a mere dark mist – a giant phantom in the air'. But this novel differs from its predecessors in being much more of a *story*, an historical tale of blood and evil, which has its counterparts in the fiction of Scott or of Ainsworth. There are other affinities also. Much of its plot might have come straight from the Restoration stage, just as some of the more pictur-

esque horror might have come out of the Jacobean theatre – not a fanciful comparison this, either, when we remember how deeply affected Dickens was by all forms of drama. When it is also remembered how often in this novel Dickens seems to be half-quoting, or misquoting, from the works of William Shakespeare it is possible to understand what kind of continuity he represents. It is easy enough to draw a line through the fiction of this country and see Dickens as the direct heir of Smollett or of Fielding, but it is equally important to realise that in English culture the novel has often been directly associated with the drama. Dickens's own works testify to that allegiance, and in *Barnaby Rudge* itself we see one important example of it. It has not been his most popular book, at least in recent years, but this has more to do with the general intellectual prejudice against 'historical fiction' (*A Tale of Two Cities* has suffered a similar fate for similar reasons); on any objective judgment, it is one of his most energetic and powerful narratives. It is filled with his own wild energy, sustained by his own bracing sense of form, and complicated by his own ambivalent reactions to crime and punishment.

American Notes for General Circulation &
Pictures from Italy

I T IS often assumed that Charles Dickens, being so close
and even obsessive a chronicler of London life, never
willingly left the bounds of that city. He may have been a
Londoner *in excelsis*, as some contemporary observers
thought, but he came to hate the place itself and he was in any
case always an enthusiastic and indefatigable traveller. In
the last years of his life, for example, he spent almost as much
time in France as he did in England. He even produced these
two volumes of travel writing (there were also incidental
sketches which appeared occasionally in his own periodicals),
both of them distinctive and both of them imbued with his
genius.

American Notes was started by Dickens within two weeks
of his return from the United States, in June 1842, for there
is a sense in which he had travelled to that country simply in
order that he could write about it. No doubt he remembered
Sam Weller's advice to Mr Pickwick: '". . . let him come back
and write a book about the 'Merrikins as'll pay all his expenses
and more, if he blows 'em up enough."' Certainly Dickens felt
he had every reason to 'blow 'em up' on his return, and Mary
Shelley told a friend after meeting him in this period that
'Charles Dickens has just come home in a state of violent dis-
like of the Americans – and means to devour them in his next
work – he says they are so frightfully dishonest'.

Yet it had all started so well. He had travelled by steamship
across the Atlantic at the beginning of the year, together with

his wife and his wife's maid, prepared for six months in a country to which he already had a genuine attachment. He was, after all, himself almost an epitome of the New World – a young man of modest origins who had thrust his way forward by his own efforts and who was by instinct a radical. What could the New World do but welcome such a novelist in return? Indeed he already had some advance knowledge of his renown there; his books sold almost as many copies in the United States as they did in England (although of course, without the benefit of copyright, bearing no royalties) and we have seen the anxiety with which the American public waited to hear the fate of Little Nell. Such was the popularity of Charles Dickens, still only in his thirtieth year.

In fact his first weeks in the United States were spent in a condition of genuine excitement and enthusiasm. 'How can I give you the faintest notion of my reception here,' he wrote to his friend, John Forster, 'of the crowds that pour in and out the whole day; of the people that line the streets when I go out; of the cheering when I went to the theatre; of the copies of verses, letters of congratulation, welcomes of all kinds, balls, dinners, assemblies without end?' And indeed he was not, for once, exaggerating; the welcome was quite as effusive as he described it here, and for a young man who had been accustomed only to the milder and less vociferous attentions of his fellow-countrymen it came as a gigantic, overwhelming experience. For the first time in his life he truly understood the extent of his fame, of what he would call on another occasion his 'Power'. But then it all began to sour; when he started to make speeches demanding the establishment of some copyright agreement between England and the United States – in other words, when he started asking to be paid for the sale of his books – the applause died down. Where once the press had hailed him as the conquering hero, they now turned upon him and accused him of being both mercenary and hypocritical. Just as he had never experienced such a welcome, so he had never suffered such savage assaults upon his

character and reputation. 'I vow to Heaven,' he wrote to an American friend, 'that the scorn and indignation I have felt under this unmanly and ungenerous treatment has been to me an amount of agony such as I never experienced since my birth.' Strong words, but again no less than the truth.

Yet he was never a person to break off what he had once begun and so, having, as it were, wilted in the glare of publicity, he and his wife decided to spend their last months in the country travelling as privately as possible. Of course it was not always easy to do so – in most of the cities and towns he visited he was given something close to a civic welcome or 'Levee' – but at least he and his party were able to travel over large sections of the country. They visited Boston, New York, New Haven, Washington, Philadelphia, Baltimore, Richmond, Harrisburgh, Pittsburgh, Cincinnati, Columbus, forever moving onwards, Dickens all the time making observations and notes which he characteristically put into the letters he was constantly sending back to his friends in England.

These letters in fact provided a great deal of information which he used in *American Notes* itself and, when he and his wife eventually returned to England in the early summer, he was fully prepared to begin writing his book at once: he had even brought back newspapers and magazines to assist him in assembling all the information he thought he would require for a proper survey of America and its customs. He did not intend to write an account of his own reception in America, in other words, and he excised almost all the references to himself which had occurred in his correspondence. *American Notes* is a much more objective and sometimes almost impersonal record; its narrative is more elaborate and more artful than anything he had written in confidence to his friends, with a kind of dispassionate sprightliness which remains its dominant note. This travel book also differs markedly, in tone and substance, from the account of America which Dickens was later to include within the pages of *Martin Chuzzlewit*. The novel provides a darker, more condensed and more deliber-

ately thematic description of America and its inhabitants: the paler shades of reality have been repainted in Dickens's native chiaroscuro whereas in this account he is happy to provide a much more conventional mid-nineteenth-century journalistic narrative. In *American Notes* his characters rarely speak; in *Martin Chuzzlewit* they do nothing but speak. In *American Notes* Dickens's own opinions and reflections tend to brighten what is on occasions a sombre narrative; in *Martin Chuzzlewit* it is the action and speech of his protagonists which perform that service.

In any case *American Notes* is primarily concerned with what might be described as the public institutions of American life – in particular with the prisons, the workhouses and the asylums. The first extended description in this book is of the Massachusetts Asylum for the Blind in Boston (in his letters which account for this period of his stay in America, he was primarily interested in his own reception), but this is not to suggest that his prose lacks interest or even vivacity. The fact is that Dickens was fascinated, almost obsessed, by such places; and one can feel throughout *American Notes* the extraordinary intensity of that interest. When he visits an asylum for mad women (which in his description might just as well have been filled by all the extraordinary females of his own fiction) he notes that the true 'danger' lay in their songs turning '. . . into a screech or howl' which is, on the face of it, an extraordinary remark to make. Then there is his constant preoccupation with the details of prisons and of punishment. As he says in the course of his American observations, a jail should really be 'a place of ignominious punishment and endurance' and yet even so he cannot resist sympathetically experiencing the thrill of fear when he encounters those unfortunate inmates who suffered under the 'separate system' (more or less of solitary confinement) in Philadelphia: 'I never in my life was more affected by anything which was not strictly my own grief, than I was by this sight,' he wrote in one of his many letters which complement the narrative itself.

His 'objective' account is always being subdued by his own sharp responses; so, when he visited a factory at Lowell, he praised the workers there for being clean and neat: '. . . I like to see the humbler classes of society careful of their dress and appearance, and even, if they please, decorated with such little trinkets as come within the compass of their means . . .' There were times in America when Dickens was genuinely moved and delighted by the improvements in public institutions and in the general condition of public welfare; he despised the general 'smartness' of the people and the inordinate concern with business but, in social matters at least, the country seemed to him to be ahead of England. In his comments on the benevolent paternalism of the factory system as well as on the generally humane treatment of the insane, Dickens was signalling the precise direction in which he thought his own country ought to move. And yet there is another more mournful, and more private, tone beneath his observations – in *American Notes*, as in his fiction, he is concerned with the outcasts, the oppressed and the maimed. He is fascinated by the solid power of the state at the same time as he is obsessed by those upon whom that state power encroaches most grievously.

American Notes was his first extensive work of non-fiction, and of course it cannot help but reflect all the preoccupations and interests which emerge in much more substantial form within his own fiction. It cannot help but also reflect the man himself, for he emerges here as punctilious, watchful, nervously high-spirited while remaining extremely susceptible to atmosphere: whenever he appears in his own pages the narrative takes on a melodramatic, fiery and even pantomimic life. It reflects a peculiarity of his temperament also that, at the end of this book, after he has expatiated on the evils of slavery and the horrors of the American press, he can suddenly insert a quite redundant but humorous anecdote about a bootmaker. Yet this was how Dickens's imagination worked, moving effortlessly from one level to another, combining the most bitter

polemic with the most farcical comedy. And that in the end is the true significance of *American Notes*: as an account of American life it may be partial and even on occasions wrong-headed (certainly Americans at the time thought as much), but as a record of Dickens's consciousness and behaviour it has a profound human interest. Here is the man standing before us, with all his prejudice, fear and wild hilarity.

Pictures from Italy was also an account of his travels, largely taken from the letters which he had written to his friends at the time, but it is quite different in tone and spirit from *American Notes*. In the later volume he was returning to an old world, not travelling through the New. He and his family had moved to Genoa in the summer of 1844, and eventually they took up residence in the Palazzo Peschiere on a hill overlooking the old city. It was this old city that in fact he came to love, and in his account of his Italian sojourn Dickens is clearly fascinated by the age and the decay, the grotesquerie and the darkness. He loved ruins, and crumbling walls, and cracked pavements, and there are times in his account when the remains of the Italian past take on an almost theatrical life – as if he were remembering the backdrops to all the Italian burlettas and melodramas he had seen in the London theatres.

But even while he was ensconced in Genoa he could not stay still. Not content with his fifteen-mile walks in the rain, or his perambulations along the narrow streets and alleys of the old city, he had to keep on moving. In fact he made two extended journeys through Italy during the year he and his family stayed in that country, and one of the essential characteristics of *Pictures from Italy* is its sense of constant motion and hurry. Parma. Venice. Bologna. Ferrara. Mantua. Milan. And then, on a later journey (with all of his family in attendance) he travelled on to Pisa. Rome. Capua. Naples. Pompeii. Florence. It was noticeable in his account of his American travels how interested Dickens was in the various forms of transport, as if they represented some objective equivalent of his own passion for speed and forward progress; the same

spirit is alive in *Pictures from Italy* also for, as Dickens said in a letter written while he was on the road, 'My only comfort is, in Motion . . .'

A similar atmosphere envelops his interest in buildings, and people, and paintings, and 'sights' in general: he had what his friend, Daniel Maclise, called a 'clutching' eye: he received his impressions straight away, and then was in a desperate hurry to move on to the next thing, and the next. This of course accounts for his interest in crowds, in carnivals, and in festivals of all kinds where the eye is continually being besieged by novelties and new sensations. That is why, in his descriptions of Italian life, he saw only the surfaces of things. The Catholic Church, for example, became for him no more than a parade of mummers and he seemed to have no interest in the history or traditions of that faith. He is always best at seeing things in passing, landscapes and sights flashing across him in quick succession. There are wonderful set-pieces, like his disquisition on Venice or his account of an execution in Rome, but to a large extent he eschews even the kind of analysis he was prepared to make in *American Notes*. In that earlier volume he had significant questions to raise about the nature of public institutions and serious points to make about the penal system of that country; but there is not the same theoretical or polemical edge to *Pictures from Italy*. He is not now concerned with gaols, or with asylums, or with the press, but with gloomy façades and absurd religious rites. In a sense he turns the Italian landscape into the material from one of his novels, because of its '. . . bewildering phantasmagoria, with all the inconsistency of a dream, and all the pain and all the pleasure of an extravagant reality!' It provides just a colourful panorama, against which the quick shape of Charles Dickens can be seen to move. Indeed, in certain respects, *Pictures from Italy* is most interesting for the light which it throws upon Dickens himself – with his delight in novelty, his fierce joy in contrast, and his constant untiring energy. His was a visual, emphatic imagination, always moving onward; in these pages one re-

ceives almost a physical sense of that movement, as if he were striding through a thoroughfare. *Pictures from Italy* may have been his journey into the past, just as *American Notes* was his journey into the future, but both contain at least the sparks of Charles Dickens's genius as he confronted the world.

Martin Chuzzlewit

*M**artin Chuzzlewit* is often considered to be Dickens's 'American novel', but it did not begin life in that way. Certainly he started work on its composition soon after his journey to America but he had already been writing *American Notes for General Circulation*, and was in any case now really concerned only to write what might be called his first 'serious' novel – at least in the sense, as he said in his eventual preface to it, that he had decided to eschew all the pleasures of the picaresque fiction he had previously been writing and instead '. . . to keep a steadier eye upon the general purpose and design'. It was in addition his first novel for over a year – for Dickens, who had begun his career by writing two novels at once, this was an extraordinary long period of abstinence and it seems clear that he wanted to write something very special indeed in order to resume his relationship with the reading public. He had promised his publishers before he left for America at the beginning of 1842 that he would have the first number or episode of the new novel ready by November of that year; but by the summer, after his return, he was busily engaged upon his travel book and had no real idea about the nature of the forthcoming fiction. He spent that summer in Broadstairs and, when he returned to London at the beginning of October, he still had to finish the last chapters of *American Notes* and was in no position to provide the first chapters of the novel as well. By this stage, however, his ideas were 'simmering', and he was 'plotting and contriving' the shape of the new book. He had already gone down to Cornwall with friends to inspect the dangerous conditions of the tin-mines

there – that was a possible theme, to be seen as part of his struggle against public abuses represented by his exposure of the New Poor Law in *Oliver Twist* and of the Yorkshire schools in *Nicholas Nickleby*. Certainly he wished to employ a contemporary theme: his previous novel, *Barnaby Rudge*, had been an historical fiction and now Dickens wanted to return to 'the present day' and, in particular, to what he described at this time as 'the busy concourse struggling for existence'. It also seems likely that he made a conscious decision to introduce much more comedy into this novel than had existed in its predecessor – a decision, of course, which was to lead to the glorious birth of Mr Pecksniff and Mrs Gamp.

By November he was writing out lists of possible names – Chubblewig, Chuzzletoe, Sweezlewag – until finally he came up with Chuzzlewit and was able to proceed by degrees to the full and deliberately cumbersome title: 'The Life and Adventures of Martin Chuzzlewit, His relatives, friends, and enemies, Comprising all His Wills and his Ways, with an Historical Record of what he did, and what he didn't. Shewing Moreover who inherited the Family Plate; who came in for the Silver Spoons, And who for the wooden ladles. The whole forming a complete Key To The House of Chuzzlewit. Edited by "Boz". With illustrations by "Phiz".' He was writing the opening chapters in December and doing so with his usual speed and decision – but also with great care and self-consciousness, as he proclaimed in his preface, principally because he had decided that this new novel would fulfil 'the design of exhibiting, in various aspects, the commonest of all the vices . . .', by which he meant selfishness. This preoccupation was in fact a new development in his art, and was no doubt in part provoked (as so often happens) by adverse criticism; there were reviewers, and others, who applauded Dickens's gift at characterisation while censuring his inability to provide a larger 'design' or 'plot'.

So there is a discernible change in Dickens's approach to

his art, a change signalled also in his creation of such compli-
cated and strangely unaccountable beings as Mark Tapley,
the young man who wishes only to be merry when life goes
against him and who cannot wait for the 'chance' of unfavour-
able circumstances. In one sense he is only mouthing what
can be described as quintessentially Dickensian sentiments –
'. . . for if he began to brood over their miseries instead of
trying to make head against them, there could be little doubt
that such a state of mind would powerfully assist the influence
of the pestilent climate' – but he does so in such a curious and
wayward manner that he has an identity quite beyond the
range of single-minded 'humours' with which Dickens once
customarily invested his characters. This was only one of the
surprises, however, to be sprung upon the expectant readers
of *Martin Chuzzlewit*.

Its first number was published on the last day of 1842, and
almost from the beginning it was clear that its sales were going
to be nowhere near as high as those of his previous episodic
novels – the average figure at the beginning of the run was
something close to 20,000. The reason for that relative lack of
success is hard at this late date to discern: it may have had
something to do with the somewhat dismal opening chapter
which provides an elaborate and not altogether funny parody
of genealogical research. Whatever the reason, however,
Dickens realised that something had to be done at once to re-
vive public interest and arrest his novel's declining fortunes.
There was still the prospect of attacking the owners of Cornish
tin-mines, and there was also the possibility of striking a blow
against the abuses of child employment: he had just been read-
ing a pamphlet on that very question. In the end he dropped
both ideas (they would make their way instead into a smaller
fable he was about to compose, *A Christmas Carol*) and hit
upon another notion which had greater possibilities for devel-
opment. He would send his hero, young Martin Chuzzlewit,
to America.

It was of course in one sense a reprise of Dickens's own

journey to that country, a journey which had been as much towards himself as towards a new continent. For although he had been initially welcomed and applauded there, as the greatest novelist of his age, he soon discovered to his horror what other 'celebrities' have discovered since – the newspapers could turn just as easily against him, and excoriate him in terms that would rival the fulsomeness of their previous praise. He recognised in America the real extent of his fame, thus providing him with a new and fuller sense of his identity; but, when he began to attack the Americans for disregarding copyright, he found himself labelled as a mercenary Cockney and a hypocrite who had come to the United States simply to make more money for himself. He had never before been abused in such a personal way, and the effects were all the more injurious because he must have realised at the time that there was some justification in the attacks, at least, of those who criticised his evident concern for money. It was not an ignoble concern, but he was always especially sensitive when anyone questioned his motives. Throughout his life some buried sense of guilt prompted him to insist that he was the just man, the innocent man, and any reproach against him inspired a positive agony of fury and self-justification.

By sending Martin to America then, in a fantastic and exaggerated version of his own journey, he was touching upon the most troubled area of his own self-awareness. And that is why Martin himself represents quite a new development in the presentation of Dickens's central characters: he is no Pickwick, no Oliver, no Nicholas Nickleby, no Little Nell, but rather an ambiguous figure, selfish, self-willed, and blind to the real merits or emotions of those around him. Of course he changes in the course of the narrative – and that, in itself, marks a subtle change in Dickens's art. He was not relying to the same extent on what might be described as the then conventional theatrical representation of characters who are impelled by the same emotions and motives throughout the novel: just as he must have felt his own sense of himself chang-

ing during his American journey, so now his characters begin to evolve and change under the pressure of circumstances. Dickens was attending very carefully to the 'design' of his fiction, therefore, and it takes only a cursory glance at his travel book, *American Notes*, to realise how in *Martin Chuzzlewit* Dickens uses his own experiences to create a much more closely woven and closely felt narrative. The same details are integrated into a larger symbolic whole, the greys of daily reality transformed into the chiaroscuro of Dickens's strident imagination.

Such matters of literary intent ought not to obscure, however, the one most noticeable and important fact about *Martin Chuzzlewit*: it is one of the funniest of Dickens's novels, and not least in its American chapters. Even while he had been a visitor in that country he had told his friend, John Forster, in a letter, 'Oh! the sublimated essence of comicality that I *could* distil, from the materials I have!' And thus were created such notable Americans as Mrs Hominy and Putnam Smif. But there is also that grand gallery of English comic creations, most notably Pecksniff (the scenes at Mrs Todgers's boarding house, when he gets drunk, are some of the funniest in the whole of English fiction) but pre-eminently Mrs Gamp, the redoubtable nurse who like all great comic figures is an object of terror as much as of laughter.

There is another additional and curious aspect to his humour in this novel (as well as in his later work), for it takes only the smallest effort of historical reconstruction to realise that the most comic passages and scenes in *Martin Chuzzlewit* were written in precisely the period when he was labouring under the most difficult and painful circumstances of his private life. In the last months of 1843, for example, he was beset by so many pressures that any ordinary man would have come close to breaking down under the strain – he had decided to write *A Christmas Carol* and, almost as soon as he had finished it (composing it literally alongside *Martin Chuzzlewit*, of which it can be said to be the condensed dream version), he

was forced to go to Chancery to defend this first and most famous of his Christmas stories against literary pirates: he won the case but had to pay his own costs, some seven hundred pounds, a blow which was compounded by the fact that the book was not the financial success he had expected and needed. When this was combined with the poor sales of *Martin Chuzzlewit*, it is easy to understand why in this period, even as he was writing the comic scenes of Gamp and Pecksniff, he was haunted by fears of financial ruin. His wife was also suffering acute distress as a result of post-natal depression. He was in bitter disagreement with his publishers as well, and decided to leave them. In addition he was compelled to break off his work time and again to attend various public duties, most noticeably in his patronage of educational establishments for working men. The pressures grew around him all the time, and at last he decided to escape – to get away from the net which was closing around him, and to live on the Continent with his family for a year. He wrote the last chapters of *Martin Chuzzlewit* while living in temporary rented accommodation, having leased out his house in anticipation of his year in Europe, and that strange conjunction of circumstances may be taken as emblematic of the troubled and exhausting conditions under which he was forced to write the novel. So these were the circumstances surrounding a fiction which, despite low sales, he still considered to be '. . . in a hundred points immeasurably the best of my stories'. There are some who might wish to dispute this estimate – despite his care over its 'design' and construction, there are many readers who prefer the more impassioned and powerful essays in feeling which *Oliver Twist* and *The Old Curiosity Shop* represent. But in respect of its comedy it marks the high point of Dickens's achievement to date. He had originally decided to rest after *Barnaby Rudge* and travel to America precisely because he feared that his imaginative and creative powers were becoming exhausted by over-use; it turned out that his instincts had been correct, after all. The American passages of

this novel, as well as the whole new range of English characters which have since attained immortality, testify to the fact that the stay in the United States truly revivified his powers.

A *Christmas Carol* & *The Chimes*

A Christmas Carol, which now seems so immortal a fable, is in fact invaded as much by the spirit of the time as by any of the famous ghosts which also inhabit it. Its inception can be dated very precisely to the summer of 1843, when Charles Dickens visited a 'ragged school' in Field Lane: this was one of a number of such places, generally established by Evangelicals, where the children of the very poor were supposed to be given the rudiments of an education. The Field Lane school was one of the worst, situated in the very nest of alleys where Dickens had placed Fagin and his gang in *Oliver Twist*, but the reality was more appalling than anything Dickens had recreated in his fiction. 'I have very seldom seen,' he wrote to a friend, 'in all the strange and dreadful things I have seen in London and elsewhere, anything so shocking as the dire neglect of soul and body exhibited in these children.' It was one of his constant preoccupations for, as he wrote in the *Examiner*, 'Side by side with Crime, Disease, and Misery in England, Ignorance is always brooding . . .' These children were thieves, or prostitutes, or worse; they were filthy, half-starved, and barely clad. So in their midst were also born the two children, Ignorance and Want, who are displayed to a tremulous Scrooge in all their 'wretched, abject, frightful, hideous, miserable' shape. *A Christmas Carol* was on one level an attack on the very conditions of the time.

There was one other determining influence on the Christmas fable Dickens was about to compose. Three weeks after his visit to the 'ragged school', he made a speech at the Manchester Athenaeum, an establishment set up to educate the

working men of that city; in the course of his address he declared once more that ignorance itself was 'the most prolific parent of misery and crime' and then went on to emphasise that employers and employed should come together and share 'a mutual duty and responsibility'. This was one of his constant themes – he saw the country as one vast family, just like the families gathered about the Christmas hearth, and throughout his life he tried to inculcate the familial virtues of harmony and unity. Of course this was also the spirit of his incipient Christmas story, and a week after his return to London from Manchester he started work on what he called his 'little scheme'.

It was a 'scheme' certainly in one sense, since he had first conceived the idea of a specifically Christmas Book in order to earn some money; he was in debt to his publishers and, apart from the needs of his ever increasing family, he was continually facing demands from his importunate relatives. But the story itself soon took hold of him, since it came from sources far deeper than the anxieties of the moment. He worked on it very quickly, alternately weeping and laughing and weeping again, according to his friend and biographer, John Forster; it held such 'a strange mastery' over him that he could not rest but took long walks in the streets of London through the reaches of the night. He was in a sense possessed by this story of redemption, for within it somewhere he could see the shape of his own life.

In this same period he was writing a long novel, *Martin Chuzzlewit*, which is also concerned with the malign effects of greed and selfishness: it would also end with a sudden access of happy beneficence, and in one sense *A Christmas Carol* is a fantastic condensation of that book. But there were other elements involved in its composition which make it much more than a variation upon the same theme; for perhaps the strangest aspect of the story is the extent to which Dickens's memories of his own past are used to create the childhood of Ebenezer Scrooge. The school where the little

Scrooge sits is a dream-like reworking of the decaying blacking factory in which Dickens had once worked as a boy, and the young Scrooge *sees* such characters as Ali Baba and Orson in exactly the same fashion as Dickens had once done. Scrooge is rescued by his sister, 'little Fan', and Dickens's own elder sister was called 'Fanny'; the Cratchits are placed in a small terraced house which might be the image of the small house in Bayham Street, Camden Town, where Dickens and his family stayed after their removal to London. So many different images recur that it would be invidious to note them all here; but this can be said in summary – that many of Dickens's feelings about his own childhood are placed within the story, and it is because of their presence that the figure of Scrooge is so profoundly imagined and so powerfully effective. Dickens enters Scrooge in another sense also for, just at the time when he was creating that miserly figure, he himself was trying to ward off the financial demands of his parents and other relatives. It ought to be remembered that in the portrait of the miser there are insights into his condition which are of great psychological accuracy. 'You fear the world too much,' one person tells him, and there can be no better explanation of the way Scrooge piles up money and goods to ward off the depredations of reality. In one aspect of his temperament Dickens *is* Scrooge: that is why he has to be redeemed at the end.

Of course *A Christmas Carol* may be said to have reinvented Christmas itself. The door-knocker turning into Marley's face, the appearance of the ghosts of Christmas Past and Present, the Cratchit family celebrating in their little home, Tiny Tim ('who did NOT die'), seem to have become as much a part of the season as Santa Claus and the lighted tree. It was an extraordinary achievement on Dickens's part – to take what was essentially a religious festival and to humanise it, to soften its evangelical elements, to mitigate its grosser secular aspects (like the orgies of drunkenness he would have seen as a child in the naval port of Chatham), and instead to instil the lessons

of kindness and mutual forbearance. The religious elements of Charity and Mercy are also there, but they are incorporated within the motifs of the fairy tale; for if it is in part a religious fable, it is one characterised by the ghosts or spirits which are part of folklore and superstition. It was Dickens's instinctive skill in combining all of these elements that explains the peculiar power of *A Christmas Carol*; and this largely because, as a story-teller who still had his roots deep in the indigenous culture of chap-book and pantomime, he was himself very close to all the fables of the season and of the period.

He finished the story at the beginning of December, and made his own arrangements for its illustration and for its binding. It was very much his book, in other words, conceived and written within a very short time (unlike the episodic nature of his novels), and containing within it all the basic principles of his social philosophy as well as those more private elements running beneath its surface. In a way the story is emblematic of his real genius: to use his own memories in order to lend weight and substance to his social concerns, so that his own life can be seen as a sort of lightning conductor for the nineteenth century. The public response was overwhelmingly favourable – the critic on *Fraser's Magazine* declared, '. . . who can listen to objection regarding such a book as this?' – and from this time forward Dickens decided to write a Christmas Book each year.

Certainly he was intent on starting another in the autumn of the following year. He was in Italy with his family, staying in the Palazzo Peschiere in Genoa, among which ornate surroundings he found it difficult to concentrate upon the task in hand. In any case it was hard for him to write outside England; in particular he needed the thoroughfares and crowds of London to provide him with a fresh supply of imaginative energy and excitement. But then, at the beginning of October 1844, he wrote a short letter to John Forster: 'We have heard THE CHIMES at midnight, Master Shallow!' By which he meant that he had heard the bells of Genoa borne on the wind

towards him, and in the sound of those bells he had discovered his great theme for the next Christmas Book.

It was entitled *The Chimes*, for the bells themselves act as the spirits of the past and the future, the pulse of Time. Dickens described it as having 'a grip upon the very throat of the time' because, like its predecessor, it managed to bring Dickens's social and political preoccupations within the scope of a moral or religious fable. It was another fairy-tale of the industrial age, in which the claims of Charity and Mercy are placed within a contemporary framework. For this is the story of Trotty Veck, the poor man who believes that the poor have no place on this earth and who is brought face to face with the extremes of human suffering.

In this second Christmas Book Dickens was attacking certain specific contemporary abuses – Malthusian doctrine and the malign effects of the New Poor Law were two of the targets at which he was aiming – but he had also been reading in *The Times* reports on the plight of the impoverished labourers of Dorset as well as harrowing testimony from a young woman who tried to drown herself and her child for fear of the workhouse. These were also elements which Dickens placed within his story, for he wanted the act of magical redemption, which always occurs at the end of his Christmas Books, to have more than a magical point. This was the secret of his seasonal fables. Dickens was able to emphasise the warmth and cosiness of the fireside hearth only because he took great care in describing the depths of poverty and despair which lay beyond it; he allowed a final vision of redemption and beneficence only after he had exposed the horrors and iniquities of the contemporary world.

He worked on throughout October, taking restless and relentless walks through the streets of Genoa. As imaginatively he entered the sufferings of the poor he became 'hot and giddy', his eyes growing 'immensely large', and at the close he 'had what women call "a real good cry"!' For in *The Chimes* he had delivered a plea for 'the fallen and disfigured', with all

the pain and desperation of the poor somewhere within this little fable. In his attack upon the follies of the utilitarians and statisticians, as well as the absurdities of those who look back upon 'the good old days', he was attacking most of the palliatives or excuses of the day; indeed in his final polemic he was giving forceful utterance to some of his most radical sentiments: 'I know that our inheritance is held in store for us by Time. I know there is a Sea of Time to rise one day, before which all who wrong us or oppress us will be swept away like leaves. I see it, on the flow!' In some moods Dickens really did despise the political and social conditions of his day – and why should he not do so since he, as a boy, had also been at their mercy?

He travelled back to London from Genoa in order to arrange the publication of his new Christmas Book. He was so excited by it that he wanted to read it out loud to a gathering of his friends. 'What a thing it is to have Power,' he wrote to his wife after reducing the actor, William Macready, to tears over the plight of Trotty Veck and his family. And that was at the heart of it – the power to move, the power to change the world, the power to take the feast of Christmas and advance his own most urgent preoccupations within it, the power to write seasonal fables which would have a direct contemporary relevance. *The Chimes* was attacked by many reviewers as simply the tract of a romantic revolutionary, ready to support the 'felon' or the 'rick-burner', but it was more than that. It was a kind of personal testament, different in tone and conception to Dickens's novels, filled with his presence (for, as he said to the reader, '. . . I am standing in the spirit at your elbow . . .') and his most urgent beliefs. There would be more Christmas Books to follow, although not all of them would be written with quite the same polemical intent.

The Cricket on the Hearth,
The Battle of Life &
The Haunted Man and the Ghost's Bargain

AFTER THE success of *A Christmas Carol* and *The Chimes*, Dickens had decided to keep up the steady momentum of a Christmas Book each year – a seasonal fable in which he could spell out his social principles in the context of grace and magical redemption. His third one was to be entitled *The Cricket on the Hearth*, but it turned out to be quite different from anything he had written before. For, as his life changed, so did his work. On his return from Italy, where he had written *The Chimes* the previous autumn, he thought of editing a new periodical. He had a title for it, *The Cricket*, and his purpose was to continue what he called the '*Carol* philosophy'; in other words he wanted to instil the tone and atmosphere which he had already created in his Christmas Books since, as he said of his readers, 'I would at once sit down upon their very hobs; and take a personal and confidential position with them . . .' He wanted to be close to his public, and in his seasonal fables he almost imposed his presence upon them as if he were an actor or a speaker in their very midst. The periodical came to nothing, but the name stayed with him.

In fact almost immediately he became involved with a much greater venture, since he agreed to take on the editorship of a new journal, the *Daily News*; his arduous work on that newspaper meant, however, that in the autumn months of 1845 he had very little time to spare for his own fiction. As a result he was working on his next Christmas Book in a hurried and

discontinuous way, and indeed it may be that the circumstances of its composition materially affected the nature of the story. For it was a departure from *A Christmas Carol* and *The Chimes*; in *The Cricket on the Hearth* Dickens abandons the social preoccupations which had characterised the earlier fables and instead turns to what the *Edinburgh Journal* at the time called 'a subject of purely moral interest'. In fact the story is concerned with a husband's unjust suspicions about the fidelity of his much younger wife, although this domestic theme does have at least one connection with the earlier Christmas Books: once again disaster threatens but is dispelled at the last minute, in the kind of *coup de théâtre* at which Dickens excelled. Charity and mutual forbearance can, and must, win through in the end – that is always his seasonal message.

The fact that he was working in a rushed way meant, paradoxically, that this latest Christmas Book contained more private material than its predecessors: *A Christmas Carol* and *The Chimes* had emerged in an almost impersonal way, already completely formed in Dickens's imagination, but in *The Cricket on the Hearth* he was searching for a theme with rather more conscious intent. He may even have been using material from his own domestic life, since the husband's suspicions about his wife in the story seem to reflect doubts which Dickens's wife had harboured about her husband's behaviour in the previous year. When they had been residing in Italy he had 'treated' a certain Madame de la Rue. Dickens was an expert hypnotist, and through his mesmeric powers he alleviated that woman's hysterical symptoms. But Catherine Dickens had become jealous of what was necessarily a close relationship, and it seems likely that her husband was now drawing upon this episode to furnish his Christmas tale.

Once more he was able to reach, and move, a popular audience with his story. He was in a sense becoming the great entertainer, the national story-teller, and it was this consciousness of his role that prompted him to take care over the drama-

tisation of *The Cricket on the Hearth*: it was performed at the Lyceum, where he even assisted at some of the rehearsals. And yet the more popular he became, the more violently the critics dismissed his work; *The Times*, for example, described *The Cricket on the Hearth* as 'the babblings of genius in its premature dotage'. This was of course unfair: it is not the finest of his stories, but it has moments of genuine power. There is in particular the sub-plot of Caleb who creates a wonderful world for his blind daughter, quite at variance with the one in which they both actually live; it is a powerful theme because it seems in a sense to reflect Dickens's own artifice as a novelist. 'I have altered objects, changed the characters of people, invented many things that have never been, to make you happier.' To make you happier – that might also be Dickens's catchphrase in the creation of his Christmas Books and, with the success of *The Cricket on the Hearth*, he knew that he could now count on a receptive and faithful audience.

In fact he was determined to carry on his Christmas tradition even when he was travelling abroad, which meant that he began his next fable while he was staying with his family in Lausanne. It was the autumn of 1846 and he was already deeply involved with the composition of *Dombey and Son* when he was suddenly visited by a 'very ghostly and wild idea' for a new Christmas Book. He even thought of a title for it – *The Battle of Life*. He was not at all sure that he could write two fictions at the same time, however; these were no longer the days of his youthful energy and creativity, when he had been able to work on both *Oliver Twist* and *The Pickwick Papers*. He was composing more slowly, now, and more carefully. He was, however, just as determined as ever and he explained to his friend, John Forster, that 'If I don't do it, it will be the first time I ever abandoned anything I had once taken in hand; and I shall not have abandoned it until after a most desperate fight.' He wanted to complete it by the end of September, so that he could return at once to *Dombey and Son*, but he was beset by misgivings. Was this 'very ghostly

and wild idea' too interesting to be wasted on a short fable? Was he destroying the energy which should have been reserved for his novel? He was despondent and told Forster, 'I fear there may be NO CHRISTMAS BOOK!' But Dickens's temperament was not one to yield to even the most distressing or exhausting circumstances: he hurried from Lausanne to Geneva, in the hope that urban surroundings might galvanise him: and indeed he did seem to acquire fresh energy and determination. He finished the whole story by the middle of September, having completed the third and final part in a wild rush of five days' work.

It was once more a popular but not a critical success – some twenty-five thousand copies were sold on the first day of publication, in the middle of December, and when Dickens came back to London in order to read the story out loud to the actors who were going to dramatise his new Christmas offering, he reported that 'There was immense enthusiasm at its close, and great uproar and shouting for me.' It seems that he had triumphed again, although it cannot be said at this late date that *The Battle of Life* is the best of his Christmas Books. It has a complicated plot which cannot really be properly worked out in so small a space; in that sense Dickens was right in his belief that he ought to have reserved the story for a long novel. But in any case the theme itself, that of two sisters who love the same man, is not one of his most powerful or even most convincing exercises in domestic melodrama. It may owe something to the fact that he now shared his household with both his wife and his sister-in-law but the element of wish-fulfilment, if such it is, is in the end overlaid by Dickens's usual Christmas emphasis on the benefits of patience, charity and self-sacrifice. There are some of the usual elements of his longer fiction here also – young innocent girls as well as comic lawyers and comic servants, blessedly happy homes as well as snug little public houses; all the quintessentially Dickensian characteristics are present, and it is hard to resist the belief that when he was rushed or exhausted he reached for these

familiar elements simply as a way of sustaining the momentum of his plot. In fact *The Battle of Life* has often been described as the most sentimental of his Christmas Books, by which is no doubt meant the fact that the movements of feeling are most heavily emphasised here. But it was part of a theatrical culture – or rather part of the legacy of a theatrical culture which Dickens so much admired – in which feelings of every kind were projected by speech and movement; they had to be displayed in order to become real, and when we talk about the explicit sentiment in this tale of amatory sacrifice we need not assume that it is necessarily maudlin or inappropriate.

Certainly that is not a description which could be applied to the last Christmas Book which Dickens wrote, *The Haunted Man and the Ghost's Bargain* – the last and possibly also the strangest. It was written during the winter of 1848, two years after *The Battle of Life*. In the previous year he had been too concerned with his work on *Dombey and Son* to contemplate any other fiction, although he was 'loath to lose the money', as he told a friend, or to leave 'any gap at Christmas firesides'. But then in the following year events prompted what is in some ways his most personal Christmas Book.

His sister, Fanny, had just died – the sister with whom he had grown up in Chatham and London, the one member of the family upon whom he could rely and whom he had quite unaffectedly loved. He had spent many hours by her bedside in her final weeks, and together they had talked of the old times – she had even recalled 'the smell of the fallen leaves in the woods where we had habitually walked as very young children'. So it was that, in the seasonal fable he began a few weeks after her death, he was preoccupied with 'the revolving years' and with 'the memory of sorrow'. There were other incursions of sorrowful memory also, for it was in this period that Dickens wrote down certain passages of autobiography; in a fit of melancholy or, more likely, self-examination, he recounted his experiences as a 'labouring hind' in the blacking factory by Hungerford Stairs and retold in doleful form the

whole history of his father's incarceration for debt in the Marshalsea Prison. It is an extraordinary fragment, and itself throws an oblique light on *The Haunted Man and the Ghost's Bargain* – for this is a fable in which the haunted protagonist in the end understands the words, 'Lord, Keep My Memory Green'. In this Christmas Book memory is seen as the surest and most faithful source of imaginative sympathy, as it was for Dickens, also, who never forgot the sorrows of his childhood and thus always understood the misery of the homeless and the outcast. It is of some significance, too, that he wrote this Christmas Book immediately before starting work on his most autobiographical novel, *David Copperfield*, in which the terrors and pleasures of memory hold the preeminent place.

He began *The Haunted Man and the Ghost's Bargain* in November of that year and was composing it very carefully, working on it both in London and in Brighton. He completed it on the last day of the month and then wrote to his publisher, 'I finished last night, having been crying my eyes out over it.' For indeed it is in some ways the most poignant of all his Christmas Books – with the sorrowful man at its centre who finds in his memory the truest token of his own identity. All the images of his dead sister, and of a lost love, '. . . come back to me in music, in the wind, in the dead stillness of the night, in the revolving years'. It is a wonderful story, filled with darkness and shadow, with the atmosphere of loss and dread so perfectly evoked that it must stand alongside *A Christmas Carol* for its rendering of true feeling. Memory of sorrow softens the heart – that is the seasonal message which Dickens suggests here, and it was not an inappropriate one with which to end his series of Christmas Books. (In future years he would write only short Christmas stories for his own periodical.) Indeed *The Haunted Man and the Ghost's Bargain* represents the proper culmination of this work, for in the fable Dickens asserts the primacy of the creative imagination at the same time as he emphasises its moral dimension – '. . . but for some trouble and sorrow we should never know

half the good there is about us'. That sounds like the merest truism, but in the context of Dickens's own work it could be written in letters of fire. Indeed all of the Christmas Books represent the purest, and in certain respects most significant, expression of that idea. That is why they will live as long as the festival itself.

Dombey and Son

*D*ombey and Son is the novel which, in certain respects, has the closest connection with the immediate circumstances of Charles Dickens's life. He started to consider it in the spring of 1846, at a time of much discontent and disappointment: he had just resigned from the editorship of the *Daily News*, an appointment which lasted less than a month and which left him open to the charge of being unable to deal with conventional financial and commercial life; it is not surprising, perhaps, that in Dombey he created a coldly symbolic figure of one who had mastered just such activities. In addition he had written no novel since *Martin Chuzzlewit*, the final number of which had appeared almost two years before; this was an unprecedented gap in Dickens's writing career, and he approached the new task with more self-consciousness and hesitation than had ever before been apparent.

It is not that he had been inactive during that interval: he had travelled to Italy immediately after completing *Martin Chuzzlewit* and, although the stimulus of that novel atmosphere led him into his usual excess of walking and dreaming and sightseeing, he was writing almost as soon as he had arrived in Genoa. It was here, after all, that he composed the second of his Christmas Books, *The Chimes*. When he returned to England after a year's absence he completed *The Cricket on the Hearth*, the third of his Christmas Books, and also wrote a book of travels, *Pictures from Italy*. The Christmas stories had been a popular success, but their sentimentality and perhaps excessive obeisance to the mood of the 'season' meant that they were not necessarily a critical tri-

umph. He knew that, in beginning another novel after so long an interval, he would have to prove himself all over again. *The Times*, in its usual acerbic way, had put the matter very briefly: 'He has not only to sustain his past reputation, but to repair the mischief which we assure him has been done by his latest publications . . .'

Yet still he could not begin: he was, for one thing, heavily involved in the unravelling of his commitments to the *Daily News*. He had been editor, after all, albeit for a short period, and was a shareholder in what was a new and perilous venture; there were many administrative matters with which he had to assist, and he confessed to being 'at sixes and sevens' over the whole business. In addition he was becoming involved with a great friend, Miss Burdett-Coutts, in what was to prove the most important and the most substantial of his philanthropic ventures: the establishment of a Home or Asylum for 'fallen women'. He was not some distant patron or benevolent guardian but, typically, the most eager and urgent of all those assisting in the enterprise: he arranged the daily regimen of the Home, he outlined the course of training the unfortunate women would undergo, and even concerned himself with such details as the layout of the building itself. But such active and practical work meant that he had found very little time for what he once described as those 'confidential interviews with myself' in the course of which his fiction was established. There are several passages in his correspondence when he reflects upon the 'dream of life' – for the curious aspect of this man who busied himself in all the affairs of his age is that there were many times when that business seemed to him to be no more than a shadow play in a world of phantasms. These were the occasions, too, when the real world seemed to him to be taking place within the brighter orbit of his fiction. So there are episodes in his life, just as now, in the spring months of 1846, when he seems to be dashing himself to pieces against the barriers of the world, aware that his proper work was being postponed and aware, also, that in his ever-active and ever-

moving life the images of his fiction were being continually denied access to his brooding imagination.

So he decided upon a course of action he had taken before: he would escape once more, flee from England, and resume his real work in a place where he would be afforded the space and time for his fictional dreams. He decided to leave England for a year and travel first to Switzerland and then to France; of course his family came with him (they were by now used to his imperious and restless ways), and at the very end of May in three separate coaches they made their way to Lausanne. So calm a place after the frenetic atmosphere of London – this town beside the lake, with its wooded hills, its small houses and green pastures, while beyond them loomed that spectacle of which Dickens never grew tired, the icy mountains of the Alpine region. They quickly found a house which looked from a hillside down onto the lake itself, and it was here that Dickens began his first serious planning of *Dombey and Son*. It is in fact the first novel for which a complete set of his 'number plans' survive – these were sheets of notepaper, folded in half, on which he sketched out the essential themes and stories of his narrative while at the same time keeping up a running summary of the events within each chapter or each number. He was planning so far in advance, in fact, that he knew what part of the story he would have reached by the time he arrived in Paris some five or six months later. Certainly the novel itself bears all the signs of prior construction, and on the very first page he characterises Dombey himself as 'a tree that was to come down in good time', from the beginning, too, his prose here is marked by a deliberation and restraint that were not so readily apparent in his earlier fictions.

He strolled by the lake and climbed the narrow streets of Lausanne, pondering on Dombey himself, on the fate of little Paul Dombey, on the meaning of Florence Dombey's life. And although *Dombey and Son* is most closely concerned with what at one point Walter Gay calls '. . . the true feeling of my heart', there were other, less individual, concerns which

animated it. Dickens was a journalist as well as a novelist, after all, and there is no doubt that much of the contemporary appeal of *Dombey and Son* lay in its account of commercial speculation and financial disaster – primarily because in this period the entire country was seized by what was described as 'railway mania'. There was an obsession with them during these years, and the *Daily News* itself had been established to support the railway interests. Perhaps Dickens's unfortunate involvement with that newspaper colours his view of the railway and, although it does not directly enter the novel as an aspect of financial speculation, it does appear as a harbinger of fatality. The fact that the railway is on one occasion equated with 'Death!', and that it is a train which bears down upon and crushes Carker, suggests that the inevitable change it represented was not necessarily always viewed by Dickens with equanimity. Of course he was in many ways a representative Victorian and saw the new transport as an important sign of progress and human civilisation; but there were occasions, too, when he noted all the wreckage it might create during its advance. The best analogy for this aspect of the novel is in fact to be found in Turner's wonderful painting, 'Rain, Steam and Speed – The Great Western Railway', which was completed two years before *Dombey and Son*. Here, too, the train is seen as an image of great power and even of beauty – but in its whirlpool of colour there are also intimations of menace and fatality.

There were other matters of more private import which affected him as he wandered around Lausanne and contemplated the fiction rising around him: many of the associations and affiliations cannot now of course be recovered, but certain stray connections can perhaps be made. He had a few months before run over a little dog in Regent's Park, for example, and caused such distress to its young mistress that the event marks the real origin of the dog, Diogenes, which Dickens gives to Florence Dombey in an act of imaginative restitution. More importantly Dickens had also been sporadically engaged while

at Lausanne on writing out for his children *The Life of Our Lord*, a short work based upon his reading of the New Testament. It has often been suggested that *Dombey and Son* is touched by something akin to a religious spirit, and it is possible to see how his own thoughts and feelings were circling around just such concerns in this period. The first number or episode of the novel came to him easily enough and, with that new measure of deliberation and restraint already recorded, there is also manifest in his prose what can only be described as a new interest in moral analysis or a new ability to express a moral sensibility.

After a few weeks, however, he found that his work was not coming easily to him – in particular he suffered from what he described to his friend, John Forster, as 'the absence of streets'. That is why he is preeminently the novelist of London, the first true urban genius, and one of his daughters has recalled how '. . . he was sometimes obliged to seek the noise and hurry of a town to enable him to struggle through some difficult part of a long story . . .' He needed crowds; he needed to wander through brightly lit thoroughfares and through reeking alleys. He needed all the excitement and danger and wonder of being one Londoner among many just as, in his fiction, he is one author among many creations. But all these stimuli were denied to him in Lausanne and, in addition, he found his imagination being buffetted and strained by other ideas. This was his first novel for two years and, as soon as he had begun it, it was as if the floodgates of his creativity had been raised – along with the torrent of *Dombey and Son* came other unclaimed objects and unknown debris. He was struck by ideas for other books (some of which did indeed come to fruition at a later date) but, more significantly, he was suddenly invaded by a notion for his next Christmas Book, *The Battle of Life*.

Though *The Pickwick Papers* had been written alongside *Oliver Twist* at the beginning of his career, Dickens could no longer perform the feat of writing two books at once. It was

not a question of advancing age and any subsequent loss of energy – that commodity was never in short supply. It was simply that he had become, and he knew himself to be, a more serious novelist now; his experience of his own gifts had chastened and directed his powers. But he had another great characteristic also: once he had begun a project he had an almost obsessive need to complete it and so, as soon as *The Battle of Life* had occurred to him, he knew that he could not postpone or discard it. Eventually he reached a compromise with himself. He finished *The Battle of Life* as quickly as he could and then went back to *Dombey and Son* with all convenient speed. He finished the third episode of the novel in Lausanne, and then in November travelled to Paris with his family. It was here that he began to contemplate the first great 'turning point' of his story, the death of Paul Dombey. Dickens was very skilled at child death – he had the experience of Little Nell behind him – and so great was the power of this latest scene that, according to one contemporary, it 'flung a nation into mourning'. Already, he knew that the novel was a success: the first instalment had sold something like twenty-five thousand copies, and by the end of its run it would exceed that number by another ten thousand.

And so, buoyed up by his success and exhilarated by another popular death, he worked on through the coldest months in Paris and then, in February 1847, he returned to London. He was working very much more slowly now than in the past, but this does not mean that there was any self-consciousness or abbreviation in his characteristic humour; it is in this period, for example, that he introduces one of his most amusing grotesques, Mrs Skewton. 'Cows are my passion . . . I want Nature everywhere. It would be so extremely charming.' She is one of the most 'theatrical' of his creations – at least in the sense that any real identity she may once have possessed has long since been obscured by a carapace of fashionable costume and simpering manner – and it is perhaps apposite to mention that it was after his return to London that he became

heavily involved in amateur theatricals. These theatricals became his most important recreation, the most significant 'release' from his writing, throughout his middle years; a matter only of biographical interest, perhaps, except for the fact that from this time forward his more theatrical antics and devices would be diverted away from his novels onto the real stage. But they were by no means his only extra-curricular activity and, even as his work on *Dombey and Son* slowed down, so his involvement with Miss Burdett-Coutt's Asylum for 'fallen women' gathered pace. He was now choosing the girls for the Home, and superintending such matters as the sanitation arrangements of the establishment. Nothing escaped his attention: he even chose the material for the girls' dresses. Nothing escaped his attention in another sense, also, since all the life of the circumambient world enters the novel which he was even then composing; so it is that, in the scenes concerning Edith Dombey's elopement, Dickens includes a plea for the outcast in precisely the week during which the Home was formally opened. In his work, which charges the events of his life with a symbolic wholeness and a thematic fullness, everything comes together.

There are certain passages, however, and perhaps even certain chapters, which show occasional signs of Dickens's weariness or inattention as a result of these continual and arduous activities. Yet the complete narrative manifests a more than usual sense of order. He told John Forster that *Dombey and Son* would be concerned with Pride, in the same way that *Martin Chuzzlewit* had been concerned with Selfishness, and that is indeed one of the springs of his narrative. But there are larger themes at work here also – no previous fiction of his had been so illuminated by what can only be described as a religious spirit, and the images of grace and redemption are particularly obvious in the closing chapters of the narrative where Dickens invokes the presence of '. . . that higher Father who does not reject his children's love, or spurn their tried and broken hearts . . .' So there are universal longings, expressed

here, which is perhaps also why the elements of fairy-tale are more consistently invoked than in any of Dickens's previous works. In his use of the imagery of fairy-tale as well as the imagery of the New Testament (it is not always clear that he was aware of any real difference between the two), an air of mystery and enchantment is characteristically combined with aspirations towards some ultimate human goodness and universal beneficence. There is less exuberance of fancy here than in its predecessor, *Martin Chuzzlewit*, and yet *Dombey and Son* does have an extraordinarily haunting quality; even in such apparently random scenes as that of Mr Toots wandering by the seashore, faintly aware that the waves 'are saying something of a time when he was sensible of being brighter and not addle-brained', there is the radiance of last things. And if indeed there is some diminution in the extravagance of this work, it is because Dickens's creative energy flowed into that cloud of poetry which hovers over the narrative and into which it is finally folded. He had finished the novel by the spring of 1848 and declared that '. . . I have great faith in Dombey, and a strong belief that it will be remembered and read years hence.' In that prediction he was of course to be proved, magnificently and triumphantly, right.

David Copperfield

W HEN Charles Dickens eventually came to write the preface to this, his eighth novel, he declared that he felt as if he were '. . . dismissing some portion of himself into the shadowy world . . . no one can ever believe this Narrative in the reading more than I have believed it in the writing'. This was no less than the truth for, of all his novels, *David Copperfield* is the one which draws most closely upon his character and experiences; indeed it is filled with the very life blood of his genius. It might be said to have begun when his own life began but, more prosaically, there are a number of more obvious connections which can be made between his life and his art – for it was in the period immediately before he began work upon his narrative that his own past came back to unsettle him. In September 1848, his sister, Fanny, died of consumption; she was only a little older than her famous brother, and in fact had been his constant companion from his earliest years. It was she who played with him in the fields opposite their house in Chatham; it was she who had gone with him to his first 'dame school'; it was she who seemed to have deserted him, albeit unwittingly, when she was enrolled at the Royal College of Music while he remained a 'little labouring hind' in the blacking factory by Hungerford Stairs. All these things returned to him at the time of her death (if they can properly be said ever to have left him) and in the Christmas Book which he wrote a few weeks later, he devised a haunting fable around the theme of memories which 'come back to me in music, in the wind, in the dead stillness of the night, in the revolving years'. More importantly, perhaps, it was also in this period

that he composed a fragment of autobiography – some seven thousand words in all, comprising his time at Warren's blacking factory and his father's incarceration for debt in the Marshalsea Prison. He broke off this exercise in self-revelation just after he had written about his release from manual labour, and a few months later showed the fragment to his friend and future biographer, John Forster, but not to anyone else. Clearly he was uncertain about its eventual form or even its proper significance but it was also in this period that he began once more to be visited by 'dim visions of divers things'. He was contemplating a new novel, in other words, and when Forster suggested to him that he should try his hand at a first-person narrative all the ideas which had been floating around his autobiographical fragment seemed ready to be integrated into something possessing a larger and more substantial scale.

At the very beginning of 1849 he travelled, on one of his 'jaunts', to Norwich and Great Yarmouth. Never did a man make as much use of his leisure as Charles Dickens, however, and what started out as a diversion from his work soon represented an intensification of it – for it was at Great Yarmouth that the scenario for much of *David Copperfield* was disclosed to him. It was along its sands that Peggotty's upturned boat would be placed, and along its shore that the great storm would eventually rise and destroy both Ham and Steerforth. And it was while walking from Great Yarmouth to Lowestoft, also, that he saw a small signpost pointing to the village of Blundeston. Thus was David Copperfield's birthplace found.

Soon after he returned to London, Dickens began to write a series of articles for the *Examiner* on the case of Benjamin Drouet, and his systematic abuse of orphan children living, and dying, in his 'care'. And so it was that the wretchedness of such blighted children came vividly to his attention at a time just before the creation of David Copperfield himself, who is first without a father and then without a mother. In fact children without fathers, or without mothers, play a central role in the novel – Uriah Heep, Little Em'ly, Steerforth,

Agnes, Traddles, Dora, Martha, all of them the lost children of Dickens's imagination now rising up around him as he brooded upon his narrative. The book was with him always now. When another son was born to him, he named him Henry Fielding Dickens – after the author whom he intended to emulate in a novel which represents some transition between picaresque adventure and *Bildungsroman*. By February he was in Brighton, his mind 'running like a high sea' on various names and titles. There were some seventeen attempts, still preserved in his working notes, until finally he emerged with 'The Copperfield Survey of the World as it rolled. Being the personal history, adventures, experience, and observation, of Mr David Copperfield the Younger of Blunderstone Rookery'. Then he added, later, 'which he never meant to be published, On any account'. Just as Dickens himself 'never meant' his own autobiographical fragment to be published – unless, that is, it could be transformed or concealed within some other design.

He began writing in the last week of February, inaugurating a period of concentrated and intense activity upon the novel; there would be no foreign excursions, and no amateur theatricals, to divert him from this literally fabulous exploration of his own past. He worked slowly enough, although he had so clear an idea of the general direction of his narrative that he readily introduced David Copperfield himself, Little Em'ly, Peggotty, Betsey Trotwood and the Murdstones. In these characters alone we find the essential constituents of Dickens's vision, and the pattern of the narrative must have been apparent to him from the very beginning of his work. Nevertheless all the care and attention which he gave to his writing now (quite unlike the speedy improvisation of his earlier days) necessitated slow progress – slow, that is, until he reached the fifth number, or instalment, in which he was ready to employ the autobiographical fragment he had already written. These passages in the manuscript are written in a much freer and more rapid hand; all the details of his infant reading, of the ware-

house to which he was consigned, of the Marshalsea prison in which his father was incarcerated, are reproduced with only minor alterations in his account of David Copperfield's juvenile miseries. It may be Mr Micawber rather than Mr Dickens who is placed in the Marshalsea, but the details and the feelings evoked in this account are those emanating from the young Dickens himself: '. . . and when at last I did see a turnkey (poor little fellow that I was!), and thought how, when Roderick Random was in a debtors' prison, there was a man there with nothing on him but an old rug, the turnkey swam before my dimmed eyes and my beating heart . . .'

These passages set within the darker recesses of London life are not the only ones in which Dickens employs autobiographical material. The narrative reflects his own early life in many other ways also, not least in his constant description of David's infant capacity as an observer. 'I was a child of close observation,' the narrator writes '. . . [I] saw in the first glance after I crossed the threshold . . . I believe the power of observation in numbers of very young children to be quite wonderful in its closeness and accuracy . . .' This is Dickens's own sense of himself as a child – and little David does seem to be in many important respects a simulacrum of little Charles. A self-willed boy, awkward when he believes himself to be observed, anxious, affectionate, industrious, ambitious to please. He is a boy filled with fears, but never expressing them to anyone; a boy who continually notices the eyes of adults, watching him; the boy whose very experience of emotion is bound up with the idea of theatrical display as, for example, when he is told about the death of his mother and 'stood upon a chair when I was left alone, and looked into the glass to see how red my eyes were, and how sorrowful my face'. This is the real, the quintessential Dickens refracted through the image of Copperfield examining himself in the mirror.

There are other clear autobiographical associations, albeit of a more mundane kind. In the account of David going to the

theatre for the first time, for example, the experience of new and 'illimitable regions of delight' accurately reflects Dickens's own youthful passion for the stage. Copperfield's experience of Doctors' Commons again acts as a reprise of Dickens's own work in that nest of courts and legal men engaged in a 'very pleasant profitable little affair of private theatricals', and of course Copperfield's work as a shorthand reporter in the Houses of Parliament is a direct transcription of the novelist's anonymous service in that capacity. Copperfield's love for Dora Spenlow is no less than the revival of Dickens's youthful infatuation for Maria Beadnell, and the fictional hero's eventual renown as an author has more than a fictional basis. It can be said, in fact, that all the formative stages in Dickens's own development are marshalled here in imaginative array. And who is it but the author himself who stands behind Copperfield's somewhat self-congratulatory accounts of his hardiness, persistence and resolution – that '. . . patient and continuous energy which then began to be matured within me, and which I know to be the strong part of my character . . .' Yet alongside that energy and the determination dwell less glorious characteristics, most notably among them Copperfield's continual awareness of '. . . a vague unhappy loss or want of something'. This is precisely the sentiment which Dickens ascribes to himself in his correspondence, so there can be little doubt that in the figure of Copperfield he was raising up an image of his own life and character – strangely changed, of course, in that transition from troubled self-awareness to fictional creation; and indeed it might be said that it was in the very act of inventing David Copperfield that Dickens for the first time confronted the shape and meaning of his own life.

That may in itself help to account for the fact that he began to feel the oddest discomfort on completing the most overtly autobiographical passages in the book. He had gone down for the summer of 1849 with his family (and various friends) to the Isle of Wight, in which place he soon began to feel a most unpleasant combination of exhaustion, giddiness and inertia.

He became inordinately depressed as a result and, although he blamed these deleterious effects upon the climate of the area, it seems at least as likely that he was suffering from some kind of self-inflicted malaise. Just as the young Copperfield keeps on noticing the eyes of others, watching him, measuring him, judging him, so Dickens may have felt some psychic discomfort after his oblique exercise in self-revelation. What would his parents have thought of their partial recreation as the feckless and frequently ridiculous Micawbers? What would Catherine Dickens have felt about her husband's loving invocation of the youthful infatuation between David Copperfield and Dora Spenlow? Did he also, perhaps, feel some general kind of guilt – and did he irrationally fear some form of retribution? These would be the merest biographical fantasies were it not for the fact that, throughout his life, Dickens seems to have experienced something close to paranoia at moments of personal crisis.

He had returned to London by the autumn, where his work on the novel was distracted and sometimes even curtailed by the duties and rigours of his ordinary life. His labours on behalf of Urania Cottage, the Home for 'fallen women' which he had established with Miss Burdett-Coutts, took up much of his time even though, in his usual economical way, he redeployed many of his experiences and observations there in his depiction of the prostitute, Martha, whose shadow haunts the narrative of Little Em'ly. But there were also diversions of a more private kind – in particular his plans for a new weekly periodical, which he wished to edit, created in him such a whirlpool of anticipation and anxiety (what he called in the novel David's 'fever of expectation') that his concentration upon the novel suffered. He travelled down to Brighton in March 1850, simply in order to remove himself from the pressures of his urban existence, and then in June he went over to Paris for a brief respite from the imaginative work which always exhausted him. As soon as he returned to London, however, he was planning the last episodes of the novel

and, in order to complete the task, he took a large house in Broadstairs which looked out to sea. It was here that he dispatched Steerforth in the terrible storm, and where he wrote the wonderful descriptions of the emigration of Little Em'ly and the Micawbers. These scenes were written in the September of the year, and towards the close of the following month he came to the end of his long narrative. *David Copperfield* was completed at last. 'Oh, my dear Forster,' he wrote in a letter to his friend, 'if I were to say half of what *Copperfield* makes me feel to-night, how strangely, even to you, I would be turned inside-out! I seem to be sending some part of myself into the Shadowy World.'

He always considered it to be his best work, and in that judgement both his contemporaries and posterity have been happy to concur. Of course it contains the comedy and the vivacity always associated with Dickens's work, just as it has its fair share of sentimentality and farce; but all of these characteristic aspects of his genius are chastened and restrained here, in the service of a narrative which is at once more lyrical and more powerfully suggestive than any which had preceded it. It is a novel of great psychological acuteness, also, and one which exhibits what might be described as a Proustian concern for memory and for the nature of reality charged with memory. There is that wonderful moment, for example, when David sees his mother for the last time. It bears requoting here precisely because it exemplifies that strange, sad, plangent tone which suffuses much of the narrative: 'I was in the carrier's cart when I heard her calling to me. I looked out, and she stood at the garden-gate alone, holding her baby up in her arms for me to see. It was cold still weather, and not a hair of her head, or a fold of her dress, was stirred, as she looked intently at me, holding up her child. So I lost her. So I saw her afterwards, in my sleep at school – a silent presence near my bed – looking at me with the same intent face – holding up her baby in her arms.' We can hear in this the true music of Dickens's prose, and indeed the true

music of his being. If there is one book which establishes Dickens's unique presence as a writer who can be considered the last of the great eighteenth-century novelists and the first of the great symbolic novelists, and which explains why it is that he is considered to be the true heir of the Romantic poets, it is *David Copperfield*.

Bleak House

As Charles Dickens reached the period of middle age, his life had never been more filled with duties and responsibilities. Of all novelists he was perhaps the one most committed to the doctrines of social progress and the principles of social welfare, but his always heavy burden of philanthropic activities and public speeches was now compounded by work of a more sustained kind. By 1851 he had become the editor and guiding force of a periodical, *Household Words*, on which he laboured week by week; in addition he had established a group of Amateur Players, and toured the country with them in order to raise money on behalf of his scheme for a Guild of Literature and Art. Public burdens were, however, of less significance than the private miseries which now began to pile up around him. His father died in a room which his son described as 'a slaughter house of blood' and in his grief he told his wife that 'I have sometimes felt, myself, as if I could have given up, and let the whole battle ride on over me'. But his wife, too, was even then a source of severe anxiety; she was suffering from extreme nervous depression and was forced to leave London for Malvern in order to take the waters there. And then, if all this familial distress were not enough to weigh him down, his infant daughter, Dora, died quite suddenly.

These biographical facts might not be of any consequence in themselves, were it not the case that they preceded the period in which his vision of *Bleak House* began to be distilled: and in the bleakness of all the world around him, can we not see something of that spirit of rage and that awareness of fatality which animate the novel? He travelled down to

Broadstairs in the summer of 1851, just a few weeks after the deaths of his father and his daughter, but even in the peace of the resort he became invaded by that 'violent restlessness' which generally preceded the birth of a new novel. But he could not begin it, not yet, for his generally unsettled condition was further aggravated by the need for him to move to a new house. The lease upon his previous residence was about to expire, and so he had all the trials of house-hunting, and house-cleaning, before he felt able to begin on the sustained and continuous activity which a new book would involve. Houses were very much on his mind, therefore, as the shape of *Bleak House* itself began to rise up in front of him.

He had in a sense already been preparing for it. In his new periodical, for example, he had written two essays on the parlous state of the country – in particular he had attacked the horrors of urban sanitation which condemned the poor to a 'poisoned life' and he had excoriated a system of justice which most plainly exhibited neglect and procrastination. Both of these subjects were to enter *Bleak House* itself, and it would not be going too far to say that Dickens, who was always a journalist as well as a novelist, used his periodical as a well from which he could draw up certain of his most significant images and themes. It was in *Household Words*, for example, that there appeared a description of a City churchyard which was no more than a *'Cholera Nursery'* as well as a report on the 'mental ignorance and neglect' which afflicted the labouring classes. Indeed the novel can itself be read almost like a symbolic report on the period within which it was written, a newspaper of the imagination where the most startling public issues were given the wraith-like resonance of that 'Shadow World' from which Dickens's fictions emerged. In the spring and summer months of 1851, for example, *The Times* had carried several articles on the absurd delays in Chancery proceedings, and in the same period Dickens himself had delivered a speech to the Metropolitan Sanitary Association in which he specifically refers to material which he would later redeploy in an-

other context: he talks of the fetid wind which carries disease from the poorer to the richer quarters of the city, and condemns those urban missionaries who attempt to save the souls of the poor without concerning themselves with the more visible ills of the body. One has only to read the accounts of Henry Mayhew, also, to realise that the horrors which Dickens invokes in *Bleak House* were the plainest truth. It has often been claimed that the poor crossing-sweeper, Jo, was no more than a figment of Dickens's more than usually sentimental imagination but in fact the very words which Jo utters at the famous inquest into the death of Krook are an almost exact reproduction of the cross-examination of George Ruby, a boy who worked as a crossing sweeper: 'that he did not know what prayers were; that he did not know what God was; that, though he had heard of the devil, he did not know him; that, in fact, all he knew was how to sweep the crossing . . .'

Dickens had begun writing *Bleak House* towards the end of 1851, and it soon became clear that this was the first novel in which he would intervene directly with social comments upon the conditions of the age. It does not have the nostalgic sentiment or plangent lyricism of its predecessor, *David Copperfield*, and indeed it is conceived in quite a different spirit. It has bite, fire, anger, intensity and drama. And yet at the same time it cannot be called a polemic in any conventional sense, for the literal recording of sickness and malnutrition is placed alongside such an extraordinarily non-naturalistic passage as the death of Krook by spontaneous combustion. Dickens always liked to pretend that he had relied upon the best scientific authorities in order to justify the use of such a flagrantly melodramatic device, but the truth was that, for him, the unnatural process of internal fire was a wonderful symbol for all the forces at work within the narrative itself: it became a metaphor for the threat of explosion which lurks beneath a decaying social fabric, as well as for all the powerful and indeed ferocious energy of the period. Thus melodrama and realism, symbol and topography, overlap each other to

create a most complex and mysterious reality: in *Bleak House* London is transformed, and becomes a theatre and a prison, a fair and a madhouse, a labyrinth and a grave.

By January 1852 he had completed the first two numbers, and cut down on all social and public engagements (he reduced himself to two public dinners a month) so that he could work undisturbed on the continuing narrative. In fact he seems to have been fully in command of his material from the beginning; certainly throughout the period of composition there are none of those anguished asides in his correspondence on the difficulties of writing or of 'keeping up to time' (it should never be forgotten that Dickens was always working against printers' deadlines for each month's material, and it says something about his steadiness of purpose and his firmness of resolve that he never failed to meet them). Even so, certain aspects of his narrative had to be amended or excised: in particular he felt obliged to alter some aspects of the character of Harold Skimpole so that the identification with Leigh Hunt could not be so easily made. The ruse was not successful, however, primarily because the portrait of Skimpole remained, in Dickens's own words '. . . an absolute reproduction of a real man'. There were other likenesses throughout the narrative, perhaps the most famous being that of Walter Savage Landor as Lawrence Boythorn. Dickens has often been criticised for thus transforming his friends into characters in his novels, but he could never stop himself doing so: the imperatives of his fiction, and of his fictional vision, were such that nothing in the world could impede the promptings of his imagination.

Nothing in the world, that is, except the world itself. He had begun the book steadily and continuously enough but, after a while, he could not ignore the fact that he had readily committed himself to a hundred different activities in almost as many places. In particular he had arranged to take his Amateur Players on a tour of Manchester and Liverpool in order to raise money for his most recent favourite cause, the Guild

of Literature and Art. So he felt it necessary to go down to Folkestone, and then on to Dover, in order to work undisturbed. Then he travelled to Boulogne, the French resort which over the next few years became his summer 'retreat'. He came back to London eventually, even as he continued his daily methodical work upon his narrative, and by the end of the year he had reached what he called the 'great turning idea' – the revelation of Esther Summerson's parentage. This period was a turning point, too, in another sense, for it was now that he agreed to give his first public reading of *A Christmas Carol*, thus inaugurating a new career as a public performer and one which would have a measurable effect on his succeeding novels.

He was getting up at five o'clock in the morning to continue his work on *Bleak House*, for it should never be forgotten that even as he toiled daily on his novel he was also labouring for as many hours upon his editorship of the new periodical. But the strain of his work was proving too much for him and, as at the beginning of his career when he was energetically pushing forward in the world, he became sick. His kidney, the bane of his childhood, became once more inflamed. And, as always when the pressures of life grew too much for him, he wanted to get away – to escape. So he decided to spend the summer again in Boulogne and it was there, in the first weeks of August 1854, that he finally completed the novel. It was always his custom to write a preface at the completion of his formal labours, and in his introductory remarks to the publication of *Bleak House* in volume form, he declared that in the novel 'I have purposely dwelt upon the romantic side of familiar things. I believe I have never had so many readers as in this book. May we meet again!'

Certainly his readers remained with him, but the reviewers were less loyal: the *Spectator* found it 'dull and wearisome', and it was not alone in that opinion. Even Dickens's friend, John Forster, seemed in part to share it. It seems inconceivable now that so great a novel as *Bleak House* should be rou-

tinely damned by the newspaper reviewers, but critical abuse became a feature of Dickens's writing career (as it has been for many other great writers, before and since). He simply ignored it, and went on as if nothing in the world could affect him.

There were perhaps specific or topical reasons for the lack of critical sympathy: the vexed question of Dickens's use of spontaneous combustion had alienated some of the more intellectual reviewers, and there was the familiar protest that his characters were not credible, that he relied too much upon sentiment, that he was, in short, not a realistic writer. There is a truth in that, of course, and it has been said that in the portrait of poor and suffering children in *Bleak House* he was merely rehearsing what had become old sentiment. But in truth Dickens's account of neglected children here – ranging from Jo to the Jellybys – is part of a larger theme. His concern in this novel is with want of earnestness and the ills which spring from it, perhaps its most malevolent offspring lurking in the wilful hardness of heart which characterises someone like Skimpole. Some of his suffering victims have been cast out from all human affection, and haunt the brick kilns and ruined slums; others are the victims of themselves and have cut out true human affection from their own breasts. In a sense they become representatives of a social system which seems to nurture at its core the denial of human feeling and, as a result, irresponsible levity towards human need.

There were times in his own life, and especially in his own childhood, when Dickens believed himself also to have been utterly cast away: which is why he was able to enter the consciousness of a character like Jo with such touching simplicity and truth. 'It must be a strange state, not merely to be told that I am scarcely human . . . but to feel it of my own knowledge all my life!' In *Bleak House*, then, he looks more closely than ever at the deprived and desperate lives of the poor (as he was also doing in his articles for *Household Words*); they represent in fact the thematic centre of the book, just as its

imaginative centre lies in the threat of spontaneous combustion on all levels – in the threat of irrational violence, for example, represented by a crowd of Londoners who are 'like a concourse of imprisoned demons'. There is, in other words, a strange mixture of elements at work here – sentiment, domestic intrigue, political satire, social statement, fantasy, romantic comedy, symbolic imagery and a myth-making instinct so intense that at one stage '. . . every noise is merged, this moonlight night, into a distant ringing hum, as if the city were a vast glass, vibrating'. For this is a world, too, where humankind is seen in its bare and naked state: 'In such a light both aspire alike, both rise alike, both children of the dust shine equally.'

'It was all a troubled dream?' Richard Carstone asks at the end of his wretched life. No, it is not a dream. It is a great, troubled reality – and one that in *Bleak House* is transfigured both by Dickens's own brooding, mournful, imagination and by his wild laughter at the state of the world.

Hard Times

THESE WERE hard times, and Dickens wanted to mend them in his own way. In the last month of 1853, just a few weeks before he started work upon *Hard Times* itself, he gave three public readings of his Christmas Books – chief among them, of course, *A Christmas Carol*. He read that seasonal tale in Birmingham to an audience of 'working people' (he had insisted to the organisers on addressing such a gathering) and before he began to recite the adventures of Scrooge and Cratchit he made a short speech to his audience, during the course of which he declared the need for '. . . the fusion of different classes, without confusion; in the bringing together of employers and employed; in the creating of a better common understanding among those whose interests are identical, who depend upon each other, and who can never be in unnatural antagonism without deplorable results . . .' This was the principal article of his political and social beliefs – to create precisely the same kind of benevolent unity and familial concord which he celebrated in his fiction. He wanted his audience to become one family, as if it were sitting around the hearth as he read to them, and then leaving the hall with a settled belief in the need for harmony and mutual forbearance among all classes. *Hard Times* is the direct consequence of that belief, and might be said to have sprung out of his encounter with the working people of Birmingham.

But he had not wanted to start a new novel, not yet. Only five months before, he had exhausted himself over the completion of *Bleak House*, and had been hoping for a period of rest in which he might restore his energies and repair his bat-

tered and weary spirit. But there was to be no rest. There never was, in his life. There had been an alarming drop of sales in his weekly periodical, *Household Words*, and his publishers urged him to start work upon a new serial which could be printed in it and thus arrest the decline in circulation; he may at this time have been neglected or reviled by the more intellectual of the critics, but he maintained his hold upon the public. He saw the force of their arguments and, with his usual expedition, set to work at once: in the first weeks of the new year, 1854, he began to experiment with titles for this new serial even though the main lines of its development were still obscure. Two titles which occurred to him almost immediately were 'Fact' and 'Thomas Gradgrind's Facts' and it is clear that, even at this early stage, Dickens wanted to direct his attention towards those whose political philosophy or educational principles depended solely upon facts and statistics (a science then very much in vogue) and who did not attend to the very lesson instilled in *A Christmas Carol* which he had recited only a short time before – a lesson which emphasised the importance of imaginative sympathy, and of that 'Fancy' which is to be discovered in the true use of memory. Memories of the past. Memories of childhood. Only thus could the world be redeemed – for was it not the case that the world being created all around, by those who depended solely upon facts and numbers, was a harsh and forbidding place?

He wanted to discover more about that world on his own account, however, and soon after beginning work on the novel he set off for Preston in order to investigate the progress of a weavers' strike in that city. He stayed for only a short time but he found all the material he needed, and on his return he wrote an article for *Household Words* in which he asserted that '. . . into the relations between employers and employed, as into all the relations of this life, there must enter something of feeling and sentiment; something of mutual explanation, forbearance, and consideration . . .' Feeling. Sentiment. Consideration. These were precisely the principles he had es-

poused in his fiction, and we can see how all his essential interests move easily from the world of his novels to the world of public engagement and discourse. Of course they must suffer a change in the transition, and the stated beliefs are turned into the spectacle of Louisa Gradgrind as '. . . she unconsciously closed her hand, as if upon a solid object, and slowly opened it as though she were releasing dust or ash'. She is an exemplary image of a young woman starved of the very gifts which might have saved her, and when she declares that Fancy might have become '. . . my refuge from what is sordid and bad in the real things around me . . .' she is enunciating one of the central principles of Dickens's own art.

He was writing about something larger than Preston, in other words, when he was describing the abject conditions of Coketown. That place is in any case a composite portrait of several industrial towns but, more importantly, he was carrying on the assault which he had started in his Christmas Books. That is why *Hard Times* has all the simplicity and directness of style which are characteristically associated with Dickens's Christmas fables, and as a result lacks the length and elaboration which mark his more familiar novels. Of course that brevity and directness are also connected with the fact of the novel's weekly appearance in a periodical – it was published on the front page of *Household Words* each week very much as if it were some kind of signed editorial, and does contain certain topical references to the conditions of the time. But Dickens was not interested in writing a political or social tract; he was writing a fairy story of the industrial age.

He properly embarked upon the narrative in the middle of February 1854 (serialisation was not about to start until the beginning of April, so he had given himself a little 'leeway' for his own development) and almost at once, as he confessed later '. . . the idea laid hold of me by the throat in a very violent manner'. There appeared in quick succession the principal characters of the tale – Gradgrind, Sissy Jupe, Bounderby, Sleary the circus-master, and of course that strange melan-

choly hero, Stephen Blackpool, who begins life as some emblem of the iniquities of organised labour and ends up as a symbol of humankind itself. The narrative reads easily and freely yet Dickens found that '. . . the difficulty of space is CRUSHING. Nobody can have an idea of it who has not had an experience of patient fiction-writing with some elbow-room always, and open places in perspective. In this form, with any kind of regard to the current number, there is absolutely no such thing . . .' Yet he worked on intently, insistently. Indeed the story had laid hold of him 'by the throat' in an almost physical sense, since his doctor advised him to take on a regimen of 'fresh air' to alleviate the exhaustion he was beginning to feel at his unremitting labour. Nevertheless day by day he was 'planning and planning the story' which seemed to be changing all the time.

There is a point, for example, when the narrative looks likely to become a saga of union and management, and one in which Dickens would repeat his often stated belief that the workers suffered just as much under bad union representatives as they ever did under bad employers. For although Dickens was accused of a form of 'sullen socialism', it ought to be remembered that he never espoused anything close to socialist principles; he supported the rights of working people to a proper education, as well as proper sanitation and housing, but he was an instinctive conservative in social matters. In particular his imaginative sympathy with the individual victim, like Stephen Blackpool, quickly turned to hostility or anger if those victims organised together and in any way threatened the *status quo*. Hence his treatment of the workers' representative in this book. When he could not identify with the suffering human being, then he became something of a disciplinarian. In a similar spirit he was not generally opposed to the claims or methods of the more advanced industrialists of his period; he reserved his animus for the remnants of the aristocracy, and for the government bureaucracy, which seemed to be impeding 'Progress' at every turn. That is why,

in *Hard Times*, the satire against the employer, Bounderby, has very little to do with his political or social principles and everything to do with his hypocrisy and denial of his own past. That in itself proves to be another aspect of *Hard Times*: it begins as an exercise in public statement but soon is enlarged to become a much more vivid and ambiguous record of Dickens's central vision of the world.

The novelist left London for Boulogne in June, so that in his French retreat he might finish the book in relative seclusion. Indeed he did manage to conclude it, just a month later, and in what he described as a 'hot' and nervous state – very much like that of his heroine, Rachael, who at one point utters what might be described as characteristically Dickensian sentiments: '. . . I fall into such a wild, hot hurry, that, however tired I am, I want to walk fast, miles and miles'. Dickens returned to London in his own hot haste, read the proofs of the completed story and then divided it into three 'Books' for its appearance in volume form.

That appearance was not greeted with approbation on all sides. *The Rambler*, for example, called it a '. . . mere dull melodrama, in which character is caricature, sentiment tinsel, and moral (if any) unsound'. It was in other words treated very much as a topical or political tract; not for the first, or the last, time Dickens's real intentions and preoccupations were ignored or overlooked. For the essential truth remains that *Hard Times* is in no sense a 'realistic' novel. Dickens is a visionary as much as he is a realist, and in this novel he was giving shape to his own understanding of the forces of the world which brings him closer to William Blake than to Henry Mayhew.

That is why the political and social landscape of the novel is in reality dominated not by the smoke-stacks of Coketown (although Dickens's pictures of the industrial world are in every respect powerful and moving) but rather by the rigid and unfeeling patterns of what he describes here as the 'unnatural family' – absconding fathers, like that of Sissy Jupe,

rigid fathers, like that of Louisa Gradgrind, and ungrateful or unfeeling children. It is once again a world of the self-deceivers and the deceived, the hysterical and the wretched, a grim world shot through with passages of laughter, a world in which the unhappy wanderings of Stephen Blackpool seem so much like a re-enactment of Dickens's own state during this period of his life – 'Wandering to and fro, unceasingly, without hope, and in search of he knew not what (he only knew that he was doomed to seek it) . . .' So Dickens exists everywhere within his own creation. He exists in Stephen Blackpool but he also exists in Mr Bounderby whose terrible posturings are like some rancid image of Dickens's own self-worth. He exists, too, in Louisa Gradgrind in the sense that it is her own deprivation, betrayal, and final redemption which comprise the essential statement of the novel: as he writes of Sissy Jupe in the penultimate paragraph, to be '. . . grown learned in childish lore; thinking no innocent and pretty fancy ever to be despised; trying hard to know her humbler fellow creatures, and to beautify their lives of machinery and reality with those imaginative graces and delights, without which the heart of infancy will wither up, the sturdiest physical manhood will be morally stark death . . .'

Hard Times is a spare and determined work but, as a result, it has what can only be described as an elemental concern – as Stephen Blackpool himself dies and rejoins 'the God of the poor'. This is a fable but one which deals with last and extreme things, with the plight of poor bare-forked mortality. Ruskin considered it to be one of the finest of Dickens's novels; certainly it is the one in which he mounted the fiercest defence of his own art, and the strongest argument for his own belief in the powers of the imagination.

Little Dorrit

I T WAS the autumn of 1854, in Charles Dickens's forty-second year, and he declared that he felt 'too old'. He had just completed *Hard Times* in Boulogne, but any satisfaction in a labour completed was more than offset by his own continual unease and restlessness. On his return from France he resumed his familiar duties – his work on *Household Words*, his weekly periodical, as well as his numerous public engagements – but he was altogether unsettled. The very routines of his life seemed to be imprisoning him. 'If I couldn't walk fast and far,' he told John Forster, 'I should just explode and perish.' He had reached middle age, and had achieved more renown than any writer of his generation, but he was not content. There must have been times when he questioned the nature of his fame, and all his success, since it now left him as unhappy as he had ever been. Indeed it seems likely that his most enduring sense of life was that derived from his childhood privation, so it is appropriate that in the novel he was about to write, *Little Dorrit*, the most significant memory for its heroine was of the rooms and inmates of the Marshalsea Prison. These were '. . . all lasting realities that had never changed', and it ought not to be forgotten that, many years before, Dickens's own father had been incarcerated there. Was this the reality that haunted him still?

It was a very cold winter and as he walked through the streets of London he became surrounded by what he called 'motes of new books in the dirty air'. He even bought a green-covered notebook and, for the first time in his life, began to keep notes and observations to help him with the creation of

his fiction. Forster explained the purchase thus: his old friend 'had frequently a quite unfounded apprehension of some possible breakdown, of which the end might be at any moment beginning'. Dickens needed memoranda, in other words, to bolster himself against any possible loss of creativity. His fears were quite unjustified but the very fact of their existence, in a writer whose energy was once only matched by his self-confidence, suggests the general malaise under which he now seemed to labour.

But there was another aspect to his misery: he was becoming further and further estranged from his wife, Catherine, whose years of child-bearing and post-natal depression made her quite unfit to keep up with the imperious and mercurial demands of her husband. But it seemed that nothing could be done: just as he was unable to escape from the vision of his childhood miseries, so he could not disentangle himself from a relationship which seemed also close to imprisoning him. His English life imprisoned him, too, and in *Little Dorrit* his attack upon national habits and customs is counterpointed by the continual images of prison and imprisonment which eddy through the novel.

'Why is it,' he wrote in one letter, 'that as with poor David, a sense always comes crushing upon me now, when I fall into low spirits, as of one happiness I have missed in life, and one friend and companion I have never made?' This newly declared mood (which perhaps only came into existence after he had completed *David Copperfield* and thus could see certain aspects of himself clearly for the first time) became quite evident now, when he suddenly received a letter from the old love of his adolescent years – Maria Beadnell, who at the time had spurned him but who now, as a middle-aged and married lady, wrote to her former suitor. He responded in such an earnest and almost hysterical manner that it is hard to resist the belief that he still saw Maria Beadnell just as she had been when she was a young woman – and that somehow he made himself believe that she might well be that 'one friend

and companion' whom he had desired for so long. All his passionate aspirations collapsed, however, when he met her; she was no longer the romantic girl of his youth, but a fat and garrulous woman whom he was later to mimic as Flora Finching in *Little Dorrit*. In this novel he described their meeting thus, through the medium of the lonely and melancholy hero, Arthur Clennam, who bears so strange a resemblance to Dickens himself during this period: 'Clennam's eyes no sooner fell upon the subject of his old passion, than it shivered and broke to pieces.' But even in this parlous situation Dickens himself could not refrain from employing a theatrical metaphor for the whole encounter: '. . . by putting herself and him in their old places, and going through all the old performances – now, when the stage was dusty, when the scenery was faded, when the youthful actors were dead, when the orchestra was empty, when the lights were out.' In his writing the image of the abandoned theatre often comes to represent an intense sense of dereliction and emptiness; indeed it comes to represent all the forces of mundane reality which threatened to bear him down. It characteristically provoked in him rage as well as bewilderment, denunciation as well as lamentation, and in *Little Dorrit* itself this might be said to comprise the mood of the entire narrative.

It was a mood that also invaded the journalistic essays he was writing before he began the composition of the novel, essays in which he laments the loss of youthful innocence at the same time as he condemns the growth of crass worldliness in the affairs of the nation. It is a mood, too, that helps to account for his membership of the Administrative Reform Association, a body which had been established to protest against all the maladministration and incompetence which characterised the government's conduct of the Crimean War. And, in a speech on behalf of that Association in June 1855, Dickens coined one of those phrases which might just as easily find its place in his fiction: '. . . what is everybody's business is nobody's business . . .' This political activity might seem to

be at least one remove from *Little Dorrit*, the novel he was even now contemplating, were it not for the fact that his first title for it was indeed *Nobody's Fault*. His latest fiction came out of the very conditions of the time, therefore, and not simply out of the personal malaise which hovered about him.

By the end of May, he had in fact written the first two chapters (as well as inventing the original title) but he was working only fitfully upon the narrative. 'I am in a state of restlessness impossible to be described,' he wrote, 'impossible to be imagined . . .' He diverted some of that restlessness into the rehearsals and performances of a new play by his band of amateur actors but his son, Charley, has suggested that the causes of his disquiet could not be so easily assuaged: he said of *Little Dorrit* that '. . . my father started [it] in a panic lest his powers of imagination should fail him'. This substantiates Forster's comment about Dickens's fear of a 'breakdown', and of course it sheds the strangest light on the origins of the novel itself. It might be assumed that such a great work was the fruit of long preparation and contemplation, but instead it came to life fitfully and uneasily as an extension of Dickens's own most pressing fears. Only gradually did his real preoccupations gather momentum, displacing topical concerns and affording the novel its proper shape.

Indeed it was only in July, some weeks after his first efforts upon the novel, that he managed to produce what he was accustomed to call the 'leading idea'. In the beginning he seems to have been guided only by his social and political preoccupations – in particular with the stranglehold which government bureaucracy maintained on the pursuit of war abroad and progress at home. But that was not enough, and it was in July that he composed a memorandum to himself which essentially changed the narrative: 'People to meet and part as travellers do, and the future connexion between them in the story, not to be now shewn to the reader but to be worked out as in life'. Thus was established one of the principal notes of the completed novel, a note which is sounded from the begin-

ning (as Dickens recast the opening chapters) with the invocation of 'we restless travellers through the pilgrimage of life': these are the travellers who, in a subsequent passage, are said to be '. . . coming and going so strangely, to meet and to act and to re-act on one another . . .' Images of travel, images of the road, images of pilgrimage – all of them find their place in a novel which intimates the futility of all journeys. There is no escape from the prison of the self, or of the world.

He went down to Folkestone for the summer of 1855, in order to work undisturbed upon a narrative which now took complete hold over him. He had hit upon the name for his heroine, Little Dorrit (perhaps in homage to another of his heroines, Little Nell), and now through the trackless paths of his imagination he surveyed the entire fortune of the Dorrit family. More particularly he placed Little Dorrit's father in the Marshalsea, and at once all his own brooding memories are released into the narrative; and that, after all, is where they truly belong. There are wonderful descriptions here of prison life, as the children of the inmates play in the common yard and 'made the iron bars of the inner gateway, "Home"', and even in such details as Little Dorrit's wandering across London Bridge there is a direct reference to Dickens's own journeys as a boy to and from the prison – that 'dolorous way' as it has been called. But of course there were also miseries of more recent date, and in the hero of this book, Arthur Clennam, we can trace the isolation and despair of the mature Dickens. But he had not altogether lost sight of his original satiric impulse, against a country where injustice and ineptitude can become 'Nobody's Fault', and indeed Clennam himself is first introduced into the novel on a Sunday in London, where all the weariness and despair of a morally bankrupt nation seem to seep into the grimy brickwork and dirty alleyways of the city. In fact no aspect of English life escapes Dickens's wrathful attention in *Little Dorrit*. Whether it be Society, or the Circumlocution Office, or the jingoistic inhabitants of Bleeding Heart Yard, all of them seem to creep across

the face of 'this right little, tight little island'. The very houses seem asleep and it is perhaps worthy of notice that, in this novel, Dickens emphasises again and again the close smells of old rooms, the crumbling façades of old houses, the staleness of old streets.

The first episode of the new monthly series was published at the beginning of December, and at once it took hold upon the public imagination – the second number sold approximately thirty-five thousand copies. Dickens himself could not rest easily with his achievement, however, and even as he was writing the novel he was continually moving from place to place – from London to Paris and then back again, from London to Boulogne. Even when he was in England, he was trying to lose himself in more and more arduous theatricals. 'As to repose,' he told Forster, '– for some men there's no such thing in this life.' In the same letter to his friend he had talked about his own wearying 'journey', just as in *Little Dorrit* itself he was preoccupied with the theme of travel. He was writing a novel about prisons and imprisonment, and all the while he, too, was trying to escape.

He had such command of his material, however, that he was generally able to work rapidly and freely on the narrative. Certainly he did not require elaborate notes or memoranda, and by the spring of 1857 he was back at his house in Tavistock Square preparing for the final double number of the novel. He did organise his notes carefully for the dénouement and then, three days after he had written the last words, he returned to the Marshalsea Prison. He had not visited it during the writing of the book, simply because his own childhood vision of that place was the one he wished to invoke, but at the termination of his labours he came on his own pilgrimage to the site of his childhood agonies – to the centre of *Little Dorrit* itself, a novel in which images of imprisonment cast so long a shadow that the world itself is seen as a kind of prison.

Blackwood's Magazine dismissed the novel as the merest 'Twaddle', although the public response remained almost as

enthusiastic as ever: the final instalment had a circulation of some twenty-nine thousand copies. Not for the first time in Dickens's career, the public was more sensitive and sensible than the critics. Of course many of the most significant elements in the novel were not then so readily apparent; no doubt thematic and symbolic matters were largely overlooked in favour of the story or the characters which Dickens had created. There were once more the great comic creations who always seem to spring fully-armed, as it were, from the soil of Dickens's imagination – Flora Finching, Mrs Chivery, Mr F's Aunt, Mrs General, and even William Dorrit himself, whose somewhat farcical manner is later subdued and darkened in one of those masterly exercises in transition which mark the style of the mature Dickens.

But there is also a strangely hallucinatory tone to the book, which may spring from Dickens's own restless and estranged state at the time of writing. Certainly it is a quite different achievement from *Bleak House*, with which it has been customarily associated. In the earlier novel the law had broken down and failed but, in *Little Dorrit*, it is not the 'system' (to use one of Dickens's words) which imprisons people; people imprison themselves. In fact this is a more penetrating work in many respects, although on occasions also a more confused one; it is often hard, even after repeated reading, to understand the full burden of the intrigue. Instead the reader tends to remember specific scenes and details which are lent an almost emblematic or even visionary significance – the old house where Arthur Clennam's mother broods in her wheelchair, the Marshalsea prison itself, the scene where Little Dorrit faints before she crosses the threshold of the prison, the terrible moments of self-revelation before William Dorrit's death, the discovery of Merdle's body. In *Bleak House* Dickens had presented a number of situations relating to a central story; in *Hard Times* he had anatomised a general condition of society; in *Little Dorrit* he provides images, or parallel series of images, which bind together the narrative in an emotional rather than

thematic unity. It is that emotional connection which prepares the way for an ending which ranks as one of the most poignant passages in all of Dickens's fiction, and perhaps one of the most poignant passages in English literature: 'They went quietly down into the roaring streets, inseparable and blessed; and as they passed along in sunshine and in shade, the noisy and the eager, and the arrogant and the froward and the vain, fretted, and chafed, and made their usual uproar.' It is the uproar of the novel itself, in which the whole sad world of Dickens's imagination makes its way.

A *Tale of Two Cities*

CHARLES DICKENS'S first intimations of *A Tale of Two Cities* came in the summer of 1857, as he lay on the floor of the stage during one of his amateur theatricals – the play was *The Frozen Deep* in which he had taken the role of a desperate and thwarted lover whose eventual act of self-sacrifice redeems him. In fact Dickens played the part with such direct feeling that the audiences were cowed into a form of emotional submission, and even the workmen behind the scenes were reduced to tears by his performance. His desperate intensity was heightened by the fact that playing alongside him was a young actress, Ellen Ternan, for he was to say later that '. . . never was a man so seized and rended by one spirit'. It was now, in these special circumstances, as he lay dying on the stage towards the end of the play, obsessed, haunted, that '. . . new ideas for a story have come into my head . . .' And no doubt it was the particular story of Sydney Carton, who sacrifices himself for love, which invaded him.

But a year of great turmoil and misery was to pass over his head before he actually began work on the novel itself, since it was in 1858 that he separated from his wife. They had been married for more than twenty years, and yet he turned away from her as harshly and abruptly as if she had been some importunate stranger. There had for a long time been a certain incompatibility of temperament between them, although the fault for that must lie as much in Dickens's own peculiar and mercurial character as in any presumed defects of his wife, but it is likely that his extraordinary passion for Ellen Ternan led to this final act of his domestic tragedy. First he sealed himself

away from his wife physically, by having his own bedroom par-
titioned off from hers, and then a few months later he asked
her for a separation. It was a messy and protracted business,
the difficulties of which were compounded by the rumours
about Dickens's private life (at one stage he was even accused
of committing incest with his sister-in-law, Georgina) and
then further aggravated by the novelist's own bizarre be-
haviour. He turned irrevocably against anyone whom he con-
sidered to be taking his wife's part, rejecting some of his
closest friends as a result, and then he decided to publish
his own account of the separation in which he accused his
wife of 'mental disorder' and outlined her incapacity as a
mother. The latter charge was quite untrue but, at moments
of crisis in his life, Dickens invariably turned to the themes
and patterns of his own fiction as a way of describing or con-
trolling reality: neglectful mothers play so large a part in his
novels that it seems to have been for him the simplest act of
transference to accuse his own wife of a similar fault. It will
be seen how, in *A Tale of Two Cities*, the passions of his life
are readily transformed into fiction; but the process could also
work in reverse, with the images of Dickens's novels being
literally imposed by him upon a bewildering world. He seems
truly to have felt that he was the innocent party, despite the
fact that he had pushed his wife away from his affections and
from their shared home; he considered himself to be the target
of malicious abuse, even though it was he who had published
Catherine's supposed faults to the world. It is hard not to be-
lieve that he suppressed some elements of guilt and self-
accusation in the process but, as *A Tale of Two Cities* often
intimates, buried things may come to light; was this novel's
concern with imprisonment, and with sacrificial death, an
aspect of that guilt? 'My father was like a madman,' his daugh-
ter, Kate, was later to say of this period. 'This affair brought
out all that was worst – all that was weakest in him . . . Noth-
ing could surpass the misery and unhappiness of our
home . . .' So these were the conditions of Dickens's life in

the year before the composition of *A Tale of Two Cities*. Struggle. Fear. Renunciation. Secrecy. The troubled belief in his own innocence. Suppressed violence. And can we not see these themes at work beneath the surface of the novel itself?

He actually began *A Tale of Two Cities* in order to launch his new periodical – he had severed all relations with his trusted and familiar publishers, Bradbury and Evans, on the dubious grounds that they did not fully support him in his actions against his wife. He had in the past used *Oliver Twist* and *The Old Curiosity Shop* as convenient ways of beginning new journals and now, with *All The Year Round*, he needed a similarly successful story to boost sales. In the spring of 1859 he hit upon the famous title for the new novel, and then eight days later began work upon the narrative itself; it was a task which would occupy him from May until October, as he struggled to maintain the rhythm of each weekly episode while trying to attend to the fact that it would also be published in monthly parts. The effort sometimes drove him 'frantic', he said, but it was worth all of his expended energy: the circulation of *All The Year Round* soon reached something like one hundred thousand copies, and never significantly dropped from that level.

Dickens was working quickly upon the novel, as was necessary for its weekly format, but at the same time he was taking great pains over the narrative. It is of course set at the time of the French Revolution, but he did not attempt a simple fictional reconstruction of the period: he had always admired Carlyle's *History of the French Revolution* and, quite apart from making use of that wonderful history, he asked Carlyle's advice on the books he should read for the purposes of research. In return he received something like a 'cart-load' of volumes from the London Library and, as a result, employed true incidents and places in the unfolding of his story.

But the sources of *A Tale of Two Cities* lie much deeper than the pages of even the most recondite volumes. Much of the imaginative energy of the narrative lies in Dr Manette's

troubled relationship with the Bastille, for example; he is released from his captivity but, at moments of crisis, he reverts to the psychic condition of imprisonment as if in a certain sense he has come to need the chains that once kept him down. Twelve years before Dickens had outlined in a letter '. . . the idea of a man imprisoned for ten or fifteen years . . .' and in 1853 he had written an essay of an old man set free from the Bastille but who '. . . prayed to be shut up in his old dungeon till he died'. And of course the same theme emerges in *Little Dorrit*, where neither the eponymous heroine nor her father can ever really escape the shadow of the prison-house; it even emerges in Dickens's earliest sketches, concerning Newgate, and in the pages of *The Pickwick Papers*. It was a subject which always remained close to him.

There is another theme, also, which runs through the narrative and which touches upon the need for self-sacrifice and even renunciation in the pursuit of love. It has sometimes been suggested that Lucie Manette is a partial portrait of Ellen Ternan, and that in the story of Sydney Carton's final self-sacrifice for her sake there is some re-enactment of Dickens's own helpless and hopeless passion for the young actress; but we need not go so far as this in order to realise that he has taken as his theme the bewildering mysteries of love at precisely the time in his own life when he was being invaded by a passion over which he seems to have had very little control. As Dr Manette suggests '. . . mysteries arise out of close love, as well as out of wide division; in the former case, they are subtle and delicate, and difficult to penetrate. My daughter Lucie is, in this one respect, such a mystery to me; I can make no guess at the state of her heart.' There is another curious aspect to this: Manette had been 'buried alive' in prison for almost the same length of time as Dickens had been married. Now both were free, but is there in Manette's own wavering allegiance to his helpless past some hint of Dickens's own distrust of himself in his new situation? Certainly in the novel itself the theme of imprisonment is intimately associated with

the idea of renunciation – as if love itself, like a free life, were not easily to be endured. 'I have so far verified what is done and suffered in these pages,' Dickens wrote eventually in the preface to this novel, 'as that I have certainly done and suffered it all myself.' That is why *A Tale of Two Cities* is a novel more concerned with the narration of story than with the elaboration of character, more preoccupied with action than with dialogue, as if Dickens himself were literally acting out the drama – as if he were still upon the stage where the idea for *A Tale of Two Cities* first occurred to him.

That is one of the reasons why it is written in a more spare and direct manner than such immediate predecessors as *Bleak House* or *Little Dorrit* – Dickens could literally *see* the story and its development as he composed it – but that clarity of presentation is also related to the fact that Dickens himself had only recently established for himself a second career as a public reader. He had read *The Chimes* and *A Christmas Carol* before, in the appropriate season, to public audiences; but, the year before *A Tale of Two Cities*, he had for the first time embarked upon a national reading tour – taking himself and his novels across the country, reciting them to packed assemblies, basking in the applause, baking in the gas-light and the heat. He had fully discovered the power of a direct contact with his audience, in other words, and that in itself helps to explain the directness of *A Tale of Two Cities*; he was once more addressing his audience, trying to heighten the moments of violence or terror, and thus to elicit the appropriate effects.

As soon as the reading tour was over, in fact, he had felt jaded and worn, and somehow strangely depressed. It was as if he needed all the applause and affection which public audiences lavished upon him – especially now, after the separation from his wife and the resulting obloquy in the press and elsewhere. It was a way of reaffirming his own identity and his own popularity, just as it was a method of confirming the power of his fictions to move people. And, when the reading

tour was over, when the applause had died down and the lights had faded, he found himself thrust back into the real world where all the old miseries of life threatened to overtake him. On the platform, and on the stage, he could forget himself: he could perhaps even forget his obsession with Ellen Ternan. But not otherwise.

That is why he threw himself into his next novel, *A Tale of Two Cities*, with so much fervour; he was acting out his part again, just as he was directly addressing a large audience, and in that dual capacity he could reclaim himself. Yet the tale itself sometimes tells a different story; certainly it can take off in quite a different direction from that suggested by the mood or intention of its creator. That is why, for all its energy and colour (particularly marked in the scenes concerning the Revolution itself), there are times when a solemn low note enters this narrative. The themes of escape and of violent struggle are wonderfully relayed here but, beneath them, there is a sense of wretchedness and weariness which emerges both in the rancid humour of the grave-robber, Jerry Cruncher, and in the mournful contemplations of Jarvis Lorry – '. . . as I draw closer and closer to the end, I travel in the circle, nearer and nearer to the beginning'. And was this Dickens's sense, too, now that he seemed to be re-enacting all the conditions of his own childhood? A public reader now just as he had been an entertainer when he was a young boy, standing on a table in order to sing to his father's friends. A man writing about the ambiguities of imprisonment, just as the child had once haunted the streets beneath the Marshalsea Prison. A man apparently obsessed by hopeless love for Ellen Ternan, just as the child believed he had somehow been betrayed by his older sister and mother. Were these the childhood conditions returning to haunt him, and was it his own awareness of that fact which lends this novel its gloomier shades? For *A Tale of Two Cities* is filled with horror and with darkness, just as it is marked with images of dirt and disease – and death. In fact death was very much on Dickens's mind during this period

and, in a letter to a friend, he wrote that '. . . all ways have the same finger-post at the head of them, and at every turning in them'.

A Tale of Two Cities has suffered from some loss in critical esteem in recent years, but this is primarily because it is an 'historical novel' and historical novels are generally presumed not to be serious fiction at all. Yet there are times when the most significant preoccupations can only be couched in that literary form, and when apparently 'historical' fiction is the best medium for understanding the conditions of the present. Certainly this is one of Dickens's most powerful and interesting novels, not at all inferior in theme or execution to the larger and apparently more imposing works which surround it. It is written with a discipline and a dramatic potency that in certain respects render it superior to some of the lengthier expositions in the longer novels. Dickens is no worse a writer for being forced into brevity, in this case because of the pressures of each weekly instalment in *All The Year Round*, and indeed this particular medium helps to emphasise his extraordinary gifts simply as a story-teller. His skills as a fabulist have never been shown to better effect than here but, additionally, in the very act and art of telling a story he discloses more of his own self than in some of his more deliberately composed fictions. For those who wish to understand something of the true nature of Charles Dickens, as well as one important aspect of his genius, *A Tale of Two Cities* is a necessary book.

The Uncommercial Traveller

At the beginning of 1860 Charles Dickens began to write a series of essays for his weekly periodical, *All The Year Round*, in the guise of the 'Uncommercial Traveller'. The name had not occurred to him by chance; three weeks before he began the first of these essays, he had given an address to the Commercial Travellers Association, at which event a group of orphan children were paraded singing around the dining hall. Dickens was always highly susceptible to atmosphere and, for him, something of the melancholy or poignancy of that occasion may have attached itself to the name: the reflections of the 'Uncommercial Traveller' are not generally cheerful ones.

It was in any case a most difficult period within his own life; he was often ill and dissatisfied, unable to take much comfort in his fame or find much relief from his sorrows in his own work. He had recently finished *A Tale of Two Cities*, which in certain respects must be considered the darkest of his novels. He had come to the end of a series of provincial public readings, when he managed to exhaust himself nightly by reading out episodes from his fiction, and had just completed a series of Christmas Readings in London. His relationship with Ellen Ternan was obsessive and distraught, and his own mood was tinged with a weariness which on occasions came close to fatalism: 'I am a wretched sort of creature in my way,' he wrote to a friend, 'but it is a way that gets on somehow. And all ways have the same finger-post at the head of them, and at every turning in them.' Yet, despite that bleak prospect of death, he still went down his own 'ways' – he was

still journeying forward in what he called, in one of these essays, 'that delicious traveller's trance'.

Certainly this was the mood with which he began writing in the guise of the 'Uncommercial Traveller'; he wrote sixteen essays between January and October of 1860, and his material ranged from the churches of the City of London to the workhouses of Wapping, from childhood memories of terror to descriptions of the Paris Morgue, from invocations of his lonely night walks through London to reports of his wandering through the dockside areas of Liverpool, from tramps to Mormons. He began a second series of essays under the same penname three years later, at another time in his life when the very name of 'traveller' suited him well. For he was constantly going between France and England (it is assumed that Ellen Ternan and her mother were living in a hamlet outside Boulogne), and it was a period when he confessed to being a prey to anxieties and miseries of every sort. This second group of essays also has its darker aspect, therefore.

But both series are extraordinarily interesting for the light they throw both upon Dickens himself and upon a now almost forgotten time. He was an alert and punctilious observer, after all, and there are passages in certain of these writings ('Night Walks' is a memorable example) where the whole weight of the 1860s seems to bear down upon the reader. But there is also another and more distant past enshrouded within these essays: it is Dickens's own past, and the dominant note here is often one of weary or nostalgic memory. It is not coincidental, in fact, that his novel of reverie, *Great Expectations*, actually was conceived as an essay in the 'Uncommercial Traveller' series before Dickens saw larger possibilities within it.

Of course these essays are on a smaller scale than anything he was attempting to do within his fiction, and in that respect at least they are not so significant an achievement; but they are wonderful pieces in their own right, and comparable to the work of any other essayist of the nineteenth century. It was

Dickens's belief that any work should be performed as if it were the one thing in the world worth doing, and there is nothing hasty or occasional about any of the writing he produced in this period; there are aspects of the 'Uncommercial Traveller' which are not to be found in any of his novels, and there are reflections or observations here which are invaluable for any proper understanding of Dickens.

It is within these essays, for example, that he provides the clearest and most detailed study of his own childhood – he himself is the 'very queer small boy' whom the 'Traveller' meets near Rochester; and it was to the young Charles Dickens that these words about Gad's Hill Place were actually directed: 'And ever since I can recollect my father, seeing me so fond of it, has often said to me, "If you were to be very persevering and were to work hard, you might some day come to live in it . . ."' Dickens was indeed persevering – and did one day come to live (and die) in it. There are accounts here of childhood birthdays and of childhood reading; the 'Uncommercial Traveller' recalls one occasion when he was dragged reluctantly into a chapel service and another when he attended a funeral 'wake'. He even describes the kind of nightmares he suffered as a child. Perhaps the most remarkable of these evocations, however, comes in the essay entitled 'Nurse's Stories' in which the 'Traveller' recalls the sensations of terror and anxiety which were instilled in him by a nurse who insisted on reading to him the most gruesome stories. '. . . I suspect we should find our nurses responsible for most of the dark corners we are forced to go back to against our wills.' It cannot be assumed that every detail or every portrait is an exact representation of Dickens's own past – he was, after all, given a certain imaginative licence by writing under an assumed name; but it can fairly be said that in these reminiscences of childhood he is recreating the atmosphere and general circumstances of his infancy with some fidelity. There is a wonderful evocation of his childhood haunts in 'Dullborough Town', for example, when the 'Traveller' returns to the

scenes of his early days although he is now 'so worn and torn, so much the wiser and so much the worse!'

That particular tone of infinite weariness is one that emerges in many of these short pieces – most notably in accounts of his adolescence. He recalls an occasion when he visited a church with a young lady whom he admired, and then asks '. . . what has become of Me as I was when I sat by your side!' These might be the conventional ruminations of a middle-aged man, were it not for the fact that Dickens's genius irradiates everything which it touches and, in an essay such as 'Chambers', his account of his early manhood is transformed by his extraordinary attention to detail and to mood. Incidents of the more recent past are also redeployed by Dickens within the framework of these essays; he describes the occasion he attended an inquest, and elaborates in a vivid or even theatrical manner on such subjects as a visit to an emigrants' ship and a Channel crossing.

One of the most extraordinary of these contemporary pieces is to be found in 'Night Walks', an essay in which Dickens reviews his own nocturnal wanderings through London. He makes strange journeys, this novelist who has imagined himself into a state of 'houselessness'; he passes Waterloo Bridge from where the suicides drop, and Newgate Prison, and Bethlehem Hospital for the insane. In these walks he is attracted to the dark river, upon which lies 'the very shadow of the immensity of London . . .' and to the prisons, as if they were the lodestone which he carried with him everywhere; and, as he wanders through 'the interminable tangle of streets', he invokes the presence of the dead and the mad. As he passes the asylum, for example, he is visited by the thought that 'Are not all of us outside this hospital, who dream, more or less in the condition of those inside it, every night of our lives?' It is a strange essay, in some ways the strangest Dickens ever wrote, which finds its proper climax in the novelist's encounter with a wretched, ragged creature who chattered and whined before it 'twisted out of its garment . . . and left me standing alone

with its rags in my hand'. It is possible to see something of
the curve and direction of Dickens's imagination in episodes
such as this – to locate the darker sources of his fiction as well
as the springs of his self-absorbed melancholy.

For there is much here which helps to explain Dickens –
some of his characteristics, for example, such as his indomi-
table sense of his own rightness are vividly displayed; 'I have
created a legend in my mind,' he writes at one point, 'and
consequently I believe it with the utmost pertinacity.' A small
remark, one might think, and yet within it there is contained
much of his true nature (and genius). The reader may here
begin also to glimpse something of Dickens's obsessiveness –
not the fact that he could quite easily walk twenty miles during
the course of one night and feel no strain, or the fact that he
is always fascinated by police officers and gaolers, but rather
the more lugubrious evidence of two essays, 'Travelling
Abroad' and 'The Morgue', in which he revels in his fascin-
ation for the bodies of the dead. They seem literally to haunt
him and one drowned corpse put on display in the Paris
Morgue, that of 'a large dark man whose disfigurement by
water was in a frightful manner, comic, and whose expression
was that of a prize-fighter who had closed his eyelids under a
heavy blow . . .' followed him everywhere in his imagination.
For some reason he relates this image of a drowned man to
the fears of childhood, a subject to which he often returns,
and explains that 'It would be difficult to over-state the inten-
sity and accuracy of an intelligent child's observation . . . If
the fixed impression be of an object terrible to the child it will
be . . . inseparable from great fear.' It is an odd connection to
make – a drowned man and childhood – but it is suggestive.
And then Dickens returns to the Paris Morgue to see the
clothes and the boots of the sodden corpse.

It was a 'picture' that he could not shake off and may indeed
be related to a young man, living, who Dickens saw by Wap-
ping Stairs and which he described in 'Wapping Workhouse'.
He was 'a figure all dirty and shining and slimy, who may have

been the youngest son of his filthy old father, Thames, or the drowned man about whom there was a placard on the granite post . . .' This was written before Dickens embarked upon *Our Mutual Friend*, which itself begins by the river and with the prospect of drowned men, and not the least pleasure of the 'Uncommercial' essays is to see the lineaments of Dickens's perception and imagination before they have been transposed into the larger context of his novels. Those novels are with him everywhere, in fact, and it is typical of his delight in his own creations (and his propensity for seeing them in the streets when he walked around) that he should refer in one of these essays to a nurse '. . . in whom I regretted to identify a reduced member of my honourable friend Mrs Gamp's family . . .'

In fact there seem to be two levels to these essays. When he is wandering and solitary, he customarily adopts a contemplative and even melancholy tone; but when he is acting as a reporter, describing and observing everything he sees, he becomes much more sprightly and animated. This change of perspective exists within his later novels, also, where wild humour surrounds the progress of a melancholy or anxious hero. In fact one of the most significant aspects even of these essays is the extent to which Dickens reverts to fiction or to semi-fictional situations; just as we cannot always assume that the 'Uncommercial Traveller' is the very image of Dickens himself (certainly not when he talks about his past), so we cannot assume that all the incidents and events recounted here are drawn directly from life or even from Dickens's experience. He saw and understood the world in terms of stories, and it is in the form of a story that he most freely explains himself.

Of course he had been writing essays of this kind in *Sketches By Boz*, some of which anticipate the themes and characters of this 'Uncommercial Traveller' series written some twenty-five years later. Dickens was always a wonderful journalist, in other words, and it can fairly be said that the articles by the 'Uncommercial Traveller' represent the very height of his

achievement as an essayist. There are passages and episodes here which can stand unashamedly beside the best of his fiction; as a collection it is unequalled for its presentation of mid-nineteenth-century life, and its insight into the consciousness of Charles Dickens himself.

Great Expectations

C HARLES DICKENS began 'meditating a new book' in August 1860; there was scarcely a time in his life, in fact, when he was not actively concerned with the prospects or the writing of a new novel. Fiction was his life, especially when his mundane life stretched bleakly around him. In the period when he began to consider *Great Expectations*, for example, his favourite daughter had left home for an unsuitable marriage, his brother had died, his mother was in the last stages of senile decay, and he was engaged in his obsessive and apparently hopeless relationship with Ellen Ternan. 'But we must not think of old times as sad times,' he wrote to a friend in this period. '. . . We must all climb steadily up the mountain.' And, just three weeks later, he began *Great Expectations* which looks back at the 'old times' from a new and heightened perspective.

He began writing at the end of September, although in fact the germ of the new story was planted by him in an essay he started to write in his guise as the 'Uncommercial Traveller'. But at the prompting of a friend he decided to write an essay in his 'old' humorous manner – the humour of *David Copperfield* as well as of *The Pickwick Papers* – and then, while preparing it, he was visited by a 'very fine, new, and grotesque idea . . .' This 'idea' was related to the young boy, Pip, and the convict, Magwitch – and to the extraordinary bond which links them together over so many years; no doubt it flashed so vividly before him because it is in one sense a 'grotesque' enlargement of his own relations with his father, John Dickens. At once Dickens saw the possibilities of a 'serial' in it and had every intention of resuming his familiar pattern of

twenty monthly numbers or episodes. But then commercial considerations altered his plans. The problem lay with *All The Year Round*, the sales of which were slipping with the serialisation of a disastrous novel by Charles Lever; Dickens was always aware of his 'pulling' power, and so he decided to step in at once with something of his own to bolster the flagging circulation. Thus was *Great Expectations* born.

He started work at the beginning of October and, since he already knew that these were to be the adventures of 'a boy-child, like David', he read over *David Copperfield* to avoid undue similarities. He hardly needed to have done so, however, since all the experiences of his recent life seem to have resulted in a sea-change in his characterisation of the boy and the young man; where Copperfield had been industrious, energetic and ambitious, Pip is guilty, self-deceived and secretive. Certainly Dickens knew what he wanted to achieve with this novel characterisation of Pip, because he was working quickly and easily upon the narrative. By the end of the month he had in fact written seven chapters – 'I MUST write,' he said, as if it were only in the act of composition that he could find any kind of resolution within his own troubled life. As if in creating Pip he was allaying his own fears by giving them external shape and meaning.

Much of his own childhood (and therefore adult consciousness) is to be found somewhere within these pages. Pip is a very anxious, guilty, apprehensive, sensitive, angry, quick child and many of his anxieties are centred upon the fact that he feels himself to be degraded by his familial situation. 'It is a most miserable thing to feel ashamed of home,' he confesses at one point; one may recall how the young Dickens, determined not to reveal the fact that his father was in the Marshalsea Prison, pretended that he lived near Southwark Bridge. And then there is the scene when Pip makes up stories about Miss Havisham and her house, which he explains by saying that 'I knew I was common, and that I wished I was not common, and that the lies had come of it somehow, though I

didn't know how.' In the narrative, it is clear that he made up these lies or stories (and is not fiction itself a lie?) simply because he did not want to reveal his sense of degradation at the hands of Miss Havisham's ward, Estella. So he invents an entirely different scene in which no hurt exists, and thereby comforts himself. Yet this is the paradox: the more he tells fanciful stories, the more dissatisfied he becomes with his humble home and 'common' relatives. It is hard not to remember once more Dickens's own autobiographical fragment here, at that point where he himself tells stories to the 'common men and boys' among whom he worked in the blacking factory by Hungerford Stairs – at a time when he deeply felt his own degradation and that of his family. Perhaps, in his telling lies and stories to protect or console himself, we may see one of the origins of his fiction. Of course that degradation was never mentioned in later years – or, to quote the words of the anxious Pip once again '. . . the secret was such an old one now, had so grown into me and become a part of myself, that I could not tear it away . . .' If Dickens is indeed creating an image of his childhood here, it is in a spirit quite different from that which launched the energetic Copperfield upon the world.

Great Expectations is, in other words, a work of great psychological accuracy and observation. It is almost as if Dickens were examining himself as he wrote, determining the nature of ambition and 'gentility', and scrutinising the nature of a man whose adult life still seemed to owe so much to the horrors of his childhood. The horror – that is what Pip is most aware of, also, and in the first pages of the narrative he declares that '. . . I have often thought that few people know what secrecy there is in the young, under terror.' On more than one occasion he emphasises the 'terror of childhood', and it is through the wide eyes of the frightened child that we first see Miss Havisham and Magwitch. But although these characters have an extraordinary power and presence, like hallucinations made flesh, they derive from Dickens's own nervous

preoccupations: '. . . how strange it was,' Pip says while meditating upon his connection with Magwitch, 'that I should be encompassed by all this taint of prison and crime . . .' This was also the taint which the young Dickens felt when he walked to the Marshalsea each evening to have supper with his family – the young boy still existing within the famous novelist who never tired of visiting prisons and talking to prisoners, of writing about them in his journalism, of recreating them in his fiction.

Pip is Dickens, but Dickens is not Pip – in other words, only certain characteristics and concerns of the writer are redeployed in the creation of the fictional boy and young man. Certainly we see the presence of the novelist in such details as Pip arriving hours early to greet Estella's coach (Dickens himself was always *too* punctual) and on such occasions as that when Pip reads a book with his watch on the table so that he can stop at precisely eleven o'clock. But it would be wrong to carry the identification too far and assert, for example, that in the strange and troubled relationship between Pip and Estella Dickens was projecting something of his own friendship with Ellen Ternan – and that in the cool, self-possessed, heartless Estella he was portraying the young actress. It is most unlikely. One can only say with confidence that it was highly appropriate he should be dealing with the miseries and mysteries of love at this point in his own life: 'I thought that with her I could have been happy here for life. (I was not at all happy there at the time, observe, and I knew it well.)' Perhaps that is also why the authorial interventions in this novel are not on the same public and social level as they had been in *Little Dorrit* or *Bleak House*; the tone here is more private, sometimes a little fretful, sometimes a little sour, but with a sharp edge of self-communing always present.

It says something about his own state of mind, as well, that he suffered from a variety of neuralgic ailments throughout the writing of this novel in the autumn and winter of 1860: sometimes pain attacked him in the side, sometimes in the

face. It is almost as if he were again becoming the 'sickly' child he once had been, precisely at the time when he was recreating Pip. It was a very cold winter also, and he stayed in London during most of January in order to be close to his doctor. Nevertheless he managed to work quickly on the book, although the need to produce short weekly instalments was proving to be something of a burden. 'As to the planning out from week to week,' he wrote, 'nobody can imagine what the difficulty is, without trying. But, as in all such cases, when it is overcome the pleasure is proportionate . . .' That is the true spirit of Dickens: difficulties are there only to be overcome, troubles fought down, illnesses subdued, anxieties warded off. And so he worked on despite neuralgic ailments and the usual round of public duties and engagements which he could not now avoid.

At the end of May he took a Thames steamer with some friends in order to study the nature of the tides before he described Magwitch's abortive escape towards the end of the narrative; and then, in the following month, he organised all his dates and memoranda in order to arrive at the proper conclusion to the novel – a conclusion in which Pip walks along Piccadilly and there glimpses Estella, realising all at once that 'suffering . . . had given her a heart to understand what my heart used to be'. As soon as Dickens had finished the book, his neuralgia vanished. It is a fine ending, but it is not the one which you will usually read. For he was persuaded to change it by his contemporary and fellow novelist, Bulwer Lytton, who believed that it would be too bleakly melancholic for Dickens's readers. Dickens concurred in this judgement – he had, after all, a horror of offending or alienating his public in any way – and so softened the conclusion with the more benign words which you will find at the end of most editions.

No doubt, whatever the ending, the book would have been a success. It was almost immediately issued in a three-volume format, and the newspaper reviewers welcomed it as a return to his old 'humorous' manner after the excesses of *Bleak House*

and *Little Dorrit*. This was Dickens the 'entertainer' once again, and indeed there are certain passages and episodes here which conjure up scenes from his early fiction; the episodes concerning Mr Wopsle and the amateur players, for example, might have come straight out of the pages of *Nicholas Nickleby*. Nevertheless the real comedy of the book is darker and more troubled, just as Miss Havisham and Jaggers are quite different from Mrs Nickleby and the Cheeryble brothers. There is also an undercurrent of violence here, which is linked with the major preoccupations of the story – what is the meaning of the past which imbues the present like a stain, what is the nature of true gentility in a world where aspirations and ambitions can become mere tokens of anxiety and emptiness? It is a book about the nature of passion and the survival of guilt, a book about hypocrisy, meanness, and all those 'low and small' things of which Pip finds himself guilty. Most important of all, it is a book about growing up – and not the least of Dickens's achievements is to have written in *Great Expectations* a story quite different from that of *David Copperfield*.

There is a wonderful scene towards the close of the book; it is what Dickens would have called a 'picture', and there are times in his correspondence and in his working notes when he emphasises the power of such a 'picture' to represent the meaning of the book on a different level from words alone. The scene occurs when Abel Magwitch is condemned to death along with thirty-two other criminals: 'The sun was striking in at the great windows of the court, through the glittering drops of rain upon the glass, and it made a broad shaft of light between the two-and-thirty and the Judge, linking both together . . .' This image, of the light uniting the judge and the condemned, is one that comes to the root of Dickens's sense of life in this novel – where he lives within Pip and yet exists outside him, and where the preoccupations of his own life are lent an impersonal power. Amongst all the violence, and the sentimentality, and the melodrama, and the comedy,

there is always here some sense of transcendence, some vision-
ary apprehension which unites all the rich confusion of his
fictional world. *Great Expectations* is one of his finest achieve-
ments.

Our Mutual Friend

*O**ur** Mutual Friend* was the last novel which Charles Dickens would ever complete, and his first 'long' novel (that is, one issued in twenty monthly numbers or instalments) since *Little Dorrit* some seven years before. He actually started writing it in the November of 1863, although for two years before he had been meditating upon a new story and casting around for themes and images through which he might embody it; now that he had begun, at last, he was very eager to maintain his momentum in case he lost that initial rush of inspiration which propelled him forward. Yet to go back to the old and more elaborate way of working, after completing his last two novels in short weekly instalments for his periodical, left him 'quite dazed'. He was on unfamiliar ground in another sense, also, for it was in this novel that he dropped Hablot Browne as his illustrator and instead employed a young artist, Marcus Stone, whose work was much more 'modern' and naturalistic than anything 'Phiz' had been able to achieve. *Our Mutual Friend* was, in other words, a new start.

He was planning his narrative very carefully as a result and in his working notes he continually admonished himself to '. . . lay the ground carefully . . . clear the ground, behind and before . . . Lead on carefully . . .' In addition he wanted to keep five instalments ahead of publication, and it is clear enough that he was making such elaborate preparations partly as a 'safety net' in case his old exuberant imagination and inventiveness should begin to fail him. Indeed later on, in the course of writing, he complained to a friend that he was 'want-

ing in invention', although there is little sign of that condition in the narrative itself.

'Lay the ground . . .' he had said, and in one sense he was back on his old ground. London. The Great Oven. The place of dust and ashes. Of the outcasts, like Rogue Riderhood, and the poor, like Jenny Wren. *Our Mutual Friend* opens beside the Thames, a dark river here carrying the dead: a river which in an earlier essay he had described as '. . . such an image of death in the midst of the great city's life . . .' And in another essay, 'Wapping Workhouse', he had meditated upon the posters which announced the discovery of the drowned; these images would enter the novel also. In fact his journalistic work was often like a form of shorthand, preparing the way for the larger patterns and designs which he would establish in his fiction. Another essay helped him in that process – it had been published in his periodical some fourteen years before, entitled 'Dust: Or Ugliness Redeemed' and in the course of an account of dust-heaps the author, R. H. Horne, touched upon many of the subjects which would animate Dickens's novel – a one-legged man, a drowned man restored to life, an intimation of redemption in the very cinders of the dust-heaps themselves. Dickens had read this essay all those years before, and yet somehow its essential shape and theme had lodged somewhere within his capacious imagination, until it emerged at that time in his own life when he was preoccupied with the meaning of death and identity, with the possibilities of rebirth or resurrection, and with the strange emblems of eternity which can be found in the dank and muddy streets of London. A word about the dust-heaps themselves: they were not quite the tidy piles of waste which the name implies, but rather large mounds of household waste and ordure which sent up an intolerable stench in the heat but over which many indigent people picked their way in their search for anything of even the slightest value.

By January 1864 he had written the first two instalments and then, in the following month, he took a house in London

where he continued with his work upon the novel. He had come back to the primary site of his imagination, and in fact it was on his return to the city that one of the strangest creatures in the narrative first occurred to him. He had been looking for a character with an odd occupation – 'it must be something very striking and unusual', he had told his illustrator, Marcus Stone, and then a few days later Stone took him to the shop of a taxidermist near Seven Dials. In a book which is in part about lost identity, and the nature of being reborn, the dissector of skeletons and the purveyor of stuffed animals was clearly a suitable candidate for inclusion within the narrative. And so Mr Venus was born. Other sources for Dickens's characters were even closer to hand and there is no doubt, for example, that in the figure of the obstreperous and lordly Podsnap, Dickens was attempting at least a partial pen-portrait of his friend, John Forster. Forster had become increasingly attached to society at precisely the time when Dickens himself was becoming more and more alienated from it, and in a sense he was pouring all of his rage and contempt into the figure of this peremptory and self-righteous English gentleman. *Our Mutual Friend* is the novel in which Dickens gives full force and meaning to his estrangement from the world around him.

But who were the Veneerings? In a sense the Veneerings were everywhere – in this novel Dickens really confronts for the first time the kind of society which was being established in the latter half of the nineteenth century, a society of plutocrats and financiers, of stock-jobbing and brokering, a society of false values and false lives. That is why, in *Our Mutual Friend*, he launches a bitter assault upon all aspects of English social life and seems indeed to be returning to the radicalism of his youth. He had come full circle, with Betty Hidgen fleeing from the workhouse just as Oliver Twist had once done. In addition Dickens attacks all the rumours and gossip of the metropolis, all those who prattle about other people's lives because their own are so empty of meaning. It is hard not to feel

the presence of private disaffection here, also, since there is no doubt that there was at this time much speculation and innuendo about his relationship with Ellen Ternan. And although it would be invidious to place her within the novel itself, as some commentators have done, it is perhaps worth mentioning here that in *Our Mutual Friend* Dickens gives serious consideration to the theme of unrequited love; in this novel courtship is somehow aligned with death or the prospect of death, and love itself is sometimes foreshadowed by torturing anxiety and even madness. On a more superficial level, too, Dickens is inveighing in *Our Mutual Friend* against all the dinners and the parties, the receptions and the arranged marriages, at precisely the time he was in London, tired and sick to death of what he called '. . . public speechifying, private eating and drinking, and perpetual simmering in hot rooms . . .'

He returned for the summer to his country house in Kent, Gad's Hill Place, but it seems that there was little peace for him even here. It was now that he complained about his lack of 'invention', for example, and in this period he was afflicted by various ailments which presage his fatal stroke some six years later. When in the following winter he was sorely tried by a swollen foot his friend Forster could justly claim in his biography that there was now 'a broad mark between his past life and what remained to him of the future'. Dickens used to say that entering middle age was like walking through a graveyard, and it was in this period that his great friend, John Leech, died; Dickens was so distressed that he could hardly carry on with his work. These events and illnesses would perhaps be of little consequence at this late date, were it not for the fact that they created the very atmosphere in which *Our Mutual Friend* was written – a novel in which the dead rise up in the waters, where violence and murder take place, and where the strange crippled girl, Jenny Wren, calls out 'Come up and be dead! Come up and be dead!'

Then death obtruded even more visibly than before.

Throughout the autumn and winter of 1864 he had been travelling regularly between England and France – in particular to the small village of Condette, near Boulogne, where it seems that Ellen Ternan was living with her mother. The nature of these journeys might have remained obscure if it had not been for one event which changed the whole course of Dickens's life; in June 1865, he was travelling back on the tidal train from Folkestone to London, with Ellen Ternan and Mrs Ternan, when most of the carriages crashed down from a bridge onto a river-bank below. Fortunately Dickens and his party were in a carriage which stayed intact, but Dickens at once jumped out and gave what help he could to the dying and the dead who were stretched on the ground beside the wreckage of the train. It was an experience he never forgot, and for the rest of his life he was prone to nervous terror whenever he travelled on trains; indeed he died on the fifth anniversary of the crash itself. One other detail may properly concern us here: he was carrying the manuscript for one of the instalments of *Our Mutual Friend* in the pocket of his overcoat, but the coat was still in the swaying carriage he had lately vacated with the Ternans. With his usual cool self-possession at moments of crisis, he clambered back into the carriage and retrieved the precious chapters.

He was so shaken by the experience, however, that when he tried to finish the instalment he realised that, for the first time in his writing career since *The Pickwick Papers*, he had written too little to fill the monthly number. But he nerved himself to continue, and through the rest of the summer worked on the novel at Gad's Hill Place; he finished in September and added a Postscript rather than the usual Preface to his labours in which he mentioned the crash at Staplehurst: 'I remember with devout thankfulness that I can never be much nearer parting company with my readers for ever, than I was then, until there shall be written against my life, the two words with which I have this day closed this book: THE END'. It was the first time in his writing life that he had writ-

ten a Postscript, and is it possible that he had some intuition that this would be the last time he would ever be able to write THE END to one of his works?

He had also in the Postscript made some remarks about the difficulties of writing the novel in monthly episodes, particularly with respect to the unfolding of the necessary pattern in the narrative, but this did not mollify his more severe critics – among them the young Henry James who described *Our Mutual Friend* as '. . . the poorest of Mr Dickens's works'. Many people would now in fact regard it as the greatest of his works, and the sea-change in critical attitude may suggest that, in the case of this novel at least, Dickens was writing ahead of his time. Of course there are scenes and episodes which had an immediate impact, just as they do still, and nothing is more powerful in this novel than the invocation of the Thames in the opening chapters. '"I can't get away from it, I think," said Lizzie, passing her hand across her forehead. "It's no purpose of mine that I live by it still."' And no one can get away from it: it is the bearer of death and of life, the great dark mystery which flows through the lives of the characters congregated in this book. But the novel also contains some of Dickens's funniest scenes. Sometimes the humour is of his familiar kind, particularly when it is directed against such 'Dickensian' figures as Mrs Wilfer who ate her dinner 'as if she were feeding somebody else on high public grounds', and the Dowager Lady Tippins who shakes and rattles like a partly animated skeleton from Mr Venus's shop. But there is also more poignant and fascinating comedy here, which particularly emerges in the conversations between Silas Wegg and Mr Venus: '". . . when you were," Mr Venus tells him, "as I may say, floating your powerful mind in tea."' It is a wonderful phrase, and exemplifies one aspect of this novel – its extraordinary inventiveness and capaciousness, so that there are times when Dickens is able to bring together the comic and the sublime in such fresh combinations that they testify to his essentially innovative genius. Mr Venus and Silas Wegg are walking be-

neath the stars, for example, when the spectacle of those silent orbs seems to Silas Wegg to 'glisten with old remembrances!' In Dickens's earlier writing the stars would have revived memories of earlier and happier times but now, in the case of Mr Wegg, they inspire him only to coin a memorably vicious phrase about his mortal enemy, Mr Boffin, '. . . the minion of fortune and the worm of the hour!' And who can forget the malign splendour of the scene when the Lammles, realising belatedly that they have tricked each other, decide to play a confidence trick against the entire world?

Certainly there is no diminution of power and humour in this last novel; if anything Dickens has enlarged his range with a calm and unforced humour that can encompass both the smallest details and the greatest themes. It is a more serene and less bitter work than its immediate predecessor, *Great Expectations*, and manifests a very high level of creative self-assurance. London is no longer just a mud-stricken place of chance encounters, for example, but is so enlarged and broadened that it becomes an echo-chamber for all the desires and fears and memories which Dickens invokes in this book. It has an almost hallucinatory presence, at once both vivid and nebulous, and in that sense might stand as an emblem for the narrative itself. This is the strangest of Dickens's novels, but in many ways it is also the most poignant and the most beautiful. Just as Shakespeare created *The Tempest* at the close of his career, so did Dickens create *Our Mutual Friend*.

The Mystery of Edwin Drood

The Mystery of Edwin Drood was Charles Dickens's last work. He started tentatively to work upon it some time in 1868 – or, rather, he drafted a short interlude (which has since become known as the 'Sapsea Fragment') which anticipates certain aspects of the later novel. But it remained simply that, a fragment; Dickens could not work in any sustained or concentrated way and he found, too, that he was quite unable to write anything for the customary Christmas Number of his periodical. The fact is that now, in his fifty-sixth year, he had lost some of his once unwearying energy; he looked older than his years and his friend and biographer, John Forster, noticed a '. . . manifest abatement of his natural force'. Dickens was also suffering the slowly gathering effects of vascular degeneration and on one occasion during this period 'could read only the halves of the letters over the shop doors'; as Forster went on to say '. . . absolute and pressing danger did positively exist'. But Dickens, true to his usual form, chose to ignore or underestimate the severity of his symptoms.

Indeed in the autumn of 1868 he went back relentlessly to yet another series of public readings all over the country, a projected one hundred in all, exhausting himself each night with a performance lasting some two hours, travelling by trains which after the Staplehurst disaster left him close to panic and to sudden 'rushes of terror', unable to sleep, unable to eat, all the time wearing himself down in the vivid dramatisation of his fiction. These readings also throw an incidental light on *The Mystery of Edwin Drood*, for it was in the same period that he perfected an episode from *Oliver Twist* which

concentrated upon the terrifying performance of the murder of Nancy by Bill Sikes. Dickens believed that the audience had a 'horror of me after seeing the murderer' and there were times when he restlessly wandered the streets afterwards, himself feeling 'wanted' for murder; there could have been no better preparation for a novel in which he would effortlessly enter the consciousness of another murderer, John Jasper, and explore the recesses of a thwarted and obsessive man.

He had to stop his readings: his doctors insisted upon it, since it was clear to them (and perhaps also to him) that he was close to killing himself with fatigue and over-excitement. So he went back to Gad's Hill Place and tried to recapture his strength; but he was not completely at rest – he never was – and in the spring of 1869 certain incidents began pointing the way towards the novel which he would soon begin. Two American friends, James and Annie Fields, came to visit him and one evening he took James Fields to an opium den situated in New Court off Bluegate Fields. Here, in the East End of London, Fields wrote later '. . . we found the miserable old woman blowing at a kind of pipe made of an old penny ink-bottle'. She was to enter *The Mystery of Edwin Drood*, which itself opens in just such a place. It has sometimes been suggested that Dickens himself was something of an 'addict' towards the end of his life, but this is most unlikely. He took laudanum to help him sleep, and also to combat the effects of seasickness when he travelled, but his usage did not stretch beyond that point: that should be obvious from the opium dream with which the novel so curiously begins, since it is not a very convincing simulacrum of such an experience. For the real thing, it is necessary to turn to Thomas De Quincey's *Confessions of an English Opium Eater*. Dickens was merely imagining what it might be like. But he did not lead his American friends only into the darker areas of London life, although those were the aspects which always most appealed to him; he also took the Fields on a visit to Canterbury, where he was

dismayed by what he considered to be the listlessness and emptiness of a service he witnessed in the cathedral there: that image would also enter the novel directly. And what of the man himself in this, the last full year of his life? Annie Fields wrote in her diary '. . . it is wonderful the fun and flow of spirits C.D. has for he is a sad man . . .' Sadness: perhaps we may ascribe something of the atmosphere of *The Mystery of Edwin Drood* to that detectable mood.

For even now he was about to begin work upon it. Certain stories were occurring to him, among them one which concerned an engaged couple who do not marry until the end of the book. But then in August 1869, just after he had begun to plot and scheme, he was surprised by '. . . a very curious and new idea for my new story'. Almost at once he began to write down various titles in his memoranda to himself, and at the same time he wrote to his publishers, Chapman and Hall, broaching the idea of a new story in twelve monthly parts – his usual pattern was of course to work within the framework of twenty such monthly numbers but clearly Dickens's sense of his now more easily exhausted powers made him more cautious. Even in the contract which he eventually signed, he insisted upon a clause being added to the effect that, in the event of his death or incapacity, arbitrators would determine what sum ought to be repaid to Chapman and Hall. Mortal sickness, or even death, was clearly on his mind at this juncture in his life – how strange a mood with which to begin a new novel in which death plays a significant part.

He began his real planning in September, at which point he elaborated upon the 'curious' idea which had previously occurred to him; this would be the story of a young man murdered by his uncle, although the nature of the crime and the identity of the criminal would not be revealed until the very end of the book. The murderer would strike while under the influence of opium, and might perhaps only remember what he had done in a similar state of consciousness. It was at this point, too, that he began to meditate upon the character

of his proposed murderer, John Jasper, a man so self-divided and obsessive, so solitary and estranged, that he is like some culmination of all those mournful and anxious male characters who dominate Dickens's later novels. This is a man who is also '. . . troubled with some stray sort of ambition, aspiration, restlessness, dissatisfaction, what shall we call it . . .' and in that respect, if in no other, he resembles Dickens himself whose own restlessness and dissatisfaction had provoked exactly that sadness which Annie Fields had noticed. In his notes for the first monthly instalment Dickens wrote down 'Opium-Smoking' and then, a little later, '*Cathedral town running throughout*'; the first memorandum obviously referred to his experiences in the East End of London, while the 'Cathedral town', known as Cloisterham in the novel, is explicitly based upon Rochester. London and Rochester: in his last novel Dickens was returning to the twin sites of his inspiration; he had spent his childhood near Rochester, and had helplessly experienced its betrayal in London. And how apt, then, that at the opening of the novel both places should overlay each other: for in the fevered opium dream of John Jasper, it is not clear where one ends and the other begins. Both have been merged into a grotesque but enchanted place, part fairytale and part nightmare, the source, the origin.

Dickens had finished the first instalment by the end of October, and then worked on through the autumn and the winter. It is written in a spare, almost elliptical, prose and there is an economy or constraint about the whole narrative which suggests that he was consciously harbouring his strength. Nevertheless none of his imaginative power has diminished and, indeed, he was creating quite a new thing in his own fiction. It begins with a fevered hallucination, as we have seen, which unveils a world of death and ruins and obscure passions. It is a book about doubles, about unmotivated aggression, about murderous impulses, and there is such an atmosphere of dread and fate around it that it must rank as Dickens's strangest achievement. The dialogue is different

here, also, and is at once so precise and so complex that it bears all the marks of Dickens's constant, meticulous attention to the effects of his story.

He was not free from anxieties, however, during the course of its writing. One concerned a sudden change in his illustrator: he had asked his son-in-law, Charles Collins, to arrange the pictorial aspects of the novel but Collins became too ill to continue. Dickens had to choose another artist very quickly – and he found Luke Fildes, a young man whose 'modern' naturalistic style offers an oblique commentary on Dickens's more 'timeless' preoccupations. Then Dickens himself once more began to suffer the effects of vascular degeneration; he was in great pain, and his foot was so swollen that he could not walk. Yet none of this prevented him from giving a series of 'Farewell' public readings. This was the first time in his career that he had tried to combine public readings with the composition of a novel, but he was now so used to the work of the reader that it did not seem materially to affect his progress on the story. In any case this short series of readings soon came to an end, and it was in March 1870 that he appeared for the final time in public – '. . . but from these garish lights I vanish now for ever more,' he said to his audience on that last night, 'with a heartfelt, grateful, respectful, and affectionate farewell.'

In the following month the first episode of *The Mystery of Edwin Drood* appeared (Dickens had been writing well ahead of publication in case his strength should ebb), and it was an immediate success. More than fifty thousand copies were sold and the newspaper reviewers hailed it as a reversion to his 'old' manner. In particular they noticed the comedy of the novel, even though at this late date it is not the comedy that seems its most significant aspect. Indeed for Dickens himself during this period it must sometimes have seemed to be laughter in the dark, for even as he worked on a narrative concerned with death, his old friends began to die around him: Mark Lemon, the editor of *Punch*; Daniel Maclise, the painter who had been

a close friend of the novelist since the days of *Oliver Twist* and *Nicholas Nickleby*. Life was closing in upon Dickens, too, and it was in this period that he had a conversation with a friend about the novel he was even then writing. 'Well you, or we,' he said to Dickens, 'are approaching the mystery –' by which he meant death. And Dickens '. . . who had been, and was at the moment, all vivacity, extinguished his gaiety, and fell into a long and silent reverie, from which he never broke during the remainder of the walk.'

Yet he worked on, while it was still day. There are occasions when he seems to be spinning out the narrative a little, as if fearful of using up too much material in too short a space, but even if there is some loss of variety there is a fresh access of power and atmosphere as the novel moves towards the disappearance of Edwin Drood: the story takes place against a dead and barren landscape, but as a result its human figures seem to become all the more striking and fervent. They seem to be treading on ashes while the fire remains within them, like '. . . that mysterious fire which lurks in everything'. Dickens came up regularly to London while engaged on the novel, and at the beginning of June he was staying in the capital in order to superintend some amateur theatricals. Then he went back to Gad's Hill Place on the following weekend, intent upon pursuing his work upon the novel. On Wednesday, June 8, he went across the road to his chalet, as usual, where he continued with his work. He was now describing the light of a 'brilliant morning', and in that invocation we might recall the first sentence of *The Pickwick Papers* – 'The first ray of light which illumines the gloom . . .': so in his first novel, and in his last. In *The Mystery of Edwin Drood* that light reaches the cathedral and manages to 'subdue its earthy odour'; in *The Pickwick Papers* he had described this same cathedral through the words of Alfred Jingle – 'Old cathedral too – earthy smell'. It is as if his creative life had come full circle, returning to its origins in Rochester itself. He wrote on a little, and then ended with his customary flourish.

He was to write no more of the novel, and its unfinished state has prompted many commentators to speculate about the conclusion to the plot. Was Edwin Drood actually murdered, or does he return? Was John Jasper the real killer, or might it be someone else? These questions are of course unanswerable, but in any case Dickens was not wholly preoccupied with the machinations of the plot: he was just as concerned with creating the strange, divided nature of Jasper and in recreating a world in which all of his own preoccupations with fate and mortality could assume their true dimension.

He came back from the chalet that evening, and sat down to dinner with his sister-in-law, Georgina Hogarth. But he became very ill, and fell upon the ground. He never regained consciousness, and died just after six on the following evening. *The Mystery of Edwin Drood* was abruptly curtailed – the strangest novel which he ever wrote, and one so filled with all of his concerns that it might truly act as his last testament. It is appropriate, also, to quote some words from it which in their serenity might also act as his epitaph: it is a vision of Cloisterham, or Rochester, with '. . . its river winding down from the mist on the horizon, as though that were its source, and already heaving with a restless knowledge of its approach towards the sea'.